THIS MEAGER NATURE

This Meager Nature

LANDSCAPE AND
NATIONAL IDENTITY
IN IMPERIAL RUSSIA

Christopher Ely

NORTHERN ILLINOIS UNIVERSITY PRESS
DeKalb

© 2002 by Northern Illinois University Press
Published by the Northern Illinois University Press, DeKalb, Illinois 60115
Manufactured in the United States using acid-free paper
All Rights Reserved
Design by Julia Fauci

Library of Congress Cataloging-in-Publication Data
Ely, Christopher David, 1963–
　This meager nature: landscape and national identity in Imperial Russia/Christopher Ely.
　　p.　　cm.
　Originally presented as the author's thesis (doctoral—Brown University, 1997) under title: Overgrown corners and boundless space.
　Includes bibliographical references and index.
　ISBN 0-87580-303-2 (alk. paper)
　1. Landscape—Russia—History. 2. Nationalism—Russia—History. 3. Landscape painting, Russian. 4. Nationalism and art—Russia—History. 5. Landscape in literature. 6. Russian literature—History and criticism. 7. Nationalism and literature—Russia—History. I. Title.
BH301.L3 E49 2003
700´.4247—dc21
2002067824

"The Countryside" by Alexander Pushkin, from Stephanie Sandler, *Distant Pleasures: Alexander Pushkin and the Writing of Exile*. Copyright 1989 by the Board of Trustees of the Leland Stanford Jr. University--Used with the permission of Stanford University Press, www.sup.org.

Wet Meadow by Fedor Vasil'ev. Copyright Scala/Art Resource, N.Y.

These poor villages,

This meager nature,

Long-suffering land,

Land of the Russian people!

—Fedor Tiutchev

Dedicated to the Memory of my Father,

Thomas A. Ely

(1935–1997)

Contents

Preface and Acknowledgments ix

Introduction: Russia, Landscape, and National Identity 3

1 Arcadia on the Steppe 27

2 The Search for a Picturesque Russia 59

3 Landscapes of Nationality and Nostalgia 87

4 Outer Gloom and Inner Glory 134

5 To Paint the Russian Landscape 165

6 A Portrait of the Motherland 192

Conclusion: A Russian Sense of Place 223

Notes 231

Bibliography 261

Index 273

Preface and Acknowledgments

This study grew out of my initial encounter, several years ago, with nineteenth-century Russian landscape painting. At first glance these landscapes seemed alien and a bit impenetrable. Why were the skies so often gray? The fields so open and empty? The subject matter so obscure? And what was this fascination with mud? I'd been to Russia, and while like everyone else I knew the winters were harsh and some of the terrain not overly hospitable, this didn't seem sufficient to explain the choice to commemorate such bleak scenery on canvas. Initially the paintings appeared, as I jotted down at the time, "consciously unbeautiful." I wanted to understand why the work of these painters resembled none I'd seen elsewhere.

Little attention had been paid to Russian landscape painting in the West, and although it had received careful scrutiny from scholars in the former Soviet Union (and enjoyed widespread familiarity among the public), Russian approaches remained largely documentary or eulogistic in nature. In the attempt to form a workable interpretive framework with which to make sense of these paintings, I found it necessary to widen the scope of my original plan to concentrate only on landscape painting during the final third of the nineteenth century. Over the course of one long Russian winter, I watched almost helplessly as the project transformed into a fully interdisciplinary exploration of landscape, as an image and an idea, throughout Imperial Russian culture. I attempt here to link together expressions of, or about, the appearance of the Russian land not only in painting but in literature, criticism, travel writing, and several other fields of interest.

The attempt to cross so many boundaries may be foolhardy. I am able to offer as justification only my personal fascination with the topic and my hope that it will interest others to delve more deeply into so many questions that could only be touched on here. In writing this book I have kept in mind two primary audiences: those interested in the history of Imperial Russia and those generally interested in the development of landscape and nature aesthetics. When addressing one or the other of these groups separately, the writer is at liberty to assume a certain base of knowledge. Absent the reasonable expectation of such knowledge, I have accepted the painful necessity of attempting

PREFACE

to explain complicated historical developments and multifaceted aesthetic problems in relatively simple and brief terms.

Any effort to boil down a broad and complex subject into some essential form carries with it the unfortunate side effect of multiplying mistakes (of fact, of emphasis, of attribution, etc.). Too many mistakes, no doubt, remain here. Many more have been corrected with the generous assistance of colleagues and friends. At the risk of committing yet more errors of omission, I would like to thank the many people who have helped me along the way. To begin with, the book would not have been possible without the vision and assistance of Abbott Gleason. He introduced me to images of the Russian landscape and suggested possible ways to write about them. Subsequently, he guided the project through its dissertation stage and has never since failed to lend his generous support and advice the countless times it was requested. With her pearls of wisdom and kind encouragement, Patricia Herlihy also helped bring the book to life. Three readers, Marc Raeff, David Brandenburger, and an anonymous reviewer provided numerous corrections and valuable insights. For reading parts of the manuscript and/or offering other kinds of generous assistance, I would like to thank Mark Bassin, Jennifer Cahn, Peter Davison, Sara Dickinson, David Fisher, Cathy Frierson, Joan Goody, Mary Gluck, Shelley Hawkes, Alison Hilton, Ulle Holt, Janet Kennedy, Valerie Kivelson, Diane Kriz, Anne Lounsbery, Alisa Mayer, Betsy Moeller-Sally, Hugh Olmstead, David Pretty, Priscilla Roosevelt, Andreas Schonle, Snejana Tempest, Elizabeth Kridl Valkenier, and Jonathan Wiesen.

A grant from the Social Science Research Council facilitated the initial conceptualization of this project, and the International Research and Exchanges Board arranged for a fruitful association with the faculty of the Russian Museum. There I especially benefited from the knowledgeable and considerate help of art historian Irina Shuvalova. I also received archival assistance from Irina Lapina. Both IREX and a Fulbright-Hays Area Studies grant in 1994–1995 made possible an extended research stay in Russia. Nikolai Borovskii provided support in the early stages. I must also thank my friends and keepers in Russia: Sergei and Marina Miniaev, Dmitri and Elena Nartov, John V. R. King, Aleksandr and Irina Karol', and Tatiana Grushenko. Back home, in the publication of this book, I have enjoyed the thoughtful and generous support of Mary Lincoln. A small amount of the material presented here appeared in altered form in the journal *Ecumene* [7, no. 3 (2000): 253–70] in an article entitled "Critics in the Native Soil: Landscape and Conflicting Ideals of Nationality in Imperial Russia."

I have also received help in less tangible ways that are equally deserving of gratitude. Lucinda Ely's sensible views on language and communication, once youthfully rejected, have become a part of my

PREFACE

everyday life. Thomas Ely gave me an example of integrity difficult to live up to, but by interesting me in the study of history he helped me find a field in which I am at least able to try. Jonathan Beecher first taught me Russian history, and his ability to convey ideas in the classroom remains an ideal to strive for. Daniel Brower helped train me in the complexities of Russian history and first pointed the way toward the potential interest of Russian realist art. Emma and Jane Ely are little engines of inspiration. Finally, Lesley Davison has experienced all the important moments in the long process of writing this book. She has suffered the lows and enjoyed the highs, and she is my cause for celebration at the end of the day.

A note on translation and transliteration: In the interest of space and pacing, translations here will not also appear in the original. When possible I have chosen what seemed to me solid translations. In most cases I have made my own translations. Not a translator, I have attempted insofar as possible to err on the side of the prosaic and literal. For transliterations I have primarily relied on the Library of Congress system, but in the case of names that are well known in English (Gogol, Dostoevsky, etc.), I have followed customary practice.

THIS MEAGER NATURE

INTRODUCTION

Russia, Landscape, and National Identity

We are Russian because we were born in Russia; from birth we have breathed Russian air and gazed upon Russia's sad and desolate but also sometimes beautiful nature.
—Vladimir Korolenko[1]

If we try to examine carefully our own feeling for our homeland, we would find that this feeling in us is not spontaneous, but rather is organized and cultured, since it has been nurtured not only by the spontaneous contemplation of nature as such, but also cultivated by the sum total of a country's art, by its entire cultural tradition.
—Vladimir Solukhin[2]

In the first paragraph of his 1802 essay "On Love of the Fatherland and National Pride," Nikolai Karamzin defended Russia against a charge to which it had proven vulnerable: the severity of its climate and its lack of natural beauty. "The native land is dear to one's heart," wrote Karamzin, "not because of the beauty of its landscapes, its clear sky, or its pleasant climate." Nevertheless, he had to admit that a warm and attractive natural environment helped reinforce patriotic feelings: "I do not say that natural beauties and advantages have no effect whatever on the general love for one's native land—some lands richly endowed by nature can be so much the dearer to their inhabitants. I am saying only that these beauties and advantages are not the main foundation of men's physical attachment to their country."[3]

Although this statement is couched in an affirmation of Russian nationality, it betrays an uneasiness about the native climate and terrain. Not only did Karamzin, a founding father of Russian nationalism, take for granted that his vast native land possessed little natural beauty, he even conceded that the absence of natural beauty constituted a loss for his compatriots. The essay goes on to counterbalance this one

shortcoming with a catalog of Russia's present and future glories, but Karamzin had raised an issue that would continue to bedevil Russian "national pride" throughout the nineteenth century.

As late as 1916, Russian attitudes toward the native landscape remained problematic. The sights and scenery of western Europe had continued to exert a magnetic attraction on Russian travelers right up to the First World War. When the war began to rage in Europe, Russians capable of international travel and tourism found themselves stripped of their primary destination. For the newly formed Russian Society of Tourism and Study of the Fatherland, on the other hand, curtailment of European travel presented an ideal opportunity. These promoters of Russian tourism saw the war as a chance to finally reorient Russian travelers away from Europe toward new horizons within the empire. One of their published proposals to increase Russian domestic tourism typifies this effort:

> Our wide fatherland contains within its territory very many places which, for the beauties of nature and their cultural, historical, and economic significance, not only do not yield to, but sometimes even surpass the various regions of western Europe celebrated by the whole world. Unfortunately, the latter, having long since been more carefully equipped for visitors and become known by means of guides and different kinds of directories, to this day are considerably better known by our fellow countrymen than comparable regions of our own homeland.[4]

Unfavorable comparisons to the aesthetic spectacle of western Europe posed a long-standing problem for Russian national identity. Both Karamzin and the Society for Tourism struggled against a Russian antipathy toward the native terrain that was already commonplace in the nineteenth century. Fedor Dostoevsky asked rhetorically in *Winter Notes on Summer Impressions*, "Does there exist a Russian who does not know Europe twice as well as Russia? I say twice only out of courtesy, 'ten times' would be more accurate."[5] Indeed, Russian national sentiment was steeped in discouragement over Russia's second-rate status as a European nation. Throughout the nineteenth century, Russian travel writers reacted to the countryside of European Russia in one of two ways. Either they dismissed it as unattractive and monotonous, or they discovered in it a special rural charm and consequently bemoaned their contemporaries' lack of interest in familiarizing themselves with their native surroundings. Even as a small tourist industry was forming in certain areas during the 1880s and 1890s, the perception remained that Russians never traveled for pleasure in their own country.[6] At a time when tourism had become widespread throughout Europe, Russia remained a place to leave rather than visit. Although many tried, no

Russian travel writer ever found a way to raise widespread public interest in the rural spaces that surrounded Moscow and St. Petersburg.

There were several reasons for this lack of interest in domestic tourism. Russia's combination of a vast territory with poor roads and miserable accommodations made internal travel more arduous, as Russian writers never ceased to observe. Russian cities lacked the middle-class economic development that was one of the foundations of tourism in the West. Most importantly, the image of rural space was constructed very differently in Russia than it was in Europe. The celebration of nature that pervaded nineteenth-century Western thought played as great a role in Russia as it did in other European countries. The idealized image of a unique national terrain eventually came to represent Russia to the Russians as much as distinctive landscape imagery signified national identity in other countries. But provincial Russia was never successfully designated a *scenic* space for tourism because the Russian landscape came to acquire a special significance resistant to scenic interpretations.

This study will examine the long process by which the image of Russian rural landscape was invented and reinvented until it achieved its standard aesthetic form and special emotional force within late Imperial Russian culture. Put slightly differently, it is a history of the way educated Russians taught themselves to admire their natural surroundings. Russia adopted the concept of landscape from Europe in the eighteenth century among the flood of Western cultural importations that poured across the border from the seventeenth century onward. Prior to the Petrine period neither landscape painting, pastoral poetry, nor even the idea of scenic beauty was a part of Russian culture. For a period that lasted through the eighteenth and into the nineteenth century, landscape imagery in Russia remained almost exclusively a product of European aesthetics. Before the 1820s, representations of the native landscape rarely surpassed a rudimentary and imitative level in Russian poetry and painting. Literary landscape descriptions and landscape paintings were mostly set in nonspecific pastoral settings or in beautiful and spectacular foreign locations. It wasn't until the middle of the nineteenth century that landscape painters began to rebel against the pressure to work mostly in western Europe. Only after the need to develop a well-defined sense of national identity became a pressing cultural concern did Russia finally break with the dominance of European landscape aesthetics in order to create alternative aesthetic values capable of embracing the unique appearance of the native land.

Other cultures have undergone similar processes of aesthetic education, learning how to admire formerly inhospitable and unattractive kinds of terrain. In 1630, for example, a surveyor described a certain region of England as "solitary wilderness" with "nothing but hideous

hanging Hills, and great Pooles, that, what in respect of the murmuring noyse of those great waters, and those high mountanous, tumbling, rocky hills, a man would thinke he were in another world."[7] The surveyor was describing the Lake District, a region of England that would be recognized one hundred and fifty years later as the finest jewel of picturesque scenery in the British Isles. The scenery of the Lake District evolved from "hideous" to spectacular and charming as the English developed new ways of seeing their natural environment.[8]

In the United States during the nineteenth century, Americans likewise struggled to come to grips with the terrain of the American West. Scenic landscape and pristine nature have become some of the most important hallmarks of American identity, but aesthetic appreciation of American landscape did not arise as spontaneously as "instinct" might suggest. Rather, as Anne Farrar Hyde has shown in her fascinating study of western landscape, that appreciation resulted from the efforts of innumerable Americans, working in a variety of different capacities, to modify the ingrained aesthetic habits that first induced travelers to view the West as a miserable desert. The earliest European Americans to travel west of the prairies were often appalled by the novel appearance of what they found. The explorer John C. Fremont, on first encountering the Rocky Mountains, described them as "a gigantic disorder of enormous masses, and a savage sublimity of naked rock." The arid western plain "gave a body to the foetid creations of the infernal Regions."[9] At times Fremont simply lacked words to describe a landscape for which no vocabulary had been invented. Within fifty years of his explorations, however, Americans had developed an extensive vocabulary to describe the West and an equally substantial iconography to make it visually readable. Western scenery became one of America's treasures and the West now made a desirable destination for American travelers. Luxury resort hotels began to spring up in the "pristine wilderness."

Russia similarly required time and effort to make its native landscape understandable and admirable to an educated culture familiar with standard European approaches to the admiration of nature. The vast, ancient plain of European Russia stretches across hundreds of miles without ever rising much above one thousand feet. Russia's severe continental climate limits the variety of vegetation, and nineteenth-century rural social patterns of agricultural organization created a relatively unvarying and unspectacular countryside. From a Western perspective, as European visitors would repeatedly attest, Russia's landscape appeared empty and monotonous. Only from the 1820s onward did a few Russian visionaries begin to develop new ways to see and appreciate the landscape's special properties. With them over the next several decades, writers, travelers, critics, philosophers, painters,

photographers, and others contributed to the development of a new Russian *genius loci;* they helped invent a Russian sense of place.

The desire to identify a distinctive national space first appeared around the end of the eighteenth century, no doubt in part motivated by the creation of national landscape imagery already under way in various European countries. As England, France, and Germany were busy designating special features and characteristics of their territories as representative of the "national community," Russia began to find itself in an uncomfortable position. By the standards of generally accepted European aesthetic conventions, the central heartland of Russia, with its thick forests, level plains, and harsh climate, represented some of the least pleasant and least picturesque natural space in Europe (as well as, some might argue, in much of the rest of the tsarist empire). How was Russia to enlist its local and familiar natural environment in the effort to construct an admirable vision of the nation?

Several approaches to the reconceptualization of Russian space were proposed from the turn of the eighteenth century and throughout the nineteenth century. They ranged from the pastoral ideal of rural nature that suffused sentimental poetry, painting, and garden construction in the late eighteenth century to the touristic scenic guidebooks that began to appear during the final decades of the nineteenth century. Among these approaches to Russian space, certain images of the national landscape eventually came to dominate literary and visual representations of the countryside. This imagery constituted what Georges Nivat has called "the cult of Russian space."[10] It was a vision of the Russian countryside that made a virtue of its would-be deficiency. It celebrated the Russian landscape for its vast, level plains, its unassuming villages, and its cold and difficult environment. The very lack of picturesque scenery, in other words, became a prized attribute of Russia's national landscape. What came to be valorized in its place was the vast openness of the level, unforested steppes and plains, the uncultivated, unmanicured nature of dense forests only lightly brushed by human habitation, the seasonal extremes, and even the distinctive emptiness and impoverishment of the stubborn agricultural lands. In 1904, the art historian Aleksandr Benois poetically summarized this aesthetic (or anti-aesthetic) in his description of the landscape paintings of Isaak Levitan:

> He conveyed the ineffable charm of our desolation, the grand sweep of our untrammeled spaces, the mournful celebration of Russian autumn and the enigmatic allure of Russian spring. There are no human beings in his paintings, but they are permeated with that depth of human emotion experienced in confronting the sanctity of all things. Formal *beauty* alone did not move Levitan; on the contrary, he found "classically"

beautiful landscapes unappealing. They disturbed him just as Rembrandt had been disturbed by beautiful antiques.[11]

This new image of the Great Russian landscape first achieved a sufficiently recognizable form in the 1840s in novels and verse. It appeared in painting from the late 1860s, and shortly thereafter it began to show up in the magazines, postcards, and advertising material of a nascent Russian popular culture at the turn of the century. Subsequently, in partially altered form, it maintained a powerful presence in the Soviet era and can be seen even today in post-Soviet film and advertising. Eventually the special image of Russia's landscape became sufficiently widespread to seem normal and natural, as if the capacity to admire the native landscape had always been an essential component of the Russian national character. This study is intended to function as a *de-naturalization* of that image, a reading of the Russian landscape as a historical rather than an ontological phenomenon.

The construction of a unique way of seeing Russia's natural environment mainly resulted from the intersection and combination of three key factors: (1) European landscape sensibilities and aesthetics, (2) the special nature of Russian geography and society, and (3) the quest among educated Russians to formulate an inspirational vision of the nation.

THE IDEA OF LANDSCAPE: A EUROPEAN VIEW

When the concept of land as landscape first came to Russia in the eighteenth century, it crossed the western border from Europe in almost completely unaltered form. The word "landscape" has a complicated origin both in English and Russian, and the term itself requires some clarification before proceeding further. Betraying the complexity of the word, dictionaries give different primary definitions. The essential meaning can be summarized by the following typical pair of definitions from two modern American dictionaries: a landscape is either "a picture representing a view of natural inland scenery" or "an expanse of scenery that can be seen in a single view."[12] Although one of these definitions explicitly refers to a picture and the other describes a section of actual terrain, both definitions include natural, geographical space, and both use a visual, *pictorial* language to convey the meaning of the word. The essential concept of the term "landscape," then, includes not only the land, but also the way the land is seen, i.e., as a visual artifact, as scenery.

This combination of definitions reflects the word's complicated history. The Dutch first used the word *landschap* in the 1500s to refer to a tract of land. Toward the end of the sixteenth century, when Dutch

painters began to produce images of nature as artistic works in their own right (as opposed to landscape as setting or background) *landschap* was the term they applied to this new kind of painting. As a genre of painting, the word was introduced into Elizabethan England in 1598, after which thirty-four years later in 1632 one finds the first recorded use of the word "landscape" to indicate a view of actual terrain.[13] Thus, over a relatively short span of time "landscape" had regained its former meaning as a way of referring to a tract of land; only now that meaning had fundamentally altered. "Landscape" now referred to land that was viewed in a way consonant with representations of land in paintings. To be able to conceive of the land in aesthetic, pictorial terms required a shift in perception brought about most directly by the invention of landscape painting. The idea of landscape, then, provided a new way of perceiving the surrounding world; it brought about, in the words of Denis Cosgrove, "an imagined relationship with nature."[14] In conjunction with this transformation, nature began to take on a new burden of aesthetic and emotional content. This reconceptualiztion of the natural environment along aesthetic lines meant that a tract of land could now be categorized as beautiful, awe-inspiring, monotonous, quaint, frightful, etc.

Both of the above dictionary definitions exist in Russian as well, although the Russian possesses a bit more refinement, having adopted two words to refer to landscape—one, *peizazh,* derived from French and the other, *landshaft,* from German. Both Russian terms include the dual English meanings of a geographical space and a painted image of geographical space, but in Russian they are used with different shadings: *peizazh* typically connotes the artistic, pictorial sense of landscape, while *landshaft* usually refers to a visible section of terrain.[15]

The most important thing to emphasize about the history of landscape is something too often taken for granted: human perception of nature is not direct and unmediated; it is not "natural." That perceptions of the natural world are culturally constructed is borne out by the global history of nature representation in art. In ancient Egypt, illustrations of natural objects offered the viewer maplike, diagrammatic forms, with no particular angle of vision predominating, so as to provide the most information in the clearest possible way about the natural objects portrayed.[16] This type of imagery contrasts sharply to what we understand now to be more realistic: the representation of nature in *naturalistic* linear perspective. In the Hellenic world, not until the belief in a nature populated by gods began to wane did a new interest in bucolic poetry arise among the later Greeks and Romans.[17] Ancient Rome pioneered the pastoral ideal of the countryside as a relief from the increasing urbanization of Roman life, and only in this period does one begin to see some evidence of landscape depiction in Roman art.[18]

The art and poetry of the Middle Ages, by contrast, reflects a society that expressed little appreciation of natural scenery. For centuries in western Europe, a Christian, spiritual aesthetic partially eclipsed the development of an aesthetic of temporal space.[19] Entirely independently, China developed a powerful form of landscape imagery that served the purposes of a Taoist vision of order and eternity in nature.[20] In short, landscape in any given place or time must be understood as a product of culture and history.

Familiar contemporary conceptions of landscape emerged in western Europe around the same time as capitalism and modern science, and landscape is closely associated with these innovations.[21] The development of landscape in painting and the celebration of nature in literature occurred at a time when religious explanations of the natural world were losing their formerly unshakable grip on European minds. At the same time, Europeans were collecting in greater and greater numbers in cities, cutting themselves off from an immediate relationship to the land. Landscape painting not surprisingly originated in the two most urbanized parts of Renaissance Europe—Italy and the Low Countries. Whereas the feudal world had been relatively self-contained, these new societies were in the process of reenvisioning spatial relationships on a geographical map of increasingly powerful political states and engendering economically beneficial interdependence on a newly globalizing scale. The medieval imagination of nature as a vertical structure connecting human beings to the sacred and profane realms did not suffice to explain these new horizontal, intraregional connections that linked together the near and distant peoples and places of the secular world. As the configuration of societies altered, the surrounding world had to be explained anew.

In science one learns to think about the infinite mass of nonhuman material according to certain organizing structures of knowledge such as maps, taxonomy, or the theory of gravity. Landscape supplied another method to help people ascertain the meaning of nature, another means by which to conceive of the surrounding world. Its organizing principles were based on visual aesthetic structures such as composition, color, and scale, rather than on such empirical foundations as experimentation and classification. But both science and painting provided new ways to make sense of secular space, or the physical world, at a time when European explorations and conquests were making such innovations a necessity. In this sense landscape can be understood as a cognitive structure that tells us how to process the "data" of nature, which our visual faculties are built to receive.

As an approach to nature, landscape painting was, of course, constrained by the limitations of genre and technique. In this respect, it is interesting to note that the creative ways with which painters learned

to surmount those limitations has had a lasting impact on our perception of nature. Among the important landscape painters at work during the first half of the seventeenth century, none had such an impact on the future course of landscape painting and the perception of scenic beauty as Claude Lorrain. Claude took as his subject the Roman countryside. Through the application of a remarkable new use of perspective, he softened and transformed rural Italy into a tranquil world of classical, pastoral delight. Not only do Claude's images convey an idealized rural harmony, they also seem to stretch on endlessly, deep into a vast distance. His landscapes impress upon the viewer a sense of timeless tranquility and boundless beauty. He achieved this effect through the elaboration of certain visual techniques. Among others, he raised the vantage point of the viewing eye that contemplates the scene, framed the distance with buildings or trees, and alternated bands of light and dark that propel the eye forward into the perspectival depths of the painting.[22]

By the eighteenth century, the Claudean landscape had become popular and influential throughout Europe, especially in England: "It was Claude who first opened people's eyes to the sublime beauty of nature," writes E. H. Gombrich, "and for nearly a century after his death travellers used to judge a piece of real scenery according to his standards. If it reminded them of his visions, they called it lovely and sat down to picnic there."[23] A tinted-glass viewing device called a "Claude glass" assisted the traveler in the attempt to imagine some section of real terrain as a unified and soft-hued view reminiscent of the master's paintings.[24] Claude's influence crossed over into other art forms. The "topographical poets" in eighteenth-century Britain (including James Thomson) were deeply affected by Claude's perspectival construction of landscape.[25] In Thomson's extremely popular descriptive poem *The Seasons,* one can observe the degree to which a visual understanding of nature had come to dominate European consciousness. Claudean landscape also served as an important model for the reconstruction of English gardens and parks that was subsequently exported to the rest of Europe.

Other landscape painters of the sixteenth and seventeenth centuries—among them such figures as Albrecht Altdorfer, Salvator Rosa, and Nicholas Poussin—tended to emphasize the dramatic in nature rather than Claude's tranquil ideal. Under the influence of these and other landscape painters, viewers developed the capacity to envision the natural world as a set of different aesthetic types. As interest and enjoyment in landscape grew, a body of aesthetic theory appeared in the eighteenth century to provide a logic for the pleasure produced by natural scenery. Scenic beauty had initially acquired theoretical legitimacy as an expression of geometrical perfection and classical form. Later, Edmund Burke explained the growing interest in sublime nature

imagery by appealing to the complexity of human psychology and its fascination for spaces outside the frame of everyday reference.[26]

Another important influence also shaped European conceptions of landscape in the late eighteenth century: the idea of the picturesque. With respect to landscape painting, the English concept of the picturesque derived more from the work of Rosa and the Dutch landscapists than from Claude. It distinguished itself—both from the regularity of classical beauty and the awe-inspiring appearance of the sublime—as an aesthetic of rustic irregularity. The picturesque landscape celebrated, for example, the overgrown unevenness of forest clearings, vine-covered farmsteads, craggy cliffs, and the well-situated mills and brooks of a simple, unpretentious countryside. Picturesque nature resembled the ideal of nature found in paintings, but it was a more naturalistic ideal than had been represented in the aesthetics of the beautiful and the sublime. As a result of the widespread popularity of picturesque landscape in the late eighteenth century in garden construction and scenic tourism, the opportunity to admire attractive landscapes increased dramatically. Admirable scenery became accessible to a greater number of people who lacked the means to travel to such well-designated tourist destinations as Italy or the Alps. The picturesque helped make it possible for tourism to thrive closer to home. Picturesque tourism became the rage in Britain in the late eighteenth century, and shortly thereafter the vogue for the picturesque became widespread on the Continent as well.

Admiration for landscape received another boost on the European mainland during the eighteenth century with the reinforcement of the Alpine pastoral in the work of such Swiss poets as Solomon Gessner and Albrecht von Haller. These poets were quite popular in their day, but the writer who ultimately played the most important role in disseminating a new European admiration for Alpine scenery in particular, and nature in a wider sense, was Jean-Jacques Rousseau. In essence, Rousseau transformed the pastoral ideal of rural life into a philosophy. He envisioned contemporary society as corrupt and saw its population as removed from the original purity and virtue it possessed when humanity had been more closely linked to nature: a modern update of the golden age. To rectify the dismal situation in which humanity found itself, he advocated different methods of returning to the state of nature, from the model of a socially uncorrupted education to walking tours in pristine mountain scenery. Rousseau's philosophical appeal to nature further stimulated interest in natural scenery and scenic tourism.[27]

Many other factors shaped European conceptions of nature and landscape, and only the most cursory overview is possible here. Above all, this summary of some of the main trends of European landscape aesthetics should suggest the interconnectedness of landscape and his-

tory. The common idea that landscape images are simple reflections of nature gets the equation backward. It would be more accurate to say that ways of seeing nature are determined, to a large extent, by the historical development of landscape imagery. The new emphasis on a visual appreciation of the natural world meant that the specific kinds of landscape to which viewers had access was most likely to receive their admiration. In other words, pastoral landscape as we know it would be unthinkable apart not only from the influence of Claude, but also apart from the Italian countryside itself. Similarly, visions of sublime landscape would be very different without the Alps, and the rustic picturesque remains inextricably linked to rural Britain. These geographical terrains helped produce the imagery, and later the aesthetic theory, that construed them as admirable. This basic relationship will be fundamental to any understanding of Russian landscape aesthetics since Russia's natural environment, climate, and terrain so greatly differed from those spaces that informed European scenic ideals.

Our visual experience of nature, then, is a cultural experience. As the islands of the ancient Greeks were populated by gods, or the forests and streams of Russian peasants teemed with *besi* and *rusalki,* so the leisured eighteenth-century European's nature was abundant with picturesque scenery and the chance at a glimpse of a fine prospect. Need it be said that our present interest in wilderness, wildlife, and ecosystems shape and color our own perceptions of the natural world? The new modern European landscape aesthetic first expressed itself in pictorial images. With time a pictorial sensibility came to dominate representations of nature in literature and engendered a new leisure pursuit known as scenic tourism. This pictorialization of the natural world remained a fundamental part of the way Europeans understood their surroundings throughout the nineteenth century.

THE RUSSIAN LAND

Between the sixteenth and nineteenth centuries, Europeans learned to take aesthetic pleasure in the natural spaces that surrounded them. Russian landscape was an unknown quantity for most Europeans in this period; consequently it did not exert any notable influence on the landscape aesthetics that had arisen in Europe. Russian rural space differed a great deal from most of western Europe, perhaps the most obvious difference being the extent of the territory that comprised the Russian Empire. By the eighteenth century the empire already encompassed a huge expanse that included numerous smaller ethnic populations and a wide array of different terrains, from the Scandinavian north to the temperate Crimea in the south, from the mountainous Caucasus to the Central Asian plains. There were many other geographical regions within the

vast extent of the empire as well, so to speak of any single landscape of the entire Russian Empire would be absurd.

What boundaries, then, have been marked out as the subject of this study? It is possible to identify a relatively uniform and vast area considered to be the Russian heartland of the nineteenth century: the territory that stretched from the western borderlands to the Ural Mountains in the east and from St. Petersburg in the north into the steppe lands of the south. This area contained the most populous section of the Russian Empire. It included all of western, or European, Russia, and (with certain qualifications) parts of today's Ukraine and Belarus. All other regions and landscapes were largely considered foreign to native Russians. Such parts of the empire as Finland, the Caucasus, and the Crimea were looked upon as foreign lands in the nineteenth century, as they are in the late twentieth century. It should also be mentioned that Russia officially included the territory of Siberia, but Siberia was understood mainly as an exotic frontier rather than a native region, at least during most of the period under consideration.[28]

Ukraine, or "Little Russia" as it was often referred to by Russians during the last century, had an even more complicated identity and played an ambiguous role in Russian conceptions of the native terrain. It was considered foreign at certain times and native at others. Ironically, apart from any consideration of Ukrainian landscape and national identity, the geography of Ukraine made an extremely important contribution to the history of what would come to be generally understood as Russian landscape. Images and descriptions of Ukrainian territory were deeply embedded in the imagination of Russian national space, yet many today might feel that the Ukrainian landscape was unfairly appropriated by Russia to represent its native territory.

My only answer to the complexities of these overlapping boundaries and indistinct national entities is to rely on an interpretive pragmatism. It is an unfortunate fact for the historian of national identity formation (especially with respect to the multinational Russian Empire) that the definition of a nation is the antithesis of a fixed category. Even individual identity is an open and evolving subject. As a kind of collective fiction, national identities are always multiple and always open to redefinition. National identity should be understood as no more than an organizing principle of cultural self-definition. It is a process, the attempt to limit and shape the collective imagination, rather than a fixed phenomenon that can be limited and defined in and of itself. Thus, the relationship between a geographical territory and a national identity is quite often open to interpretation.

All the more so in Russia. To speak of a single Russian nationality has always been a dubious proposition. Historically, Muscovy contained a congeries of peoples and principalities. After the Muscovite

consolidation in the sixteenth century and the establishment of the empire, the Russian tsars continued to conquer and partially assimilate widely different peoples across a huge and expanding territory. In this way the Muscovite empire came to dominate a large amount of land and ultimately succeeded in asserting itself to the world as the true and essential land and people known as Russia. In consequence of this Muscovite domination, it bears repeating that this study will concern itself primarily with the identity of Russia as articulated by Russian elites and as pertaining to Russian territory and landscape. It must be kept in mind, however, that the boundaries of Russian identity have always been fairly permeable, and they have not been resolved entirely by Russians, Ukrainians, Siberians, and many others to this day. Nikolai Gogol makes a good example of the undecided character of Russian identity in the nineteenth century. An important figure in the following pages, he was a Ukrainian obsessed with the problem of Russian identity, who wrote rapturously about the Russian countryside; at the same time during his adult life he was an inhabitant of Russia, who wrote nostalgic, romantic tales in support of a separate Ukrainian consciousness and spirit.

Its own great size notwithstanding, European Russia possesses a distinct and definable geographic form. In essence it is a massive, level plain running for many hundreds of miles east to west and north to south.[29] It is an ancient terrain that has remained relatively unaffected by more recent geological shifts that brought about, for example, the formations of the world's major mountain ranges. Through geological time this eastern European plain has remained extremely stable. Its essential movement has been characterized by one geographer as "slowly to subside or sag, thus creating an enormous basin-like lowland."[30] The territory is so level that the Russian word for mountain, *gora*, does not discriminate between geographical formations that in English would customarily be distinguished by the two separate words "mountain" and "hill."[31] This lowland plain is usually subdivided north to south into three or four climatic zones representing areas of vegetation that consist of coniferous forest in the north, through mixed and deciduous forest in the central regions, to grassy steppes in the south. The region resembles the Great Plains of North America, but covers a larger territory and lacks its relative warmth and abundance of fertile land. As every traveler notes, the terrain is remarkably flat and open over vast amounts of territory, but as in the Great Plains some areas rise and fall in undulating hills. Much of the north is thickly forested and swampy while the south tends to be level and open and more suitable for agriculture.

To appreciate what Russians would be up against in attempting to produce a viable aesthetic image of their native terrain, it is instructive to note the responses of nineteenth-century Western tourists to the

scenery they encountered in Russia. European and American travelers usually found something picturesque to admire in the Russian landscape, from lakes to forests to the striking cupolas of Orthodox churches. While the objects of admiration tended to differ from one traveler to another, there was remarkable consensus with regard to Russia's overall appearance. The following three visitors described the landscape in typical fashion:

> [The Russian countryside contains] immense plains of sand, endless morasses and interminable forests in the north, and steppes in the south. . . . There is little enough to vary the monotony of the journey; the miserable villages with their wretched inhabitants scarcely serve to enliven the scene.[32]

> The traveller sees little around him but perpetual forest or perpetual waste. The country is dreary, an occasional telegraph pole, or a solitary birch tree, are all the companions the passer-by will have on his route. . . . No nicely trimmed hedges, no honeysuckle-covered cottages, must the traveller expect to pass on a Russian road. Nothing but staringly ugly wooden boxes, most painfully destitute of colour or picturesqueness, will he have to look upon. All is ugliness, paleness, and sadness.[33]

> To the tourist in search of the picturesque, accustomed to the variety and beauty of Tuscan hilltowns, to Rhine eyries, or to the glowing splendor of the East, Russian provincial towns would be the abomination of desolation.[34]

These travelers were expressing themselves in a similar way because the expectations they brought to Russia were similar to begin with.[35]

In the travel memoir of a French writer, the Abbé Chappe d'Auteroche, one finds a similar response to Russia's comparatively unvaried terrain. The Abbé remarks that to him Russia's coniferous flora seemed "ever the same . . . the gloominess of its color saddens the most cheerful disposition." Such criticisms of Russia provoked a storm of rebuke from Catherine the Great in her *Antidote* to his book. She replies to the above passage with a question: "Is it [the trees] that are likely to make people splenetic? Or is it you that are giving a bad turn to everything?"[36] Catherine had a point, but foreign visitors also had good reason to agree on the appearance of Russian scenery. The landscape produced a distinct impression on foreign travelers because geography and society had conspired to endow European Russia with a unique physical character.

Perhaps the most extensive foreign descriptions of Russian scenery in the nineteenth century were written by the French historian of Rus-

sia, Anatole Leroy-Beaulieu. Leroy-Beaulieu was something of a geographical determinist. He interpreted Russian history according to the influence of Russia's landscape and climate, and he did not shy away from the sweeping generalization that Russia's national character and social life were in part the product of a harsh climate and a monotonous terrain. Despite this suspect interpretive framework, Leroy-Beaulieu paints a portrait of the Russian countryside with the kind of attention to detail that suggests long familiarity and careful study. His landscape descriptions provide a useful departure point for the study of the Russian image of national landscape.

Leroy-Beaulieu identified two opposing traits that, taken together, characterize Russia's landscape: "amplitude and vacuity." He believed the visitor's sense of Russia's vast size was compounded by a uniformity of terrain and vegetation that clearly distinguished it from Europe:

> Huge areas show no variety, either in forms or colors. In live and inanimate nature alike, there is an absolute want of grandeur and power. Picturesqueness is either totally absent or appears on such a minimum scale as leaves it imperceptible to a foreigner's eye. Travelling over these undulating plains, where towns and villages are sparsely scattered, produces almost the same feeling of satiety as a sea-voyage. When embarked on a long railway trip, one can, just as on board a steamer, close one's eyes at night and reopen them the next morning without being made aware of a change of locality. Only some few cities, rising in tiers on the margin of rivers or lakes, with their old walls and colored cupolas, such as Kief, the two Novgorods, Pskof, Kazan, present from a distance an imposing front. The very size of the rivers impairs their beauty; it is in vain that one bank rises into high acclivity, sometimes overgrown with handsome trees; no matter how fine in themselves, they are always too low for the width of the stream and look crushed. . . . Everything in Russia suffers from this want of proportion between the vertical section and the horizontal plan of the landscapes.[37]

Along with other European visitors, Leroy-Beaulieu took the landscapes of western Europe as his aesthetic departure point. Russia came up lacking in the above passage, and in many of his other descriptions as well, because it was different from the landscape he knew how to admire

Another major difference, which Leroy-Beaulieu and other descriptive writers pointed out, concerned the impact of Russian agricultural practices. For centuries the comparatively small, prosperous, and densely populated European countries had been undergoing "the clearance of woodland, the drainage of marshland, and the reclamation of wasteland and heathland."[38] Similar changes took place in Imperial Russia too, but the country's massive size limited the extent to which

the population needed to, or even could, transform the face of the land.[39] As the population grew, the people moved outward: to the north, to the steppe, to Siberia. In a vast and relatively underpopulated country it was not as necessary to improve cultivation or rural organization. The uncultivated, overgrown appearance that often struck the imagination of foreign visitors was, in this sense, directly related to the seemingly inexhaustible space that comprised the Russian Empire. As for the appearance of the Russian agricultural countryside, again one of the most extensive descriptions by a nineteenth-century visitor comes from the pen of Leroy-Beaulieu:

> The fields here have none of the life and variety that they often have in other lands. . . . There is hardly any juxtaposition of different crops that give so much animation to our Western countryside. It's as if everything is the same field stretching out to infinity, broken only now and then by vast fallows. Not a hamlet, not a house, not an isolated homestead. On the steppe as in the forest, the Russian seems afraid to find himself alone in the immensity of his environment. Communal property . . . augments the default of nature; it deprives the Russian of those enclosures, of those capriciously shaped hedges, which are much of the charm of the villages of England and Normandy. Instead there is the mournful flatness, the dull boredom of the impersonal and collectivized countryside where the fields lie undivided in long, equal, and symmetrical strips.[40]

For similar reasons, Russia did not boast the picturesque sight of individually situated, rustic peasant cottages, or other simple architectural structures punctuating the landscape as they did with greater regularity in much of western Europe. As for the upscale rural domicile, the sometimes modest, sometimes majestic homes and villas of the gentry landowners tended to appear as oases in the otherwise nondescript countryside of foreign travel description. Their general absence as scenic sites probably suggests their proportional (relative to the vast size of the countryside) inability to contribute to the overall appearance of the land. In accordance with the estate system, Russian peasants mostly lived in small and compactly settled villages. By all accounts these villages presented an appearance of uniformity throughout the territory. "Russian hamlets are so closely modelled on a common type," wrote one traveler, "that when you have seen one, you have seen a host; when you have seen two, you have seen the whole."[41]

We will see just how differently this same space would be interpreted by Russian viewers favorably disposed to it. But for all the difference in interpretation, a similar basic picture of Russian landscape can be recognized in widely varying perspectives. Provincial Russia had to be reinterpreted by Russians who wished to sing its praises. A new landscape

aesthetic had to be invented, and a new descriptive language of images and words made to animate what European eyes saw as "the mournful flatness, the dull boredom" of the Russian countryside.

LANDSCAPE AND RUSSIAN IDENTITY

Thus far only a small number of scholars have examined the development of a distinctive national landscape imagery in Russia. A brief discussion of earlier considerations of the topic will shed light on my own approach. The closest of these studies in time period and subject matter to the present volume is Kirill Pigarev's *Essays on the Russian National Landscape in the Mid-Nineteenth Century* [*Russkaia literatura i izobrazitel'noe iskusstvo: Ocherki o russkom natsional'nom peizazhe serediny XIX veka*] (1972).[42] In this study, Pigarev explores the relationship between literary and visual landscapes in order to trace the image of Russian nature from around 1825 to 1880. Faina Mal'tseva's *Masters of Russian Realist Landscape* [*Mastera russkogo realistecheskogo peizazha*] (1952) covers similar ground, but she limits her focus to the development of landscape painting.[43] Both works have proven invaluable resource guides, and both offer interesting and useful insights about the creation of a national response to the native landscape. Pigarev and Mal'tseva, however, conceived of landscape imagery in the progressive, dialectical terms of Soviet Marxist analysis. As a result, their methodology and conclusions differ significantly from my own.

For both scholars, Russian literature and painting in the nineteenth century were working to overcome false, inherited conceptions of landscape in order to create a naturalistic and genuine portrait of the Russian countryside. From this point of view, Russian realist writers and painters engaged in a heroic, progressive *realization* of Russia's natural environment. This interpretation of landscape aesthetics harmonized with Soviet approaches to the development of art and literature that placed realism at the apex of artistic achievement. It thus recapitulated the nationalistic goals of the original pre-Revolutionary writers and painters. Without challenging the assumption that Russian writers and artists simply engaged in an uncomplicated struggle to accurately reflect the pre-existing beauty of Russia's natural environment, Pigarev and Mal'tseva overlooked any sense in which the realistic images they produced might also have supported a new and different *idealization* of the countryside.

Mikhail Epshtein's *Nature, the World, the Mystery of the Universe* [*Priroda, mir, tainik vselennoi*] (1990) has approached the representation of nature in Russian poetry from a point of view quite unrelated to the historicist framework Pigarev and Mal'tseva adopted. Yet in formulating a new way to understand Russian landscape imagery, Epshtein must

emphasize nationality to an even greater degree. His analysis seeks out the interrelationship of all Russian nature poetry. It is dedicated to the notion that a "megatext" of Russian conceptions of nature can be discerned in the collective body of Russian poetry from the eighteenth through the twentieth centuries. In an exhaustive and methodical study of the nature imagery of 130 poets, Epshtein attempts to distinguish a "system of landscape themes" in Russian poetry in order to discover the underlying structure of the entire culture's relationship to nature.[44]

The most significant contrast between the foregoing studies and the present one is that here Russian nationality will not be treated as an unproblematic first principle, but rather as a cultural construction. A prototype for my own approach is Georges Nivat's short essay "Le Paysage russe en tant que Mythe" (1987), which recognizes the creation of a special mystique of Russian rural space as one of the foundations of Russia's national identity.[45] Nivat uses the term "myth" to designate a widely disseminated conception of the landscape that helps make it possible to envision the nation as a singular entity. While Nivat credits nineteenth-century Russia with the invention of new conceptions of the native land, his primary interest lies in their elaboration in the early twentieth century. I agree with him that new approaches to the native landscape constituted a founding myth of Russian national identity. In contrast to Nivat, however, I will focus on the origins of that mythology and on what its shifting articulation can tell us about the way Russia learned to conceive of itself as a collective national entity over the course of the nineteenth century.

It should be noted that "the myth of Russian space" by and large originated in Russian art and literature. The construction of national identity transcended the arts, of course, but discussions of nature and landscape were considered an aesthetic matter; thus, a majority of the material analyzed here has been found in the aesthetic spheres of poetry, novels, painting, and literary and art criticism. The related genre of travel literature also concerned itself with the appearance of Russian scenery, and it provides an equally important base of materials. Academic fields—most obviously geography but also history, philosophy, ethnography, and others—at times registered important contributions to the aesthetic construction of Russian terrain. They will make an appearance here as well, but even in the case of geography the focus was not essentially aesthetic as it was in the spheres of the arts and a great deal of travel literature. Thus, these academic specialties provided less impetus to the development of a Russian landscape aesthetic. Still, as much as this study will emphasize sources in art and literature, it does not aim to further our understanding of these subjects as self-contained fields. Instead it extracts descriptive material from the confines of its specific generic boundaries and places that material into a larger cul-

tural context, into what might be called an ongoing public conversation about the Russian landscape in the nineteenth century.

Although such use of literary and artistic sources cannot help but violate the integrity of individual artistic works, I do not believe this methodology necessarily runs against the grain of their wider cultural significance. In my view, the most satisfying works of art speak in a wide variety of voices with which they contribute to a large number of different concerns. I hope to show that Russian art (and its criticism) was deeply involved in national identity formation, in this case through contributions to the creation of Russian landscape imagery. In Russia in particular, art and literature were receptive to discussions of public and political import because they operated in a context of political repression in which they often served as one of the few ways to voice unauthorized ideas.

The aim of this book, then, is not to explore the quality of artistic products or the sensitivity and ingenuity of their producers. On the contrary, it will intentionally emphasize the most public and widely disseminated depictions of Russian landscape across a broad spectrum of cultural endeavors. I am interested here in commonplace, even hackneyed and mundane, representations of the Russian countryside as well as the most brilliant. The following pages explore an evolving public discourse of images and words that allowed the Russian landscape to come into play as a kind of aesthetic knowledge and shared perceptual experience available to educated Russians. Once the image of a national landscape had appeared throughout an interconnected network of media—the painting resonating with the tourist guide or the Pushkin verse influencing the scenic postcard—it came to be understood as a simple fact of perception and experience shared by the individual members of the nation as a whole.

That the image of a special national space should become, in the words of Nivat, "one of the most constant characteristics of Russian identity" resulted from the emphasis placed on nation building in nineteenth-century Russia.[46] Indeed the construction of national identities was progressing rapidly throughout Europe in this period, with far-reaching consequences. In the present day we all learn early on to think of nations not as ideological constructs but as discrete material entities, "so 'natural' as to require no definition other than self-assertion."[47] Nationhood is one of the most widely accepted and least contested of modern ideologies. As innate and fundamental as the idea of the nation may seem today, in fact modern concepts of nationhood—including participatory citizenship and shared identity—originated only relatively recently, toward the end of the eighteenth century.

The modern nation-state was founded on the development of a powerful sense of interrelatedness among vast numbers of people not

necessarily closely connected to one another. In order to reorient individuals away from non-national affiliations, i.e., to local regions or separate religious faiths, supporters of nationality reinforced extant commonalities, such as shared beliefs, a common language, or adherence to some political movement. The sense that individuals lived within a national "community" was also facilitated by the spread of print media, which fosters an illusion of identification among people who can read the same language.[48]

Further tightening the bonds of shared nationality, measures were taken to reinforce the sense of belonging to a "natural" or at least historically primordial collective. In this effort, single central languages were made to dominate national parlance; historical texts worked to reenvision the past as the shared inheritance of all the nation's inhabitants; and symbols as diverse as flags, slogans, and architectural monuments were created or recruited to embody national ideals. In conjunction with all of this, geographical territories were reinterpreted from their premodern identities as a collection of separate localities or regions with relatively permeable boundaries into the modern inviolate national homeland, the material benefits and scenic beauty of which became the national birthright of all the nation's citizens. Some theorists of national identity have even argued for the primacy of this territorial dimension in the formation of national communities. Edward Shils, for example, sees the interaction of history and geography as fundamental to a consciousness of shared nationality: "the connection with the past is effected through descent but what is transmitted is not blood and not physiological features . . . but rather the relationship which ancestors had in and to the territory."[49]

The acceptance of a national identity thus concealed the arbitrariness of belonging to such a large and amorphous entity as the modern national state within the mythological trappings of an innate, collective unity. By these means and others, individuals acquired a sense of belonging to a group the vast majority of whose members they would never meet. The more the nation appeared to be an unchosen and unquestioned affiliation, the more effectively could the individual's sense of duty to the community be accessed and made productive. Historically, the nation concept has proven remarkably tenacious, generating staunch adherence with relatively little dissent.

In certain western European countries, national consciousness was inseparable from the struggle for civic participation and citizenship. As individuals acquired an active role in self-government, through suffrage or other means of participation, they could point to a tangible connection between themselves and the whole. Similarly, governments could justify themselves by citing the entire people as the source of their legitimacy. In Imperial Russia, on the other hand, the state severely limited

opportunities to participate in or influence government.⁵⁰ To their supreme frustration, educated Russians had attained the knowledge to be able to contribute to the government of the empire, as well as the awareness that influence on government was possible in countries not far removed from their own, yet they had to live with the arbitrary rule of an autocracy jealously protective of its own authority.

The resulting emergence of a sturdy tradition of radicalism and utopianism is well known. In the meanwhile, Russia's stunted reform-era civil society also had a powerful effect on the construction of Russian identity. While one reaction to the burden of autocratic rule was utter repudiation of its essential tenets, another, not necessarily incompatible, reaction sought out positive features of Russian culture and society to hold up as a countermodel to the democratizing, industrializing, bourgeois West. In other words, Russia was reenvisioned as an answer to Europe. In this sense the frustrations of Russian civil life also helped engender the habit of theorizing and proclaiming Russian national supremacy—the tradition of Russian exceptionalism. "The Russian soul," "Holy *Rus'*," "The Russian Idea": such concepts have all claimed to represent something deeply meaningful, surpassing ordinary description, that distinguishes Russia from other countries and marks it as a superior land with an important message for the civilizations of the world.

More than thirty years ago, Hans Rogger's study of a nascent Russian national consciousness in the eighteenth century described national identity construction in Russia as a process that began to take place after 1812.⁵¹ Until recently, however, relatively little scholarship has directly addressed Russian national identity formation as a discrete subject of historical inquiry.⁵² Lack of attention to this crucial issue probably can be attributed to the dominating presence of other overt ideological influences—from autocracy and empire building to radical populism and pan-Slavism—that overshadowed and complicated the definition of Russian identity for contemporaries and historians alike.

The following pages will approach the topic of national identity formation through the lens of Russian landscape imagery. To be sure, the beauty or special character of the land never served as one of the most important foundations of Russian identity. As signifiers of Russianness a number of symbols and institutions took precedence over appeals to the appearance of the native terrain. Among these we would have to include the figure of the tsar (historical and mythical), Russia's imperial power, its military accomplishments, the Russian language, Orthodoxy, and the idealized *narod*. And yet Russia's unique geography did play an important role in the elaboration of national identity. As a recent essay on Russian nationality puts it, writers of the nineteenth and twentieth centuries "elevated the Russian land to the status of a religion in and of itself."⁵³ By the reform era, mystical evocations of the native land had

become an indispensable motif for many writers. Fedor Dostoevsky and Apollon Grigor'iev, for example, referred to themselves as *pochvenniki,* partisans of the native soil. The views of the *pochvenniki,* despite glaring political differences, shared a certain unmistakable kinship with the radical populist writings of Gleb Uspenskii, particularly with respect to his novel *The Power of the Earth* [*Vlast Zemli*].[54] While Grigor'iev and Dostoevsky envisioned rootedness in the land and its native traditions as a path to national and spiritual redemption, Uspesnkii saw the peasant's symbiotic, if harsh, relationship to nature as the cornerstone of the national experience. Both Uspenskii and the *pochvenniki* characteristically refrained from descriptive or pictorial representation of the land they so highly esteemed. Images of landscape would only conflict with their chosen subject—the eternal union of the peasant and the soil.

This refusal to aestheticize the countryside, characteristic of many Russians in the late nineteenth century, reflects an ambiguity that will be evident throughout these pages. Russian national self-appraisal tended to waver between two extremes. At one end, the embrace of Western civilization elicited the kind of shame and self-reproach familiar from Petr Chaadaev's "Philosophical Letters."[55] At the other extreme, some nationalistic writers responded to such discouragement with bravado assertions of Russian superiority, ranging from the celebration of a culturally all-embracing "Russian soul" to the idea that the peasant commune would somehow one day heal the wounds of Europe's damaging individualism. The less concrete and determinate the national myth, the more it could be transformed into an ideal of superiority to the West. In the apt wording of Liah Greenfeld, "nobody could deny the Russian nation superiority which expressed itself in the world beyond the apparent."[56]

Dostoevsky's milestone speech at the Pushkin celebration of 1880 carried this kind of thinking to an extreme; it did so by invoking in his listeners an image of Russian space. The speech cited and drew inspiration from the Tiutchev poem after which this book is named. Acknowledging a lack of scenic beauty and grandeur ("These poor villages / This meager nature"), Tiutchev's verses turn the tables on those lands outside Russia that boasted what he considered a false external beauty and misplaced pride. By contrast to specious foreign grandeur, Tiutchev relies on a meek and suffering, heaven-sent Russian legitimacy to support his celebration of Russia: "Worn by the weight of the cross / The Heavenly King in the guise of a slave / Has passed through all of you / Native land, blessing you."[57] Dostoevsky's speech capitalized on the poem's central motif and took it even further. Dostoevsky designated Russia's humble natural environment a symbol of moral supremacy and a promise of beneficent destiny: "Why then do we not contain His final word? Was not He Himself born in a manger?"[58]

Precisely this tendency to leap into metaphysical elaborations of national glory rendered the visual spectacle of the native landscape a problematic marker of Russian nationality. For that reason it serves as an interesting and important instance of the dilemmas of Russian national identity construction. Because the image of the land had to be presented in concrete terms, it did not easily yield to idealization. The problem of a Russian landscape brought the question of national identity, so to speak, down to earth. The fact of the countryside's absolute difference from that of Europe made portrayal of the native terrain a thorny problem. Russia's initial dissatisfaction with the appearance of its landscape engendered efforts to revalue that landscape as something incomparable to, and incomparably superior to, the terrains of other nations. This process sheds light on the abiding paradox of Russia's national self-conception as a country that must (and yet never can) measure up to its own exalted aims.

Uspenskii and the *pochvenniki* chose largely to ignore the outward appearance of the landscape in favor of the inward, or metaphysical, significance of the Russian earth. Others struggled to endow that external landscape with new significance. To do so they had to create a new visual language, a new aesthetic. Their efforts are the subject of this book. "Nothing in nature is ugly," wrote Nikolai Nekrasov in 1864.[59] That the Russian landscape was inherently bleak and unattractive, many Russians with the leisure to care did not doubt in the early nineteenth century. By the latter third of the century, few were not convinced that Russia's landscape possessed merits unmatched in any other land.

The following chapters seek to document the history of this transformation. They mark out the broad outlines and key moments in the evolution of Russian landscape aesthetics. Chapter 1 examines the initial appearance of landscape in Russia during the eighteenth century in poetry, painting, travel descriptions, and gardening. It stresses the importance of inherited European aesthetics. The second chapter explores attempts to devise a unique form of Russian picturesque landscape in the early nineteenth century. Chapter 3 covers the initial crystallization of an unmistakably Russian landscape imagery during the period between 1830 and 1850. Chapter 4 explores the Russian ambiguity toward the native landscape that identified rural Russia as simultaneously bleak and beautiful. The fifth chapter examines the origins of Russian realist landscape painting in the 1850s and 1860s, and chapter 6 presents the fully realized image of the native land as it appeared in the classic realist landscape paintings of 1870–1900.

At this point the image of a Russian national landscape had coalesced into what can be considered its finished form as a marker of nationality. Silver Age and Soviet writers and artists would maintain the aesthetic image and some of the national mythology, but they would

also transform the picture of Russian landscape in ways that corresponded to their own specific concerns. Once the earlier landscape imagery entered Russian popular culture it would be changed in the process of popularization. By the end of the nineteenth century, as a dynamic aesthetic and cultural force, it had run its course. And yet I would argue that nineteenth-century landscape imagery still remains an important part of the imaginative process by which individuals in Russia connect themselves to the greater national collective. Let the introductory sentence to a post-Soviet popular geography serve as the final word in this introduction: "Central Russian nature, poor in its colors and contrasts, possesses astonishing beauty, dear and comprehensible to Russians."[60]

CHAPTER ONE

Arcadia on the Steppe

O rus! Quando ego te aspiciam?

—Horace (by way of Pushkin)

 Reading through the odic literature of eighteenth-century Russia, one is apt to pause in astonishment at the fanciful metaphors poets used to describe their land. Russia was a "Northern Eden," Petersburg a "pleasant garden." Catherine's militarily expansive empire appeared "a beautiful paradise . . . flowering in delightful peace." The tsaritsa had transformed the barren landscape into "meadows, which have been dressed in flowers" and in which "the rivers, valleys, and forests rejoice all around."[1] To be sure, such imagery was not used to depict the natural environment. Stock images like these recalled familiar tropes of paradise or the golden age in an effort to bestow praise upon the state and the person of the ruler. And yet this language was not restricted to the symbolic realm of the ode. For decades the image of ideal nature dominated Russian depictions of natural terrain as well. Not until the end of the eighteenth century would it begin to be possible to portray Russia's landscape in a favorable light without invoking pictures of an unspoiled paradise.

The essential idea of landscape—that the surrounding world can provide visual, aesthetic satisfaction—did not appear in Russia until the eighteenth century. Even then, and throughout the century, the call to admire nature was never more than distantly related to the actual terrain of rural Russia. Russians first learned to aestheticize natural space in imitation of Western models. Consequently, underlying notions of what constituted beauty in nature crossed the border from Europe largely intact. As we have seen, the beauty of nature could already mean many things, but the most prominent seventeenth- and eighteenth-century European image of admirable landscape emerged from an aesthetic sensibility that goes by the Latin term *locus amoenus*, "the delightful place." Another name for it is Arcadia. It was this pastoral vision of ideal natural beauty that literate Russians first took to heart.

Dating all the way back to the poetry of ancient Greece and Rome, the image of Arcadia had long set a standard for beautiful and enjoyable nature in western Europe. In Europe pastoral poetry and idyllic images of nature underwent a powerful revival around the time of the Renaissance.[2] But only once European culture had begun to exert a significant influence on the elite sphere of Russian society (particularly during the decades following the reign of Peter the Great [1689-1724]) did educated Russians learn to reproduce for themselves and take pleasure in a nature imagery indebted to Arcadian visions and fantasies originally inherited from the Hellenic world. Ironically, during this same period in the West, the dream of a classical golden age had begun to disperse, to be interpreted in new ways, and to lose its imaginative force. The gradual demise of the pastoral in Europe was related to a gathering interest in the specific locations and actual terrains of the European countryside. Thus, striving to keep current with Western aesthetics, toward the end of the eighteenth century educated Russians began to face the difficult problem of trying to reconcile the ideal pastoral landscape they had learned to appreciate with the physical surroundings and social conditions of the country in which they lived. The present chapter will document the rise of a pastoral landscape aesthetic in eighteenth-century Russia and trace the various ways in which Russians attempted to accommodate the new forms of landscape imagery and appreciation rapidly emerging in western European art and literature.

BEFORE ARCADIA

To better appreciate the novelty of pastoral images in eighteenth-century Russia, let us first turn our attention to earlier representations of nature in the pre-Petrine period. Muscovite Russia did not aestheticize nature in any way similar to the isolated images of pure landscape that had begun appearing in Europe as early as the sixteenth century.[3] Even though limited change was already underway, Russian Orthodoxy still dominated artistic expression and controlled Muscovite aesthetics in the seventeenth century.[4] The predominance of the Byzantine tradition in the artistic life of Muscovy effectively curbed the development of nature imagery in Russian art and poetry that would burst forth in the 1700s. Icons, frescoes, and other Orthodox art forms were put to use in medieval Russia as a means of conveying Christian ideals to the largely illiterate population. The icon aimed to draw the viewer into contemplation of the sacred realm in ways that were wholly unrelated to the development of linear perspective that had seized hold of Western painting in the fourteenth and fifteenth centuries. It was as though the geography of Christianity in Muscovy obviated the need for representations of the natural world; concentration

on the sacred realm left little room for interest in landscape imagery or descriptions of natural terrain.

A revealing instance of one Muscovite's understanding of the natural environment can be found in the autobiography of the Old Believer Archpriest Avvakum (mid-1600s).[5] The work is far from typical, but it offers a rare and interesting glimpse of a Muscovite conception of temporal space and place. As a result of his struggles with the church hierarchy, Avvakum was exiled to Siberia. Over the course of many years he wandered across a vast territory from European Russia to eastern Siberia. The autobiography manages to convey the presence of physical space in the text by marking time to suggest the magnitude of the distances Avvakum traveled, i.e., "three years was I in coming from Dauria."[6] By such means, Avvakum places the reader within a relatively well-defined geographical space. Unlike most Orthodox texts, which were primarily concerned with matters of the spirit, Avvakum's autobiography, while deeply religious, is firmly grounded in the material world.

In spite of the memoir's forceful depiction of the physical world (the horizontal plane of geography), worldly territory nevertheless plays a secondary role by comparison to the text's articulation of space along the vertical plane of God's intervention. Every topographical feature in the work seems directly connected to spiritual struggle. Natural objects fall into one of two opposing categories: earthly and unclean, on the one hand, and sacred and godly, on the other. Wilderness, for example, offers no simple and direct expression of God's grandeur. For Avvakum the degree to which nature benefits or threatens human beings is the measure of its association with a Christian morality. He describes a mountainous terrain, where hunting is difficult and conditions harsh, as the home of "great serpents," and when he discovers an area near Lake Baikal that yields to cultivation and offers excellent fishing he represents it as an earthly paradise. The Baikal region inspires Avvakum's most extended landscape description, in which he expresses his joy at having found a region "fashioned by our sweet Christ for man." In the mountainous peaks surounding the lake he perceives a fortress with "towers, stone walls, and courts, all neatly fashioned," and describes an endlessly bountiful harvest of naturally occurring vegetables and game. Still, against the admiring tone of this passage Avvakum immediately counterposes a sermon condemning the vanity, absurdity, and insignificance of mankind. For Avvakum pleasure in the land, no matter how innocent, remained pleasure. As such it was connected to sin.[7]

A predominantly sacred representation of the world persisted much longer in Russia than it did in western Europe. Before the era of Peter the Great, icon painting portrayed its religious subjects within a two-dimensional space/time format.[8] Russian icons typically gave form to

an eternal, spatially unspecific world alongside the three-dimensional, time-bound spatiality of everyday existence. Icons limited the depth of the visual plane, situating figures in a flattened, stylized pictorial world in sharp contrast to the visual experience of daily life. In this way, the iconic presentation of physical space intensified the sacredness of the spiritual sphere by reconstructing the familiar physical world as an idealized holy space removed from and superior to earthly existence.[9]

We must be careful to remember that paintings operate within a specific vocabulary of pictorial convention, and one cannot presume to know whether the predominance of iconic imagery had any impact on Muscovite perceptions of natural space. Yet, keep in mind that the icon's visual language was intended to help direct the way its viewers made sense of the world they lived in. As in Avvakum's autobiography, iconic art suggests that the Russian medieval imagination envisioned the ideal self within a mystical space, dominated by divine and profane presences. At the very least, it offered few representations of the familiar surrounding world. Next to the spiritually charged vision of the Russian icon, the mundane appearance of concrete natural phenomena may have seemed relatively superficial and unworthy of aesthetic attention.

Mention should also be made of another visual art that dates back to the Muscovite era. A common type of popular illustration known as the lubok did portray local and familiar settings in bold but rudimentary forms. Like the icon the lubok typically ignored or diminished the significance of the natural environment. Although lubok engravings and drawings situated their figures within a space that often resembled the Russian village, the environment they portrayed consisted of little more than perhaps an izba and the indication of a ploughed field.[10] Interestingly, these illustrations grew more complex and naturalistic toward the latter half of the nineteenth century, evidently influenced by more sophisticated styles of painting. As they did so, their representations of the natural environment eventually came to look more like traditional landscapes.

Given the importance of the sacred realm in Muscovite aesthetics, it is not surprising to find that those representations of the secular world that did appear in icon painting, increasingly in the late seventeenth century, tended to be sketchy, decorative, and of secondary importance.[11] As we learn from Avvakum's autobiography, it would be incorrect to argue that Muscovites never responded personally to the beauty of natural scenery. To put it more judiciously, the preconditions for affirming an aesthetic response to natural space in literature and art simply did not exist in this period. Thus, relatively scant evidence remains that could help document the aesthetic appreciation of nature or the

cultural mode of perception that Muscovites might have possessed.[12] Before the arrival in Russia of Western aesthetics, it is safe to say, little formal importance was placed on the individual's aesthetic response to the surrounding world.

RUSSIAN ORIGINS OF THE PASTORAL AESTHETIC

Only in the eighteenth century did a secular aestheticization of the natural world begin to play an important role in Russian high culture. Evidence for this new approach to nature is found in the history of Russian gardens, a subject well developed by Dmitrii Likhachev in his *Poetry of Gardens* [*Poeziia sadov*]. Muscovite Russia's monastery gardens were constructed around the image of Eden, a *locus amoensus* in its own right. The monastery sought to recapitulate paradise within its walls. Monastery gardens were fenced off from the outside world, and the cultivated, organized nature within asserted a vision of order and harmony that contrasted to the disordered, sinful world on the outside.[13]

This Christian vision of sacred natural space was later outmoded by the seventeenth-century baroque pleasure gardens built for the crown and the aristocracy. The baroque garden first introduced the idea of secular amusement into Russian experiences of nature. In the early eighteenth century, under Peter the Great, the large gardens of a newly established St. Petersburg magnified the baroque model to a grand scale, adding themes from antiquity.[14] As with the Edenic model adopted by Orthodox monasteries, baroque gardens presented themselves as distinct from and superior to uncultivated nature. In their own idiom, they maintained the strict regularity and symmetry of the monastery garden. Both such garden forms betrayed a wish to avoid or overcome the natural world through the agency of human intervention. They reconstructed nature in ways that would best suit the needs of the builder. That is, of course, what gardeners do. The difference in these early gardens from the gardens of later generations hinged on the increasing degree of interest in nature's less controlled and accommodating features.

Although itself an extreme idealization of nature, the image of Arcadia would supply the first aesthetic framework in Russia to emphasize admiration for unmediated natural space. Edenic imagery had envisioned a place to which earthly humanity could never return. Like the icon, the image of Eden existed alongside reality as an unattainable ideal for sinful humanity. Arcadia was also a fantasy location, of course, but with the difference that the pastoral imagination could more easily project outward onto the real countryside, transforming natural terrain into a stage set for the imagined experience of golden

age delights. Once Peter the Great had opened up the floodgates of Western influence, the pastoral vision, already a popular convention in western European art and literature by the seventeenth century, began to replace Orthodox Christian conceptions of idealized nature, at least among the empire's elites. By the late eighteenth century this pastoral view of nature had become the dominant code for landscape appreciation among educated Russians.[15]

The influence of pastoral imagery in Russia developed at a time when the idea of nature was becoming more and more important in the West. "Nature," as Raymond Williams has written, "is perhaps the most complex word in the [English] language."[16] Much of that complexity arose between the fifteenth and seventeenth centuries, when secular interpretations of the external world began to gain hermeneutic authority on a level comparable with the formerly unchallenged stature of Christian cosmogony. In this period, the idea of a unified force called "nature" began to generate the most influential metaphysical explanatory models of the universe (and of the role of humanity within it). Once nature had been designated as a foundational notion across the spectrum of belief—becoming in many ways a replacement for God—it could be held up as the uncorrupted opposite to a debased society.[17] The image of Arcadia thus possessed tremendous symbolic potential in the early modern period. Its influence culminated in the philosophy of Jean-Jacques Rousseau, who sought ways to return humanity to what he saw as its untainted natural condition. The reemergence of the pastoral offered an easily accessible semi-utopian fantasy based on the contrast between invidious socialization and the state of grace in nature. While pastoral ideals and aesthetics would, following Rousseau, blossom into countless varieties of idyllic vision, during the eighteenth century the ideal pastoral aesthetic still remained closely linked to time-honored forms such as warm weather, babbling brooks, greenery, pleasant sounds and smells, and amorous shepherds and shepherdesses at play. This was the essential image of natural beauty that became the cornerstone of European landscape aesthetics between the sixteenth and eighteenth centuries.

As post-Petrine Russia ushered in European conceptions of nature in science and metaphysics, so too did European aesthetics begin to flourish in the tsarist empire. Reference to nature throughout the eighteenth century was dominated by poetic and artistic conventions developed in the West. Consequently, images of nature in Russian poetry and art rarely manifested any individuality or recognizable locality, and they came to be expressed in standardized and emblematic form. When Russians began to focus on the actual countryside surrounding them, they found ways to envision it as pastoral space or to describe it

in borrowed terminology that had been devised to depict the landscapes of Italy, Switzerland, or England.

THE TOPOGRAPHICAL IMAGE OF RUSSIA

One starting place for an inquiry into eighteenth-century Russian views of the native terrain is a pair of poems that appeared in the 1720s. In 1728, Russia's first major neoclassical poet, Vasilii Trediakovskii, wrote both "Verses in Praise of Paris" and "Verses in Praise of Russia." The obvious contrast between these two short works suggests a clear difference in the way Trediakovskii envisioned the two worlds in which he had lived.[18] The banks of the Seine form a "beautiful place," as Trediakovskii repeats in every other stanza of his ode to the French city. To express his admiration for Paris, Trediakovskii employed extended, visual description, albeit couched in the most fanciful kind of pastoral imagery. With such language he managed to transform the city into something resembling an idyllic country retreat. In his equally fanciful and equally idealized encomium of Russia, Trediakovskii used a much more abstract, metaphorical language that emphasized religion, rulership, and nobility, but entirely avoided pictorial descriptions of place. At a remarkably early date, Trediakovskii's imagistic admiration of Paris, as opposed to his abstract glorification of Russia, helped establish an important pattern in Russian representations of East and West that would continue into the twentieth century: Europe seen as the land of external elegance and beauty, in contrast to Russia, the admirable qualities of which cannot be expressed in concrete, visual images but are felt nostalgically within the Russian heart.

On the other hand, one concrete image of the Russian land did play an important role in Russia's incipient national consciousness from as early as the first decade of the eighteenth century. Some attention should be devoted to this vision of Russian space before further consideration of the rise of the Russian pastoral. While scarcely interested in describing any specific natural setting, Trediakovskii and his contemporaries did portray Russian territory in their work—not as landscape proper, but in topographical images borrowed from the map. Before the last decades of the eighteenth century, maps were the only commonly available visual images of Russian space. Engravings of the period exemplify this cartographic imagination of the Russian land. These works provided the viewer with geographical, political, historical, and social knowledge about a given place or event. Views, of cities or battles for example, were organized in such a way as to offer observers maximum information rather than to create the aesthetic experience that landscape implies. In fact this genre, the *"vidopis'*,*"* or view painting, as opposed to the *"peizazh,"* or landscape, remained a subject

of study at the Imperial Academy of Arts well into the nineteenth century. In the early part of the eighteenth century, while there was still little visual interest in Russian landscape as unique or aesthetically pleasing, cartographic images served as the pictorial embodiment of distinctly Russian space.

Since such images were considered more informational than representational, the artists who engraved them felt free to indulge in wonderful flights of semiological fantasy. A 1716 panorama of St. Petersburg by A. F. Zubov removes the city skyline to the background yet cleverly suggests the military and commercial power of Peter's capital by foregrounding about two dozen ships and small boats on the Neva. Above all this, Italianate angels and cherubim herald and bless the marvelous new city. One can almost imagine Peter ordered the design himself. A later urban panorama, this one an engraving of Iaroslavl on the Volga River by A. Rostovtsev (1831), emphasizes the city's numerous Orthodox spires and onion domes [fig. 1]. While this image also nods to Iaroslavl's mercantile significance, it bends the landscape to the point that the Volga seems ready to spill off the map in order to incorporate a depiction of the equally important agricultural land around the city. Naturalistic representation mattered in these engravings, if only because the viewer was expected to recognize the specific details of the city. But as on any map, informational content reigned supreme, and the information on both of these maps is deployed in such a way that it works to persuade us of a particular way of seeing and knowing these cities.[19]

The Russian solemn ode has a similar topographical pedigree. Perhaps the most important form of eighteenth-century Russian poetry, the ode was usually written in praise of powerful and important public figures—typically members of the ruling family. Since tsar and state were identified with one another, such poetry often sought to glorify the Russian land. To this end, poets invoked Russia's abundance of natural resources and agricultural wealth in their verse. They also translated the cartographic image of Russia into poetic language as a way to indicate the state's grandeur. After all, one of the most obvious differences between Russia and Europe could be seen most clearly on a map: the comparatively enormous size of the Russian Empire. As early as 1709, Feofan Prokopovich, one of Peter the Great's ideologues, had extolled what seemed to him the almost limitless territory of the empire, describing Russia from a bird's-eye view as if he were flying over the terrain and marking out the furthest limits of its vast expanse:

> Were someone to travel, or rather fly in one's mind over [this territory], starting from our river Dnepr to the shores of the Black Sea . . . from there to the East to the Caspian Sea, or even to the borders of the Persian

kingdom and from there to the remotest limits of the Chinese kingdom of which we have hardly heard, and from there . . . to the New Land [Novaia Zemlia] and the shores of the Arctic Ocean, and from there to the West to the Baltic Sea . . . and [back] to the Dnepr: those are the limits of our monarch.[20]

Following Prokopovich a few decades later, one of Russia's most important eighteenth-century figures, the poet and scientist Mikhail Lomonosov, composed verses that evoked the "far-flung Russian state," or "all the fields and wide rivers . . . all the seas and high mountains" of the empire. Lomonosov was also fond of cataloging and enumerating in his odes the various rivers and regions over which the tsar reigned.[21]

This cartographic view long retained its importance in the Russian visual imagination. In 1785, Catherine the Great began her Charter to the Nobility with the words, "The Empire of All the Russias is distinguished in the world by the extent of the lands belonging to it . . . and includes within its boundaries 165 degrees of longitude [and] stretches over 32 degrees of latitude."[22] In Catherine's Russia a handful of poems were written that celebrated specific features of the Russian landscape, most notably the Volga River. The poets Aleksandr Sumarokov, Ivan Dmitriev, and Nikolai Karamzin all wrote poetry in praise of the Volga as a symbol of Russia. Sumarokov cited the variety of terrain through which the great river passed as a sign of Russia's grandeur and immensity.[23] Dmitriev and Karamzin both referred to the Volga as "Tsaritsa," affirming the ideal of unity between land and ruler.[24] For obvious reasons, all these Volga poems made sure to place the river on the global stage as a geographical monument of international importance.

In a later more nationalistic mode during the early nineteenth century, Karamzin would again choose the cartographic image to open his multivolume history of Russia. His opening phrases equate the historical significance of the Russian and Roman Empires through a strategic comparison of their great size and the number of different territories and peoples included within them.[25] Once a more modern form of Russian nationalism had become firmly entrenched, the picture of Russia on the world map was capable of inspiring nationalistic flights of fancy. "You have only to look at the map of the world," wrote the literary critic N. I. Nadezhdin, "to be filled with awe at Russia's future destinies."[26] A cartographic vision of Russia has remained an important feature of Russian national identity to the present day, a powerful reminder of Russia's importance on the world stage. But the map could never inspire more than a recognition of Russia's unrivaled territorial extent. In this sense, although it has always supplied an important image of the Russian land, topographical representations of

Russia shared little in common with depictions of landscape. The latter would offer a way of seeing the natural world on a scale closer to that of human experience.

SOCIAL ORIGINS AND PASTORAL AESTHETICS

The identity of Russia as a distinct state possessed importance only insofar as Russians felt constrained to compare their own native land to other countries. Peter the Great, then, in bringing to Russia a tangible basis for comparison by forcibly instituting aspects of European customs, dress, and institutions, initiated the modern discussion of Russian identity. During the eighteenth century, reference to national identity did not possess the (sometimes extreme) ideological significance it would acquire in the first half of the nineteenth century. The only people for whom the issue held real significance at this time were the court and educated gentry, as well as a very small number of educated non-nobles. Even for this rarefied community, national identity was less important than the personal sense of identity, which placed Russian elites among their peers in western Europe. This cosmopolitanism typified the privileged elite throughout Europe in the eighteenth century. Until the end of the century it was more important to belong to an international community of cultured individuals than to the culture of a certain country.

A popular work of prose fiction in the Petrine era, "History of the Russian Sailor Vasilii Koriotskii and the Beautiful Queen Iraklia of the Land of Florence," while addressed to a less sophisticated audience, neatly expressed the national identity many among the Russian elite wished for at this time. The work referred to Russia as *Rossiiskaia Evropa,* or Russian Europe.[27] This expression did not gain currency, but it pointed to a new conception of Russia as a European land and, by implication, of Russians as Europeans. The term both implies and refutes its opposite—the idea of a Europeanized Russia. The difference between these two contrasting conceptions of Russian identity is substantial. "Russian Europe" suggests that in emulating European culture Russians were only acting naturally, fulfilling the destiny assigned to them by proximity to Europe; by contrast, a Europeanized Russian would be behaving in a way that was opposed to the natural order of things, acting artificially. Tension between these two conceptions of Russianness has persisted ever since. While during the nineteenth century many Russians would begin to consider their national identity as sacrosanct, in the eighteenth century the idea of Russia as essentially European remained dominant, even if it did not go unchallenged. "Russia is a European country," explained Catherine in her Instructions to the Legislative Commission of 1767.

The willing reception of foreign customs and values in this period depended on the nature of the Russian society that was accepting them. "Culture" remained exclusively the domain of the upper echelons of society. As such it circulated within an international community presided over by courts and aristocracies. Johann Herder's view that culture was the product of a national community, found in its most essential form among the folk, would not become widespread until the beginning of the next century. Not only in Russia but throughout Europe, the Enlightenment valued a universal knowledge grounded in classical thought and literature. Russian courtiers and nobles could acquire status by means of their taste and discrimination, through their skill in utilizing the proper knowledge of classical and contemporary *belles lettres*. Lomonosov, for instance, while he possessed a knack for flattering the tsar and glorifying the state, had risen to prominence in Russian society from a peasant background mainly on the strength of his poetry and his knowledge of science, acquired through an education in Germany.

That interest in the natural environment remained the possession of this restricted elite is unquestionably the most important determinant of its developing aesthetic image in eighteenth-century Russia. Aesthetics, at this time, was founded on the basis of good taste derived from well-established and generally accepted standards. Such neoclassical aesthetic values have become alien to contemporary minds, as have many of the writers and artists whose work depended on them, but these unfamiliar aesthetic criteria must be understood for one to grasp the parameters within which eighteenth-century representations of nature operated. The fact that the first cultural milieu to which landscape aesthetics appealed was overwhelmingly an aristocratic elite, comfortable with neoclassical conventions, helps explain the powerful interest in the pastoral that developed in eighteenth-century Russia.

The most influential aesthetic theory in Russia during this period was the work of French neoclassicists, such as Nicolas Boileau and Charles Batteux.[28] Both regarded the poetic depiction of nature as an attempt to re-create the ideal beauty and harmony that they believed constituted the Platonic foundations of the natural world. Today such a point of view seems self-contradictory. To contemporary minds the natural and the ideal cannot be equated. But neoclassical aesthetics made precisely such an equation: the natural world was best understood in its idealized form. Therefore the proper depiction of nature required that the artist or poet portray its "universal aesthetic validity [and] capacity for being immediately understood and enjoyed by all men."[29] Unimproved representation of nature was not acceptable in this framework. "In nature there is very much that should never enter into the realm of art, painting, and literature, and from which the

well-educated person averts his eyes" wrote Faddei Bulgarin, a late adherent of neoclassicism.[30]

Paradoxically by today's aesthetic standards, nature could be understood as both the antithesis of society and the embodiment of universal principles. The natural world did not present a contrast with human rationality; instead it made a perfect example of the reasonableness of God's conception. In visual terms, nature was portrayed as that which exemplified the harmony of the universe. "The apparent dichotomy between nature and the ideal," according to one art historian writing on neoclassicism, "was resolved by a naturalistic interpretation of classical art. Thus classical art, so far from repudiating nature, becomes itself the highest and truest form of naturalism: for it reveals nature's true intentions."[31] It follows from this that the more elegantly and completely the artist was able to combine classical form with those elements of nature which ancient Greece and Rome had found pleasing, the more accurate would be the artist's imitation of nature.

Beautiful landscape thus meant a visual summation of universally admirable qualities, accepted by ancients and moderns alike, rather than a local and recognizable picture of a given place. Solomon Gessner, a Swiss landscape painter and in his time a wildly popular writer of idyllic poetry, admired landscape painting that expressed "not a servile imitation of nature, but a selection of all the most beautiful objects she affords."[32] The pastoral retreat rose above the encumbrances of real space and time; it never included images of difficult or enforced labor or responsibility. It proposed a countermodel of idyllic peace and timelessness to the restrictions of mundane reality and the sting of history and mortality.[33] It afforded a powerful form of escapism to leisured Europeans. Even if pastoral space was an entirely imaginative construction, nevertheless the imagined pastoral location became a significant part of the daily lives of many European elites. Not only was it appreciated in art and literature, it was sought after in scenery and enjoyed in leisurely strolls through gardens and parks, the construction of which became a craze among wealthy eighteenth-century Europeans, including Russians. To find the eighteenth-century reconstruction of the pastoral environment today, one has only to stroll around such well-preserved European gardens and parks as Stourhead in England, Ermenonville in France, or Tsarskoe Selo in Russia.

To be sure, comparatively free-form and wild images of nature had long been present in European arts—most familiarly in the plays of Shakespeare or the landscapes of Ruisdael and Rosa. Pastoral delight in placid settings was by no means the only approach to nature in modern Europe, but in the seventeenth and eighteenth centuries it was the most pervasive. In response to its importance in Europe, during the

reign of Catherine the Great the standard motifs of pastoral poetry became commonplace in Russia.

PASTORAL EXPRESSIONS

Lomonosov's poetry contains numerous examples of conventional pastoral imagery. The following passage is found in an ode written for the royal wedding of Peter III and the young Catherine in 1745:

> Crystal mountains all about
> Cool streams flow past
> The flower-strewn meadow.
> Fruits are speckled red
> And branches laden with honey,
> All at once spring and summer.
> All feelings inspired with delight!
> What sweetness flows through the veins?
> The heart melts in this pleasant heat!
> Does not love rule here?[34]

In formulaic fashion, this stanza conveys a typical picture of the landscape of pastoral delight. More importantly, its particular function within the ode allowed Lomonosov to bathe the royal couple in the reflected light of classical poetry, bestowing on the marriage an aura of Arcadian warmth and antique solemnity. Such nature imagery operated within a context alien to any natural terrain; it was a picture of nature cobbled together from ancient and modern idyllic poetry.

As for descriptions of actual Russian terrain at this time, one scholar has pointed out recently that on the rare occasions when Lomonosov and his contemporaries did attempt some description of the Russian landscape, they often approached it with the same eyes as western Europeans who saw Russia as a harsh and threatening northern wilderness.[35] A similar sense of the Russian countryside as alien terrain can be found in the scientific expeditions ordered and arranged by Catherine in the 1760s and 1770s.[36] These geographical fact-finding missions began just outside the city streets of St. Petersburg; they documented information about flora and fauna, towns and agriculture within twenty versts from the capital in the same way that they collected such information for Siberia and Kamchatka. Since the Russian countryside was not, in fact, unknown to Russian landowners, whose landholdings occupied a significant percentage of Russian territory, this scientific scrutiny should be considered not as a voyage of discovery but as the search for a new way of understanding the land in terms of its distinct geographical features and its economic use value. This attempt to make the land meaningful

according to the terms of European science was conducted on a parallel track with the aesthetic attempt to make the landscape admirable to Russian eyes based on the terms of European aesthetics.

While scientists and explorers worked to identify the unique characteristics of Russian topography, settlement, flora, and fauna, etc., poets almost always held to standard neoclassical models of landscape description. In the poetry of Catherine's Russia one finds countless examples of such uncharacteristic features of the Russian landscape as piping shepherds and mountain streams. Idylls and eclogues became a basic familiar part of the repertoire of almost every eighteenth-century Russian poet. Some poets also specialized in nature poetry of the georgic, or agricultural, type. Among these are Trediakovskii's laudatory discussion of the love for country simplicity in imitation of Horace, "On the Innocence and Charm of Country Life," or Sumarokov's "Epistle on the Beauties of Nature." The key to such idyllic poetry was the complete removal of the reader from the concerns of everyday life, thus the less related the poem to an actual location, in some ways, the more satisfying its impression on the imagination. Sumarokov's literary advice in his "Second Epistle" describes the poet's task at the height of Russian neoclassicism:

> Sing to me in idylls of clear skies,
> Green meadows, springs, shrubs, and groves,
> Spring, a pleasant day and the quiet of a dark night.
> Let me feel the pastoral simplicity,
> And, reading your verses, forget my cares.[37]

As late as 1795, a Russian journal was still recommending a similar approach to nature poetry in a translation of Richard Steele's discussion of the idyll's proper function: "The essence of the idyll is the depiction of the innocent, tranquil, and artless lives of shepherds in the original state of the world. For this must be imagined a free people, who do not know tsars, nor princes, and live in a warm and bountiful country. . . . Heavy labor is as unknown here as war."[38]

The poet Mikhail Murav'ev wrote in 1779 about the common delight his contemporaries took in landscape painting.[39] In painting and garden design as well, comparable conventions informed the work of Russian artists. Like most academic landscape painters of the period, Russian painters followed in the footsteps of the two major exemplars of neoclassical landscape, Claude and Poussin. A Russian painting manual of 1793 explained to painters the proper rules for representing nature. According to academic tradition, artists made *plein air* sketches and then composed their drawings into formal, "ennobled" works. To improve the landscape in this fashion the manual suggested the painter "embellish it with cascades and pebbles around which playing water flows, and with mountains . . . presented so that they form a chain, stretching into

the distance and disappearing from view."[40] The Imperial Academy of Arts gave their painters similar detailed instructions about what to represent in their landscape paintings. Here are two examples: "on a hot summer day beneath the setting sun shepherds, leading their flock to the city, and others, stopping by a stream in the fields to rest"; or "a field growing green, with a stream flowing through it, part of a grove on one side, beneath the shade of which rests a herd of cows."[41]

Russian landscape painters such as Fedor Matveev and Semen Shchedrin had some success in this style of painting. Little of their work, however, pretended to depict the surrounding countryside. Most often their paintings of Russian locations portrayed the royal family's landscaped parks in the vicinity of Petersburg, which were, of course, already modeled on contemporary European neoclassical forms [fig. 2]. Logically (and tautologically) enough, both of these painters eventually went to the original source of the image they had been taught to reproduce—the Italian countryside. Later, during the first half of the nineteenth century, almost all the best Russian academic landscape painting—most notably that of Silvestr Shchedrin, Mikhail Lebedev, and Aleksandr Ivanov—took place in Italy.

The vast garden parks that were constructed during the Catherinian era, such as Pavlovsk, Gatchina, and Tsarskoe Selo, inhabited much the same imaginative domain as the original and more famous English parks. In fact, some of the landscape architects in Russia, for example the Scotsman Charles Cameron, came from the British Isles. The first phase of the English landscape garden had been based on two key models, pastoral nature as described by ancient poets, such as Theocritus and Virgil, and the paintings of Claude and Poussin, whose work was also in part a response to ancient pastoral.[42] One need only observe the decorative elements of the Russian parks to know that they too sought the natural ideal in classical forms. They contained ruins, domed pavilions, and classical sculptures. And they too were landscaped to create the sort of tranquil and regular views one might find in paintings that sought to convey a nature reminiscent of that in ancient Rome. Ironically then, when Russian landscape painters depicted the tsar's parks and gardens, they were painting spaces modeled on the very kinds of foreign landscape they were supposed to reproduce on their canvases. Little wonder that they preferred to paint landscaped parks instead of the surrounding countryside.

PASTORAL FANTASY

If Russian neoclassical poetry, painting, and landscape gardening displayed scant interest in the representation of actual Russian terrain, one might reasonably expect that life on the gentry estate would supply a tangible intermediary step between idyllic visions and a more

sober appreciation of the actual countryside. More noticeably, however, in many cases the cultured landowner of this era exhibited a striking ability to ignore the nonidyllic features of the countryside that did not correspond to the forms which inhabited his imagination. "I must confess that the image of existing nature without improvement [*ubranstvo*] holds no charm for me," wrote I. M. Dolgorukov, "I have seen and learned from experience that I enjoy a cultivated garden, not the untamed land the Lord has tossed upon the surface of the earth without embellishment from the hand of man."[43]

When the landowner left the confines of his garden he was also capable of projecting his own fantasy onto the "untamed land." This is confirmed by the following passage from the poet and specialist on aesthetics, A. F. Merzliakov. Here Merzliakov describes the psychological process by which he understood his contemporaries to respond to a pastoral landscape:

> When considering a landscape, peaceful village views produce in you quiet, sweet impulses and a pleasant thoughtfulness. Study your heart and you will find that at this moment you imagine yourself sitting beneath the shade of an oak, on the banks of a stream, on a patch of gentle and flowering grass, amid a herd which, returning to the village, brings you sweet, sumptuous, and healthy food. If not you, yourself, then at least you imagine one of your close friends who lives in the country and enjoys such enviable happiness: his well-being is so close to yours that it is your own, and in this regard you can enjoy it, just as he does. . . .
>
> Before this beautiful picture, which so delights you, the poet feels that something is missing. See how he selects a companion for you: he has placed a shepherdess on the banks of the stream. She is young and beautiful, not too shabbily dressed so as not to offend your feelings, and not too embellished, so as not to ruin your delight: he has given her a simple expression, open and kindhearted, for he knows that you love a heart capable of seduction. He has also endowed her with a touching voice, the voice of a sensitive soul, and, furthermore, portrayed her looking in the mirror of the stream and decorating her hair with flowers, as if hinting to you that she wants to be liked, and to love. . . . He has also portrayed a happy shepherd in the distance, moving toward her. A mixed feeling of jealousy and satisfaction fills your heart. . . .[44]

This description was written in 1813 as part of a treatise on literary aesthetics. The passage clearly demonstrates the degree to which a pastoral vision of the countryside could transform the landscape into a device to generate erotic fantasies. As such, the Arcadian dream would be spoiled by introducing any new ingredient of recognizable country-

side into its potent concoction of sensual pleasures. Outside associations would be destructive.

Merzliakov addresses himself to the male reader, and his presentation of ideal landscape effectively serves to exclude potential female readers from the pastoral aesthetic experience. Thus, his description of the pastoral response raises the important point that representation and perception of landscape were not gender-neutral acts. Just as women's bodies have been portrayed and interpreted as visual spectacle, the objects of the masculine gaze, landscape was also typically constructed so as to invite the attention of the male viewer. Theorists of landscape aesthetics have often commented on the identification between idealized landscape and male idealizations of women. As the idea of landscape transformed physical space into something increasingly productive of interest and pleasure, it also allowed the potential symbolic power of natural images to operate in ways that could serve the interests of one or another point of view. In this case, Merzliakov's vision of an ideal pastoral space works to define a masculine mentality at the same time that it excludes women as subjects, as landscape viewers in their own right. Later in the century the nexus of land/woman would come to serve larger political interests as it grew more closely intertwined with conceptions of the nation itself.[45]

That the pastoral mode proved popular and lasting throughout the Catherinian era and into the early nineteenth century also conforms to another aspect of power relations. This period marked the apex of power and prestige among the landowning classes while many among the peasantry continued in enserfed economic abjection. In 1762, the gentry service requirement was repealed, and in 1785 Catherine promulgated a charter of legal rights to the nobility. For such reasons Catherine's reign has been called the golden age of the Russian gentry. In the daily lives of the peasantry, on the other hand, subsistence living, social insignificance, traditional customs and beliefs, and unchanged agricultural technology persisted. It was in this era that the most violent and far-reaching peasant rebellion took place, that which was led by Emelian Pugachev (1773–1774). As the court and gentry continued to deepen its participation in European elite culture, the abyss between serf and landowner in Russia widened. In the words of Jerome Blum, "by the last part of the eighteenth century the serf was scarcely distinguishable from the chattel slave."[46]

In part because of this social chasm, the pastoral fulfilled an important function for the court and nobility. "The function of pastoral poetry," according to Renato Poggioli, one of its great interpreters, "is to translate to the plane of imagination man's sentimental reaction against compulsory labor, social obligations, and ethical bonds; yet, while doing so, it acts as the catharsis of its own inner pathos, and

sublimates the instinctual impulses to which it gives outlet."[47] In falsely identifying himself with the rustic commoner, in other words, the privileged aesthete helped to ward off associations of guilt brought about by glaring contrasts in real social conditions.

In Russia the dark underside of pastoral sentimentality was inevitably more extreme than in the West. By imagining the countryside as a bucolic (and erotic) retreat rather than the site of enserfed labor and subsistence living, the Russian noble indulged in a self-deceptive refutation of social injustice. Pastoral fantasy proved useful as a balm for the troubled "political unconscious" of the Russian landowner. The image of Arcadia made it easier to ignore one's complicity in the harsh reality of the Russian countryside by preordaining the rural landscape a space of unadulterated aesthetic pleasure. It helped hide away the knowledge of irrational social brutality from the very *soslovie* called upon to act as the Russian embodiment of rationality and justice.

IDYLLS OF COUNTRY LIFE

By the late eighteenth century it was already becoming more difficult for Russian landowners to sustain their pleasure in the refuge of Arcadian dreams. Although a pastoral aesthetic remained the dominant artistic approach to nature in Russia until around the early 1820s, it is clear that the pristine space of pastoral imagination was coming under siege from several directions as early as the late eighteenth century. Nonidyllic landscapes were beginning to present a variety of alternative aesthetic possibilities in Europe, and the emergence of a new willingness to represent and admire recognizable natural terrain in the West helped stimulate an increasing interest among Russians in their own natural environment. Even as pastoral aesthetics reigned supreme in the late eighteenth century, there began a gradual undermining of the pastoral as the dominant approach to landscape. Landowning elites, some of them unhappy with the restrictions of life in society and at court, began to turn to their private estates for fulfillment after Catherine's removal of the service requirement. In doing so they helped initiate a more intimate relationship with the Russian countryside. Although the gentry continued to seek out pastoral delight in their country retreats, at the same time the interest awakened in rural life by pastoral fantasy could not fail to attune them to the appearance and conditions of their native surroundings.

To define pastoral in broad terms is to recognize that visions of ideal space and pleasant refuge have varied widely across time and place, from the nymphs and satyrs of Arcadia to, for instance, a Scandinavian billboard advertising exotic vacations in the South Seas. No matter what the content of the pastoral fantasy, however, one constant persists: the

pastoral is always constructed on a contrast of opposing environments. As Leo Marx has shown, the "other" of nineteenth-century American wilderness was the rapid rise of industrial technology and society.[48] Not dissimilarly, for certain contemporary urbanites, assailed by the disruptions of ever encroaching technology and the stresses of busy lives, it seems necessary to escape to a remote location somewhere on another continent in order to concoct a latter-day pastoral retreat.

With respect to Catherinian Russia, Hans Rogger has argued that a distinction between country and city, between the estate and the court, formed the original basis in the eighteenth century on which the nineteenth-century idealization of the Russian village and its peasant inhabitants would ultimately emerge.[49] Rogger suggests that although the neoclassical nature poetry of eighteenth-century Russia betrays no sign of locality or indigenous character, nevertheless it fell on the receptive ears of a gentry that found in the countryside a much-needed release from the strains of urban life and self-abasement at court. The contrast created between a corrupt, artificial city, and a genuine, innocent country life made even the pastoral conception of the countryside appear real and attainable on some level. Although Rogger's argument downplays the escapism inherent in pastoral fantasy, he rightly emphasizes an increasing interest in the music, literature, and everyday lives of the Russian peasantry, which encouraged the formulation of such cultural antitheses in Russia as town and country, or court and estate. By implication, the city and court became associated with European artificiality, and the country estate appeared to some landowners to be the wellspring of authentic Russianness.[50]

Rogger's argument works best at the level of cultural and intellectual substructure. As much as an intellectual basis for later idealization of Russian life may have been established at this time, more recent scholarship on the history of gentry estates in the late eighteenth century, in particular the work of Priscilla Roosevelt, reflects an attempt to construct them as ideal environments in sharp contrast to the surrounding peasant village and open countryside.[51] New estates were being constructed at a rapid rate in the late eighteenth century. In building them, Russian landowners closely followed Western models of architecture and landscape design. Superimposing these estates on the Russian countryside, they created private enclaves that isolated the wealthy gentry even further from their immediate surroundings.

The prototypical Russian estate (of the wealthy landowner) became a largely self-contained world; it was the refuge and retreat of the high nobility. As such, the garden and park designs of estate grounds were often modeled to suit the image of Arcadia that educated landowners had imbibed from literature, painting, and landscape architecture. In imitation of English gardens, Russian gardens sought to rearrange natural

space into the tranquil perfection of the golden age. They eschewed earlier interest in regularity and order, favoring gardens that strictly maintained the mixture of picturesque irregularity and classical symmetry found in the best landscape painting.

In England this sort of garden was intended, to some degree, to blend in with the surrounding landscape. The ha-ha, a ditch or barrier that imperceptibly separated the surrounding countryside from the estate, is the ultimate symbol of this aesthetic reconciliation of different terrains. For evident reasons the ha-ha never saw much use in Russia. The creation of an English (or as it was sometimes called a "natural") garden on Russian territory meant by definition the introduction of something foreign and unnatural. Evidence of what the English garden meant in Russia is found in Aleksandr Kurakin's 1794 description of the grounds of his estate: "There are no pines and practically no birches," he boasted, "one sees only oaks, lindens, elms, etc. The most temperate climates cannot produce a more pleasant woods."[52] In aesthetic terms, the estate carved out a slice of European landscape beauty in the Russian countryside. Roosevelt points to a particularly revealing example in her study of the Russian country estate. Describing the Hubert Robert Room in the Yusupov's Arkhangelskoe, she writes, "Each wall holds a large canvas of an imaginary classical landscape; to look out upon the park from an intervening window is to add a third landscape to the view."[53] Prince Yusupov's framed window located his landscaped garden right in the middle of two classical pastoral views, underlining for his visitors the ancient, idyllic context in which they were supposed to see and admire the grounds of his residence.

But as much as the estate could provide a means for constructing a pastoral retreat, one sees in such tributes to actual personal estates as Derzhavin's "To Evgeny. Life at Zvanka" or Kapnist's "Obukhova" that some landowners had moved beyond pastoral fantasy toward a deeper connection with the community and daily life on their own lands. Derzhavin's poem places his estate within the larger surrounding landscape on the Volkovo River, and Kapnist, in sharp contrast to the interest of Kurakin in foreign vegetation, dreams of being buried beneath a simple Russian birch.[54]

A similar example of the gentry's attention to the rural terrain appears in the memoirs of the Russian agronomist and litterateur, Andrei Bolotov. After the gentry service requirement had been abolished, Bolotov returned to his family estate. "How my heart jumped and quivered with joy and satisfaction," he recalled in his memoirs, "when suddenly I saw before me those high birch groves that surround our village."[55] Bolotov's evident pleasure in the countryside reminds the reader that pastoral escapism and actual rural experience were not necessarily antithetical to one another. And yet whether the memoirs

recorded his reaction precisely, it should be kept in mind—as Bolotov himself notes—that not until he encountered a German book of aesthetics, *Conversations on Natural Beauty,* did he develop an admiration for the Russian countryside. Indeed, his main interest in rural life was not aesthetic appreciation of the existing landscape but its transformation and cultivation through gardening and farming.[56] When he did write nature description, it fell squarely under the heading of sentimental pastoral, a genre developed by writers with urban and cosmopolitan connections.[57]

SENTIMENTALITY AND THE PASTORAL IDIOM

Such a private subject as the landowner's personal experience of nature presents an elusive target. It can only be seen through the haze of public pronouncements about the appreciation and significance of the rural environment. Yet public expression does not necessarily run counter to private sentiment. As Iurii Lotman reminds us in his essays on gentry culture, the "separate spheres" of public and private were often deeply intertwined for the gentry of the late eighteenth century.[58] In Russian literature, a new Western aesthetic related to emotion rather than form and taste gradually gained currency. This trend came to be referred to as "sensibility" or "sentimentality"; today it is usually called "sentimentalism."[59] Sentimentalism involved the literary arousal of emotion, and it grew increasingly common over the course of the eighteenth century. By the middle of the century a lachrymose response to poetry and novels had become not merely acceptable, but even a sign of good breeding. The new interest in sentimentality did not challenge neoclassical images of nature; rather it redirected the focus from outward formal structure to inward individual response. European, and later Russian, literary sentimentalism helped transform Russian nature aesthetics by calling for an emphasis on the writer's personal experience of the landscape.

Some of the first stirrings of sentimentalism in Russian poetry can be found in the verses of Murav'ev, written in the 1770s. By that time the influence of writers associated with strong emotion—Laurence Sterne, James Macpherson (Ossian), Thomas Gray, Thomson, Gessner, and Rousseau—had become widespread in Europe and was growing familiar in Russia as well. Gessner was the first of these writers to be translated into Russian in a series of articles in the *St. Petersburg Herald* [*Sankt-Peterburgskii Vestnik*] from 1778 to 1781, and part of Thomson's work was translated in 1779.[60] By the early 1800s, Russian journals included numerous translations and imitations of all these authors.[61]

The figure who was to become the most important Russian sentimentalist, Nikolai Mikhailovich Karamzin, produced a translation of

Gessner as his first published work. That Gessner and Thomson described actual locations in their literary landscapes proved to be one of their most attractive qualities to readers. By prioritizing the inward response to nature over the outward form, the move toward sentimentalism helped writers develop new approaches that freed them from unswerving adherence to pastoral conventions. Gessner's idylls, which described shepherds and shepherdesses in the Swiss Alps, retained a stylized pastoral quality remote from real experience, but their Alpine settings allowed him to create a novel mode of idyllic landscape description. Similarly, Thomson's long poem *The Seasons* (1730) helped invent a new tradition of nature poetry, in which description of the English countryside served as an intermediate step between pastoral and naturalistic landscape. From Thomson's era onward, interest developed in representations of actual and recognizable, rather than imagined and idealized, natural space. Mainly spreading outward from England, this new emphasis on identifiable terrain took the European continent by storm in what has been called a *"revolution pittoresque."*[62]

The main function of this "picturesque revolution" was to arouse interest in concrete rural landscapes as a new subject of contemplation and appreciation. Yet appreciation of picturesque scenery remained bound to conventional notions of natural beauty inherited from poetry and painting. In this sense the picturesque can be understood as a transitional aesthetic standing between neoclassical convention and romantic imagination. A principal representative of the picturesque on the Continent, Jacques Delille, became popular in Russia in the early years of the nineteenth century. The views expressed in his poem, *Les Jardins, ou l'Art d'orner les paysages,* which was translated into Russian several times, demonstrate the degree to which garden design had evolved a new sympathy for the imitation of uncultivated natural space.[63]

Delille encouraged the landscape gardener to imitate nature in all its variety, but at the same time like his contemporaries he always had in mind the nature of the Italian countryside as represented in landscape painting. He expressed this contradictory position in one of his couplets: "All that painting could take from nature / Gardener! hurry up and give it back."[64] Delille's views were gleaned mainly from late eighteenth-century British discussions of picturesque landscape and gardening. The role of the gardener was to admire the beautiful features of natural landscape, and then to reintroduce them to the garden or park in the form of improvements. Above all, it required proper judgment and good taste to be able to perceive what was simultaneously admirable in painting and in the transformation of nature via gardening.

Without a doubt Nikolai Karamzin was the most influential purveyor of this sort of sentimental nature appreciation in Russia. In several cases, Karamzin relocated the pastoral venue from its unfixed setting in

time and space to specific, geographical locations. In "The Countryside," one of his early pieces of nature description, he placed his narrator in a region in Russia he describes as "on the edge of Europe, among Barbarian peoples."[65] At the beginning of this account the narrator passes through a garden and walks into the wilderness, intentionally avoiding all manifestations of human interference in nature: "Wildness is holy to me; it exalts my soul," he exclaims.[66] At first it appears that Karamzin might have bypassed pastoral conventionality altogether and launched into a romantic celebration of pristine wilderness, like some sort of Russian Thoreau. It soon becomes clear, however, that his purpose in avoiding the garden setting is to establish the Russian countryside as a realizable, personal Arcadian retreat. This "wilderness" to which he has retreated proves to contain allegorical Greek shepherds, not to mention servants bringing him breakfast. It is unabashedly idealized in every particular, and the scenery Karamzin describes has more in common with landscaped gardens, as Likhachev has pointed out, than with any uncultivated natural environment.[67] Nature for Karamzin is intimately connected to literature. His narrator collects flowers and makes rhapsodic notes about them, and when he wanders off into a grove he brings along a copy of Thomson's *The Seasons*.

Probably more than any single text, Karamzin's widely read *Letters of a Russian Traveler* helped propagate this sentimental approach to nature. In the 1790s when he wrote the letters, Karamzin was in his early twenties and had already mastered the outward forms and language of European nature aesthetics. He consistently applied these conventions to the passing European landscape for the sake of his Russian audience. Different scenery in the text—some picturesque, some sublime, and some bearing a resemblance to the paintings of Rosa and Poussin—embodied predominant aesthetic typologies. Not long after entering Switzerland, Karamzin's delight at the countryside he knew best through literature launched him into a preordained ecstasy:

> What views! What scenes! About two versts from Basel I jumped out of the coach and flung myself upon the flowering bank of the green Rhine, ready to kiss the earth in rapture. Happy Swiss! Dwelling in sweet nature's embrace, under beneficent laws of brotherly union, with simple ways, serving God, do you not each day, each hour, thank Heaven for your good fortune? Surely your entire life is a pleasant dream. . . .[68]

The letters were actually written and published during the decade after Karamzin's return, which helps to explain their bookish, preconceived quality. The presence of sentimental nature writers such as Rousseau and Gessner is felt in every line of Karamzin's exalted description of Switzerland.[69] He seems as ready to credit an idyllic

picture of Swiss society and politics as he is to assume the authenticity of Gessner's idylls.

Whereas some years earlier European travel had caused the Russian playwright Denis Fonvizin to fulminate against the French and Italians, Karamzin's travelogue supported the opposite tendency in Russia to admire all things European.[70] That Europe's various terrains corresponded to prevailing Russian tastes in landscape helped Karamzin convey a glorious portrait of Europe. At the same time, the devout admiration for European scenery could only frustrate the attempts of Karamzin and his followers to foster a taste for the local landscapes of the Russian countryside.

Perhaps conscious of this dilemma, Karamzin intentionally set out to Russify the setting of his most famous work of fiction. The novella *Poor Liza* depicted an actual location next to a monastery, and a Moscow pond that sentimental Russians visited for years after the story had become a huge success. Familiar locations notwithstanding, in creating his pictorial representation of the Russian landscape Karamzin still chose to place a stereotypical pastoral setting within view of the towers and domes of Moscow.[71] In the foreground "young shepherds sitting beneath the shade of a tree sing simple, melancholy songs to cut short their uniform summer days." The middle ground contains "lush green flowering meadows, and beyond them a bright river flows over golden sands." In the distance "the Vorobiev Hills turn blue almost at the edge of the horizon."[72] In short, the setting of Karamzin's novella is a Claudean landscape, only slightly Russified by the familiar presence of the Moscow skyline. As in the ideal pastoral location described above by Merzliakov, Karamzin's idyllic scenery sets the stage for an erotic encounter: enter the tenderhearted, uncommonly beautiful, and impoverished peasant Liza, a stand-in shepherdess. Liza will shortly require our pity because her suitor Erast, a reader of too many romances and idylls, gets carried away and turns the story into a morality tale about the dangers of love between social unequals.

Idyllic landscape performed a necessary function in *Poor Liza*. Karamzin used the setting to debunk Arcadian fantasies, pointing out their potential consequences in the real world. Yet, having succeeded in disabusing himself of the pastoral fantasy found in his earliest work, Karamzin never managed to find an alternative way to derive aesthetic satisfaction from the Russian landscape in his writings. His tract on "National Pride," as noted above, acknowledges that on a concrete level he had accepted European landscape as aesthetically superior to the landscape of Russia. While he continued to find the outskirts of Moscow pleasant and conventionally picturesque, in his history of Russia he would return to the age-old geographical celebration of the

empire.[73] Karamzin never managed to reconcile his pastoral love of nature with his separate love of country.

PASTORAL IMAGERY IN TRAVEL LITERATURE

After the publication of Karamzin's travel letters "a veritable deluge of imitative literature" appeared.[74] Travel in western Europe became more common in the late eighteenth century for Russian nobles. Their trips facilitated comparisons between Europe and their own country, and as a result European journeys engendered both national pride and national regrets. Much of the travel literature produced between the 1790s and the 1820s leaned heavily on the work of Karamzin. Travelers went to Europe along a similar route, described many of the same sights, and expressed many of the same reactions.[75] More interesting for purposes of this study, others among Karamzin's followers chose to write their travelogues about areas within the Russian Empire.[76] These writers often exceeded Karamzin in their sentimentality and flights of fancy. One critic chastised the travelogue writer Petr Shalikov for traveling to Ukraine and finding there only "Arcadia." The poet Vasilii Zhukovskii wrote about Shalikov's travelogue that "he travels not to describe the cities or provinces but to ride out of time."[77] Indeed, Shalikov's confrontation with the Ukrainian countryside moved him to recall Virgil, Delille, and Karamzin and to compose a whole section, rather incredibly, on Ukrainian "Shades of Switzerland."[78] This was no practical Baedeker guide.

Another sometime travel writer, M. A. Dmitriev, was a nephew of the important Russian poet, I. I. Dmitriev, a close associate of Karamzin. Although a contemporary of Pushkin, the younger Dmitriev's regard for his natural surroundings echoed the sentimental and picturesque landscape aesthetics of his uncle. In his memoirs one finds a lucid, if smug and self-important, explanation of the sentimental response to Russian nature, which deserves to be cited at length:

> It's not possible to judge country life in the olden days by today's standards.... We love pictures of nature: at that time they had no concept of them. Is it any wonder that Sumarokov and his followers described in their eclogues fictitious customs and fictitious nature, and none of them our own? Their customs were entirely unpoetic and inelegant; nature simply didn't exist! How could it not exist? It did not because nature only exists for those who can see it, and only the enlightened have that ability! For the landowner of those days nature was what it is for the peasant and the merchant now. And how do they look at nature? The peasant sees in a magnificent forest—logs and firewood; in velvet fields, *enamelled* with flowers—haymaking; in the cool shade of a

spreading tree—that it would be a good place to put down a sheepskin coat and take a nap, if the mosquitoes weren't so annoying. And the merchant sees in the forest, with its rustling, hundred-year-old treetops—usable boards, or a samovar and the pie with rich stuffing that is a necessary component of his country pleasure; in *a silver stream's harmonious babbling over the golden-hued sand*—that it would be good to dam it up, throw a bit of brushwood and manure over it, put a mill in and get some use out of it. After this is there really nature for them? That's why Sumarokov populated his eclogues with the improbable beings of shepherds and shepherdesses, there was nothing to take from village life, and that's why for our old landowners there was no nature.[79]

Judging from Dmitriev's italicized imagery, Russian sentimentalism unselfconsciously adhered to well-worn pastoral tropes. But one also detects here an obvious pride in the fact that, as opposed to the landowners of Sumarokov's era, Dmitriev believed that his cohort had learned how to admire "pictures of nature" in the Russian countryside. Dmitriev distances himself from Sumarokov by interpreting his own poetic perception of nature as a realistic view of the actual countryside, rather than a conventional pastoral projection.

The position Dmitriev carves out for himself in this argument is important to note as an example of the way many Russians approached their native terrain. For Dmitriev and others, landscape could not exist in an unpoeticized form. Otherwise the observer would be seeing nature as nothing but brute material (as Dmitriev's peasant and merchant saw it). But Dmitriev still boasts about the *reality* of his perception. This language prefigures a common theme in Russian responses to the native terrain. Nature is cast in some ideal form so that it can be admired *as landscape,* and at the same time that idealization contrasts itself to some earlier representation of nature as a more authentic image of the countryside. The new image presents itself as a poetic evocation of nature, at once more authentic and more beautiful than the former image, which now appears stilted and outmoded by comparison. As we shall see, this game of authenticity leapfrog would characterize the development of landscape description in nineteenth-century Russia.

European aesthetic influences on Russian taste in landscape simply remained too pronounced during the late eighteenth and early nineteenth century for Russian writers and artists to be able to create what would amount to an entirely new landscape aesthetic. Early travelers in Siberia further illustrate the ponderous influence of European aesthetics in their attempts to describe the new terrains they encountered. The artist and travel writer Andrei Martynov, for example, traveled to the Chinese border with a diplomatic entourage in the early nineteenth century. He kept a diary and watercolor sketchbook to record

the trip, which resulted in the publication of an illustrated travelogue. Martynov's work is full of enthusiasm about the scenery of the Urals and Siberia, but his enthusiasm is expressed in the only aesthetic language he knew. About Krasnoiarsk, for example, Martynov wrote, "both in the city and in its environs, at every step one encounters views meriting the brush of an artist remembering delightful Switzerland."[80] The resulting landscapes, probably painted after his return home, exhibit a gentle placelessness as reminiscent of England as it is of Siberia [fig. 3].

Another Siberian traveler, the little-known poet, V. V. Dmitriev, was assigned to a governmental post in Tobolsk, from whence he traveled through southern and western Siberia. He seems to have been deeply inspired by his experiences. From his travels he compiled a collection of observations entitled "The Beauty of the Wild Parts of My Fatherland." This work was never published in its entirety, but the one volume he did manage to print contains exceptional nature poetry quite unlike that of his contemporaries. To judge from his prose commentaries, his work was clearly related to his personal experiences in Siberia and relatively free of literary influences. This independence is borne out in the poetry as well. One of his poems, for example, sings the praises of the Siberian cedar in winter. His commentaries argued that natural beauty exists everywhere in equal measure, providing a justification for his odd (at the time) choice to describe the Siberian landscape. Dmitriev seems to have learned in his isolation how to admire a nonpastoral and (mostly) nonderivative landscape.

Yet despite his atypical inclinations in nature appreciation, when promoting his work for an audience he justified his travel description in terms of classical mythology. For the title of his collection he chose the term "Oread," a Greek mountain nymph, because he found in that image a useful analogy:

> Returning from the wild country of my fatherland, which is comparable to the images of Greek imagination, where similar high mountain ranges were the objects of my astonishment, where rushing rivers and noisy waterfalls arrested my attention, where the holy quiet of forests was my temple of contemplation, there a good part of my free activities, now proclaimed to the world, were first conceived—there they also got their name: My Oread.[81]

In attempting to convince his compatriots to travel in Siberia, he felt compelled to use images from the European landscape with which they were familiar: "Would you like to be happy, even if only for a few moments? Travel—especially in your own fatherland. Everything, you will find everything in it: Pyrenees valleys, Tivoli cascades, Swiss

beauty, and Alpine mornings."[82] Everything landscape beauty had to offer, in other words, even to an avid admirer of Siberia, could still be found in its prototypical form in western Europe.

ANTI-ARCADIA

At the end of the eighteenth century, both the sentimental stress on an individual, passionate response to nature and the picturesque admiration for tangible scenery had begun to reorient Russian landscape imagery away from a purely pastoral idealization. In the writings of Karamzin and Shalikov, of course, it sometimes seemed that Arcadia had materialized on Russian soil. Many writers were willing and able to detect ideal pastoral beauty in the real Russian countryside. At the same time, however, the call to exercise one's feelings in aesthetic judgment and the focus on actual terrains also had the opposite effect; it was starting to rip a hole in the fabric of the Arcadian dream. To some Russian observers it had begun to appear that the Russian countryside was not in fact a very good facsimile of the *locus amoensus*. Quite often those who had already traveled in the West looked around them in Russia and saw impoverished serfs rather than shepherds and shepherdesses, or harsh and monotonous scenery rather than "enamelled" meadows and cool glades. Interestingly, such observations often appeared in the travelogue, the same literary genre that painted the countryside in the most glowing pastoral hues.

The act of traveling could, it seems, render awareness of real conditions difficult to elude, thus of all forms of literature it can be held accountable for precipitating a crisis in Russian responses to nature. Karamzin and his followers temporarily tried to sustain the pastoral image, while other travel writers used the genre as a critical weapon with which to attack Russian conditions. Perhaps the first hostile description of Russian landscape was published in 1772 in N. I. Novikov's journal *Zhivopisets (The Painter)*. It recounts the journey of a sentimental traveler to a rundown village. The narrator is thrown into agony at the discovery of the miserable conditions he witnesses. His landscape description emphasizes that misery: "The village *Razorennaia* [Ruin] is settled in the lowest and swampiest place.... The huts, or more precisely the collapsed shacks, present to the traveler's gaze a village abandoned by man. The streets are covered in mud, mire, and every kind of filth."[83]

This description is found in the anonymous "Fragment of a Journey in *** by I***T***." It was probably written by Novikov himself, but some have attributed it to Alexander Radishchev, whose full-scale travelogue became the first published cry of outrage against serfdom and has subsequently won a place more in Russian political than literary history.[84] Radishchev's *Journey From Petersburg to Moscow* was based in

part on Sterne's *Sentimental Journey*. Posing as a sort of Russian Sterne, Radishchev made use of the sentimental mode as a rhetorical device with which to launch his attack against Russian institutions. Radishchev's traveler does not find happy shepherds in the countryside, nor does he meet the enserfed population whose lives had grown largely unintelligible to "enlightened" landowners. Rather he encounters Russian peasants who speak a language familiar to the Europeanized elite and whose feelings of injustice are perfectly understandable within the framework of Radishchev's gentry liberalism.

Radishchev's readers get a distorted picture of the Russian countryside, since his characters tend to resemble nobles in peasant attire. But the polemic worked brilliantly. Radishchev was not interested in landscape description, and yet his work still turns the tables on pastoral conceits in an important way. If it is possible to sympathize with rural shepherds as they appear in idylls, Radishchev might have proposed, then let us place these same characters in the circumstances in which Russian peasants often lived. Not surprisingly, the juxtaposition presents a spectacle of tremendous injustice, which accounts for much of the rhetorical force of the work's critique.

By contrast, sentimental travelogues that idealized Russia, because of their remarkable implausibility, provoked some heavy criticism. At the height of their influence in 1805 a play by Aleksandr Shakhovskoi entitled *A New Sterne* satirized their flights of fancy. As a satire of sentimental travelers the play enjoyed great success. It also aroused furious debate about the use of foreign terms in the Russian language, an issue that divided literary circles at the time. When applied to Russian scenery, the patent artificiality of picturesque description made a wonderful target against which to vent frustration about foreign influences.

In the same decade, an anonymous satirical travel account, entitled *A Critic's Journey,* used a description of the Russian countryside to mock the use of pastoral imagery in the depiction of actual places. Disappointed by the discrepancy between travel descriptions of the countryside he had come to know as an urbanite and the rustic landscape he actually encounters once he reaches rural Russia, the critic complains: "There are not myrtle alleys everywhere; nor beautiful plains, dotted with sweet-smelling flowers; nor do playful streams run over pebbles, babbling gently; nor is there heard all 'round the sweet-voiced singing of the nightingale. There are wild, rocky, sandy, waterless places where nothing can be heard but the miserable cawing of jackdaws and crows."[85]

Even in some ostensibly sentimental and picturesque Russian travelogues, writers sometimes struggled to bring together the idyllic and the observed countryside. Recounting a trip along the Volga in the winter of 1800, M. Nevzorov tried to reconcile his pastoral inclinations with his own experiences:

If your correspondent possessed the imagination of a Gessner or some other painter of nature akin to him, he would strip away the cold northern covering of the earth, immediately dress it in greenery and flowers and decorate the trees with leaves. . . . But why do we need such a transformation of nature? Clever Cupid in the realm of the snows can produce a flame, and with the bold hand of the winter bird [*ziablikovskii*] Vanyusha, throwing a snowball at the breast of the rosy Dunyasha, sometimes greater miracles are created than by the tired hand of the Arcadian shepherd Menalk pinning a rose to the breast of the wonderfully singing Daphne.[86]

Nevzorov expends a great deal of energy in this passage to preserve a space for pastoral fantasy in the admittedly quite distinct Russian countryside. By the first decade of the nineteenth century, adherence to trends in western European arts and letters had brought the sentimental traveler, criticized by contemporaries as one of the most shameless imitators of Western literature, to a point where imitation, at least imitative landscape description, was often leading to ridicule and self-doubt. The possibility of maintaining Arcadia somewhere in the imaginations of Russian nobles had begun to collapse, but no new approach to Russian nature had been conceived as an alternative or was yet near at hand.

FRESH DEPARTURES

In addition to visions of Arcadia, other literary approaches to nature description informed European landscape aesthetics in the eighteenth century. More and more toward the end of the century they came to exert an important influence on Russian aesthetics. One of the most influential aesthetic models of the period was the sublime. With respect to natural phenomena, the sublime was associated with "the infinite, solitude, emptiness, darkness, and terror."[87] The genre allowed writers and artists to transform grand and awe-inspiring landscapes from merely horrific to positively delightful in safe and domesticated forms on canvas and the printed page. When sublime, awe-inspiring nature description caught on, it helped intensify the European fascination for picturesque scenery in painting, literature, and scenic travel.

Sublime landscape came to Russia primarily in the form of a Europe-wide craze for Ossian, the mock-ancient, epic bard, later discovered to be the invention of the Scotsman James Macpherson, whose works first appeared in the 1760s. The Ossianic landscape presented a dramatic picture of barren, windswept plains, mountainous crags, an unfriendly climate, and lonely, forbidding fortresses. Macpherson was first translated into Russian in 1792, but his impact had been present even earlier through writers who had read Ossian in the original or some other

translation.[88] Ossianic nature imagery did not have as significant and long-term an impact in Russia as the pastoral, but from the last decade of the eighteenth century (into the 1810s and 1820s), it encouraged an interest in the mythic Russian past and in the exotic, and potentially sublime, landscapes of such territory as Finland and the Caucasus. As it had in other parts of northern Europe, Ossian's aestheticization of northern nature made it possible for Russians to envisage a certain stern, terrifying beauty in the appearance of their northern terrain. Ossianic landscape might have come to Russia in the form of a packaged and overwrought romanticism, just as much as any pastoral imagery had adhered to neoclassical or sentimental conventions. Yet its appearance foretold change. First, simply by presenting an alternative approach to landscape imagery it contributed to weakening the grip of the pastoral as the accepted—the default—celebration of nature. Second, its own stock imagery, while developed outside of Russia to represent windswept isles in the North Atlantic, was decidedly closer to the northern, continental climate of Russia. For this reason, Ossian's "northern style" supplied an important starting point from which to move toward an interest in the special features of Russian geography.

The most prominent Russian poet of the late eighteenth century, Gavriil Derzhavin, at times worked under the influence of Ossian. Derzhavin's work has defied categorical description by critics of Russian literature; it contains neoclassical elements, but particularly with respect to nature description Derzhavin managed to create a personal descriptive style that placed the reader in a new relationship to the objects he described. He was often less interested in evoking vast natural panoramas than he was in calling to mind—in minute and recognizable detail—the everyday, familiar objects of the natural world. And yet his nature description, even when consciously portraying a Russian setting, still evoked a generalized, not obviously native, image of nature. In most of Derzhavin's poetry, the location is subordinate to the universally significant emotions and ideas in the poem.

His debt to Ossian is most evident in his poem "The Waterfall" (1791–1794), written as an ode to Grigorii Potemkin. The waterfall of the title refers to the Kivach Falls, a cataract Derzhavin had visited in Karelia, located in northern Russia next to Finland. The poet magnifies the falls, which were in no way remarkable for their size or grandeur, into the sublime setting for his musings on the transitory nature of human existence and heroic glory. Recalling the sublime and gloomy settings of Ossian, the landscape here does all it can to conjure up an image of "nature's terrible beauty." Rushing waters, howling winds, flashes of light in the darkness, dreary, thick stands of pine, and snow-capped mountain peaks set the stage of the poem. The work is filled with the dramatic sights and sounds of an austere northern forest.[89]

Although by no means his main intention, with the help of Ossian, and via an interest in less dramatic settings, Derzhavin was moving toward a more naturalistic portrait of Russian space. He frequently received inspiration from the objects and places he encountered, and this relationship to the material world produced fleeting but powerful images of natural scenery, which at times become identifiable as specific Russian locales. Other poets of the latter decades of the eighteenth century, such as Murav'ev and Kapnist, also occasionally moved away from pastoral imagery toward more recognizable landscape description. Kapnist's "Obukhovka," cited above, and Murav'ev's "Village Life" are two good examples. Such poets were setting the stage for the creation of a Russian picturesque aesthetic that would occupy the attention of Russian writers and artists during the first half of the nineteenth century.

In certain ways, pastoral models of nature remained current in Russia long into the nineteenth century. The landscaped estate remained clearly delineated from the surrounding countryside even after the abolition of serfdom, and the imagination of such a mid-nineteenth-century poet as Afanasii Fet thrived in the sort of perfected fantasy of ideal nature and love that the estate environment could sometimes sustain. Indulging in the vision of an isolated *locus amoensus,* Fet produced a remarkable body of nature poetry that was clearly linked to pastoral dreams and was utterly iconoclastic in his own emancipation-era context.[90] On the whole, however, the continuation of impulses already apparent in Derzhavin and certain sentimental travelogues would initiate an extended period of uncertainty in Russian depictions of the native countryside. The crisis would generate many separate solutions to the problem of Russian nature aesthetics, but no widespread resolution would appear until the middle of the next century, by which time an entirely new set of aesthetic values was taking shape.

CHAPTER TWO

The Search for a Picturesque Russia

Inye nuzhny mne kartiny.

[I need other pictures.]

—Aleksandr Pushkin

 During the "golden age" of the Russian gentry, the countryside had offered itself up as a space for the free play of invention and imagination. Even if pastoral visions of the rural environment shared little in common with the actual terrain passing travelers might observe as they journeyed through the countryside, that disjunction scarcely mattered to admirers of idyllic nature. Unencumbered aesthetic revaluation of objective conditions in the countryside had been possible in part because actual geographical terrain had not yet assumed any great value or aesthetic significance in the culture of Russian elites. While certain critics had already begun to mock the sentimental pretentions of pastoral imagery in the eighteenth century, the death knell of Arcadia sounded only when Russians began to envision a new role for the countryside in the early nineteenth century.

As the dominance of neoclassicism was yielding to different aesthetic currents (typically collected under the umbrella heading "romanticism") in the late eighteenth century, still larger upheavals awaited Russian culture in the first decades of the nineteenth century, upheavals that would all but obliterate the pastoral idiom as it had been understood in Catherine's day. Writers like Karamzin and Aleksandr Shishkov had begun to show a keen interest in Russian national identity as early as the first decade of the century. But it was not until the year 1812, when Napoleon's troops marched on Russian soil, that the status and significance of Russian nationality suddenly and thenceforward attained a greatly enlarged stature in the minds of educated Russians. This sea change had an impact on all facets of Russian life, including representation of the landscape.

Napoleon's invasion and subsequent defeat placed Russia squarely in the center of European politics. In the aftermath of 1812, Russia found itself a leading power among the nations of the West. "The

triumph over Napoleon and the march to Paris," wrote Isaiah Berlin, "were events in the history of Russian ideas as vitally important as the reforms of Peter. They made Russia aware of her national unity, and generated in her a sense of herself as a great European nation."[1] Not only did Napoleon's invasion inspire the inevitable patriotism involved in a war for the defense of home territory, but the fact that his armies were routed with the help of contributions at all levels of Russian society seems to have provided a crystallizing moment for the reconceptualization of the Russian Empire itself.

The concept of the nation-state composed of free and autonomous citizens became a European reality for the first time during the French Revolution. This vision of the modern nation appeared an inconceivable model for Russia, so distant was it from the enserfed and rigidly hierarchical nature of Russian society. Thus the advent of Russia's great power national consciousness may have engendered confidence in Russia's might and influence, but along with that confidence came profound anxiety. As most of western Europe gradually adopted some form of civic nationalism over the course of the century, Russia was compelled to set out on its long quest for a suitable means of social and political reconfiguration. How was an absolutist government and a socioeconomic system that relied on captive labor to contend with the rise of the nation-state and the ever expanding power of rapidly industrializing economies that had begun to characterize the Western world? The year 1812 marks the beginning of Russia's struggle to establish a meaningful identity for the Russian Empire not necessarily identical with, but in some way equivalent or superior to, the nations of western Europe.

From this point forward, attempts to rethink Russia as a national community began to occupy a large share of Russia's political and intellectual life. Among some of the most prominent reconsiderations of Russian nationality, the initial volume of Karamzin's landmark *History of the Russian State* first appeared in 1818. The abortive attempt of the Decembrists to establish a constitutional monarchy (or a Russian republic) got underway in the early 1820s but was quashed in 1825. Finally, the state itself declared an "Official Nationality" policy in 1833. Nicholas I's Minister of Education, Sergei Uvarov, directed the policy, which famously rested on the three foundations of its slogan "Orthodoxy, Autocracy, and Nationality." The policy was not merely official; a substantial segment of Russia's educated public accepted its dictates and found ways to contribute to its crown-sanctioned conception of nationality. Those who did not accept "Official Nationality" began the effort to forge alternative visions of Russia's future. From traditionalistic Slavophile communalism to versions of socialism inspired by the West, each alternative attracted adherents within Russian society.[2]

It did not take long for the search for a suitable form of nationality to make an impact on landscape aesthetics. Following Napoleon's de-

feat, descriptions of the Russian countryside expressed diminished concern for the ideal and unlocalized pastoral landscape. Place began to matter. Writers now commonly sought to convey the special Russianness of the rural landscape. It was as though Napoleon's invasion had more sharply etched in the lines around the Russian border. Where descriptions of Russian countryside had emphasized the stockpiled myths and meanings of *countryside,* they now tended to emphasize *Russia.* Portrayal of the Russian land as beautiful, or at least worthy of note, did not decrease; instead the terms of the problem changed. Rather than invoke the landscape as a means of articulating and experiencing the pleasures of a certain pre-established aesthetic convention, images of the countryside now came to be used as a way of representing region, nation, or empire.

Thus began the era of the Russian picturesque. Picturesque landscape, in its simplest form defined as a view that resembles a picture, blended aesthetic convention and geographical fact. In conjunction with Europe's developing self-conception as a collection of separate nations, an interest in picturesque landscape spread throughout the continent during the first decades of the nineteenth century. Russia was not immune to the rising fascination for national scenery, but it did experience the impact of the picturesque in distinctive ways. Those Russians who created images of the native land faced the difficult task of negotiating between, on the one hand, the continuing preponderance of aesthetic conventions established in the West to capture the particular beauty of western European terrains and, on the other, the specific characteristics of Russia's unique natural environment.

The attempt to overcome the discrepancies between inherited landscape aesthetics and "unconventional" landscape ultimately helped pave the way for the creation of an entirely new aesthetic imagery developed in response to the peculiarities of Russian space. In the period between Napoleon's invasion and the late 1830s, critics, poets, novelists, travel writers, and painters first struggled to create what might be called a pictorial vocabulary for the depiction of Russian terrain. Much of their work would subsequently appear antiquated, but in some of their imagery, most evidently in the poetry of Aleksandr Pushkin, an original and durable aesthetic of Russian landscape first focused sustained attention on the special nature of Russia's rural environment.

THE LESSONS OF NORTH AND SOUTH

As early as the final decade of the eighteenth century one finds evidence of a propensity to reenvision the native landscape in more concrete forms. The early writers who tackled this problem ardently desired to see images of Russian landscape portrayed in art and literature, but they lacked any practical plan for attaining that goal. As mentioned in

the previous chapter, Macpherson's Ossian served a pivotal role in helping to solve the problem.[3] Ossian gave Russians a reason to approve of certain features of the native terrain they had previously considered unworthy of attention, in particular the vast forests, the barren plains, and the harsh winter climate. As Petr Viazemskii explained in his introduction to the works of Ozerov, "The northern poet is transported by a sky, which is similar to his sky, he contemplates a nature similar to his nature. . . . Our very language contains more beauty for the depiction of northern nature."[4] The acquisition of this new, expressly northern, language finally made it possible for Russian writers to identify certain aspects of their land as admirable, if only because of the stern severity and independence that Ossianic landscape implied about its northern inhabitants.

S. A. Shirinskii-Shikhmatov, a member of the conservative, nationalist coterie surrounding the linguist Shishkov, published a highly nationalistic mixture of Ossianic and pastoral nature description in a travelogue of 1810. In describing his native land, Shirinskii-Shikhmatov compared northern Russia to an implied southern Europe: "Born into the wide world under a cold northern star, fostered from youthful years by stern, grey winter, we despise foreign luxury; and loving our own fatherland more than ourselves, seeing in it a promised land flowing with milk and honey, for all the delights of southern nature we would not exchange our snows and the ice of our fatherland."[5] Although Shirinskii-Shikhmatov expresses no ambiguity here about the superiority of Russia's natural environment, he is still unable to produce one word of description that identifies his beloved northern land as specifically Russian, or as a different landscape from that of any other northern European country. For the time being, such were the limits of both pastoral and Ossianic stock imagery.

In the same period Russian writers and artists faced the more pressing problem of unburdening themselves of an attachment to the warm pastoral ideal of southern climates, in particular the Arcadian homeland of the Mediterranean. K. N. Batiushkov's "Stroll Through the Academy of Arts" (1814), an article that has been called Russia's first important work of art criticism, advised Russian painters to concentrate on the city of St. Petersburg rather than overinflate the importance of foreign landscapes: "How sad that my colleagues scarcely make use of their own treasures; landscape painters more willingly paint views of Italy and other lands than our charming subject matter. I have often watched with sorrow as, during a harsh frost, they labor over the flaming Neapolitan sky that tyrannizes their imaginations, and often our gaze. A landscape must be a portrait. If it isn't a perfect likeness of nature, then what is it worth?"[6] Despite his best intentions to promote the beauty of the Russian landscape, however, in place of

this "tyrannical" Italian scenery, Batiushkov can only suggest that painters depict St. Petersburg's architectural structures, or the "high lindens, elms, and oaks" of the Summer Garden—an urban park constructed in neoclassical fashion.

Another example of the desire to portray accurately the Russian landscape without yet possessing the descriptive capacity to do so can be found in F. N. Glinka's *Letters of a Russian Officer* (1816). Glinka sought to create a positive image of the Russian countryside in his text "despite all the opinions of foreigners about the severity of our climate, the coarseness of our people, etc."[7] In this effort, here and there he refers to "beautiful, high izbas" or the "fresh" and "merry" country folk, but Glinka was still a product of the late eighteenth century. He was only able to describe the natural world by drawing on aesthetic formulas common to the Catherinian era. In one passage devoted entirely to the natural landscape he tries to outdistance pastoral conventions by shifting the descriptive environment from spring to fall. Thus in place of pastoral imagery he resorts to the conventional language of the sublime. In the resulting description he mimics the approach of Derzhavin's Ossianic waterfall: "almost everyone can enjoy spring days—flourishing nature, the babbling of spring brooks, but we felt it was possible to enjoy the autumn too, standing on the banks of a river (we were on the Volga) and watching as storms, with their foaming furrows, upturned the surface of the waters and howled in the mists."[8]

One could not but expect these writers to meet with difficulty in trying to produce a recognizable depiction of Russian terrain. Western European nature poetry and painting already enjoyed a number of longstanding precedents for naturalistic landscape representation, but in the 1810s Russia still lacked almost any such tradition. In Russia it remained unclear how the countryside might be depicted and perceived without reference to established conventions. Even Ossianic depictions of the north contained, in Pushkin's words, "nothing national, nothing Russian in them."[9] Russia had to start from scratch to produce a native landscape imagery. As literary trends associated with romanticism became a significant part of Russian literature, both a new realism and a new exoticism in landscape depiction emerged. Italy itself played an important role in this transitional phase. The Russian celebration and glorification of Italy that took place in the early nineteenth century formed a pivotal step between the predominance of stock pastoral and the dawning interest in specific geographical locations.

While retaining the old admiration for pastoral color and warmth, Russian writers and artists became interested in beautiful landscape as an expression of the special qualities of the Italian peninsula. Italy became, to use the poet Dmitrii Venevitvinov's phrase, "the fatherland of beauty."[10] Although Italy had been sharply criticized by Denis Fonvizin

in the 1770s and 1780s, and Karamzin had not even chosen to visit on his journey through Europe in 1789–1790, by the first decades of the nineteenth century Italy had become the primary destination for Russian travelers abroad. Wealthy Russian tourists, and Russian artists on stipends, went to Italy to immerse themselves in the warm climate, the majesty of Italian art, and the beauty of southern landscape. Italy, it is fair to say, became fetishized in Russian culture. The expression *"toska po Italii"* conveyed the potent nostalgia Russians sometimes felt for Italy, often before they had even set foot there.[11] Gogol's poem "Italy," written eight years before he actually visited Rome, typifies the Italian cult in Russia during the first half of the nineteenth century:

> Italy, magnificent country!
> The soul cries out for you, and is consumed;
> You are heaven, you full delight,
> And in you dazzling love is in bloom.[12]

Not insignificantly, the rise of a Russian fascination for Italy in the 1810s coincides with the decline of pastoral imagery. Perhaps Italy even provided a certain compensation for the loss. It fed the passion for classical cultures and Mediterranean landscapes that had flourished in the Russian arts, and it helped sustain the fantasy of an idealized natural space that had become an integral part of Russian elite culture in the eighteenth century.

Given the increased interest in national identity in this period, it wasn't long before Russia's own native landscape would find its champions wishing to promote its aesthetic qualities. The literary critic Orest Somov's landmark essay "On Romantic Poetry" (1823) argued that, contrary to popular opinion, the Russian landscape was capable of arousing the same fascination and patriotic pride as the vaunted landscapes of the West. In order to make this claim, Somov countered his contemporaries' anxieties about the apparent lack of beauty in the central Russian landscape by invoking the geographical scale and natural and ethnic diversity contained within the vast expanse of the tsar's domains:

> I have often heard the opinion that in Russia there cannot be a national poetry . . . that the nature of our fatherland is flat and monotonous and does not have that shining beauty, nor that magnificent sublimity, which distinguishes the nature of several other countries, and thus our nature does not inspire poets. . . . The injustice of this opinion will correct itself when we begin to look around us. . . .
>
> Where is [nature] more varied than in Russia—several zones encircle its extent, it has several climates in it, gradually altering the forms of the land by their activity. We look north and we see eternal ice, the northern

lights; never ending day and never ending night divide the seasons there. Closer to us are the wild cliffs of Finland, the magnificent lakes, rivers, and waterfalls. Extending our gaze to cold Siberia, endless treasures are unearthed from the depths of the mountains: rich mines, piles of precious stones, fossils, and other wonders of nature below the cold cover of melting snow have earned Siberia the appellation "gold mine." We turn to the south and see boundless, unforested plains covered with thick grasses and spread about with endless herds. Charming Tavride, with its enchanting valleys and magnificent mountains that gaze down upon two seas, serves to relax the gaze, which is tired out by the monotonous vision of flat, green carpet and white flocks. Further, the dreadful Caucasus loom up above walls of clouds, shackling the eye and the imagination with their terrific wildness.[13]

Somov pieces together a remarkable composite portrait of "the Russian landscape" from this panoramic overview of the empire. At first he refrains from describing central Great Russia or Ukraine where most of his readers lived. When he attempts to convey the distinctive landscape of these regions his descriptive powers notably weaken, and his tone shifts from confident to hopeful:

Here we will still find an abundant harvest for poetry. Our songsmiths have already celebrated the luxuriant Volga, with its distant flow and its blessed banks. But so many places and objects, spread across the face of the Russian land, still remain for today's singers and those of future generations. The flowering gardens of the fruitful Ukraine, the picturesque banks of the Dnieper, the Psel, and other rivers of Little Russia, the overflowing Don, in which vineyards can be seen in all their splendor—all these places and a multitude of others await their poets and demand tribute from the talented of the fatherland.[14]

For all his optimism, Somov's remarks on central Russia reveal a paucity of descriptive terminology with which to offer "tribute" to the various landscapes of these regions. While he relies on stock imagery to discuss both landscapes, the natural beauty of non-Russian areas outshines that of central Russia because it profits from a richer vocabulary already developed to celebrate the exotic and dramatic landscapes of Europe. Indeed, Russian writers generally found it easier to apply this vocabulary to parts of the empire in the extreme north and south.

The diverse terrains of the northern and southern, non-Russian, parts of the empire became a useful training ground for Russian writers who would later take up the subject of central Russian landscape. In this regard, it is important to keep in mind that landscape description is never a transparent rendering of objects seen by the writer or artist. It is

always mediated by some form of conventional language. After all, it is that descriptive language that makes the landscape an aesthetic object in the first place. Russian descriptions of the Caucasus or Finland often inspired popular and formulaic landscape descriptions, but these regions allowed Russian writers to participate in the romantic fascination for nonpastoral, uncultivated, and sometimes exotic terrain. It helped them move beyond purely literary approaches to nature.

Susan Layton's study of the literary construction of the Caucasus is particularly instructive in this regard. The mountainous Caucasus region was one of the most compelling and important parts of the empire for Russian writers in the 1820s and 1830s. Layton points out that when poets such as Pushkin wrote about nature in the Caucasus they used imagery previously developed to describe Alpine scenery. One reason the image of the Caucasus loomed large during this period was its double purpose in Russian letters. It allowed Russian writers to fulfill the romantic, Rousseauian imperative to become immersed in some wild, primordial terrain, and simultaneously it functioned as a symbol of Russia's national importance. Since, in the dramatic idiom of romantic landscape imagery, the central Russian landscape was little more than a nonentity, areas such as the Crimea and the Caucasus offered Russians access to their own world of wondrous scenery and exotic cultures. In addition, the representation of an alpine Caucasus let Russians feel the national pride that, in Layton's phrase, "Piatigorsk was as good as Switzerland."[15]

Remote from the Caucasus geographically, Finland proved closer to the empire's southern mountains in aesthetic terms. Descriptions of Finnish landscape were published as early as 1810 in Batiushkov's "Excerpt from the Letters of a Russian Officer on Finland." Batiushkov's depiction of Finland relied heavily on Ossianic models of northern nature. His Finland is a land "where nature is poor and gloomy . . . a new land, wild, but wonderful in its wildness."[16] His nature descriptions are full of compelling visual detail, filled with granite cliffs, vast lakes, windswept pines, and wild waterfowl. Batiushkov established a pattern that many writers followed when they traveled to Finland in the 1820s. Somov, for example, published some letters on Finland at around this time, but the most interesting and successful Scandinavian landscape description was found in the poetry of Glinka and Evgenii Baratynskii.[17] Baratynskii's imagery went even further to construct Finland as a fantastical, northern wilderness. Like Macpherson's Scotland, Baratynskii's Finland was cold, enormous, and severe—removed from the human scale and made otherworldly:

> Severe region, its frightening
> Colors astonish the eyes;
> There on the stony heights

> The mountains have toppled over;
> In their arbitrary immensity
> They turn blue, ascending to the sky;
> The pines whistle on them,
> Waterfalls pour forth torrents,
> Covered over with granite lava;
> The valley gladdens not the eye.[18]

Glinka was exiled to the northern Russian wilderness of Karelia in 1826 for Decembrist activities. Karelia resembles Finland with its glaciated, rocky, and lake-covered terrain. Glinka's poem "Karelia" combined some of Baratynskii's sublime elements with what is virtually a tour guide's description of the dramatic and fickle northern summer.

In these works Finland's landscape was doubly significant in its influence on Russian landscape imagery. It had two advantages, which appear contradictory but in practice worked in tandem with one another. First, it provided a northern, exotic "other" to Russian space that made Russia appear more southern and less exotic, more a part of the rest of Europe. Second, being close to the Russian capital, Finland could stand as an analogous terrain to that of the Russian countryside. It provided access to a romantic image of northern beauty that, like the "Alpine" Caucasus and the "luxurious" Crimea, was accessible without being too familiar.

In this latter sense, the idea of Russia itself as "the north" could also form the basis of a less exalted kind of nature description. That the invocation of northern nature was not limited to exotic, gloomy [*ugriumyi*] Finland or Karelia is attested to in a short piece by Faddei Bulgarin. Describing an excursion to the dacha region outside Petersburg in the summer of 1825, Bulgarin managed to mingle a bland scenic pastoral with a mild evocation of "northernness" to form a simple picturesque landscape of the St. Petersburg outskirts: "Here northern nature is seen in all its beauty. Hills breathing fragrant grasses and scattered with marvelous, age-old trees of every sort. Each hill, each valley opens varied views to your gaze."[19] Although not an inspiring or pictorially striking image, Bulgarin's interest in recommending views to his readers in this excerpt from the *Northern Bee* [*Severnaia Pchela*] conformed to a developing conception of the Russian countryside as a place worthy of scenic travel and aesthetic attention.

IDYLLIC SCENERY MADE FAMILIAR

Meanwhile in the early 1820s an increasing number of poets had been struggling to produce recognizable and aesthetically accessible descriptions of the central Russian landscape. Glinka's "Dream of the

Russian Abroad," K. F. Ryleev's "Ivan Susanin," and N. M. Iazykov's "Motherland" are some important, although mostly insubstantial, examples of the growing ambition to establish a poetic image of Russian terrain.[20] Petr Viazemskii was one of the most influential landscape poets in this era. Although Viazemskii has not generally received a great deal of attention as an innovator, with respect to nature description Mikhail Epshtein has justly gone so far as to call him one of the "founders of the national landscape."[21] In 1816 Viazemskii first announced his interest in Russian landscape by taking up the same theme that Dmitriev and Karamzin (incidentally, Viazemskii's father-in-law) had written about two decades before: the Volga River. Viazemskii's "Evening on the Volga" reveals some of the changes that nature description had undergone between the 1790s and 1810s. His attention is focused on concrete, visual details that celebrate the river for its picturesqueness. Karamzin and Dmitriev had portrayed the river as a symbol of nationality, but they would have considered such decidedly pictorial imagery beside the point. Viazemskii's Volga poetry often resorted to descriptive commonplaces and sentimental stock phrases such as "fields, clothed in waving gold," but for the most part he built his imagery from concrete, if rather grandiloquent, descriptions of the Volga region. Collected together, they capture a recognizable space, as in the following lines:

> A dark row of forests here beneath a mantle of fog
> An airy range of bluish burial mounds
> In the great distance a village arrayed below the hills
> Meadows, paying their golden tribute to the flocks. . . .[22]

"Evening on the Volga" breaks from the Volga poems of Karamzin and Dmitriev in its enlistment of landscape as a means to celebrate the river as a marker of nationality: "Utterly fascinated, I love of an evening / To listen, O great Volga! / To the poetic voice of your holy waves; / In them is heard Russia's ancient glory." With this poem Viazemskii produced an early example of the emerging interest in picturesque native scenery.

Not unrelatedly, Viazemskii was one of the leading figures of his era in the construction of Russian identity. It was he in fact who coined the term *narodnost'* in 1819 to refer to a nationality that emphasized the Herderian conception of an organic national culture originating in the folk.[23] In that same year, Viazemskii wrote a sentimental work with its roots in idyllic poetry that, nevertheless, must be considered one of the first direct attempts to formulate an aesthetic response to the everyday Russian countryside. "First Snow" opens with a simple equation between the southern fondness for the coming of spring and the Russian

appreciation of the first snowfall after the oppressiveness of autumn. The first wintry day, almost a Russian idyll, appears in this work:

> Here, like a light down, snow hangs on the bent fir;
> There, having sprinkled the dark emerald with silver,
> It has drawn patterns on the dark pines.
> Vapors are scattered about and the hills shine.
> The sun flashes in its arc of blue.
> The whole world is transformed by the sorceress winter. . . .[24]

Further on, the scene is enlivened by descriptions of skating children, hunters, and lovers riding in a sleigh. Viazemskii made use of his enraptured description of winter and its pleasures to comment on the brevity of life and happiness, just as sentimental poets had used Arcadia as a foil for meditations on death. His evocation of the Russian countryside idealized rural winter in much the same way that idyllic poetry renders an idealized portrait of spring and summer. Most importantly, in order to create this contrasting image Viazemskii produced one of the earliest recognizable portrayals of the Russian winter landscape.

"First Snow" reveals a growing confidence in the aesthetic viability of Russian space, a confidence that life as it was lived in the Russian countryside, away from the tended gardens of the gentry estate, was worthy of public representation in poeticized form. Viazemskii himself was acutely aware of the national element in his descriptive poetry. His friend, the historian and writer Aleksandr Turgenev, had praised "First Snow" for overcoming the influence of the French sentimental garden poet, Jacques Delille. Viazemskii responded by dismissing the comparison altogether: "Why do you think in 'First Snow' I went beyond Delille? Where does he have a similar picture? I call myself a natural Russian poet because I delve into everything from my own land. By and large, I curse, praise, and describe what is Russian: Russian winter, consumptive Petersburg, the Petersburg Christmas, etc., etc.; that's what I sing of. The majority of our poets . . . have nothing of their own."[25] Viazemskii would similarly argue a few years later that "national character" and "local color" were the essential components of great literature.[26] Given the continued recognition of conventional neoclassical imagery as the standard for poetry in this period, Viazemskii's portrayal of the Russian countryside, although conservative in its use of language, had the flavor of an ideological transgression, which allowed him to boast of his originality.

The idyll in its standard literary form also came under attack in these years by the poet and editor Nikolai Gnedich. The influence of Gessner in Russia had not died out with the high sentimentalism of the late eighteenth–early nineteenth century, and the idyll continued to thrive

as a literary form in Russia into the 1820s. The most popular practitioner of idyllic poetry in the 1810s and 1820s was V. I. Panaev, known as "the Russian Gessner." Panaev's idylls were traditional in the extreme. Written for salon society, they depicted classical figures and lacked any identifiable expression of time or place. Against this example, Gnedich proposed to modernize the idyll. He believed idyllic poetry could and should be placed in an expressly Russian setting. Gnedich argued that Gessner's Alpine idylls compared poorly to the original idylls of Theocritus because they idealized Swiss peasants based on inapplicable ancient models. By contrast, Theocritus, Virgil, and other ancient writers of idylls and eclogues had envisioned an ideal environment closer to their own world. "Nymphs, fauns, and satyrs have died for us," wrote Gnedich, "and they cannot appear in the poetry of our times."[27]

As a corrective to this tendency, Gnedich's idyll "The Fishermen" (1821) sought to create a pastoral world from the materials of Russian life. He argued from the etymology of the Greek word idyll that the essence of such poetry was to produce a simple view, picture, or scene.[28] The idyll, in the hands of its first practitioners, had originally painted a relatively accurate picture of rural life in ancient times. Gnedich argued that Russian "village poetry was so unsuccessful in the present" because contemporary poets refused to describe the actual rural countryside surrounding them. "Where if not in Russia," he asked, "is the state of the people such that their morals, customs, and life is so simple, so close to nature? . . . don't they have *their* hearts, *their* passions . . . their Russian natural setting?"[29]

"The Fishermen" is set on the shores of the Neva near St. Petersburg. The most extended landscape description it contains portrays the beauty of the white nights in June over the city. One of the poem's impoverished fishermen encounters a Russian gentleman who treats him well and presents him with a precious flute of palm wood, ivory, and gold. The peasant fisherman is rewarded by this flute, while the gentleman in turn is rewarded by the fisherman's music. That this idyll became Gnedich's most popular work probably resulted from its gratifying idealization of the relationship between members of separate social stations. Like eighteenth-century idyllic poetry, it soothed the reader's conscience by using the countryside (in this case just on the outskirts of the city) to invent an imaginary relationship of mutual benefit between members of different estates. Gnedich moved away from the classical basis of the idyll but held fast to its fanciful idealization of rural life. Despite Gnedich's temporary success, the idyll's patent idealization would ensure its virtual demise as a literary form not many years after the publication of this work.

In painting as well as in poetry, landscape imagery began to express certain distinctly national traits. For the most part, the best landscape

painters of this era—among them Shchedrin and Lebedev—went to Italy and painted the Italian scenery that they (and the Imperial Academy of Arts) considered the appropriate subject for artistic representation. Painters who remained at home were influenced by their light touch and romantic style. The first important apostate from this tradition was the painter Aleksei Venetsianov. After a successful career rendering portraits and caricatures of the Moscow elite, at around the age of forty Venetsianov moved to a small estate he had purchased in Tver' province. To improve his painting, Venetsianov believed, "it was necessary to abandon all the rules and styles obtained from twelve years of copying at the Hermitage." He had resolved to paint "without imitating other artists, that is not to paint *à la* Rembrandt, *à la* Rubens or others, but simply to paint, so to speak, *à la* nature."[30] His main theme in these years was the peasant at labor and out-of-doors. Technically speaking, Venetsianov was more a genre than a landscape painter, but in depicting peasants in their customary outdoor surroundings he produced a number of works that included strikingly fresh images of the Russian countryside.

Like Gnedich's hybrid idyll, Venetsianov's paintings combine classical stylization and pastoral elements with an entirely new interest in recognizable images of ordinary agricultural land. Some such combination of styles was nearly inevitable for both Gnedich and Venetsianov since pastoral imagery still remained the only viable aestheticization of Russian country life. Venetsianov's peasants are well dressed and well fed; the sun is always shining, and the harvest abounds. Among his various scenes we find a mother ploughing the fields and tenderly watching over her child; peasant couple, sickles in hand, admiring a pair of butterflies; a peasant boy sleeping peacefully under a tree by a river [fig. 4]. Warm light fills Venetsianov's landscapes, his palette is bright without being unsettling, the atmospheres are invitingly delicate, and a comfortable symmetry of figures and objects dominates his composition.

Venetsianov's landscapes themselves are simple and unassuming, yet they are astonishingly bold in their rejection of academic convention. The main techniques of neoclassical landscape painting—striking effects of light, dramatic scenery, the coulisse (or framing device), and propulsion of the eye into the deep distance—play little or no part in his work. These landscapes are not intended to engage and thrill the outside observer with their beauty or majesty. Instead they encircle the world of the peasants they represent, imparting a kind of unbreakable stillness and unity to the rural atmosphere. This idealization of the peasant world as a timeless whole once again is rooted in pastoral visions of country life, but if this is a sort of Arcadia, it is an Arcadia on Russian terms. The wide-open spaces, the slightly undulating terrain, and the small and unspectacular trees lend his settings both an unobtrusive, pastoral gentleness and a distinctly Russian appearance.

Owing to the low status of his chosen field of genre painting, Venetsianov was granted only limited respect as an artist in his own era. Later, to art critics of the late nineteenth century, such as the preeminent Vladimir Stasov, his work appeared specious and contrived. His paintings lacked the conventional beauty his contemporaries expected to find, yet they appeared too composed for the realists of the reform era. In the twentieth century his paintings have rightfully been accorded an important position in Russian art history. One might argue that the original distaste for his work arose from the transitional character of the period during which he was painting. Both Gnedich and Venetsianov worked on the cusp of an aesthetic paradigm shift; they innovated, but in doing so could satisfy neither earlier nor later conventions. In common with most of his contemporaries, Venetsianov sought to produce works of symmetry and beauty, and in this respect his images retain a classical sense of harmony and proportion. At the same time, together with many of the writers already mentioned, he hoped to create an accurate depiction of his native land. What he wound up with was a sort of hybrid form that in retrospect appears remarkably innovative, but could not satisfy the rapidly shifting tastes of his own age. It seems likely that Venetsianov's ability to meld a classical sensibility with depictions of recognizable scenery could have been possible only for a short period of time, just as Gnedich's distinctly Russian idyll only enjoyed a short-lived popularity.

Precisely because Venetsianov's landscapes were backdrops for peasant figures, they would remain the most naturalistic painted expression of Russian landscape for many years to come. The unspectacular terrain of central Russia could not yet stand on its own as an aesthetic image in an era that still adhered to relatively rigid models of landscape beauty. As a setting for peaceful Russian peasants, however, Venetsianov's depiction of a gentle and unassuming Russian terrain could fit in with lingering pastoral traditions that envisioned peasants as contented agriculturalists in their proper natural state. When ideological battles surrounding the meaning of the Russian countryside heated up in subsequent years, the application of classical ideals to actual conditions quickly became an object of ridicule. An entirely new way of envisioning the Russian countryside would have to be found before landscape painting could thrive on Russian soil.

THE RUSSIAN PICTURESQUE JOURNEY

One ardent admirer of Venetsianov's work greeted an 1824 exhibit of his paintings as a major event: "We have finally seen the arrival of an artist who has turned his wonderful talent toward the fatherland alone, toward the depiction of the objects that surround him, that are

near to his heart and to ours."[31] This review was written in the journal *Notes of the Fatherland* [*Otechestvennye zapiski*] by its founder and primary contributor during the 1820s—Pavel Svinin. Svinin detected a sympathetic mind at work behind Venetsianov's paintings, perhaps because he had chosen as his own life's work the promotion of the beauty and importance of his native land. He undertook this task by creating *Notes of the Fatherland* as a sort of running picturesque guidebook to provincial Russia.

His seemingly simple goal would prove daunting. Russian travel writing found itself in a bind similar to that of Russian literature and painting during the first half of the nineteenth century. It was unclear precisely what merited looking at in the Russian countryside. What was Russian scenery? The critic and playwright Nestor Kukolnik complained as late as 1837 that books of picturesque sights were published "in France, England, and even in Switzerland; but we . . . translate and reprint the old ones, so that we only respect foreigners and are all the more convinced we have nothing good of our own."[32] Even for scenic travel and books of picturesque landscape, Russia had so internalized European aesthetic values that, although many wished to reject this European influence, they found themselves powerless to do so.[33]

Svinin was the first writer to systematically attack the problem. He may be best known today as the butt of Pushkin's humorous epigrams or as a possible model for Gogol's *Inspector General*.[34] Despite the ridicule he (sometimes justly) endured, Svinin was a remarkably accomplished man. He had a degree from the Imperial Academy of Arts, wrote verse and prose, spoke several languages, and traveled throughout Europe and the United States in diplomatic service. During his time abroad he absorbed the European fascination for picturesque travel. In the United States he demonstrated his aptitude for the travelogue genre, writing and illustrating both a picturesque journey through the American countryside in Russian and an account of Moscow and Petersburg for English-speaking readers.[35]

In these works Svinin had focused on the appearance and beauty of the natural landscape, which was standard practice in the picturesque travelogues of his day. Although he was adept at writing inspired descriptions of American wilderness or English gardens near Petersburg, *natural* scenery never played a significant role in Svinin's accounts of provincial Russia.[36] He conceived of his native land in a different way. The approach he would take to Russian travel was evident as early as 1820 in the inscription to *Notes of the Fatherland*: "God and Nature command we love our country / But to know it is an honor, a virtue, and a duty."[37] *Notes of the Fatherland* became Svinin's vehicle for fulfilling his debt to his country. He wrote and edited its pages in the spirit of national patriotism, offering up the journal as a lesson in Russian

history, geography, architecture, and archaeology, rather than a guide to the beauty of the natural landscape.

In order to make his travel notes visually interesting, Svinin reinterpreted the model of picturesque travel he had imbibed in the West in a way that allowed him to formulate a special scenic vision of the Russian countryside. In his effort to portray rural Russia as scenic space, he introduced the monastery and the provincial church as the most visible and important features of the Russian landscape. Svinin generally refrained from close, detailed descriptions of these structures, preferring to invoke what might be called the "tourist's view" of Russian architecture. Readers were invited to appreciate the aesthetic qualities of monasteries and churches in provincial cities from a removed perspective. A word that continually arises in Svinin's descriptive vocabulary is *"mestopolozhenie,"* perhaps best translated as the "situation" in the landscape of a building or city. His portrayal of the Khutynskii Monastery outside Novgorod gives a characteristic example of his enthusiastic but economical descriptions: "One could not pick out a more pleasant and beautiful monastery. Standing atop the highest place in its surroundings it can be seen from anywhere. Its open spaces are covered with gardens and stone walls."[38]

In publishing his travel sketches, Svinin clearly intended to establish a pattern of Russian touristic travel. Regarding one of these pieces he commented that he wrote it "in the hope it can be put to use by many wanderers like me—rich in curiosity but poor in free time."[39] But Svinin had a special kind of tourism in mind. His vision of Russian travel did not express the familiar element of escape from urban into rural life so characteristic of the European picturesque journey. Svinin's conception of tourism was less an escape from the present than an engagement with the past. That past concealed within itself an essential knowledge of the "national character" that would generate Russian pride and dignity. The scenic beauty of provincial church architecture was the hinge that opened a door into a deeper understanding of Russianness.

Traveling vicariously through Russia with Svinin as a guide, the reader of *Notes of the Fatherland* encountered a wide array of well-situated monasteries and churches. Once the picturesque view of a given building had been established, however, Svinin typically moved straight into his primary focus, describing the site as a historical point of interest. His spare aesthetic imagery notwithstanding, in the dozens of travel sketches that appeared over the course of more than a decade, *Notes of the Fatherland* built up an elaborate panorama of Russian space. By emphasizing the appearance and historical importance of the monastery, it set a pattern that would be followed by future travel writers. Most importantly, Svinin's journal worked to show that provincial Russia could not be considered an empty wilderness. It was

crowded with picturesque points of interest that deserved to be appreciated and studied.

A new model for Russian travel appeared in 1836. In the early 1830s Andrei Murav'ev had visited the Holy Land. He later recalled that on his journey a group of monks in Jerusalem had asked him about the Trinity–St. Sergius Monastery outside Moscow. Although he had been raised in Moscow, he had to confess that he was unfamiliar with the site.[40] Inspired to know more, Murav'ev began a tour of Russian religious monuments that took him to most of the important monasteries in Russia and Ukraine. Based on this tour, he published a book of travel descriptions under the title *Journey Through the Holy Places of Russia*. The work became popular and was reissued and expanded four times over the next ten years.[41] Murav'ev's *Journey* built on and transformed a variety of travel that had deep roots in Orthodox Russia: the pilgrimage. Not only did he treat Russian monasteries with religious veneration, but he also benefited from the special meals and lodging prepared by the monks for the use of pilgrims. Yet as respectful as he was of the pilgrimage tradition, Murav'ev's aims as a travel writer lay elsewhere. In comparing the nineteenth-century traveler to pilgrims of past centuries, he pointed out that his contemporaries were less interested in "great feats of travel" than in "descriptions of sacred places."[42] In this sense Murav'ev's reasons for writing mirrored those of Svinin. "At the least," he wrote, "I wanted to direct the attention of passers-by to the most important objects and familiarize them with the ancient, holy places of our Fatherland."[43] Murav'ev's *Journey*, then, also set itself up as an early model of Russian tourism. Like Svinin, Murav'ev sought to instill in the public an admiration for Russia by attracting interest to the notable places in the provincial landscape.

Interestingly, however, Murav'ev's vision of Russia differed from Svinin's by the measure of the difference between their original examples of touristic travel. Whereas Svinin sought to portray Russian space as picturesque countryside, in Murav'ev's work, Russia appears to be nothing so much as an Orthodox holy land. His travel descriptions cleverly transformed the vast distances he covered—from northern Russia to southern Ukraine—into a seemingly single, unified realm of Orthodox sites. He achieved this effect by almost entirely ignoring the landscapes and objects between the monasteries. The monastic spaces he describes are sacred locations; by presenting them in magnificent and spiritually untainted isolation he likens them to minor Edenic retreats. With scant reference to nonsacred places, yet describing monasteries across a vast extent of territory in Russia and Ukraine, Murav'ev's *Journey* seems to enfold the entire countryside into its inspired vision of Russia as a sacred Orthodox space.

This effect was facilitated by Murav'ev's descriptive method. New sections of the *Journey* typically begin with the entrance into view of the monastery as it is seen from the road. Most chapters open as Murav'ev travels through some part of the countryside. He reaches a promontory and suddenly the splendid domes and spires of a given monastery arrest his attention and call forth a rapturous description of the beauty of the sacred place. He then enters the monastic setting, and there follows a description of its daily life, its history, its gardens, its architecture, and the noteworthy objects it contains. Everything is a reflection of the spirituality of the place, which in turn represents the spirituality of Russia as a whole. By narrowing the focus of his travels, Murav'ev found a way to make the Russian landscape interesting and attractive—not as a world of scenery and history, but as a hallowed and resplendent Orthodox land.[44]

The attempt to fashion a picturesque image of the Russian countryside would remain an important concern, and picturesque travelogues of the Russian countryside continued to appear into the early 1850s.[45] The most unusual of Russia's picturesque journeys was undertaken by two brothers named Grigorii and Nikanor Chernetsov, both of them painters at the Imperial Academy of Arts. In 1838, the Ministry of the Imperial Palace provided funds for them to travel the length of the Volga River, from Rybinsk to Astrakhan, in a "floating studio," outfitted to help them sketch and paint their impressions. According to a ministry decree, the Chernetsovs had been commissioned to "draw from nature the beautiful places on both banks of the Volga in panoramic views." The purpose of their task was to document the beauty of the great river: "At the time of this voyage," the ministry stipulated, "they are intended to take [*sniat'*] for their subjects general views of the cities, sizable villages, other picturesque sites, places marked by historical events, vestiges from antiquity, clothing, and other finds that, in whatever way, merit attention."[46] Part Lewis and Clark explorers, part academic aesthetes, and part wide-eyed tourists, they set out in early May of 1838 to discover a picturesque Russia along the banks of the Volga River.

The ultimate result of the Chernetsovs' effort was an enormous panorama around two thousand feet in length, which they managed to display to the public only in 1851. This work is more properly called a cyclorama because it was slowly reeled from one spool onto another in front of an audience. The room in St. Petersburg where it was displayed was made to look like a shipboard cabin, and sound was added to simulate the effect of river travel. Unfortunately the work was badly damaged by frequent unwindings, and it no longer exists. Some visual remnants of the Chernetsovs' journey still remain in the form of drawings, watercolors, and a few oils. Most importantly, the brothers docu-

mented their trip in journals that are still extant. They condensed the journals into a travelogue called *The Parallel Banks of the Volga,* and offered it to Tsar Alexander II in 1862.[47] A clear picture emerges from these travel notes as to how they envisioned their project and of the successes and failures they encountered along the way.

Admiration for the Volga River had long been a common theme in Russian folk songs, and it had already been almost a half-century since Karamzin and Dmitriev had established the Volga as a poetic theme, but few painters had yet attempted to depict the river and its surroundings. The Chernetsovs conceived of their trip down the Volga, in the language common to travelers of the day, as a "picturesque journey." Especially for landscape painters this expression carried a heavy burden. They understood their task as a search for "beautiful pictures," "magnificent, panoramic views," and "astonishing or wonderful phenomena."[48] Unlike Svinin and Murav'ev, the Chernetsovs could not designate the sites proper to their vision of scenery, since they were compelled by the preconditions of their voyage to devote relatively equal attention to all regions of the river. Along the banks of the more populous upper Volga, they turned their attention almost exclusively to cities and monasteries, just as Svinin and Murav'ev had emphasized architectural structures. But the banks of the lower Volga were more sparsely populated. The Chernetsovs' struggles to incorporate these spaces into their visual conception of picturesqueness reveals a great deal about the difficulties painters confronted in trying to depict Russia's landscape.

Neither of the brothers seems to have had much interest in uncultivated natural space. The highest praise they gave to any natural area in their travel notes concerned an island near Iaroslavl: "Here nature itself has arranged a wonderful garden with alleys, walkways, and flowerbeds; the bright green grass, the aroma of flowers, the warm summer day, and the clear, quiet weather so delighted us that we took leave unwillingly of this wonderful, uninhabited island."[49] Similarly, they admired some unusual rock formations on the southern Volga for their resemblance to architectural monuments. Forests, on the other hand, entered their journals only as primordial wilderness, and they described the steppe as an empty waste: "not a sapling, nor a shrub, only the bitter sage waves in this desert."[50]

The river itself was the most important element in the Chernetsovs' sketches and paintings. It helped provide the proper length of perspective to turn a distant church, city, or riverbank into a view. Mountainous terrain proved less accommodating. The Zhiguli Mountains are a series of high hills that rise steeply from the right bank of the Volga just upriver from Samara. They project bluntly from the banks, so that they are difficult to view from a distance, and they are covered by a thick unbroken forest. Thus, although the Zhiguli range is one of the

most prominent features of the central Russian landscape, it lacks the kind of perspective and variety conducive to conventional landscape depiction. The Chernetsovs spent two days climbing these hills in order to find the sorts of views they could accept as picturesque. "Wishing to survey the circumference of the space occupied by the mountains," they reported, "we somehow scrambled to the top of one of the hills less covered by forest, but our plan was in error: the mountains, rising higher by degrees, overshadowed one another, entirely concealing the distance." They finally discovered the village of Morkvash, where the valley and surrounding hills were more open. Once they had climbed to a summit above the village, they found a view of the river and the village outskirts. This location they finally deemed "a view remarkable for its picturesqueness."[51]

Uncultivated Russian terrain was often at odds with the whole enterprise of the picturesque journey. The Chernetsovs had to search for an area clear of trees: such a terrain resembled the kind of space they understood as picturesque, based on the conventional landscape imagery they had been trained to portray as a proper picture. The Chernetsovs' trip down the Volga represents the furthest extent this search for a kind of traditional picturesque would be taken in Russia. The two brothers did manage to find enough of the sort of material they needed to portray the Volga as a picturesque Russian region, but as they moved off the river and away from Russian architectural monuments, the landscape lost the scenic qualities they were looking for.

PUSHKIN'S PICTURESQUE

Painters and travel writers had been able to draw on certain features of the countryside to create an isolated and limited picturesque landscape. But by the mid-1820s evidence of a fundamental revision of Russian landscape imagery had already begun to appear in the work of Russia's foremost national poet, Aleksandr Pushkin. Pushkin reconsidered the entire question of landscape aesthetics in his work, and once he had discarded traditional assumptions he formulated new ways to appreciate his native terrain. The aesthetic model he developed would become an important foundation for a new standard of Russian landscape depiction and appreciation in subsequent years.

It should be noted that Pushkin's innovative landscape imagery has often been described as a sort of literary conquest of new territory, in which his unflinching honesty and remarkable talent led him to see and portray the *real* Russian landscape for the first time. Dmitrii Likhachev made the point in bold terms: "Pushkin, the Columbus of Russian poetry, discovered the simple Russian landscape."[52] Pushkin certainly did describe Russian scenery more accurately than his prede-

cessors had, but it seems to me that the metaphor of discovery poorly conveys the most interesting and far-reaching aspects of his achievement. He did not so much "discover" a landscape heretofore invisible to eyes that could appreciate only idyllic nature; rather he *created* a new idealization of Russian terrain that made the landscape interesting and admirable to Russian readers. He "discovered" ways to make the Russian countryside aesthetically accessible to his public. Those who still see Pushkin's work as an unveiling of reality by means of authentic description continue to operate within the confines of the very ideal he first devised.

No matter what the opinion of the commentator, discussions of Pushkin's landscape have been cast in a language of authenticity versus artificiality. "The strength of Pushkin's landscape," wrote one Soviet scholar, "is that the poet managed to convey in sharply individual, concrete forms the typical, prevailing character of Russian nature."[53] Vladimir Nabokov held an opposing view of Pushkin's work. He argued that Pushkin primarily repeated the conventions of idyllic landscape:

> As a poet Pushkin does not show any genuine knowledge of the Russian countryside (as Turgenev and Tolstoy were to show fifteen years after our poet's death). Stylistically, he remains true to the eighteenth-century concepts of generalized "nature," and either avoids specific features and subjective details of landscape altogether or serves them up with a self-conscious smile as something that might perplex or amuse an ordinary reader.[54]

How is it possible for two such contradictory readings of Pushkin's landscape imagery to exist? This question lies at the heart of Pushkin's unique creative abilities. In a way, both interpretations are correct. Like Venetsianov or Gnedich, Pushkin engaged in the delicate balancing act of an artist working on the threshold of two very distinct cultural periods. Most of Pushkin's imagery, as Nabokov maintained, keeps within the bounds of tradition, but Pushkin ingeniously managed to deploy the conventional imagery he had inherited from his literary predecessors to devise a wholly original solution to the representation of Russian nature as an aesthetic subject. He certainly broke with the landscape imagery commonly appreciated by his contemporaries, but in portraying the Russian countryside he did not simply "convey the typical and prevailing character" of Russian space. Rather he worked to make appreciation of unconventional landscape possible for his readers. In order to understand the particular attainments of Pushkin's landscape, it will be useful to follow his nature description through the course of his career.

In his teens Pushkin had proven himself adept at writing idyllic verse. An example of this is "Memories of Tsarskoe Selo," in which he

sings the praises of Catherine's garden park, located near the lycée he attended. The park is described as "northern Elysium, the beautiful garden."[55] Even earlier he had written a few remarkably naturalistic lines in his folkish poem "The Cossack."[56] As he grew older Pushkin began to write political poetry. One of the poems that would prove instrumental in bringing about his exile to southern parts of the empire was "The Countryside." Pushkin used this work to point out the irony and hypocrisy of the landowner's country life.

The poem begins traditionally, as the poet relinquishes the vice and anxiety of the city for the healthy calm of the country. Such georgic appeals to country living date back to Trediakovskii in Russia and to their original models in ancient Greece and Rome. There follows a word-picture of Pushkin's estate that moves from foreground to background in what appears to be a deliberate imitation of a conventional landscape painting:

> I love this dark garden,
> Its cool shade, its flowers,
> This meadow piled with fragrant haystacks,
> Where radiant brooks murmur in the shrubs.
> Pictures are moving everywhere around me:
> Here I see the azure ravines of two lakes
> Whitened in places by the fisherman's sail,
> Beyond them, a row of hills, stripes of cornfields,
> Further still a sprinkling of peasant houses,
> Roaming herds on the damp banks,
> Smoke rising from barns and winged windmills.
> Everywhere—the traces of satisfaction and / labor. . . .[57]

The second half of the poem (unpublished but read privately by contemporaries) stands in stark contrast to the first. The first half had presented neoclassical and traditionally picturesque visions of the countryside. The second half introduces one of the local and specific elements of Russian country life—the brute reality of labor and need for the majority of its inhabitants: "Here savage Serfdom, constrained by neither feeling nor law / Has used the rod of coercion to appropriate / The labor, the property and the hours of the farmer."

The juxtaposition of the two halves of this poem emphasizes with breathtaking clarity the contradictions Russians faced in attempting to apply pastoral and picturesque conventions to the countryside, once they had begun to confront the injustices that were a part of Russian country life. In Stephanie Sandler's detailed analysis of this poem, she points out that Pushkin contrasts "two kinds of seeing."[58] "The Countryside" reveals Pushkin's dawning awareness that perception itself is a

form of power. The landscape described here works on what might be called the "ha-ha principle." The ha-ha was an invisible barrier invented by a British garden designer to separate the grounds of an estate from the surrounding countryside while maintaining the illusion that the two spaces were united. The poet in "The Countryside" stands in the garden and incorporates the entire surrounding view into his own private idealization of the world without, however, allowing any unwanted elements to intrude upon his idealized rural domain. Because of the untroubled peace and beauty of the first half of the poem, the second half comes all the more as a shock to the reader. The contrast immediately demonstrates that by composing the world into a beautiful landscape, in which one's pastoral leisure will remain undisturbed, the landowner is supporting the unjust relations of power that invisibly pervade his beautiful view.[59]

At the age of nineteen when he wrote this poem, Pushkin demonstrated an awareness that ways of seeing the surrounding countryside helped to maintain the status quo. Unproblematized conventional images of beautiful landscape would no longer suffice for him as descriptions of rural Russia. Yet poetry was still a highly formal art in the Russia of the 1820s, and Pushkin had few models that would allow him to portray the countryside as anything other than pastoral or reminiscent of a neoclassical landscape. For the next few years, at least, this question would not pose an immediate problem. Shortly after writing "The Countryside," Pushkin was sent to the south in political exile. Confined mainly to Bessarabia, he managed to spend time in the Caucasus, the Crimea, and Odessa. Once familiar with these areas, he quickly put to use their alien cultures and exotic scenery as a stimulus for his poetic imagination. His Byronic, "Oriental" adventure poems set an important model for the romanticization of the Caucasus. By affording a safe context within which his romantic sensibility could mature, the south allowed Pushkin's descriptive talent to develop. But he did not put aside writing about his native region for long. In *Eugene Onegin,* written after his return to internal exile in the mid-1820s, Pushkin began his experiment to formulate a new kind of picturesque image of rural Russia without succumbing to the falsification warned of in "The Countryside."

Pushkin's references in *Eugene Onegin,* even in a cursory reading of the poem, reveal an intense interest in the representation of Russian space. One footnote reproduces twenty-eight lines from Gnedich's description of the Neva in "The Fishermen." His inscription to chapter 1 is taken from Viazemskii's "First Snow," which is mentioned again in chapter 5 along with Baratynskii's "Eda." In other words, Pushkin cites three of the most important attempts to describe the Russian, or northern, landscape undertaken by his contemporaries. Like these poets, Pushkin had to struggle with the aesthetic standards for good poetry

that made any image inconsistent with *la belle nature* unworthy of expression. For this reason, most of the specific landscape imagery in *Eugene Onegin* must first conform to poetic formulas of nature description. But once we step back to observe the work as a whole, a different picture emerges.

The model of ideal nature represented most typically in idyllic poetry or Claudean landscape found its reverse aesthetic image in the genre painting of Flemish art. The Russian word *tener'stvo*, used by neoclassical critics to cast aspersions on naturalistic tendencies in Russian literature, was derived from the name of the artist David Teniers II, a Dutch genre painter (specializing in earthly, popular scenes) whose work could be found in the Hermitage.[60] It is this reference Pushkin has in mind when he ironically refers to some of his own nature imagery as "colorful trash of the Flemish school."[61] In the running asides that so distinguish the tone of *Eugene Onegin*, Pushkin keeps the distinction between high and low art, the idealized and the debased image, clearly in view. At the beginning of chapter 5, for example, having described a realistic scene of peasants in a winter landscape, he then concedes, again ironically, that such an image is scarcely worthy of the reader's attention: "But perhaps that kind of / Picture does not interest you / It's all lowly nature / Not much elegance here."[62] Rather than resign himself to a position on the spectrum of low to high art, however, Pushkin plays with these concepts throughout the text, undermining simple readings and sabotaging his readers' expectations. Out of these games and asides emerges a metatextual commentary on the different possible ways writers and readers have tacitly agreed to envision landscape.

Nowhere does Pushkin allow the reader to accept a single uncomplicated portrayal of the countryside. The narrator attributes to himself an extremely hackneyed delight in pastoral pleasures—"*far niente* is my law"—but Onegin only spends two days enjoying "the solitude of the field / the cool of a twilight grove / the gurgling of a quiet brook" before he is seized with boredom.[63] Later the narrator (or what may even be another narrative voice supposed to represent Pushkin himself) all but dismisses the possibility for a pastoral conception of the Russian countryside: "our northern summer / Is a caricature of southern winters / It flashes by and is gone. This we know / But we don't want to admit it."[64] And just as Pushkin refuses to grant the reader a pastoral landscape, he subverts other conventional images. The otherwise sentimental picture of Lenskii's grave, for example, upon which maidens have woven wreaths and placed flowers, in the end becomes a bench for an elderly shepherd lacing his sandals. Similarly, an optimistic and beautifully rendered portrait of the early spring in one stanza is greeted in the next by the lament, "How sad your appearance is to me / Spring, spring! time of love!"[65] And as if to

ensure that his readers will not accept his naturalistic scenes as the "real" landscapes of the text, Pushkin makes certain to inject some light humor into them, such as an overly fretful mother watching her son play in the snow, or a fat goose slipping on the ice.

What is left to the reader after all these miscues and subversions of conventional form? To begin with, the reader has to consider the instability and artificial character of the literary landscape. Perception here, just as in "The Countryside," becomes the main subject. The supposed ontological referent, the land itself, becomes a contingent phenomenon. By questioning the way nature is represented in the text, Pushkin moves his readers away from reliance on conventional form as a way to approach landscape images. This strategy produces a particular effect. The development of picturesque landscape in Europe was in some ways analogous to Pushkin's approach to nature imagery in *Eugene Onegin*. In an often quoted statement from his classic study *The Picturesque*, Christopher Hussey wrote that "the picturesque interregnum between classical and romantic art was necessary in order to enable the imagination to form the habit of feeling through the eyes."[66] When Pushkin undermines the importance of conventional ways of seeing rural Russia, he places the burden of perception back on the reader. To envision the Russian countryside becomes the reader's responsibility in *Eugene Onegin*. The text works as a training ground for the conceptualization of the Russian countryside, a call to Pushkin's compatriots to form the habit of feeling the Russian landscape through the eyes. By diminishing the importance of conventional landscape, Pushkin was working to make a wider variety of landscape admirable, or picturesque, to his readers.

This aim mirrors the evolution of picturesque aesthetics in late eighteenth-century England that John Dixon Hunt has described as moving "from a learned and universally translatable picturesque to one much more hospitable to the language of forms and to the vague, the local, the sentimental, and the subjective."[67] As a result of the continued reliance on neoclassical form in Russia, not until Pushkin's time did Russian landscape aesthetics really begin to move in this same direction. For the first time in *Eugene Onegin,* local and subjective landscapes become aesthetic categories. Each character is associated here with a certain type of landscape experience. The narrator enjoys the pastoral; Onegin disdains nature; Lenskii's landscape is sentimental; and the most admirable character in the novel appreciates the Russian winter: "Tatiana (Russian in her soul / Not knowing why herself) / Loved the Russian winter / With its cold beauty."[68] As Viazemskii had, Pushkin presents autumn and winter as the leitmotif of Russian space. Landscapes from the cold seasons here, to give Nabokov's criticism its due, are not particularly distinct in their

evocation of Russia, but by making them preponderant in the text, they seem to lend the Russian countryside its distinctive local color.

One of the most frequently discussed landscapes in the text did not appear in the original publication of *Eugene Onegin* but in a section extracted from chapter 8 and then published separately, under the title "Onegin's Journey." Here Pushkin relies on a poeticized version of the travelogue to discuss the Russian landscape. Although the following passage is typically adduced as the supreme model of Pushkin's innovation in realistic landscape description, in fact it is framed precisely as a matter of perception and picturesqueness.

> At that time it seemed to me I needed
> Deserts, waves on pearly shores,
> The ocean's roar, and craggy cliffs,
>
> I need other pictures:
> I love a sandy hillside,
> Before a little hut two rowan trees,
> A fence and a broken gate,
> Grey clouds in the sky,
> Piles of straw before harvest
> And a pond beneath the canopy of a thick willow,
> The expanse of two young ducks;
> Now the balalaika is dear to me
> As is the drunken stamp of a *trepak*
> In front of a tavern.[69]

The narrator contextualizes this image of the simple Russian countryside as a matter of "pictures." In contrast to the romantic, southern landscape that had provoked the narrator's interest earlier, Pushkin produces a fully realized aesthetic image of the Russian countryside. To some degree the peasant dance, the tavern, and the duck pond intentionally connect this image to a quaint, Dutch scene, but on the whole it is clearly Russian. The cloudy skies, the short and unspectacular trees, the peasant's hut, the sandy rather than grassy hillside all work to emphasize the appeal to Russianness. Significantly, this space contrasts with both romantic *and* pastoral images of nature. And yet it is intended to be admirable and associated with a peaceful life in the country. Pushkin was the first writer to associate the landscape, in a sentimental, nostalgic way, with a ramshackle, unassuming simplicity.

These "pictures" of the Russian landscape present a fresh idealization of Russian space. They represent an early expression of the desire on the part of Russian elites to identify with the *narod*. A long tradition of interest in peasant culture as one of the remaining sources of uncor-

rupted Russianness already existed among educated Russians. As early as Karamzin's generation, some members of the gentry had taken an interest in peasant folk songs and tales. But Pushkin's deliberate aestheticization of a landscape associated with peasant life reveals a new desire for a deeper connection to peasant culture. The fantasy of immersion in the gray, sparse, and unspectacular space of the Russian countryside marks the beginning of a new aesthetic ideal. Through its willingness to emphasize a quaint but mundane picturesque, Pushkin's landscape in "Onegin's Journey" first established an image of the countryside as the domain of the people. From this point forward, the simple and unassuming landscape would blossom into one of the essential components of a new, national aesthetic that celebrated, rather than ignored or disdained, the characteristic features of the Russian countryside. Pushkin had laid the foundation of a new aesthetic ideal of Russian space.

Some of Pushkin's lyrical poetry continued in this same vein. The poem "Winter Morning," for example, expresses the poet's joy at the sight of empty fields and bare trees in winter. In "Autumn (A Fragment)," Pushkin seems to almost polemicize against the Arcadian tradition of landscape appreciation. The poem begins with an unfanciful and generally naturalistic stanza describing an autumn scene. Then it rates the aesthetic potential of the different seasons. On the negative side, spring "is not for me; / The thaw nags; slush and smells—spring makes me vapid." In the same vein, summer brings to mind "heat and dust and flies and midges." On the positive side, winter, as it had in *Eugene Onegin* and in Viazemskii's "First Snow," appears to be a time of special Russian health and contentment. But whereas Viazemskii had portrayed autumn as gloomy and unattractive, in order to stress the beauty of the first snowfall, Pushkin says of the autumn, "her of all seasons I hold dear alone."

Calling autumn "a poor child unloved among her own," he draws attention to Russia's geographical position in Europe as a sort of home territory of inclement weather. Continuing the description, Pushkin uses a language familiar from the sentimental elegy. Autumn is "a consumptive girl. . . . Today she is alive, tomorrow gone." But rather than languish in melancholy as the sentimental poet might have, he construes the autumnal scene as particularly attractive: "I find you eye-beguiling, mournful season, / Your valedictory splendors make me glad— / For sumptuous in her death is nature, pleasing / The forest all in gold and purple clad." The next stanza places this admiration for the fall and winter within a national context: "With each new autumn I come fresh in bud; / The Russian winter makes my nature stronger."[70] The elegiac aspects of the poem work in an entirely different way than in sentimental poetry. They demarcate a special, melancholy beauty as an original and

attractive feature of the native terrain that can be appreciated as an expression of Russian distinctiveness.

Pushkin's landscape has become a symbol of Russian nationality. The estates of Mikhailovskoe and Trigorskoe where he lived have been preserved as national monuments. In describing Mikhailovskoe and its surroundings, the Soviet Union's first Minister of Culture, Anatolii Lunacharskii, wrote the following enraptured description:

> This piece of land is worthy to be the cradle of a poet, and probably precisely of a Russian poet. . . . A charming piece of the motherland. . . . Breadth, open space! [*prostor!*]—that's the first thing you say before this picture, but in this breadth there is a kind of gentleness, there is a kind of sad simplicity. Oh no—not a miserable simplicity, on the contrary, a self-confidence, simple in its unmediated beauty.[71]

This description of the landscape around Mikhailovskoe could not have been written in Pushkin's own time. It is too full of the language that would become the standard vocabulary for Russian landscape description in the years after Pushkin's death in 1837. But the phrases "sad simplicity" and "unmediated beauty," although they had long since become the cliches of a new tradition of landscape aesthetics by Lunacharskii's time, were the direct result of Pushkin's attempt to find a new way of representing the world around him. The "self-confidence" of that landscape was largely a matter of Russia's continued confidence in Pushkin's particular construction of Russian nature.

CHAPTER THREE

Landscapes of Nationality and Nostalgia

> You are wide, Russia,
> You have unfurled
> Your majestic beauty
> Over the face of the land!
> —Ivan Nikitin

Pastoral poetry finally died, and disappeared from sight. Yet the pastoral ideal survived, although devitalized and unrecognizable.
—Renato Poggioli

> I escape to it at times.
> I escape to the world of nature,
> A world of peace and freedom,
> To the realm of fish and snipe,
> To my own native waters,
> To the expanse of the steppe meadows,
> Into the cool shade of the forests,
> And—into the years of my youth!
> —Sergei Aksakov[1]

❧ The attempt to establish a picturesque image of Russia had by definition been a European venture. A picturesque Russia was meant to line up self-confidently alongside the other scenic landscapes of Europe. To be sure it would boast its own special characteristics, but it would do so in an aesthetic vocabulary easily understandable to any European tourist or admirer of natural beauty. Simple parity or equivalency with other lands, however, did not long satisfy those who sought to define the meaning of this new and perplexingly atypical European

state. Russia's picturesque landscape could be humble and gently charming as Pushkin, Venetsianov, and Svinin, among others, had demonstrated. But did such mild qualities really capture the essence of an empire larger than any other in the world? Could they represent the country that had defeated Napoleon? Evidently not. New ways of seeing and portraying the landscape arose in the 1840s that superseded and sometimes openly rejected the picturesque image of Russia. By the end of that decade the new imagery would amount to the creation of an entirely unprecedented aesthetic sense of Russia's unique terrain.

The change began in the late 1830s, and it coincided with other groundbreaking developments in Russian intellectual and cultural history. In the 1830s, German idealism, particularly through Hegel, came to dominate Russian thought. Petr Chaadaev's famous "Philosophical Letter," published in 1836, threw down the gauntlet to Russian nationality. It asserted with fearfully persuasive eloquence that Russia lacked any meaningful role in the civilized world because its historical path lay outside the grand European traditions. The letter struck a raw nerve in a culture steeped in a romantic sense of national identity that at times raised Russianness to the level of a sacred principle. Russian patriots could no longer unthinkingly celebrate the nation; if they wanted to pay tribute to Russia they would have to demonstrate its superiority to, or at least parity with, the West that Chaadaev had so highly esteemed.

The ensuing disputes between Slavophiles and Westerners are well known and do not need to be retold here. For the purposes of this study, one should note that the Slavophiles first enshrined in the debate what would perhaps become the central dilemma of Russian nationality for the rest of the century: the role and significance of the *narod,* the Russian peasant population. As the peasant question assumed greater and greater importance, it grew entangled with the subject of a nationally distinctive landscape. How was an educated, Europeanized urban population to envision a unified society that included the mass of Russian peasants with whom it had almost nothing in common? How could Russian nationality be made to express a popular or national will? The separation of Russia's landed elite from the majority of the Russian population that worked the land created something akin to a situation in which two cultures shared one soil. This separation set the stage for the extended struggles in the nineteenth century to reconnect the elite and the peasantry.

The image of Russia's landscape would be reconceived in conjunction with a reconceptualization of the Russian countryside as a whole. Sometime around 1840, the term *"rodina,"* meaning "native land" or "motherland," began to appear regularly in literary descriptions of landscape, partially pushing aside what until then had been the more

common term *"otechestvo"* [fatherland]. The word *"rodina"* had originally applied only to one's local region, but beginning at some point in the late eighteenth century *"rodina"* came to refer to the entire nation, encoding Russia itself as the individual's native home. As images of the Russian landscape coalesced into recognizable descriptive or visual forms, they provided a way to visualize the nation as the unified homeland of all the Russian people.[2] The resulting image of a *national* landscape would enable educated members of society to imagine a unity between themselves and the illiterate, laboring peasants. The landscape became a pictorial and descriptive representation of Russia as a united national community.

LANDSCAPE AND THE NEW ROLE OF LITERATURE

Because viewpoints that contradicted official state opinion were zealously sought out and punished during the reign of Nicholas I (1825–1855), one of the characteristic features of this period was the predominance of imaginative literature as an arena for social thought. Vissarion Belinskii, perhaps the most influential Russian thinker in these years, wrote as a literary critic. Ideas of social criticism or political content were expressed in the form of poetry and prose, and Belinskii's (as well as other critics') approval or censure carried tremendous weight in educated society. During the latter part of Nicholas's reign, Belinskii turned an increasingly critical eye on the world around him. It was under Belinskii's tutelage in the 1840s that Russian writers began to adopt literary realism as a means of working through and disseminating critical views of Russia. Belinskii tended to promote writing that exposed the hardships and contradictions of Russian life. The writers of the "natural school" he championed portrayed both the urban and rural spheres as realms of harsh injustice meted out to the poor.

Belinskii's austere influence, however, was not enough to reverse the already deeply ingrained tendencies that celebrated the countryside as a reprieve from urban life. Neither was Belinskii long able to counter Slavophile views that portrayed peasant culture as the vessel of Russian identity and the key to a renascent Russian future. Thus, in Russian literature during this period there developed a rather paradoxical combination of idealistic and pragmatic approaches to the rural world. Expository writing, which often attempted to depict the "objective" circumstances of country life, was combined with an inclination to enshrine the countryside as the source of an imperiled ideal of Russian identity. Rather than contradict one another, as one might expect, these separate strains came together and supported each other in the most influential portrayals of rural Russia—the claim of objectivity authenticating the idealization, and the idealization making the alleged

objective reality more appealing. It was at this time, particularly during the early 1840s, that the myth of Russia's national superiority, contained *in vitro* in the simple and unsophisticated Russian countryside, began to attain increasingly grandiose dimensions. The idea that the simple Russian peasant harbored within him a "broad nature," a special native courage and expansiveness, was first popularized in this period.

As the question of Russia's problematic national identity came more and more to occupy a central place in Russian thought, for the first time in the work of many Russian writers the landscape came to symbolize, or embody, the Russianness of the Russian land. No longer merely supplying Russia's own version of beautiful scenery, the native terrain now offered a blank page on which writers could work out a sense of their own national identity. Moreover, not only could rural Russia be read as the home of the Russian people, it was also in many cases the origin of most landowners' childhood memories. Some writers confronted the influence of European landscape imagery directly, condemning it as insignificant or inauthentic. Others developed novel approaches to landscape aesthetics that eschewed already codified pictorial imagery such as the beautiful or the sublime. By the end of the 1840s, the Russian land had attained a new stature in the eyes of educated Russians, and a nature aesthetic not quite comparable to any other in the world had found its essential form.

Pushkin was the point of departure. In *Eugene Onegin* and some of his lyrical verse, he had been struggling to create a poetic imagery out of the familiar central Russian landscape. One contemporary who responded enthusiastically to Pushkin's portrayal of rural Russia was Nikolai Gogol. "Where Russian nature breathes in Pushkin's work," Gogol wrote in 1832, "it is as quiet and unbroken as Russian nature itself . . . the more usual the object, the greater must be the poet so as to extract from it the unusual, and so that this unusual will be, moreover, the entire truth."[3] Gogol's statement indicates that Pushkin's picturesque landscape was being interpreted in new ways as an expression of "truth" or reality, not simply as a "new picture," to use Pushkin's own terms. Reinforcing Gogol's assessment in the 1840s, Belinskii lauded Pushkin because, in his words, "he didn't need to go to Italy for pictures of beautiful nature: beautiful nature was here beneath his feet, in Russia, in its flat and monotonous steppes, beneath its eternally gray skies, in its sad villages. . . . What was low to earlier poets, was noble to Pushkin. What to them was prose, to him was poetry."[4]

Both Gogol and Belinskii saw in Pushkin the first impulse toward an affirmation of Russia's rural landscape. Belinskii's interpretation of Pushkin's approach to Russian nature appeared only in 1844, once a new image of the countryside had clearly begun to supersede concerns about picturesqueness. The transition from an insistence on the pic-

turesque quality of Russian landscape to a new aesthetic vision of Russian terrain can be traced to three writers working around the late 1830s and the early 1840s. Gogol himself, Aleksei Kol'tsov, and Mikhail Lermontov, using very different methods, pioneered a way to valorize the landscape while simultaneously marking it as wholly and distinctly Russian.

GOGOL'S UKRAINE

Gogol's contribution to the development of this new landscape aesthetic was particularly significant. Throughout his career Gogol struggled to establish an acceptable way of understanding and appreciating Russian and Ukrainian terrain. An intractable aesthete, Gogol often expressed admiration for beautiful and picturesque scenery, but he responded to Russia's lack of conventional picturesqueness quite differently from the way Pushkin had. Ultimately, Gogol would reject picturesque imagery as a suitable approach to Russian landscape description. In place of a search for picturesqueness, he came to see Russian space as entirely original; its very lack of conventional beauty became for him a sign of Russia's promise as a nation.

During his early years as a writer, Gogol focused on his native Ukraine. His evocation of Ukrainian landscape marks one of the key junctures at which the idea of a *national* Russian landscape becomes problematic. Unlike some writers, such as the Ukrainian Somov, who incorporated "Little Russia" into Great Russia as part of the same national territory, Gogol described Ukraine as a self-contained space in opposition to Russia; Ukraine possessed a distinctive and more satisfying beauty. Gogol's most extensive celebration of Ukrainian space is found in his first two collections of stories: *Evenings on a Farm near Dikanka* (1831–1832) and *Mirgorod* (1835). "How intoxicating, how luxurious is a summer day in Little Russia!" begins the first collection of stories.[5] Throughout these stories Gogol portrays Ukrainian territory, further south and warmer than much of Russia, as a region of superlative natural beauty, unique in the empire. His landscape descriptions frequently refer to specifically Ukrainian features such as the Dnieper River, the Ukrainian night, the "Little Russian" estate, and the southern steppe.

In certain respects, at least at first, Gogol sentimentalized Ukrainian space as an idyllic haven. In a letter to the elder poet Ivan Dmitriev in 1832 he wrote, "I am now living in a village which is exactly the same kind as described by the unforgettable Karamzin. It seems to me that he was copying a Little Russian village, so bright are his colors and so similar are they to nature as it is here."[6] Gogol has in mind here one of Karamzin's idyllic descriptions of the Russian country estate. Although Karamzin's (and Dmitriev's) pastoral approach to nature already

appeared quite dated by the 1830s, Gogol envisions their Arcadian imagery as something of a continuing possibility in Ukraine.

A few years later he published the story "Old World Landowners" (1835) in which he portrays an elderly couple from the Ukrainian gentry as modern-day embodiments of Ovid's Philemon and Baucis. Their estate provides them with an endless abundance of provisions, their lives seem to be utterly removed from the effects of historical time, and they live in a pastoral haven consisting of a "tumbledown picturesque" house with a beautiful orchard, all of which evokes in the narrator a feeling of "inexpressible charm." Having established this idyllic portrait of the Ukrainian estate, Gogol proceeds to point out the impossibility of maintaining a pastoral setting anywhere in the real world of historical time and place. He emphasizes the banality of the deaths of his two protagonists, and describes the subsequent collapse of the estate once it enters modern historical time under the auspices of a new owner. By the end of the story, the reader feels as though Gogol meant to preside over the collapse of the idyll as a viable expression of Russian/Ukrainian space.

A year or so later, Gogol began to move in another direction with Ukrainian landscape description, this time working in the same mode as the British historical novelist Walter Scott, who was extremely popular in Russia in the 1820s and 1830s.[7] Scott used landscape imagery masterfully as a way of forging a link with the past in the minds of his readers. His familiar but exaggeratedly pristine and dramatic landscapes represented the primordial past of Scotland and England and helped instill an image of the golden age of the British past. One has only to remember the greenwood in *Ivanhoe* to sense the potential of this technique. In Gogol's historical novella *Taras Bulba* (1836, revised 1842) one finds a similar inspired description of the Ukrainian steppe, unprecedented in the Russian literature of its time for vivid detail.[8] The description is remarkably precise, almost resembling that of a geographer. Gogol begins by defining the boundaries of the region, names the specific animals and plants, and leaves the reader with a sense of having grasped the exact appearance of the steppe terrain. At the same time he seeks to inspire a vision of the steppe's beauty.

Before looking at Gogol's descrption of the steppe region, it bears repeating that depicting the steppe in scenic terms was no easy task in the 1830s. An adequate descriptive language was not yet available. In 1838, the writer Vadim Passek attempted a picturesque description, entitled "Pictures of the Steppe," in which he engaged the problem but wound up with some rather odd results. In the same year that the Chernetsov brothers had simply ignored the steppe along the Volga as impossible to portray, Passek boldly struck out into the untested terrain of steppe description. His difficulty expressing the special nature

of this terrain in "pictures" points to some of the problems a writer faced. The foremost obstacle was, as it had been for the Chernetsovs, the lack of hills for the attainment of proper depth, variety, and perspective. Passek tried to turn the tables on the problem as a conceit of more undulating regions: "True, you cannot see hills or knolls aside from the burial mounds, but the heights that give variety to other countries by jutting out from the earth, are replaced in the steppe by a variety of depths [*uglublenie*]. The views of other countries are reflected in them as though overturned in the waters." Even Passek himself seems to have discerned a certain inadequacy to this method of description because he quickly turned to other, nonpicturesque, descriptive techniques, listing the geographical features, the abundance of marketable products, or the dangers of fire and drought.[9]

In order for Gogol to convey his own vision of the Ukrainian steppe, the manner of description had to contradict prescribed techniques that depict landscape as a series of pictures. Whereas the picturesque view places the reader/observer outside the landscape, looking toward it, Gogol chose to start from the opposite direction. He places the reader deep inside the tall steppe grass, higher than a horse's head, and describes the landscape—at one time or another enlisting all five senses—as an *experiential* rather than an *observed* space. Readers of *Taras Bulba* feel themselves immersed in the grass, "an ocean of green and gold, glittering with millions of different flowers." They peer upward through "the immense waves of wildflowers" to glimpse hawks and a gull "bathed in the blue ocean of the air"; they hear the distant cry of a swan "ringing like silver" and are surrounded by "a thousand different bird calls." They feel "the freshest breath of wind, alluring as a wave of the sea" caressing their cheeks. They taste the Cossack's bread, vodka, and "steaming stew"; and they are engulfed in different aromas: "every flower, every blade of grass exhaled fragrance, and the whole steppe was bathed in sweet scent."[10]

Note the recurring theme of water and sea in these excerpts. Gogol's imagery submerges and surrounds his readers with a multitude of sights, sounds, and sensations, as if the steppe were a terrestrial ocean.[11] In Gogol's landscape, the steppe becomes aesthetically accessible not as a picture but as a multilayered experience of nature. This method of conveying the beauty of the landscape would soon be adopted by other Russian authors. Once the open, flat expanse of the steppe is described "from inside" it acquires a different significance. It becomes possible for the writer to convey an aesthetic sensation closely related to the sublime. But this is not the angst-provoking sublime of empty, open places that Kant describes, and which is well known in the landscape paintings of Casper David Friedrich.[12] It is the opposite: an enraptured and welcoming vast open space.

By linking the openness of the steppe to the freewheeling and violent pursuits of the Cossack band the story follows, Gogol registered one of the earliest characterizations of the steppe as simultaneously an "endless" expanse and a realm of freedom.[13] In this way, Gogol's dizzy celebration of Ukrainian nationality ironically helped build the myth of the "broad Russian soul," given to freedom and action and inseparable from the vast expanse of open space that constituted much of both Ukrainian and Russian territory. Although the ground of *Taras Bulba* was explicitly Ukrainian and the characters Cossack to the marrow, this innovative approach to landscape description would soon be applied to images of Great Russian landscape, and the notion of a boundless and freedom-inspiring terrain would soon become a hallmark of Russian territory as well.

KOL'TSOV AND HIS ADMIRERS

One of the most important contributions to this new image of the Russian landscape was made by the poet Alexei Kol'tsov. Perhaps even more than his poetry, Kol'tsov's *person* had an impact on his contemporaries. He came from a non-noble family of well-to-do cattle dealers in the Voronezh region of southern Great Russia. For the sophisticated, urban gentry public, Kol'tsov was something of a phenomenon. Although he wrote poetry for this urban audience, he was inspired by the language, imagery, and rhythms of peasant song.[14] In the 1830s, as the urban public was beginning to express a deep interest in the peasant population as the source of authentic Russianness, the desire to forge some kind of connection was manifesting itself. "We want what is purely Russian and national [*narodnyi*]," Nikolai Polevoi demanded for Russian literature in 1832, "both in its natural coarseness and in its genuine beauty."[15] Kol'tsov had worked as a rancher for his family, and his relatively close connection to the land and the people, coupled with his folkish poetic style, positioned him as close enough to the sort of "peasant poet" the public had been waiting for.

Belinskii's response to Kol'tsov is particularly interesting because it helps demonstrate the rapid development of a new approach to the national landscape in this period. In 1835, he had written a short and tentatively admiring article about Kol'tsov's first book of verse in which he praises the poet as "genuine" and "non-imitative." In this piece he briefly referred to Kol'tsov's nature imagery as "village pictures."[16] By 1846, after Kol'tsov's death, Belinskii's admiration had expanded dramatically. He wrote a long and deeply sympathetic review of Kol'tsov's life and work in which he presented him as one of Russia's most important poets. In this article Belinskii singled out Kol'tsov's love of nature, particularly of the steppe, as one of the most important features of his

poetic gift. It was Kol'tsov's personal knowledge and experience of rural Russia that made him, in Belinskii's phrase, a "son of the people." In the following passage one sees how Belinskii read Kol'tsov's nature imagery as an integral expression of his kinship with the Russian peasant:

> The life [*byt*] in which he was raised and grew up was the same as peasant life, although somewhat more elevated. Kol'tsov grew up among the steppes and the peasants. Not for phrases, nor for eloquent words, nor imagination, nor dreams, but with his soul, his heart, and his blood did he love Russian nature and all the goodness and beauty that, in embryonic form, as a possibility, lives in the nature of the Russian peasant.[17]

Belinskii was careful to point out here that he did not subscribe to a simplistic idealization of peasant life, as he felt his Slavophile contemporaries did, but he also revealed his own participation in the widespread fascination with the Russian *narod*. Indeed, just prior to this celebration of Kol'tsov's closeness to the people, Belinskii had cited the impossibility of a gentry poet ever understanding "the Russian man" because of "the sharp divide produced by the reforms of Peter the Great between the educated classes of Russian society and the mass of the people."[18] Because of his alleged personal connectedness to peasant culture, Kol'tsov's poetry seemed to bridge the gap between the peasants and the literate public.

Kol'tsov's most important literary device was imitation of the peasant song. He often tried to express the peasant's love for nature in this format. By such means he helped produce a new kind of landscape description—the countryside as seen by the rural laborer. The first poem Belinskii cited in his second article is "The Mower" (1836), which was written in the same year as *Taras Bulba*. This poem contains one of Kol'tsov's most detailed evocations of the peasant's relationship to nature. Just as in Gogol's novella, the steppe is admired for the freedom afforded by its vast expanse:

> The steppe vast and free [*step' razdol'naia*]
> With its feathery grasses
> Spreads outward!
> It lies wide
> And far-off around.
> Oh, you, my steppe,
> Steppe, vast and free [*step' privol'naia*],
> You widening steppe,
> You have spread yourself out,
> To the Black Sea
> You have stretched![19]

Kol'tsov's language is resistant to translation. Both compact and colloquial, it moves in a rhythm that English cannot repeat and contains expressions intrinsic to Russian culture. The Russian words used here, *razdol'nyi, privol'nyi*, along with their counterpart *prostornyi*, all convey a concept that does not have any equivalent in English. They refer to both the image of wide-open space and the idea of unfettered freedom. What is untranslatable is the combination of these two elements into a single idea.[20] These words were all a part of the peasant vocabulary, and it would appear that Kol'tsov merely transferred this special peasant sense of the landscape into Russian literature. Belinskii certainly implied this about Kol'tsov's poetry, and later commentators have for the most part left this implication intact. And yet Belinskii's admiration for Kol'tsov as an authentic man of the people and a lover of Russian nature was rather disingenuous. In 1838, Kol'tsov had written a letter to Belinskii in which he said of the steppe: "it's beautiful for a minute, but only if you're not there alone . . . by itself it's too monotonous and silent."[21]

Because Kol'tsov appeared to be (or was made out to be) a "son of the people," it seemed that he was only conveying a transparent sample of the peasant's response to nature. But such a reading of Kol'tsov's landscape ignores the context in which he was writing. For peasants, such words as *razdol'e* and *privol'e* seem to have conveyed a sense of the freedom of open space in relation to their own daily lives. In peasant proverbs such words tended to imply freedom of movement, such as in the saying, "To the peasant constriction [*tesnota*], to the Lord freedom [*razdol'e*]."[22] This expression clearly contains a certain conception of open space, but it does not suggest the relationship between that space and the larger geographical territory. At times peasant song did express a vision of the larger landscape, as in the familiar folk song "Down Along the Mother Volga" in which the river is referred to as "*razdol'naia.*" Such an image, however, conjured up a specific, visible terrain, i.e., the wide Volga River on which one has a sense of freedom.

Kol'tsov's imagery goes further. His mower, singing of the expanse and freedom of the steppe, has in mind not just a particular location but the entire steppe "stretching to the Black Sea." This image represents the Russian steppe as a discrete and whole entity. The singer's words function metonymically, as a representation of the national space in its entirety. There is no evidence that peasants conceived of Russian terrain in this way, and there is no reason they should have. The peasant worldview had not been forged by implicit comparison to other nations as had the urban Russians' sense of the land they inhabited. Kol'tsov's poetic steppe was the space of someone with access to maps and an interest in the landscape as something that represented the larger national territory. Kol'tsov's actual audience, moreover, was the urban public, which unquestionably thought in these terms. In

the context of its reception, "the steppe, vast and free" does not refer to a personal sense of space; it makes sense as an attribute of nationality. By confirming what appeared to be an organic link between the people and the national terrain, Kol'tsov provided a new way for his contemporaries to express their appreciation for the landscape as a representation of Russia.

GOGOL AND RUSSIA

At first, by contrast to his favored Ukrainian natural setting, Gogol took a dim view of northern, Great Russian landscape. This is evident in his St. Petersburg story "Nevskii Prospekt" (1835), in which he mocks Russian artists. "A strange phenomenon, is it not?" asks Gogol, "An artist in the land of snows. An artist in the land of the Finns where everything is wet, flat, pale, gray, foggy. These artists are utterly unlike the Italian artists, proud and fiery as Italy and her skies."[23] The comparison between Italy and Russia was an important one to Gogol. The landscapes of Russian painters must remain "unfinished," he goes on to say, because of the constraints placed on them by their northern surroundings. If the painters were in Italy, "they would no doubt develop as freely, broadly, and brilliantly as a plant at last brought from indoors into the open air."[24] Around this time, in an unpublished article, Gogol expressed his own personal distaste for northern Russia by comparison to the landscape he would rather see around him: "It is wonderful to imagine at the end of some Petersburg street the snow-capped mountains of the Caucasus, or the lakes of Switzerland, or Italy crowned with laurels and anemones, or Greece, lovely in its emptiness. . . . But wait! The houses of Petersburg are still piled-up on either side of me."[25]

Shortly after making this remark, Gogol began an extended stay abroad, mostly residing in Italy. His reaction to traveling through northern Europe reveals an admiration of the landscape coupled with a certain dissatisfaction for picturesque scenery. "The picturesque little houses, which are now beneath your feet, now over your head, the blue mountains, the spreading lime-trees, the ivy, which along with grapevines covers the walls and fences," wrote Gogol in a letter home, "that is all pretty and pleasing and new, because it is nowhere to be found in the vast expanse of our Russia."[26] But as much as he may have appreciated Germany and Switzerland, more than once in his correspondence Gogol made clear his dislike for what he considered the exclusively *visual* quality of their landscapes. Traveling on the Rhine River produced a reaction of boredom rather than excitement: "I finally grew tired of all the incessant views. Your eyes get completely worn out, as in a panorama or a picture. Before the windows of your cabin pass, one after another, towns, crags, hills, and old ruined

knights' castles."[27] In Switzerland he was more blunt: "it's all one view after another until I finally begin to get sick to my stomach."[28]

Italy elicited a different response from Gogol. Soon after having arrived in Rome, he became enraptured by the beauty of the ancient city. He was taken with its felicitous combination of landscape and architectural elements, of nature and art. "Not my homeland," wrote Gogol, "but the homeland of my soul I found here."[29] As already noted, such language was common among nineteenth-century Russian visitors to Italy. Gogol discovered in Italy the "fatherland of beauty" that he had been searching for, and he remained in Rome for much of the next decade. "The rest of Europe is for looking," wrote Gogol; "Italy is for living."[30] He even expressed the desire to be transformed into an enormous nose, "with nostrils the size of buckets," so that he could perceive Rome as an entirely olfactory sensation.[31] Here again Gogol evinced a preference for enjoying the landscape as an integrated sensual experience rather than merely as visual scenery.

Absence, however, sometimes had the effect of renewing Gogol's attraction to Russia. As early as 1837, he had written to the historian, M. P. Pogodin, "By an unbreakable chain I am bound to my own land, to our poor and dismal world; our peasant huts and our bare expanses I prefer to the bright skies that smile down upon me."[32] Yet on returning to Russia for a short time in the early 1840s, he once again felt the need to put distance between himself and his (adoptive) native land: "about Russia I can only write in Rome. Only there is it present to me in its entirety, in all its immensity."[33]

In these years a painful ambivalence with respect to place and landscape had seized Gogol. In the section of his novel/poem *Dead Souls* (1842) where he describes Pliushkin's garden in intricate detail, one encounters an ideal of beautiful landscape (closely related to his conception of Italy) as a mutually reinforcing combination of nature and art. He describes the garden as "the one refreshing feature of the large village . . . the only thing that was truly picturesque."[34] "In short," he writes, "it was all beautiful, as neither nature nor art could contrive, but as only happens when they unite together."[35] This typically picturesque garden forms an obvious contrast to the rest of the Russian countryside portrayed in the novel. Gogol was troubled by what he understood to be the absence of beautiful landscape in Russia, yet he never abandoned his powerful attachment to Russia, nor the desire to be of service to it.

In the famous passage at the end of *Dead Souls*, Gogol's struggle with this dilemma was finally transformed into a new interpretation of Russian landscape. The passage is one of the most interesting and influential statements about the Russian landscape written in the nineteenth century. For clarity, it is broken down here into three sections.[36]

1. **A. Rostovtsev, City of Iaroslavl** (1731) Topographical renderings of Russian places were common in the eighteenth and early nineteenth centuries; they provided viewers with an informational, rather than a predominantly aesthetic, landscape.

2. **Semen Shchedrin, View of Gatchinskii Park** (date unknown) Landscape painting developed in Russia roughly contemporaneously with the landscaped garden park; both forms modeled themselves on European aesthetic values.

3. Andrei Martynov, View of Lake Baikal (1814) Russian painters did not always rely on prefabricated parks to express conventional aesthetics, as suggested by this fanciful vision of Siberian scenery.

4. **Aleksei Venetsianov, Sleeping Shepherd** (1823–1826) Venetsianov's rural paintings often blended standard pastoral motifs with a representation of recognizable Russian space.

5. **Aleksei Savrasov, View of the Kremlin from the Crimean Bridge in Foul Weather** (1851) In this early effort, Savrasov relied on the drama of romantic conventions to arouse interest in the Moscow environs.

6. **Aleksei Savrasov, Steppe in the Daytime** (1852) While Savrasov had not yet worked out certain technical problems, this image provides an impressive early example of the realist celebration of Russian space.

7. *(above)* **Petr Sukhodol'skii, Noon in the Village** (1864) In his attempts to portray Russian peasants, at times Sukhodol'skii found himself threatened with physical harm.

8. *(left)* **Mikhail Klodt, Big Road in Autumn** (1863) This landscape underlined its depiction of Russia as a broad and dreary open expanse by including a stranded traveler with a broken cart.

9. *(above)* **Fedor Vasil'ev, The Village** (1869) This sunny village scene exposes peasant poverty while simultaneously paying tribute to a life lived close to nature.

10. *(right)* **Fedor Vasil'ev, The Thaw** (1871) Here Vasil'ev combines the impression of a bleak and desolate early spring countryside with an evocation of almost quaint peasant typicality.

11. **Fedor Vasil'ev, Wet Meadow** (1872) Ivan Kramskoi wrote to Vasil'ev in the Crimea that, observing this painting, viewers' faces "wore the expression of crushed peas."

12. **Ivan Shishkin, Pine Forest, Viatka Province** (1872) This early forest landscape maintains an open view only by distorting the appearance of the treetops, making them seem farther away from the viewer than the bears at their trunks.

13. **Ivan Shishkin, Backwoods** (1872) Here Shishkin first enters into the deep forest as a landscape painter.

14. Ivan Shishkin, Trees Felled by the Wind, Vologda Woods (1888) By the time of this painting, Shishkin's attention has turned toward depiction of the minute details of the forest floor.

15. **Aleksei Savrasov, Village View** (1867) More delicate than Shishkin's work, and focused on the open countryside, Savrasov's landscapes also turned attention to foregrounds, letting the eye wander in the large and empty distance.

16. **Aleksei Savrasov, Elk Island in Sokolniki** (1869) A study for this painting united the foreground and background into a typical scenic view, while the finished work intentionally emphasized the otherwise unremarkable foreground.

17. **Aleksei Savrasov, The Rooks Have Returned** (1871) Savrasov's tour de force, and today almost an iconic image of Russian landscape, this work might be called "antipanoramic"; it forces the viewer's attention on a humble moment in time and space.

18. **Ivan Shishkin, Countess Mordvinova's Forest, Peterhof** (1891) Shishkin suggests the predominance of nature over culture by portraying an elderly stroller shorter than the sapling pines.

19. **Mikhail Nesterov, Vision of the Youth Bartholomew** (1890) For Nesterov, Russia's unspectacular scenery had become the proper setting for mystical evocations of Orthodox spirituality and Russian nationality.

20. **Isaak Levitan, At the Pool** (1892) Levitan would take Russian landscape painting to new aesthetic heights, but for subject matter he continued to depict the simple and unassuming imagery favored by his predecessors.

The first section begins with Gogol's version of the vernacular Russian landscape: the everyday rural scene. He crams the description with a seemingly interminable collection of mundane sights, piling up in a disjointed heap, as though Russian landscape were the precise antithesis of picturesque scenery:

> And once more at either side of the highroad there was a quick succession of milestones, station-masters, wells, strings of village carts, drab villages with samovars, peasant women, and a brisk bearded innkeeper running out of his yard carrying oats, a tramp in worn bast-shoes who had trudged over five hundred miles, little towns built in a hurry with little wooden shops, barrels of flour, bast-shoes, white loaves, and all sorts of other cheap articles, striped turnpikes, bridges under repair, fields stretching for miles on either side of the highway, old-fashioned, bulky landowner's carriages, a soldier on horseback carrying a green box with grape-shot and the name of some artillery battery inscribed on it, green, yellow, and freshly ploughed black furrows flashing by on the steppes, a song struck up somewhere far away, the tops of pine trees in the mist, the peal of church bells fading away in the distance, crows as thick as flies, and a horizon without an end....

By cataloging so many of the roadside sights in the plural—"station-masters, wells, strings of village carts"—Gogol's language seems to multiply to infinite monotony the profoundly unremarkable features of his countryside. Even such otherwise pleasant phenomena as church bells and pine trees in the mist are enfolded into the tedium.

At this point Gogol compounds the damage by comparing the decidedly unpicturesque Russian countryside to the scenic treasures of European landscape. Note the reappearance here of some of the very sights he had mentioned in his correspondence. This picture of Europe is not far removed from that which Karamzin had popularized in *Letters of a Russian Traveler:*

> Russia! Russia! [*Rus'! Rus'!*] I see you from my wondrous, beautiful afar [i.e., Italy]: I see you now. Everything in you is poor, straggling, and uncomfortable: no bold wonders of nature crowned with ever bolder wonders of art, no cities with many-windowed tall palaces built upon rocks, no picturesque trees, no ivy-covered houses in the roar and the everlasting spray of waterfalls will rejoice the traveller or startle his eyes; the head will not be thrown back to gaze at the huge rocks piled up endlessly on the heights above it; through dark arches, stacked one on top of the other in a tangle of vines, ivy, and countless millions of wild roses— through dark arches he will catch no glimpse in the distance of the eternal lines of gleaming mountains soaring into bright and silvery skies.

> Everything in you is open, empty, flat; your lowly towns are stuck like dots upon your plains, like scarcely visible marks; there is nothing to beguile and ravish the eye.

By comparison to the landscape of the traveler in Europe, Russian space shrinks to the two-dimensionality of "dots," as if seen on a map. Relative to such spectacular scenery Russia seems "scarcely visible."

Yet having made this unfavorable comparison, Gogol proceeds in the third part of the passage to interpret the Russian landscape in an unexpected way, which like his landscape in *Taras Bulba* rejects picturesqueness as the proper approach to Russian space:

> But what is the incomprehensible, mysterious force that draws me to you? Why does your mournful song, carried along your whole length and breadth from sea to sea, echo and re-echo incessantly in my ears? What is there in it? What is there in that song? What is it that calls and sobs and clutches at my heart? What are those sounds that caress me so poignantly, that go straight to my soul and twine about my heart? Russia! What do you want of me? What is that mysterious hidden bond between us? Why do you look at me like that? And why does everything in you turn eyes full of expectation on me? . . . And while, deep in perplexity, I stand motionless, a cloud full of menace and heavy with approaching downpours of rain, already casts its shadow over my head and thought grows numb confronted with your vast expanse. What do those immense, wide, far-flung spaces hold in store? Is it not here, is it not in you that some boundless thought will be born, since you yourself are without end? Is not this the place for the legendary hero of Russian fable, here where there is plenty of room for him to spread himself and move about freely? And menacingly your mighty expanse enfolds me, reflected with terrifying force in the depths of me; my eyes are lighted up with supernatural power—oh what a glittering wondrous infinity of space the world knows nothing of! Russia!

This final passage might be called an anti-description. Gogol does not look at the landscape; the landscape looks at him. By posing a series of rhetorical questions, Gogol appears to relinquish the authorial power of molding the landscape by means of visual description. The landscape in turn becomes a sort of active force, capable of penetrating him with its gaze and its ineffable music. The open, empty and flat [*otkryto-pustynna i rovno*] landscape of the first section here becomes immense, wide and far-flung [*neob'iatnyi prostor*] in this section. The former describes the visual reception of Russian space from the point of view of a passing observer. The latter evokes an association of magnitude, first with the cartographic image of Russian space as vast and promising,

and second with the notion of freedom and open space that Gogol conveyed in *Taras Bulba* and Kol'tsov helped designate as the peasant conception of Russia.

With this passage Gogol managed to turn the tables on the picturesque, simultaneously diminishing the authority of a Europe-based aesthetic and cementing the vision of vast open space as a fundamental trope of Russia's national self-image. Boundless space becomes a symbol of Russia's supposed heroic past, and it also suggests inevitable future greatness. In short, Gogol turns the very emptiness of Russian landscape to account as the promise of a temporarily obscured yet ever-present national superiority. Gogol's aesthetic sensibility may have been inspired by the beautiful Mediterranean scenery he encountered in Italy, but when he reconceives of the landscape on an "extra-visual" level, his eyes become "lighted with supernatural power." The aesthetic resonance of scenic beauty is rendered trivial by a "supernatural" force that seems to exist on a metaphysical plane beyond the comprehension of the casual observer. Compared to this "wondrous infinity of space," the merely visual appreciation of picturesque landscape (Gogol's "beautiful afar") grows decidedly pale.

LERMONTOV'S "NATIVE LAND"

Prior to the publication of *Dead Souls* in 1841, Lermontov wrote a short lyric poem on Great Russian landscape that established another influential model of Russian landscape description. Most of his nature writing and illustration had been inspired by the dramatic scenery of the mountainous Caucasus, but the poem "Native Land" [*Rodina*] grappled with the terrain of central Russia. In "Native Land," Lermontov drew on imagery that had been pioneered by both Pushkin and Gogol in order to justify his novel approach to nationality. The poem's first line foretells that its linkage of landscape and national sentiment will be innovative and unusual:

> I love my native land, but with a strange love,
> My judgment cannot conquer it.
> Neither glory bought with blood,
> Nor full pride in the certainty of peace,
> Nor cherished legends of the ancient past,
> Stir pleasant dreams within me.
> But I love—I know not why—
> The cold silence of her steppes,
> Her endless, swaying forests,
> Her overflowing rivers, wide as seas;
> In a cart I love to gallop over village paths.

> And, longing for shelter, to meet
> The flickering fires of sad villages
> With a steady gaze that pierces night's darkness.
> I love the smoke of cut stubble,
> A string of carts in the steppe at night
> And on a hill amid golden fields
> Two birches, gleaming white.
> With a joy unknown to many,
> I see a full threshing floor,
> A thatch-roofed hut,
> A window with carved shutters;
> And, on the dewy evening of a holiday,
> I shall watch until midnight
> A dance, with stamps and whistles,
> And the chatter of drunken peasants.[37]

This poem used, and partly invented, images of Russian landscape that have been repeated so often by now they have become trite stereotypes of Russian nature. Where a modern American might object to such expressions as "majestic, snow-capped peaks" or "fields of golden grain" as inexpressive of anything but stock scenery, so might the contemporary Russian reader balk at images of straw-covered huts and vast forests or swelling rivers. Both cultures have grown distant from a time when such imagery was new and even "strange," as Lermontov called it. Lermontov's vision of the central Russian landscape as the basis for national pride was sufficiently unprecedented that he had to prepare his readers for it in the opening line of the poem. He proceeds to list and reject three familiar models of national identity: appeals to national pride based on military exploits, the assurance of peace in an indomitable state, and national historical mythology, all of which were conventional forms of Russian nationalism after Napoleon's defeat.[38]

As the basis of his own personal testament to national pride, Lermontov instead chose to invoke his love for the open countryside. At the time he wrote the poem, his conception of the landscape possessed a novelty that may be difficult for contemporary readers to grasp. To begin with, such images as "the cold silence of her steppe" or "overflowing rivers, resembling oceans," lacked the warmth and picturesqueness that had been used by the previous generation to excite admiration for Russian scenery. Even Gogol's oceanlike, all-encompassing steppe in *Taras Bulba* was intended to inspire pleasant sensations. Lermontov's landscape has more in common with the disparaging turns of phrase travelers of the time sometimes employed to convey the endless monotony and vast emptiness of Russian terrain.

But unlike Pushkin's wry view of the simple peasant countryside, which smilingly kept that ridicule in mind, here such imagery is treated in earnest. It is consciously deployed to express a deep connectedness to Russian space.

Through the structure of the poem, Lermontov was able to construct a new model of national identity. As a picture of the Russian landscape, the poem's description works in reverse direction from the eye's movement across a traditional landscape painting. Rather than starting from the foreground and moving out into the distance, Lermontov begins with the vast distance and travels into the personal foreground of the poet and peasants. From a broad panorama of the national landscape as a whole—with its steppe, forest, and rivers—Lermontov takes the reader on a kind of scenic cart ride through the middle distance of the countryside, with a village and fields that smell of burning hay. Then, suggesting that this is his (or the narrator's) own experience—"with a joy unknown to many"—he takes the reader into the village to encounter the peasants themselves. As the prototypical Russian space, the poem asks one to admire not the gentry estate, nor the city. At the center of it all is the peasant village. Lermontov's "Native Land" does not conjure up a scenic impression so much as it offers a reinterpretation of Russian space. First the broad contours of the national terrain are sketched in, then one moves deeper into the heart of the peasant village. If vast steppes, forests, and rivers summarize the landscape's universal quality, then an *izba* full of joyful peasants constitutes its distilled form. Not only does Lermontov reimagine the countryside in both macro- and microversions, but through the journey of his narrator he unites the topographical and the local, the educated and the folk, the abstract and the personal.

Although in the second half of the poem Lermontov uses a similar imagery to that of Pushkin's in "Onegin's Journey," evoking a plain and unprepossessing "genre" scene, unlike Pushkin he centers the description around his narrator's own involvement in the landscape and personal connection to it. Twice the narrator flaunts his failure to explain his love of this space in rational terms. In this way Lermontov erases the boundary between the narrator's educated voice and the peasants it comments on by identifying within the narrative voice an instinctive, rather than rationalized, admiration for the spaces inhabited by the Russian people. The countryside becomes a place where boundaries between the presumably authentic culture of the *narod* and the inauthentic Westernized elite dissolve. It is precisely Lermontov's *unreasoned* admiration for the countryside that makes this reconnection possible on the basis of a mutual immersion within the obscure yet familiar spaces of the national territory. In other words, admiration for the landscape allows the educated narrator, and the reader along

with him, to imagine a primordial bond to the national culture from which he has been unnaturally separated.

THE NATION'S NATURE

Lermontov's "Native Land" was written in the same year as the publication of *Dead Souls*. The combination of these two reinterpretations of the rural terrain mark a turning point in Russian landscape aesthetics. Their impact seems to have inaugurated a new interest in the Russian countryside. *Dead Souls* was certainly a huge popular success, and it generated an outpouring of discussion. As T. V. Kolesnichenko has written, following the various polemics attending the reception of Gogol's novel "nature began to play an important role as a material and spiritual basis of Russian national life."[39] By the second half of the 1840s, many writers were reaffirming Gogol's and Lermontov's celebration of the Russian landscape. The open countryside was coming to be considered one of Russia's important and characteristic national features, whereas only a decade earlier it was still largely disdained or ignored.

Travel writing gives an indication of how landscape perception was evolving in a more popular context. Stepan Shevyrev's account of an 1847 trip through Russia, *Journey to the Kirillo-Belozerskii Monastery* (1850), offers one example of the influence of new representations of Russian landscape in a less distinguished literary genre. Shevyrev, professor of literature at Moscow University, had been one of the most ardent admirers of *Dead Souls*. His review of the book cited Gogol's passage on Russian landscape, suggesting that this particular section of the book "reflects in miniature the character of the entire poem."[40] But Shevyrev was a doctrinaire supporter of Official Nationality: as much as he admired the novel, to his mind Gogol had given too stern and bleak a description of the countryside. In his review, Shevyrev chose to supplement Gogol's "one-sided" portrayal of the landscape with his own more favorable imagery. Shevyrev's lengthy supplement to Gogol's landscape description emphasized the *razdol'e* of the fields, the colorful vegetation of the marshes, the picturesque, long-suffering peasants, and the beautiful church architecture.[41] This compilation of landscape elements would later serve as the basis for Shevyrev's travel writing.

Like Svinin and Muravev, Shevyrev considered the monastery the most important feature in the Russian landscape. But where the earlier travel writers had limited their descriptions to portrayal of the monastery itself, Shevyrev willingly depicted the regions in between the monasteries. In fact, every other chapter of his *Journey* describes the environment on the road between the monasteries he visits. This was a new approach. For many Russians the idea of traveling through their own country still seemed pointless, if not ridiculous. A Russian

travel writer and publicist by the name of David Matskevich wrote about the problem in the late 1840s: "travel, in the sense that western Europeans understand and practice it, still does not exist here. . . . Here travel is not an end but a means. That is perhaps the reason that we know so little of Russia."[42]

Shevyrev set out to correct this attitude by creating an unequivocally favorable scenic portrait of his native land. He profited from the new approach to the Russian landscape he had learned from Gogol and others, translating it into the first Russian travelogue that expressed a touristic interest in the ordinary Russian landscape. Seeking to arouse a spiritual appreciation for the monasteries he visited, Shevyrev intentionally contextualized them as part of the scenery. "Their light and playful architecture," he wrote, "agreed with the merry impressions of their natural surroundings. . . . How beautiful is nature in these holy places. God's blessing and [nature's] pure beauty join in the mind of the viewer."[43] The landscape becomes an integral feature of "Holy Russia" for the Orthodox Shevyrev. Russian nature constitutes an expression of God's affirmation of the empire.

Gogol had suggested that Russian space hinted at something grand and majestic in its past and future. Shevyrev, on the other hand, considered the special characteristics of the landscape forthrightly attractive, enough to be accessible to Russian tourists. Unlike Gogol, he was able to conceive of Russian space as picturesque, yet still in a way that clearly betrays Gogol's influence:

> These panoramas [*krugozory*], through which the traveler loves to spread out his gaze in our fatherland, give northern Russian nature its special picturesqueness. The land beneath you stretches out flatter and flatter when you unnoticeably rise up to some sort of height from which your eye willingly wanders through the endless space. In these panoramas, which continually appear, there is something that entices you further and further. This property of our earth partly explains how our forefathers, still migrating through the vast spaces of the future Russia, were drawn further and further into the depths of the far north.[44]

Shevyrev wanted to convince his compatriots that their landscape merited attention as an object of beauty. As had Gogol in *Dead Souls,* Shevyrev makes direct comparisons to Europe in his travelogue, but again in contrast to Gogol he argues that one may admire Russian landscape by means of the same aesthetic criteria one applies to Europe: "Italy and Switzerland, the Apennines and the Alps have greatly indulged me with their views, but I submit there is a moment of nature in our diverse fatherland, which does not yield to the beauty of the Apennines or the Alps, although it has an entirely different character."[45]

The penultimate paragraph of Shevyrev's travelogue summarizes his essential construction of Russian space:

> I cannot pass over one impression that I experienced two nights before returning to Moscow. We were traveling from Uglich to Kaliazin. The level, flat steppe spread out all around beneath us, reminding me of the endlessly flat steppes of the south. It seemed we were racing along in just the same spot, and the steppe would never end. Little by little the moon rose in the sky; at first it only lit up the edge of the horizon and fields, but then it brightened the whole sky and steppe. Tired out from travel, I lay down in a kind of half sleep. Around me on all sides and high into the sky arose a wonderful white cathedral temple with its gold domes. Above us a gigantic bell tower grew right into the heavens. I'd only just closed my eyes when I was struck by this magnificence, and no matter where I turned, on all sides there appeared a cathedral full of prayer. It shook my soul with its gigantic form, as if all our endless Russia had united its temples, which from the ground to the peak of the sky had formed together into a singular infinity.[46]

This passage projects a novel conception of the national space. The level, open plains form the necessary backdrop for the unification of the Russian people in an ecstasy of Orthodox spirituality. It is fitting to find this vision in a dream. Even in Shevyrev's travelogue itself, the idea of Holy Russia as a space of Orthodoxy and autocracy was already losing ground to a new sanctification of the Russian land and people. Two such separate idealizations of one place could not long exist side by side, and the initial importance of the monastery in Russian travel writing would fade after the 1850s for several years to come.[47]

For Shevyrev the natural beauty and spiritual grandeur of the Russian landscape were perfectly evident and quite compatible with one another. He felt a time would come when Russia's landscape would be widely admired. Inspired by a lake he observes en route, Shevyrev even predicts the rise of recreation in the Russian countryside:

> When Russian life within the fatherland pours forth more strongly, when we recognize the good and beauty of our land, when simple, empty comfort, tasty dinners, and endless games of "Preference" shift over to the pure and noble pleasures of a thinking life, then beneath a thousand oars will splash the waves of Lake Pereslavskii, brightened by the boats' multicolored flags. . . . Not in vain did God lavish the beauty of nature on the Russian land. Pereslavskii Lake does not exist for the herring alone. If in its solemn prayers the church has sanctified nature for us, why do we not profit from it for good social pleasures—and why do the lake's waters slumber unused, as our Russian life slumbers without thought, without

feeling, without song, and without pure joys? If not for this why do these blue, overflowing rivers exist? Is that not why we have the thick shades of forest and the wide expanses of field?[48]

Shevyrev's *Journey to Kirillo-Belozerskii Monastery* was the most persuasive among a collection of travel writings in the late 1840s and 1850s that found ways to reinterpret the Russian countryside as a beautiful and pleasurable environment.[49]

Although his contemporaries on the left disdained him as a conservative nationalist, in communicating his impressions of the landscape, Shevyrev engaged in a nationalist polemic removed from more explicitly political disputes. He was working to establish a widely recognizable image of the national terrain. His travelogue reflected an ongoing and extensive reconceptualization of the landscape carried out on both sides of the political spectrum. A particularly nationalistic example of the popularization of this new landscape aesthetic is found in the poems of Ivan Nikitin. Nikitin came from Voronezh, the same southern provincial Russian city where Kol'tsov had lived. His poetry is often compared to that of Kol'tsov since both wrote about the steppe and its inhabitants, but the bulk of Kol'tsov's poetry was produced in the 1830s, whereas almost all of Nikitin's was written in the 1850s. The difference of twenty years is evident in the use they make of their landscapes. Kol'tsov's Russian songs tried to imitate (and polish) the rhythms and themes of folk poetry; his landscapes often depicted the viewpoint of peasant laborers at first hand. Nikitin's verse, on the other hand, usually presented itself as the direct expression of an educated, urban voice.

One of Nikitin's poems directly confronts the difference between Russian and European (specifically Italian) space. In the first section of "South and North" (1851), Nikitin pays the southern environment its usual tribute as a place of "picturesque" beauty and "cloudless" skies. In the remainder, however, he makes what has by now become a commonplace comparison, and elevates the beauty of the Russian north. Nikitin's nature description contains little that is original—"the expanse of the steppes . . . the thick pine forest"—but he strikes a new note of overt nationalism in the lines "I am Russia's son! [*Rusi syn*] the land of my fathers is here!"[50] In the same year, which witnessed the beginning of the Crimean War, Nikitin wrote the poem "Russia" [*Rus'*]. This work mingled praise for Russia's military glory and national character with descriptions of the fields, steppes, and forests.[51] No longer was the admiration for this distinctive landscape "strange," as Lermontov had declared it in 1841. Now it constituted an integral part of the nationalist arsenal. Nikitin's use of the new landscape imagery for openly propagandistic purposes calls attention to its increasing reification as a symbol of national identity.

From a different but in some ways equally nationalistic point of view, Aleksandr Herzen's "Letters from France and Italy" (1847–1852) includes a comparison between the landscape of southern France and that of central Russia. Herzen affirms this new vision of Russia's landscape as a positive reflection of the national character, even though his conception of Russian nationality had little in common with that of Shevyrev or Nikitin. Confronting the landscape of southern France on his travels, Herzen took the opportunity to vilify Western private property and laud its apparent absence in the Russian peasant village:

> One thing pains the eye and oppresses the Slavic soul: high stone fences covered with broken glass separate flower gardens, vegetable gardens, and sometimes even fields. They represent a kind of perpetuation of exclusive ownership, the insolence of the right of ownership. For the poor person on the dusty road, the cruel and offensive wall reminds him constantly that he's impoverished, that he doesn't even have a view of the distance. It's impossible to imagine the gloom these walls impart to the surrounding land and fields. The trees appear as prisoners behind them, spoiling this most charming landscape. There is nothing like the Russian village in Europe. . . . What can there be in common between the rich landords and the hungry workers who only possess *le droit de glaner?* Gentlemen, long live the Russian village! Its future is great.[52]

In Herzen's view the Russian system of ownership, while it may have kept serfdom intact, allowed Russian peasants to develop their own system of communalism that distinguished Russia from western Europe and made it the potential vessel of a socialist future. The two distinct landscapes reflected the different historical paths and divergent social capacities of Russia and western Europe. Although Herzen's politics were in many ways antithetical to those of Shevyrev, the two shared the view that Western civilization was in a state of decay and would need to be saved by a young and dynamic Russia, soon to imprint its presence on the world. The special character of the native landscape represented this inherent capacity and pointed the way to a glorious Russian future.

REALISM, NOSTALGIA, AND THE ANTI-PICTURESQUE

Sergei Aksakov had reached his fifties before he took up writing as a serious occupation around 1845. As an experienced fisherman, hunter, and amateur naturalist, Aksakov made his first important contribution to Russian literature in the form of nonfiction (though elegantly written) fishing and hunting manuals. With *Notes on Fishing*, Aksakov claimed a place for himself as Russia's foremost nature writer. The body

of writing Aksakov produced in the 1840s and 1850s was one of the main expressions of the reconceptualization of Russian landscape in this period. As a first principle, in the introduction to *Notes on Fishing*, Aksakov established his position with respect to nature by dismissing the picturesque:

> Of course, almost no one can be found who would be entirely indifferent to the so-called *beauties of nature,* that is to a beautiful location, to a picturesque distant view, to a magnificent sunrise or sunset, to a bright moonlit night, but this is not yet love of nature; this is love of landscape, decorations, the prismatic refractions of light. The most stale, dry people, in whom poetic feeling has never arisen or is entirely muted can love this: but their love ends there.... Their love of nature is external, visual, they love pictures, and not for long; looking at them they are already thinking about their banal affairs.... But enough of them! The countryside, not around Moscow but the distant countryside—only there is it possible to feel the full life of nature unpolluted by society. The countryside, peace, quiet, calm![53]

Not only does Aksakov condemn a picturesque conception of nature as artificial, but he contrasts that approach to the countryside against his own (implicitly genuine) relationship to the natural world, through which he claims to comprehend nature from within. The correct perception of nature requires full immersion in "the boundless steppe covered in thick, high grass" or "on the bank of a sleepy lake, overgrown with reeds."[54]

One cannot help but note the remarkable coincidence between Aksakov's (or Gogol's) rejection of the picturesque in the 1840s with that taking place around the same time in the United States. The American landscape painter Thomas Cole first delivered his "Lecture on American Scenery" in 1835. In it he rejected European scenery in favor of the less tamed wilds of New England, the appreciation of which, according to Cole, was proof of a certain American moral superiority. About American landscape he wrote, "you see no ruined tower to tell of outrage, no gorgeous temple to tell of ostentation; but freedom's offspring—peace and security dwell there, the spirits of the scene."[55] A few years later, sounding not unlike Aksakov, Henry David Thoreau wrote, "we have scarce ground to hope every admirer of *picturesque beauty* is an admirer of the *beauty of virtue.*"[56]

Because Aksakov wanted to perceive nature "from within," one might expect him to rely, as had many of his Russian contemporaries, on the relationship between the peasant and the land. He had in fact attempted this in his first prose work entitled "The Blizzard" (1833). In this short sketch of just a few pages, Aksakov described a group of

Russian peasants caught in a snowstorm on the steppe. An old and experienced member of the group saves some of the others as a result of his accumulated knowledge of nature acquired through long familiarity with his surroundings.[57] Peasants, however, figured only peripherally in Aksakov's future writings. Aksakov would go on to describe a similarly deep acquaintance with nature in the gentry narrators of his fishing and hunting manuals. In a letter to his son Ivan about his second work, *Notes of an Armed Hunter in Orenburg Province*, he described the narrator as "a simple hunter with an unconscious poetic sensitivity, who in the simplicity of his heart isn't aware that he is describing nature poetically."[58] In other words, Aksakov consciously endeavored to create the likeness and form of an unconscious connection to nature.

In his study of Aksakov, Andrew Durkin chose the term "pastoral" as the most appropriate way to encapsulate the main theme of Aksakov's work. Durkin's use of the term is significant in many respects. For one thing, it contradicts Aksakov's position in the canon of Soviet criticism as a realist whose main value was his contribution to realist prose. The notion that Aksakov essentially idealized life in the Russian countryside runs against the grain of Soviet literary history. As we have seen, nominally idyllic poetry and traditionally pastoral writing had died out by the 1820s. It may be interesting to note, however, that Aksakov was already twenty years old in 1811 when pastoral imagery was still very much in vogue. In 1824 he even wrote a "Russian idyll."[59] Although in his early years he had included himself among the unsentimental anti-Karamzinians, sentimental pastoral conceptions of the landscape were quite familiar to him. It is worth pointing out in this respect that Aksakov's sons, particularly the Slavophile Konstantin, had in their own way emphatically idealized the Russian countryside in their interpretation of the peasant commune.

The pastoral mode, although fully discredited by the 1840s, came to life again under very different circumstances in the naturalistic prose that was coming to dominate Russian literature at midcentury. When he began work on *Notes on Fishing* Aksakov wrote to his son, "With each day this labor becomes more pleasant for me. I have raised from the bottom much that was forgotten, decayed in the dim repository of my memories. A good deal of myself, of my youthful impressions, will be in this book."[60] Shortly thereafter Aksakov turned to memoir writing. In his "youthful impressions" Aksakov's memory transformed his semiautobiographical texts into a kind of nostalgic blend of the rural idyll and family history.

Aksakov conceived of his world as divided into two realities: the moral, relaxed, and genuine country versus the false, impure, and austere city. Although this basic dichotomy originated in the eighteenth century, Aksakov's idealization of rural Russia had few external com-

monalities with the writings of his eighteenth-century predecessors. His countryside in no sense resembled the pastoral of piping shepherds, southern breezes, and Arcadian landscape that was still popular in the early 1800s. Aksakov's *locus amoensus* was the forest and steppe, his "own native waters," as he put it in the poetic inscription he intended for *Notes of an Armed Hunter*, which appears at the head of this chapter.

To writers from the Russian gentry the countryside often promised a sense of return to the unimpeded warmth and ease of their rural upbringing. Much of the energy that drove this reconstruction of Russian national space derived less from an interest in forging connections with the peasantry than from childhood memories and other nostalgic reminiscences of the happiness and leisure of country life in and around the gentry estate. In short, the Russian landscape became a "place" where the landowning elite could reconnect with what they considered the authentic aspects of Russian life—and by implication with the latent elements of their own identity—by familiarizing themselves with the pristine nature and genuine peasant culture of the countryside.

Thus a double nostalgia was projected onto the rural landscape in these years. The countryside came to represent the national spirit, as in Nikitin or Herzen, and at the same time it was construed as an antiurban space of peace and pleasure. Even though all traces of pastoral landscape had disappeared from Russian nature imagery, and descriptions of downtrodden serfs had nothing in common with the joyful shepherds of Sumarokov or Karamzin, nevertheless the pastoral sensibility did not so much die out as take on a new form. The universalist, ahistorical, and erotic aspects of the traditional and neoclassical pastoral had been discarded, but the countryside was still connected to visions of unspoiled nature, simple and genuine human relationships, and the innocence of youth. This reinterpretation of rural Russia offered elites the imagined experience of a cleansing and reawakening to their innate native sensibilities, which seemed to have been lost in the urban, Europeanized environment in which they spent so much of their time.

PASTORAL REDUX

Between the mid-1840s and mid-1850s, this pastoral idealization of the countryside constituted an important element in Aksakov's work, and it also played a role in the writings of Goncharov, Tolstoy, and Turgenev.[61] These writers are considered pioneers of Russian realist prose, yet all at times idealized the countryside as a space of pleasure and delight in Russian life. Through depictions of childhood and leisure pursuits, they brought to life an image of the Russian countryside as a world of peace and beauty. In most of their work the pastoral passages refer not to the enclosed terrain of the park or garden but to

the open countryside. Their idyllic descriptions of landscape and country life helped establish an image of the Russian countryside off the estate as a new, if limited, space of beauty and delight.

In 1849, Ivan Goncharov published an excerpt from his novel *Oblomov* entitled "Oblomov's Dream." The excerpt recalls Oblomov's gentry childhood in a secluded village near the Volga. Written with great attention to minute details, it reads more like a nostalgic memory than a dream. Goncharov felt that to describe the landscape of Oblomov's childhood he had to begin by erasing the influence of romantic landscape familiar to his readers from descriptions of Europe or the Caucasus. The first three paragraphs of "Oblomov's Dream" point out what the landscape is not: "there is no sea there, no high mountains, cliffs or precipices, no virgin forests—nothing grand, gloomy, and wild."[62] By comparison to these sublime and frightening spaces, the Russian landscape of Oblomov's village appears to be as gentle and quaint as stage scenery for an idyllic drama:

> The whole place, for ten or fifteen miles around, consists of a series of picturesque, smiling, gay landscapes. The sandy, sloping banks of the clear stream, the small bushes that steal down to the water from the hills, the twisting ravine with a brook running at the bottom, and the birch copse—all seem to have been carefully chosen and composed with the hand of a master.[63]

This "blessed little corner of the earth" that Goncharov describes is clearly a direct descendant of the pastoral ideal, maintaining all the idyllic features but transposing them to a specifically Russian environment. The sun shines for precisely six months during the year, the people eat to their heart's content, and the air is filled not "with the fragrance of lemons and laurels, but only with the scent of wormwood, pine, and wild cherry." When it rains "the peasant welcomes the rain joyfully . . . holding up his face, shoulders, and back to the warm shower."[64] There is no crime and no disease; labor is merely a fact in the course of things; and even death is gentle and rare: "when someone had gone to his eternal sleep, either from old age or from some other chronic illness, the people there had gone on marvelling at such an extraordinary event for months."[65] Further, the setting of "Oblomov's Dream" is historically and geographically self-contained. As in the world of the idyll, the villagers possess nothing more than a vague premonition of any world beyond their own, and as for their perception of time, "they would have been miserable if to-morrow were not like yesterday and if the day after to-morrow were not like to-morrow."[66]

Precisely because of its separation from the outside world, the image of the Russian countryside in "Oblomov's Dream" forms a nontradi-

tional yet fully realized idyll. It represents simultaneously both Oblomov's fantasy and the real world of the archaic Russian landowner whose time has passed. Although in the completed novel this overpowering memory of an idyllic childhood becomes a source of Oblomov's difficulty maneuvering through modern life as a "superfluous man," it remains a powerful nostalgic vision of the Russian village itself. In his own way, Goncharov transformed the simple and unassuming character of the Russian landscape from a weakness into a strength.

Of all the nostalgic descriptions of the countryside written in these years, Goncharov's landscape relied most heavily on standard pastoral themes. Tolstoy also created an idealized image of the Russian landscape in his first novel, *Childhood*. The novel is a psychological portrait of a gentry upbringing, and its main image of the countryside appears in the gaze of a young boy first experiencing the natural world. In the chapter entitled "The Hunt," Tolstoy used the device of childhood impressions to assert his own version of Russian nature. As with Gogol's and Aksakov's landscape, Tolstoy's child sees the world not from a removed vantage point, as would the observer of a scenic view, but from within, surrounded by new sights, sounds, and smells:

> The clatter of the peasants, the tramp of the horses and the creaking of the carts, the merry whistle of quail, the hum of insects hovering in the air in motionless swarms, the smell of wormwood, straw and horses' sweat, the thousand different lights and shadows with which the burning sun flooded the light yellow stubble, the dark blue of the distant forest and the pale lilac of the clouds, the white gossamer threads which floated in the air or lay stretched across the stubble—all these things I saw, heard and felt.[67]

The question of picturesqueness does not intrude on the reader's notice here because the "view" of the narrator is so close to the objects he describes. Tolstoy's young protagonist seems fully immersed in nature, and the reader experiences his surroundings along with him as a sort of immediate impression. By this means Tolstoy avoids the problem of illustrating Russia's natural environment. The landscape appears as a series of impressions calculated to arouse the nostalgia of an audience that shared similar fond recollections of childhood in the country.

A few years after Tolstoy, Aksakov pursued the theme of gentry nostalgia for the countryside in his partially autobiographical novels of family history *A Family Chronicle* (1856) and *Childhood Years of the Young Bagrov* (1856). These works re-create the life of Aksakov's grandfather, who moved his family and serfs from the Volga region southeastward to a semifrontier area near the city of Ufa. Aksakov's introductory sections portray the new properties as a happy blending of

man and nature in the creation of an ideal environment. But it is a particular sort of humanity that blends into this setting. The novel describes the world of a Russian landowner at the height of gentry power during the reign of Catherine the Great. Unlike the gentler pastoral reminiscences typical of that time period, Aksakov describes his grandfather's hardheaded, practical response to the difficulties of subduing a frontier terrain. The landowner, Bagrov, and his serfs carve out for themselves a self-sufficient estate and village in which the age-old customs of Russian life intermingle with the "wild and virginal" new territory to form a microcosmic ideal of the gentry estate. At some times the estate and its environs seem to embody pastoral peace and plenty; at others they give rise to all the troubles and traumas that could appear in such a world.

A Family Chronicle rests on Aksakov's above-noted dichotomy between a false love of picturesque landscape and a genuine affection for nature as a matter of immediate personal experience. This idea is personified in the contrast between the narrator's urban mother and his country father. His mother finds the country estate unattractive because she has only learned to appreciate nature as a matter of picturesqueness: "she had been accustomed to the noble views from the mountainous bank of the river Byelaia; and this little village in a hollow, the time-stained and weather-beaten wooden house, the pond surrounded by swamps, and the unending clack of the mill—all this seemed to her actually repulsive."[68] For the father the visual spectacle of landscape was not important. Aksakov describes the father's favorite retreat as an "unpretentious place" in the open steppe:

> It was a bare empty spot, quite flat and fully exposed to the sun, without a bush or a tree; the level steppe with its marmot-burrows lay all around; and the quiet river flowed by, deep in places and overgrown with reeds. It had nothing striking or picturesque to attract anyone. . . . I had a strong liking for that quiet little house on the riverbank, the clear stream, the weeds swaying in the current, the wide stretch of grassy steppe and . . . the wider steppe, where the prairie grass stretched straight southwards to what seemed an illimitable distance.[69]

Entirely lacking conventional beauty, this small corner of the steppe serves as a sort of descriptive refutation of traditional landscape aesthetics. Aksakov reiterates Gogol's portrayal of Russian landscape, made several years earlier in *Dead Souls,* as characteristically open and unpicturesque. Yet in one way he goes a step further by making this kind of landscape particularly pleasant for the character in his novel who is most deeply devoted to nature. In the 1820s, Pushkin had deemed "unpretentious" space a particular form of Russian picturesqueness. For

Aksakov in the 1850s, the admiration for unpretentious space represented a more profound attachment to the natural world. Here the absence of picturesqueness has become a positive virtue.

Although Aksakov did not shy away from pointing out the problems of his serf-owning heritage (such as the towering rages of his grandfather and the landowner's tendency toward authoritarianism on a local scale), on balance he, like his Slavophile sons, supported the traditions of the Russian gentry. This allowed him to idealize his family's past. In Durkin's words, Aksakov's works are pastoral because he "favors simplicity and wholeness over complexity and fragmentation."[70] And yet as much as Aksakov, Goncharov, and Tolstoy drew on the pastoral mode for their approach to Russian landscape, their writing also reflected the limits of pastoral description in their era. All of them turned either to the past, or to childhood memories, or to immersion in nature via hunting. This late flourishing of pastoral imagery may well reflect a nostalgia that tends to arise when a way of life is threatened: the abolition of serfdom in 1861 was already on the horizon by the time Aksakov published *A Family Chronicle*.

Perhaps the most original depiction of Russian landscape in this era is found in the stories of Ivan Turgenev. Turgenev wrote his *Notes of a Hunter* as a "cry against serfdom." Many of the stories in this diffuse collection, which ostensibly relate the reminiscences of a gentry hunter wandering the countryside in pursuit of his prey, drew attention to the miserable condition of the inhabitants of rural Russia. More importantly, the stories gently yet persuasively disclose the humanity of the enserfed peasants, something habitually disdained and ignored in pre-emancipation Russia. Turgenev's stories seem to describe rural Russia from the perspective of a dispassionate bystander. But the sense of objectivity his narrative tone imparts was a cover. The collected impact of the stories in *Notes of a Hunter* made readers feel as though they had come into direct contact with the everyday life and environment of the Russian countryside.

That countryside provides a space in which the gentry hunter and the peasants he encounters mingle with one another on the level of equals, equals at least in terms of their human dignity. At times the peasants even leave the narrator bewildered by their possession of knowledge he does not have access to. In contrast to life in the city and on the estate, once the narrator and reader enter the countryside they drop the physical and social boundaries that separate human beings from one another. The narrator always finds relief or refreshment from difficulties in this landscape, even though the peasants often do not. The peasants own little, but they constantly offer up what they have to him, from companionship, to shelter, to simply a cup at a spring "left by a passing peasant for the public benefit."[71] Furthermore, although

the countryside contains great suffering, it is also the source of the narrator's and the peasants' joy in life. In these ways, notwithstanding the harsh realities of country life, Turgenev's rural environment represents its own sort of modified pastoral. In the idyll or eclogue the pleasure and beauty of nature unify the given community. Similarly, in *Notes of a Hunter* nature dominates the lives of both peasants and hunter and unites them in its all-encompassing presence and unquenchable beauty.

Notes of a Hunter was also instrumental in suggesting the connection between landscape and nationality. The awakening of an identification with the native land is felt throughout the stories. It surfaces most explicitly in "The Singers," in which a peasant sings a folksong with such power and grace that he drives both the narrator and the rest of the village audience into a state of impassioned awe. Their rapture related directly to their collective sense of nationality: "In every sound his voice made there breathed something familiar as our birthright and so vast no eye could encompass it, just as if the Russian steppe were being unrolled before us, stretching away into an endless distance."[72] Turgenev's singer links the two isolated cultures of Russia into one in their mutual love of the boundless space of the Russian steppe.

Many stories in *Notes of a Hunter* begin with a landscape description. In some, such as "Bezhin Meadow" and "Kas'ian of the Beautiful Lands" the natural environment plays as large a role as any character. The closing sketch, "Forest and Steppe," includes little more than a series of descriptive landscapes. Considering that Russian writers had been struggling to find a language with which to portray their natural environment only a few years before he began these stories, Turgenev's achievement was spectacular. His nature descriptions managed to capture the imaginations of western Europeans as fresh and appealing. Georges Sand, for example, admired Turgenev's ability to convey the beauty of his native land, and Hippolyte Taine went so far as to call Turgenev "the most perfect of landscapists."[73]

Turgenev's essential understanding of the natural environment often closely resembled that of Aksakov. He admired Aksakov's fishing and hunting manuals, paying tribute to *Notes of an Armed Hunter* in two separate reviews that mainly expressed esteem for the elder writer and sportsman. It was precisely the profound, experiential knowledge of nature that Turgenev appreciated in Aksakov's writing. He admired Aksakov's ability to conceive of himself as a part of nature and to describe his environment from an intimate perspective: "He looks at nature . . . not from an exclusive point of view, but just as one must look at it: clearly, simply, and with full participation . . . and before such a gaze nature is revealed and allows him to 'look into' himself."[74]

In his own nature description Turgenev continued the tradition of depicting the natural world "from within." A remarkable and charac-

teristic example of this favored vantage point in *Notes of a Hunter* finds the narrator lying on his back peering up at the sky through the trees:

> A marvelously sweet occupation it is to lie on your back in a wood and gaze upwards! You may fancy you are looking into a bottomless sea; that it stretches wide *below* you; that the trees are not rising out of the earth, but, like the roots of gigantic weeds, are dropping—falling straight down into those glassy limpid depths. . . . One does not move—one looks, and no words can tell what peace, what joy, what sweetness fills the heart. One looks: the deep, pure blue stirs on one's lips a smile, innocent as itself, as the clouds over the sky, and with them happy memories, pass in slow procession through the soul, and you fancy your gaze goes deeper and deeper, and draws you with it up into that peaceful, shining immensity, and that you cannot be brought back from that height, that depth.[75]

With this immersion in the "depths" of the landscape awakens a sense of escape into a blissful alternative reality. As faithfully as possible, Turgenev describes the familiar sights and sounds of the Russian countryside, but at the same time like so many of his contemporaries he uses this experiential, rather than merely visual, conception of nature as a way to suggest the "peace," "joy," and "innocence" derived from rural pursuits.

This celebration of nature as a realm of calm, pleasure, and beauty served as the primary function of landscape description in *Notes of a Hunter*. But Turgenev's understanding of nature extended beyond the simpler forms of pastoral. Nature brought not only joy and hardship but intimations of mortality as well. An underlying theme of these stories is that the peasantry, in spite of its coarseness and lack of education, was clearly attuned to its own existence as a part of the natural world, whereas the educated classes had lost touch with their own implication in nature. In "Bezhin Meadow," for example, nature at first nearly kills the hunter when he almost steps over a cliff. Having been humbled by the precariousness of his own existence, he then receives a lesson on living from a group of peasant children who believe in wood demons and river spirits. The characters Ermolai, Biriuk, and Kas'ian, moreover, all display a kind of wisdom about surviving in the world that the narrator never seems to fully grasp.

The prototype of the peasant in tune with nature is the diminutive Kas'ian, whose appearance is elfin, almost inhuman, and who is compared, at various times, to a mushroom, a flea, a child, a quail, and a lark. Kas'ian's deep acquaintance with nature enables him to cure people using herbs he collects in the forest. He seems to have fused with the natural world, as he stuffs bits and pieces of vegetation into his shirt and appears to communicate with animals. He has blended his

own being with the natural world to the extent that his immersion in the forest represents a kind of animistic Christianity that clearly surpasses the understanding of the narrator. His conception of Christian mercy, for example, induces him to scold the hunter/narrator for killing forest birds. In short, Kas'ian embodies an Orthodox ideal of charity and simplicity reoriented in a new direction through his interpenetration with his natural environment.

As the character of Kas'ian indicates, Turgenev viewed peasant perception of nature as a matter of intimate experience. He was not averse, however, to rendering picturesque descriptions of Russian scenery. In 1847, the same year that Shevyrev took his trip to the Kirillo-Belozerskii Monastery, Turgenev introduced the story "Tatiana Borisovna and Her Nephew" with the scenic landscape description of a picturesque traveler. Like Shevyrev's vision of the countryside, this passage seems to offer a counterimage to the bleak Russian countryside of Gogol's *Dead Souls*. The imagery is mundane, as in Gogol's view of Russia, but Turgenev nevertheless manages to render it bright and scenic. In place of Gogol's "quick succession of milestones and . . . drab villages," Turgenev shows "the dark mass of forests, the glitter of ponds, yellow patches of villages." In place of Gogol's "fields stretching for miles on either side of the highway," on Turgenev's road "to right and to left, over the long, sloping hillsides, the green rye is softly waving." And instead of "crows as thick as flies," in Turgenev's landscape "larks in hundreds are soaring, singing, diving headlong with outstretched necks." Such scenic traveler's landscape also finds its way into the concluding chapter, "Forest and Steppe."[76]

Even though he generally shied away from this type of description, one might note that Turgenev's portrayal of scenic Russian landscape seems to arise almost effortlessly by comparison to the awkwardness of Pushkin, Gogol, and earlier Russian travel writers. Turgenev's facility with this sort of description points to the fact that by the late 1840s the attempt to "live up to" the landscape of Europe had lost some of its earlier challenge, thanks to the dawning acceptance of a unique and affirmative Russian sense of place. Russia could now claim a distinctive landscape of its own. Not only was the Russian environment unique, its inhabitants had developed a new relationship to nature, a relationship that claimed to surmount the platitudes of Europe's vogue for picturesque scenery. This relationship was presented as national in essence, shared by peasant and noble alike.

Almost all of a sudden in the early 1840s, the countryside became a potent symbol of Russian nationality. Especially after the publication of "Native Land" and *Dead Souls,* Russia began to exhibit a newfound confidence in the distinctive nationality of its natural environment, even to the degree that the landscape could be reinterpreted as scenic

by some and pastoral by others. As an example of this confidence, it would be difficult to find a better embodiment of all the traits discussed in this chapter than in a letter written in 1848 by Aksakov's son Ivan (a twenty-five-year-old Slavophile and future leader of the Pan-Slav movement). The younger Aksakov's enthusiastic view of Russian nature unites the nationalism of a Nikitin, some of the Orthodox spirituality of Shevyrev, the senior Aksakov's love of uncultivated spaces, Gogol's evocation of boundlessness, and the peasant harmony with the land found in *Notes of a Hunter*. It makes a fitting way to conclude the present chapter:

> It is impossible to convey the impression, the feeling of peace and simplicity . . . the quiet, the safety, the trust, and the strength [of the Russian countryside]. Only such an absence of triviality, only such a condition of being face to face with this nature, with this magnificence of open space and solemnity of peace, this inexhaustible, unchangeable beauty could form a person like the Russian peasant. No nature can be as good as ours. Hills are fine, but somehow one-sided; it's cramped in them. One nature is too bright and proud, another is too luxurious, passionate, and syrupy, and subordinates man to itself, but nowhere is there such a peaceful character, where it is possible to find such simple beauty, such boundless space, with the knowledge that all this is ours, our own, that everywhere is home, everywhere *Rus'*. . . . To be sure, the poor German, living in cramped conditions and deprived of these impressions also lacks the most important element in the make-up of the Russian soul. In a Russian field it is hard to sing anything but a Russian song: that same simplicity, that same boundlessness, and distance and space, that same peace and the same softly and lightly varied uniformity. Nothing compares to impressions on the road, when (true—in dry weather) you ride easily along the lively, soft road . . . now you drop into a ravine, now you ride up on a hill, and in the distance shine strips of a meandering river, and each moment nature unfurls its inexhaustible beauty and distance, and the blue-gray vistas open their mystery before you, removing and obscuring a new distance as you draw closer. And amid all of this, sitting on a sawhorse wearing only a shirt, the Tsar and Lord of it all, the Russian peasant; his soul freely mixes this nature into itself.[77]

CHAPTER FOUR

Outer Gloom and Inner Glory

Ne vesela ty, rodnaia kartina!

[You are not happy, native picture.]

—Nikolai Nekrasov

Mysticism of race and blood is alien to the Russians, but the mysticism of the soil is very much akin to them.

—Nikolai Berdyaev[1]

At this point it is necessary to backtrack chronologically in order to examine the same period from a different perspective, to give full consideration to a set of images that developed simultaneously with the celebrations of national space considered in the previous chapter. During the 1830s and 1840s, a darker picture of the Russian landscape began to emerge: the image of rural Russia as an unattractive, inhospitable place. This vision of the countryside was the result of two sometimes contradictory but interrelated factors. First, the taste for European landscape remained a strong influence within the culture of educated Russians, and that influence never ceased to shape Russian perceptions of the native landscape. Second, the outrage aroused by serfdom and the generally dismal conditions among the peasantry transformed the countryside, for some observers, into an ideologically charged space in which the land reflected the misery of the Russian people.

This chapter will focus attention on such negative readings of Russian landscape and describe another process by which Russians turned the perceived absence of beautiful and spectacular scenery into a special national virtue. Not until a consciousness of national particularity began to develop were comparisons between Russia and Europe made, and in some instances Russia was found wanting. From this point forward the view that Russia's landscape was unattractive in relation to the beautiful scenery of western Europe became a common complaint. In the meantime the development of a widespread conviction that the

Russian folk were the true bearers of Russia's national character initiated a new search for the meaning and image of rural Russia. As the peasant came to occupy a more and more central role in the definition of Russian identity, the hardship and suffering of rural laborers came to represent—for many—an inner spiritual strength, a special kind of Russian virtue.[2] By a similar logic, the meager and modest appearance of the rural landscape was made to stand for the quiet, hidden grandeur of the nation as a whole. The combination of these two elements, the abiding negation of Russian landscape by comparison to that of Europe and the emerging tendency to celebrate a special, even virtuous, Russian misery paradoxically made attractive an image of the Russian land as a uniquely grim and unappealing space.

THE PICTURESQUE INVERTED

One necessary step toward reversing or erasing conventional aesthetic assumptions is to discredit them. Here too Pushkin helped initiate the process. In *Eugene Onegin* he managed to carve out a space for the appreciation of "ordinary" Russian countryside in a picturesque vein. In other works he struggled more openly against the vogue for picturesque scenery. As seen in "The Countryside," Pushkin condemned appreciation of scenic views as the callous and hypocritical luxury of gentry landowners living off the labor of their serfs. His juxtaposition of lush gardens, murmuring brooks, and azure lakes against the awful power of serfdom made evident the de facto union of these two ostensible opposites on the same ground. The poem implied that pastoral and picturesque admiration for nature intentionally obscured other salient features of rural Russia, namely the brute force necessary to maintain serfdom and keep the gentry in a position of power and privilege. Pushkin had subtly implicated himself and his fellow landowners in the maintenance of an unjust system. One might interpret the message of "The Countryside" as a hint that educated admirers of scenic landscape were metaphorically engaging in an act of violence.

Another one of Pushkin's short verses, "My Ruddy Critic" (1830), mocked the abiding use of pastoral imagery in representations of the Russian countryside:

> Take a look at the view here: a row of miserable huts,
> Beyond them the fertile soil, a slightly sloping valley,
> Above, a thick stripe of grey clouds.
> Where are the radiant fields? Where the darkling forest?
> Where the brook? In the courtyard at the lower gate
> Two poor trees brighten the view,

> Only two trees, and of these one
> Wholly denuded by the autumn rain . . .
> There, true, is a peasant with two women behind him.
> Capless, he carries the coffin of a child.[3]

As these lines suggest, in 1830 Pushkin still had to struggle against the dominance of pastoral cliché in nature poetry. Here he attacks those critics who could not tolerate literature that drew attention to the hardship and misery of rural life. By contrast to *Eugene Onegin*, this poem's evocation of the countryside offers no alternative Russian picturesque; it simply invites readers to open their eyes to the apparent relationship between the difficult conditions and unspectacular landscape of their rural surroundings. Such grim imagery as that found in "My Ruddy Critic" is appropriately read as a step toward critical realism, but it would never serve as the basis for a new national landscape imagery. To point out that the landscape was melancholy and nondescript relative to the exaggerated poetic liberties of certain writers was one thing; to represent the nation in such unrestrictedly bleak terms was something else again.

Purely critical depictions of the countryside did, however, begin to lead toward a new affirmation of Russian space. In the previous chapter, Gogol's landscape in *Dead Souls* was interpreted as a step toward the creation of a new and aesthetically pleasing image of the Russian land. But his description of the open countryside, it will be recalled, also expressed an unresolved despair and confusion over how to make sense of the unique character of Russian space. Gogol reacted to Russia's vast plains not in descriptive terms but with a series of unanswered questions: "Russia! What do you want of me? What is that mysterious hidden bond between us? Why do you look at me like that? And why does everything in you turn eyes full of expectation on me?"[4] The landscape in this passage never assumes any tangible form. Throughout, it remains an inscrutable, mysterious force. In his summarizing final sentence Gogol gives the most concrete description he can muster, calling Russia's landscape "a glittering, wondrous infinity of space the world knows nothing of."[5] Thus, for Gogol, the Russian landscape is wonderful, awe inspiring, beyond mortal comprehension, and at the same time—quite literally—unknown, empty space.

Gogol's empty landscape fulfills a dual role. First, by reminding his readers of Russia's unusually vast, level terrain, Gogol imparted to the landscape a character of its own that could be appreciated much as any other national territory might have been. But Gogol's nationalistic perspective dictated that Russia was *not* like any other European country.

His sense of Russian exceptionality kept him from accepting Russia as merely comparable to other countries, as one nation among others. Russia was not Europe; it was *the other option,* the alternative to Europe. The landscape, then, could not be considered a separate but equal kind of terrain. It had to represent in some way the unique character of Russia's national culture and its potential superiority to the West. Vast empty space called to mind untapped possibility, the promise of a young nation, and hopes of future greatness. The very emptiness made Gogol's inspired vision seem viable. It was a gesture of *ressentiment* reminiscent of Chaadaev's "Apology of a Madman," in which his earlier charge against Russia as empty and ahistorical reemerged as a path to future success. Alexander Gershchenkron's "advantages of backwardness" argument would later pursue a similar logic in the realm of economics.[6]

Gogol's strained and convoluted sense of Russia did not simply spring up fully formed from his notoriously fecund imagination. In the mid-nineteenth century Russia possessed what Martin Malia has referred to as "an 'unhappy' national consciousness." Russian identity had become a hotly contested and deeply disturbing issue by the 1840s. This anxiety may have been rooted primarily in the inescapable duality of a culture that identified itself as European while remaining distinctly different from many of its Western counterparts in political structure and socioeconomic foundations.[7] At the same time, Russia's autocratic rule and bureaucratic mire would deprive educated elites of the opportunity to guide the nation except in very restricted ways. Malia points to a common psychology of compensation underlying cultures in which the national community proves limited and unfulfilling: "Whatever was most cruelly lacking in the national existence was rationalized as unimportant, or even construed as a virtue, while those elements of positive achievement which did exist were exalted to the first principle of life."[8]

Just such a mechanism of compensation was put to work in the opposition to picturesqueness that had become common by the 1840s. Europe's artificial enjoyment of an external, scenic beauty diminished a genuine love of nature and compromised a truly ethical understanding of the world. Such an attitude was characteristic of Aksakov, and Gogol felt the same way. In one of the remaining sections of the second part of *Dead Souls* (much of which Gogol burned) the model landowner Kostanzhonglo attacks admirers of scenery and nobles who construct gardens for their own pleasure. He tells Chichikov, "Let me warn you, if you start chasing after views, you'll be left without bread and without views. Always think of what is useful and not of what is beautiful. . . . Never mind beauty! Concentrate on the things that matter."[9] Out of this

antithesis between form and function began to emerge a positive admiration for nonpicturesque landscape in Russia. The less external beauty, from this point of view, the greater internal truth and righteousness.

The poet Fedor Tiutchev responded to the problem of national landscape in similar terms. One of his best-known poems summed up the mystical notion of Russia as a national entity in the same way Gogol had—by leaping over the stumbling block of actual physical space, directly into the realm of metaphysics:

> Russia cannot be understood with the mind,
> Nor measured with a common yardstick:
> She has a measure all her own—
> In Russia one can only believe.[10]

Gogol and Tiutchev had much in common. They both spent a significant part of their lives abroad, both greatly admired the natural and cultural environments of southern Europe, and both harbored strong patriotic sentiments, bordering on mysticism. The conflict between a passionate patriotism and a strong attachment to foreign surroundings seems to have made the dilemma of Russian landscape particularly acute for both writers.

From the age of eighteen, Tiutchev had spent twenty-two years of his life in foreign service in Germany and Italy. During this time, and after returning home, he wrote a number of poems contrasting the Russian north unfavorably to the Italian south. The revulsion with which he seems to react against his native environment in several of these poems is striking. Describing a trip home to his family estate, he rejects his own connection to the place: "Oh no, not here, this empty region / Was not the native land of my soul."[11] The contrast between a "gaunt," "pale," and "deathly" Russian landscape and a longed-for southern paradise of sunshine and blue seas imparts some of the poignancy to Tiutchev's poetic persona, especially in the poetry written after he had returned to Russia. "On the Way Home," about a journey from Berlin to Petersburg in 1859, offers a rather extreme example of this distaste for his native surroundings:

> My native landscape ... Beneath a smoky awning
> Of enormous snow clouds
> The distance turns blue; with its gloomy forest
> Wrapped in the autumn haze ...
> It's all so bare and vastly empty
> In its mute monotony ...
> Only here and there shine patches
> Of stagnant water, covered by the first ice.

> No sound here, nor color, nor movement:
> Life has left—resigning itself to fate
> In some sort of forgotten, deep exhaustion,
> Here a man dreams only of himself.
> Like the day's light, his glance dims,
> He does not believe, though he has just seen it,
> That there is a land where iridescent mountains
> Gaze upon azure lakes.[12]

Ivan Aksakov was Tiutchev's son-in-law and the poet's first biographer. About Tiutchev's personal reaction to the Russian countryside Aksakov wrote that, "Russian nature, the Russian countryside, possessed for him no active magnetic attraction, although he understood and highly valued its, so to speak, inner spiritual beauty."[13] Like Gogol, Tiutchev overcame his aversion to Russian space by revaluing the meaning of the terrain. The outward emptiness and lack of beauty in the countryside became a sign of inner, spiritual richness. This is evident in one of his best-known poems, "These Poor Villages" (1859). The last stanza of this work is widely known because it appears in Dostoevsky's "Grand Inquisitor" chapter of *The Brothers Karamazov*:

> These poor villages,
> This meager nature:
> Long-suffering native land,
> Land of the Russian people!
>
> Proud foreign eyes
> Will not notice nor grasp
> The light that shines through
> Your humble barrenness.
>
> Worn by the weight of the cross,
> The Heavenly King in the guise of a slave
> Has passed through all of you,
> Native land, blessing you.[14]

Rather than hearken back to legends or anticipate the future, as Gogol had, Tiutchev draws on Christian themes to institute his own revaluation of the landscape. "Meager nature" and a long-suffering population does not imply the abandonment of God, as the self-satisfied foreigner might conclude. Instead Tiutchev interprets the nation and the landscape as *analogous* to a Christ weighed down by burdens and dressed in the rags of a Russian serf. The lack of outward beauty

becomes a symbol of Christian worthiness. Tiutchev sees Russia as a meek land, one might say, preparing to inherit the earth.

ON THE RUSSIAN ROAD

The image of Russia as impoverished, sad, empty, and unbeautiful was not limited to the work of such figures as Gogol and Tiutchev, who had experienced and learned to admire other regions. Descriptions of Russian travel typically depicted the Russian road as a miserable place. Pushkin and Viazemskii, notwithstanding their sometimes optimistic and picturesque portrayals of Russia, both wrote verses condemning the countryside, particularly in descriptions of travel on Russian highways. Viazemskii held that the Russian God presided over "potholes," "excruciating roads," and cockroach-infested way stations.[15] Pushkin's "Winter Road" painted a bleak picture of "wilderness and snow" where "only mileposts / crop up / to meet me," leaving him "bored and sad."[16]

Criticism of Russian travel conditions was common in the early part of the century for understandable reasons. Russian travelers often had to cover a vast amount of territory simply to move from the city to the country estate, or between the two capitals. Conditions would improve rapidly with the introduction of trains during the second half of the century, but in the early 1830s even travel between Moscow and Petersburg still could take, in one scholar's apt expression, "from one to six weeks."[17] Owing in part to Russia's vast terrain, roads and bridges were in terrible shape. They were usually repaired by serf labor, a method neither reliable nor effective. Way stations and inns, moreover, suffered by comparison to travel accommodations in Europe.

Russian travelogues of course had tried to throw a positive light on the scenery and experience of travel in Russia, but the general consensus held Russian travel to be a special national form of torture.[18] Pushkin, mocking the search for national character among such travel writers as Svinin, wrote, "nothing so resembles the Russian countryside in 1662, as the Russian countryside in 1833.... The *izba*, the windmill, the gate—even this fir tree, this sad mark of northern nature—it seems that nothing has changed."[19] In the 1840s, Matskevich wrote simply: "many native Petersburgers think that beyond Tsarskoe Selo and Gatchina begin the wilds, the wilderness, something akin to the Arabian Desert."[20]

One Russian novel took as its central theme the question of whether it was possible to travel through Russia in search of the national character. Count Vladimir Sollogub's *The Tarantas* (which appeared in full for the first time in 1845) raised questions to which the midcentury public was keenly attuned. Not surprisingly it became a

popular success. Sollogub's point of view is ironic and ambiguous, and the novel's apparent conclusions tend to work at cross purposes. In a way, *The Tarantas* reflects the confusion about Russian identity that plagued the entire era. Subtitled "Impressions of a Journey," it records the experiences of two Russian landowners traveling through central Russia. Vasilii Ivanovich, an unimaginative, yet keenly pragmatic landowner, contrasts with Ivan Vasil'evich, an ambitious but empty-headed young dreamer. Ivan Vasil'evich intends to write a book of travel impressions that will bring to light his native land's best and most characteristic features.

Sollogub directs much of his wit against the young man and his project. His main message is that Ivan Vasil'evich has acquired his vision of national community from a long education in Europe. In trying to extract from Russia the sort of impressions he had enjoyed in Germany, France, and Italy, he is destined for failure. To Sollogub, Russia cannot be seen and understood in the same way that one sees and understands Europe. The project goes awry from the start because those features of the countryside that Ivan Vasil'evich hopes will form the subject of his book never present themselves the way he expects them to. The commonsensical Vasilii Ivanovich remarks at the outset that it will not be possible to travel in Russia in the same way that the younger man has traveled abroad: "People travel in foreign countries, in those German places. But what kind of travelers are we? Just gentlemen going back to our country homes."[21]

By such means Sollogub criticizes the whole endeavor of travel writing in Russia as superficial and inappropriate to the circumstances of the country. Indeed, all of Ivan Vasil'evich's points of interest one by one resolve themselves into a single large, gloomy, unpicturesque mass he deems unsuitable for his intended publication. Eventually he admits it to himself:

> At first I seized on antiquities, but there are no antiquities. I considered studying provincial associations, but there are no provincial associations. They are all, as they say, uniform. Life in the capital is not Russian life, instead we are adopting from Europe a little culture and a lot of vice. Where do you look for Russia? Maybe in the simple people, in the simple nature of everyday Russian life? But here I've been traveling for four days, I listen and give heed, I focus and look around, and no matter what I do, I notice nothing and can't write anything down. The scenery is dead—land, land, so much land that your eyes get tired of looking; the road is horrendous . . . strings of carts travel along it . . . the muzhiks curse at each other. . . . That's that. . . . Once you get there: now the station master's drunk, now cockroaches are climbing up the walls, now the shchi smells like tallow candles. . . . Can a decent person study this kind

of nonsense? . . . And most dismal of all is the fact that over the entire enormous expanse reigns a kind of horrible monotony, which wears one down exceedingly and doesn't give any rest. . . . There's nothing new, nothing unexpected. Everything the same, the same, the same. . . .[22]

The Russian countryside, preaches Sollogub, cannot be understood from the tourist's viewpoint as a collection of sights, points of interest, scenic vistas, or picturesque peasants. As for the landscape, except for one "beautiful" vista in Vladimir, Sollogub dismisses it in disdainful terms common to many Russian and foreign travelers in the nineteenth century: "Flat on the left . . . flat on the right," remarks Vasilii Ivanovich.[23] Such dismissive language occurs several times: "on both sides stretched uneven fields, here and there with a little fir tree. It seemed that even nature was bored."[24]

Sollogub had finished seven of the first chapters by 1840 and published them in *Notes of the Fatherland*. When he presented these chapters to friends they apparently received an unsatisfactory reception, and he was not able to finish the rest of the work until 1845.[25] It is interesting to note that Gogol's *Dead Souls* first appeared in 1842, between the publication of the first seven chapters and the completion of the remaining thirteen chapters of *The Tarantas*. Much of the latter departs from the mocking tone of the first half, just as Gogol had shifted emphasis from humorous critique to inspired description toward the end of the first part (and in much of the remaining second part) of *Dead Souls*. Sollogub's new approach first crops up in a chapter on the Pechorskii Monastery in Nizhnii-Novgorod. Interestingly, this chapter rather closely resembles Murav'ev's travel descriptions, eliciting the architectural beauty of the monastery and holding up the Orthodox monument as an example of Russia's national distinctiveness. This straightforward descriptive passage fits awkwardly with the frequently ironic tone of *The Tarantas*. Understandably, Sollogub did not allow his character Ivan Vasil'evich to see the monastery. This would have destroyed the plot of the book by giving him something concrete to enter into his travel impressions.

As much as Sollogub renders the superficial visual character of the Russian countryside as bleak and monotonous, like Gogol and Tiutchev he refuses to let this picture stand alone. The final chapter, in the guise of Ivan Vasil'evich's dream, proposes an entirely different and unexpected vision of Russian space. It portrays a utopian future Russia, which has excised European influence, foretelling the dawn of an entirely independent Russia. Since the book was first published, one of its most problematic aspects for critics has been the difficulty it presents in separating Ivan Vasil'evich's glorified vision of Russia from the author's own aspirations for Russia's national destiny. Sollogub proba-

bly intentionally retained this ambiguity as an attempt to leave himself an escape route through the ideological minefields of his day. Whatever might have been Sollogub's personal point of view, in *The Tarantas* he included both criticism and unstinting praise of the Russian countryside. The dream affirmed the country's mysterious essence that would, of necessity, one day lift Russia above the West.

In the dream the tarantas (a simple Russian carriage) transforms itself into a bird, and eventually takes Ivan Vasil'evich up into the sky where he witnesses an idealized panorama of the entire country in some indefinite future. Both the natural and cultural sights of Russia have been cleaned up and made beautiful. Russia has rejected the destructive influences of both the West and the East and come into its own as a distinctive, peaceful, and spiritually fulfilled nation. The dream portrays Russian space as exactly the opposite of the empty, monotonous countryside that was the setting for the rest of the novel. Once Ivan Vasil'evich has returned to earth in this dream he views the landscape anew:

> The lands through which he was swiftly carried seemed familiar to Ivan Vasil'evich. He must have been there often at some time, on his own business on official matters, but it seemed that everything had taken on a different appearance. . . . Places where in the past there had been immeasurable barren expanses, swamps, steppes, wildernesses are now alive with people, with animation, and activity. The forests are cleaned up and kept as national reserves. The fields and plains, like multicolored seas, spread out to the horizon, and the blessed soil everywhere generously rewards the care of the villager. The herds picturesquely graze on the meadows, and little villages scatter farmers around themselves in a symmetrical web, as if they keep watch on the conservation of time and human labor. No matter where you look, everywhere is abundance, everywhere effort, everywhere enlightened consideration.[26]

Sollogub implies that the sad life of the countryside his travelers have been passing through may contain this pastoral, perfected national space in embryonic form. Unlike Gogol and Tiutchev, who maintained the image of a miserable countryside, Sollogub offers a concrete picture of a bright, inspiring future. This reified portrait of Russian destiny seemed ridiculous to most of Sollogub's contemporaries, which accounts for the widespread dissatisfaction with the final parts of the novel.

It should not go unmentioned that this rosy vision of Russia's future was clearly connected to Sollogub's idealized image of the European present. If that is not evident in the above passage, he makes it explicit for us. "Italy . . . Italy . . ." cries Ivan Vasil'evich on seeing the future

version of Moscow, "have we not really outshined you?"[27] For all of these writers, both the revulsion against the Russian status quo and the aspiration to lift Russia above the West was the result of their admiration for a Europe, or at least certain features of Europe, that their own country seemed to lack.

The difference between Sollogub's two contrasting visions of Russian space reflects a widespread ambiguity about rural Russia. The willingness to criticize Russia's landscape, as well as the quickness to defend it, both remind us of this tension. Gogol and Tiutchev had attempted to bring together these two distinct interpretations of the countryside into a single whole. The same attempt even appeared in standard travel literature. As much as any other text, E. A. Verderevskii's travelogue *From Beyond the Urals to Beyond the Caucasus* (1857) adopted the stance toward provincial Russia that its outer gloom signified its inner beauty. Unlike his better known counterparts, however, Verderevskii applied his reading of the landscape not to the open plains or forests of central Russia but to the Ural Mountains:

> Black and white colors predominate in this boundless picture, which can serve as a model of all the winter nature in the Urals—everywhere dark, impoverished in coloration and indistinct, but somehow spreading out all around in front of the viewer. There is something cold, unwelcoming to your soul in this nature; but when you recall the treasures hidden in her innermost depths, you will instinctively realize the immutability of the general rule by which a meager and cold surface everywhere, in things as well as people, contains within itself the truly strong, the truly great and the precious.[28]

That Verderevskii describes the Urals as outwardly poor and inwardly rich (in mineral wealth among other things) demonstrates that this conception of the land as unattractive but full of potential could encompass a larger image of the nation beyond central European Russia. In his introduction, Verderevskii justified the publication of his travel notes by arguing, not unlike Ivan Vasil'evich, that impressions of Russia should be welcome amid the glut of travel descriptions of foreign lands. Once he has reached (Tibilisi) in the Caucasus, he argues that the combination of "brilliant colors" in the south and the "pale grey" of the north render any other nation in the world "pallid and insignificant by comparison."[29] Verderevskii asserts that in combination with the exotic nature of the south, the unattractive landscape of the north can be seen as a purely positive feature of Russia because it makes for a greater degree of contrast than can be found in any other country.

Of course one must be careful in drawing comparisons between Verderevskii's light-hearted travelogue, Sollogub's sardonic novel about Russian travel, Gogol's mystical appeal to the land in *Dead Souls,* and Tiutchev's Christian symbolism, all of which differ considerably in conception and intent. These writings do possess in common, however, a desire to broadcast an affirmative vision of Russia to the reading public by way of an unpicturesque and monotonous, yet inspired vision of the rural environment. All of them betray the influence of European landscape on the imaginations of Russians, and all try to cope with this influence by creating an image of the native land that accepts a certain lack of superficial beauty in order to imply the presence of something deeper and more significant in their native land.

Every one of these writers was trying to extricate himself from a trap common among educated Russians, a trap that was produced by the special circumstances of Russian culture. To acquire a place in their own cultural environment, educated Russians needed to possess the varieties of knowledge (including aesthetic knowledge) that were constantly being advanced and extended in the tumultuously progressive countries of western Europe. Yet at the same time they had to overcome the sense of national inferiority and backwardness—the anxiety of living within a second-rate culture—that this state of affairs produced. All of these writers accepted and reconfirmed the common view that Russian landscape was outwardly unattractive, but each of them devised special interpretations of this unattractive space in order to render it more beautiful, more important, or more evocative than the landscape of western Europe.

LANDSCAPES OF RURAL HARDSHIP

Some Russians in the public eye did not trouble themselves with anxiety about Russia's second-rate status as a European nation. Belinskii, for instance, generally advocated Russia's need to follow the example of the West. As a staunch Westerner he had no sympathy for Ivan Vasil'evich's dream of a future Russia purged of Western influence. In his critique of *The Tarantas* he cleverly ignored the novel's open-ended quality and claimed to see Ivan Vasil'evich as a Slavophile. He read the entire book for his own purposes as a satirical attack against what he considered Slavophile idealizations of Russian life. Belinskii happily agreed with Vasilii Ivanovich that travel for education or entertainment in Russia was a futile endeavor. Reflecting the Slavophile's conceptual confusion, the young Ivan Vasil'evich could not but grow dissatisfied with both European *and* Russian reality. "Where the land is covered with the ruins of knights' castles and gothic cathedrals, he saw only

windmills and sheep," Belinskii noted, "but where there are only windmills and sheep, he looks for knights."[30]

Belinskii frankly accepted that the Russian landscape contained little to capture the imagination of the traveler, for he was interested in accurate reflections of the nation's problems rather than evocations of its beauty. Furthermore, he was still waging a battle against the influence of "dressed up," artificial imagery in Russian literature. From this perspective a desolate landscape at least appeared native and genuine. Belinskii frowned on the entire genre of the picturesque journey as a pointless exercise.[31] Admiration for landscape or historical sights got in the way of the proper business of contemporary Russian literature: to function as a "mirror of reality" and to embody in itself the spirit of the national culture. As a countermeasure against the picturesque journey, in the early 1840s Belinskii had called for a kind of travel writing that focused on "the social" aspects of Russian life.[32] By this he had in mind something resembling an early version of the ethnographic sketch that would later come to dominate Russian travelogues.

Literary representations of the countryside in the vein of social criticism appeared as early as 1846 in the "village sketch"—originally and most closely associated with the writer Dmitrii Grigorovich. While Grigorovich contributed in certain ways to the new pastoral idealization of rural Russia, he was also a key member of the "natural school" Belinskii championed, and he sought to portray the less exalted side of Russian life accurately and dispassionately. Published in the same year as Aksakov's *Notes on Fishing*, and just a month before the first of Turgenev's stories for *Notes of a Hunter*, Grigorovich's short story "The Village" (1846) supplied the original example of a rural "physiological sketch"—an exposé of hardship in the Russian countryside. This story describes the sufferings of a young peasant woman against the backdrop of life in the countryside, close to nature. "The Village" has been regarded by some as one of the first successful attempts to convey a recognizable portrait of a Russian peasant village. The landscapes of "The Village" are mainly idyllic and picturesque. Grigorovich used them to create a poignant contrast to the miserable life of the young protagonist Akulina.

In Grigorovich's next story, "Anton Goremyka" (1847), the Russian countryside itself becomes a *topos* of misery. The landscape in this story serves to accentuate the woes of the eponymous principal character. The first few pages describe Anton's daily surroundings. Over his work place, in "the most dense and out of the way" forest, reigns a "deathly silence." Traveling through the countryside, he encounters "endless flat fields," through which "only a dead road stretched out before him." His own *izba* is worse still: "Its disrepair was striking . . . a single little window closed up with odds and ends and smeared over

with clay, looked inexpressibly sour. From all sides the *izba* was propped up with gnarled logs, making it look like a hunched old beggar leaning on crutches; in a word everything in it was, as they say, tumbledown and upended. The heart grew inexpressibly heavy and sad as you gazed at this dwelling."[33]

Such melancholy surroundings became a commonplace of the "natural school's" reportage. Grigorovich used landscape imagery as a weapon against the obliviousness to social injustice of his contemporaries. He turned the tables on idealization of open Russian space by interpreting Russia's characteristic level expanse as a difficult, confusing, and mournful terrain. When Anton must ride to the city to sell his horse, he becomes lost and unsettled in the open fields: "Anton simply could not recall the place where he found himself, nor even how many versts remained to reach the city."[34] In this story *prostor* does not inspire freedom and joy but foreboding and loneliness: "on every side in the boundless panorama [*krugozor*] opened up black fields, drenched by rain; only rarely did stripes of pine forest or small hamlets appear in the distance."[35] This landscape recalls something of the emptiness Gogol had initially bemoaned in *Dead Souls:* "No matter where he looked Anton did not see mile markers, nor earthen walls, nor the little willows which would demarcate a boundary: ever so simply the boundless fields stretched outward amid other fields and swamps; the only variety here consisted in the fact that everywhere deep holes were visible."[36] Unlike Gogol, Grigorovich took no trouble to correct this impression.

An even more severe approach to representations of landscape would be adopted by the radical, or "nihilist," writers and critics of the reform era. For the radicals of this period, aesthetic expression of any kind was generally understood to be an obstacle to the proper function of literature. The best literature revealed the injustice of Russian life, and might perhaps even alter reality by contrasting it with better models. Such writing came into its own in the late 1850s. Once the abolition of serfdom (1861) became a likely possibility, practical economic and political issues began to dominate public discussions of rural Russia. The nostalgic gentry idealization of the countryside that characterized much of village literature in the 1840s appeared suspect to a new generation of educated Russians in the reform era because it interfered with the serious task of building a new socioeconomic basis for Russian rural life. In 1863, for example, Mikhail Saltykov-Shchedrin attacked idyllic visions of the countryside as a harmful falsification of harsh reality:

> "Village work" is not pleasant work, reader! It all revolves around the earth and consists in different kinds of care for it. . . . The picture of simple village men and women, gathered together for completion of their

labors, is rather charming. . . . But don't let the viewer get too carried away with the charming scene, let him once and for all convince himself that his eyes lie, that the artist, having copied down the picture, also does something unjustifiable, and that in rural life there are neither splendid landscapes, nor entrancing *tableaux de genre,* but hard and ugly labor.[37]

For the first time in the 1860s, Russian liberals and radicals began to evince a great interest in the everyday lives and social patterns of the peasants. With this interest in mind, admiration for the beauty of nature was often condemned as an expression of retrograde elitism.

Nikolai Chernyshevskii inaugurated this new conception of landscape in his widely read dissertation *The Aesthetic Relation of Art to Reality.* Chernyshevskii's dissertation attempted to subordinate the entire concept of aesthetic beauty to the overriding influence of material reality. Its bold thesis produced an immediate impact on Russian aesthetics. As was inevitable for a work that submits subjective criteria to an objective standard, the argument is philosophically untenable, and in retrospect it often seems ridiculous. As a polemic, on the other hand, it was quite successful. Chernyshevskii used aesthetics to establish the foundation of a new ideological position in Russian culture. By invalidating the importance of aesthetics in intellectual life, the dissertation paved the way for a generation of radical intellectuals to focus attention exclusively on social issues (although ironically still quite often via the best means it had at its disposal—the interpretation of artistic works).

Aesthetic Relation argued that beauty could not be a product of the imagination. In every case beauty depended on the original source of the beautiful in all things—physical reality. Landscape supplied Chernyshevskii with a useful case in point. While a picturesque approach to nature had already been condemned in certain literary works, Chernyshevskii tried to invalidate it on theoretical grounds. Arguing against the essential premises of the picturesque, he rejected the notion, for example, that nature could be enhanced by light or atmosphere: "most beautiful landscapes are beautiful in all lights." He declared the viewer's perspective insufficient to affect the beauty of the landscape: "a beautiful landscape is beautiful no matter from what angle you look at it." Indeed, he did not feel that nature could be improved in any way: "Would anybody really think of saying that a landscape is not beautiful if at a certain spot there are three bushes where it would have been better had there been two or four?"[38] Aesthetic discrimination, the function of taste, made little difference in Chernyshevskii's view of natural beauty. Beauty depended exclusively on the presence of flourishing life and biological health rather than on any culturally determined aesthetic standards. From this point of

view the difference between separate regional and national landscapes was greatly diminished: "There are very many beautiful and magnificent landscapes; in some countries they are met with at every turn, for example Finland, the Crimea, the banks of the Dnieper, even the banks of the middle part of the Volga, not to speak of Switzerland, the Alps, Italy."[39]

Chernyshevskii's rejection of the picturesque worked to persuade the reader that the landscape of central Russia could stand as the equal to any other. He developed this thought by characterizing the admiration for picturesque scenery as a moral failure:

> Travel two or three hundred versts along the road—we will not say in Italy or in Switzerland, or in the parts of Germany contiguous to it—but in central Russia, which is said to be poor in scenery—how many places you will come across during this short journey which you will admire, and while admiring them you will not say "if this were added here and this taken away from there the scene would be improved." A man whose aesthetic sense has not been corrupted finds full pleasure in nature and sees no flaws in its beauty. The opinion that a painted landscape can be more magnificent, grander, or in some other way better than real nature, partly originated from the prejudice that in our times is complacently laughed at even by those who, in essence, have not yet rid themselves of it, viz., that nature is coarse, base, grimy, that it must be washed and adorned to make it dignified. This is the principle of trimmed gardens.[40]

Chernyshevskii's argument leads to the conclusion that any aesthetic distinction with regard to nature is specious. His reasoning implied that landscape viewers must change themselves and the criteria for judgment they have internalized, rather than pursue an interest in any other kind of nature than that which they find before them.

Superficially, this view appears to be close to that of Aksakov in the 1840s in his introduction to *Notes on Fishing*. One might expect Chernyshevskii's conception of landscape to contribute to the appreciation of national space the way Aksakov's had. From the above passage, it is difficult to avoid the suspicion that Chernyshevskii still harbored at least a small degree of national pride in 1852. The larger context of Chernyshevskii's argument, however, leads in a very different direction. His attacks on the picturesque were instances in a crusade against aesthetics as a whole. Landscape, whether represented in literature and painting, or admired as scenery, was an aestheticization of reality, and therefore unncessary and harmful.

By subordinating art to "reality," Chernyshevskii put social questions at the top of his agenda in literary criticism. He would later

chastise such authors as Turgenev for excessive interest in "pictures of nature."[41] His promotion of "reality" over aesthetics resulted from a near religious devotion to a version of utopian utilitarianism that would become more evident before his exile in 1864. In the following years, landscape description, aesthetics, and even discussions of nationality were dismissed by Chernyshevskii and other radical critics in favor of an interest in social philosophy and the state of the Russian *narod*. "Nature is important to us," wrote Nikolai Shelgunov, an associate of Chernyshevskii's, "insofar as man depends on it."[42]

This shift of interest had a major impact on representations of the Russian countryside in the 1860s and 1870s. Many progressive writers now opted for the removal of even a hint of a pleasant environment in rural Russia. The ethnographic sketches of Nikolai Uspenskii or Fedor Reshetnikov, for example, went much further than the stories of Grigorovich and Turgenev to intentionally emphasize "the most dismal features of peasant life."[43] A particularly revealing indication of the change in approach to rural Russia appeared in a children's book entitled *The Village* [*Derevnia*]. Published in 1859 and reviewed by another materialist critic, Nikolai Dobroliubov, the book united nature descriptions with an evocation of peasant life as a kind of instruction manual for urban children, teaching them an appreciation for everyday life in the Russian countryside. The anonymous female author sought to break down the social barriers between peasants and educated, urban children. Having criticized what she perceives to be an excessive interest in things foreign at the expense of a knowledge of Russia, she explains why Russian children should make an effort to get acquainted with their own rural environment:

> As we look at them and at their way of life and their conversation, we feel that their lives and their language are not completely foreign to us. . . . No matter where we live, even in the most brilliant capital city of Petersburg, and no matter who we are, even if the richest or the best educated in the city, we nevertheless feel that between us and the Russian muzhik, no matter in what out-of-the-way corner he hides himself, there is much in common, a great resemblance of inherent characteristics and inclinations.[44]

Dobroliubov commended this section of the book for its understanding of the countryside. He approved of everything that touched on the lives and work of the peasants, but argued against the inclusion of "long-winded" discussions of nature. He also criticized the work for its avoidance of the "rather dark" aspects of peasant life, "their grief, need, and helplessness" as well as their "sins."[45]

Children's literature justifiably shied away from such a dreary evocation of the countryside, but in the hands of a new breed of travel writer

in the 1860s and 1870s, the darker sides of country life supplied a new theme. Critics of travel literature in the late 1850s, as one scholar has recently pointed out, called for a focus on "geography, history, economics, and mainly on ethnography."[46] Writers were paying attention: few travel memoirs of Great Russia appeared during the reform era that did not have a practical, often ethnographic, perspective on the countryside. In the new "travel notes" that were published during this period, the rural landscape looked nothing like the landscape described in the "picturesque journeys" of the first half of the century. Nature no longer appears as an aesthetic phenomenon. It is either described in an intentionally mundane and straightforward language or couched in a semiscientific vocabulary. Such descriptions intended to convey, in the words of one writer, the "physiognomy of the region."[47] The interest here was almost entirely limited to the peasants themselves. Writers wanted to know them accurately and without idealization.

Ethnographers had begun to study the Russian countryside intensively as early as 1845. The ethnographical study of Great Russia was established as one of the initial projects of the Russian Geographical Society, which had formed in that year.[48] The first ethnographic travel writers were Sergei Maksimov and Pavel Iakushkin. They began to publish their travelogues in the late 1850s as interest in Russian peasants intensified in the period surrounding the emancipation. Both authors made the Russian peasant the central focus of their writing. Maksimov mainly concentrated on trades practiced in the provinces. Iakushkin has been called "the first *narodnik*—a man who had discovered that the way to the good life and good society of the future ran through the peasant village."[49] His travel writing has little in common with previous Russian travel literature. Yet by calling his work "travel notes" he emphasized the novelty of his nonpicturesque approach to the rural environment. Iakushkin was initially encouraged by his publishers to seek out historical records or archaeological sites, but he became much more interested in recording his conversations and interactions with peasants on the byways of provincial Russia. His travel writing documented a sort of journey into the peasant character.

Neither Iakushkin nor Maksimov ventured beyond the spare and functional in their landscape descriptions. Both mainly confined their portrayal of nature to a few adjectives like "beautiful" or "boring," and they tended to emphasize the severity of the Russian climate as an indication of the perseverance of its inhabitants.[50] From the perspective they shared with Chernyshevskii, there was no need to distinguish Russia from other places on the basis of its natural terrain. Nature contained no potentially transformative significance, as it had in the work of such writers as Gogol, Tiutchev, Turgenev, Aksakov, etc. For the progressive and protopopulist writers of this era, appeal to the peculiar

beauty of the Russian landscape was nothing more than a misleading mystification of reality. Bazarov, the nihilist hero of Turgenev's *Fathers and Sons*, exemplifies this indifference to the beauty of the natural environment in his exclusively scientific interest in the natural world, or even in his tendency to "break off twigs" as he walks through the forest. "Nature," he says to his would-be protege Arkadii (an Arcadian against his own inclinations), "is nonsense in the sense you understand it. Nature's not a temple, but a workshop, and man's the workman in it."[51] One might note that Bazarov was embraced by another radical critic, Dmitrii Pisarev, who affirmed in the conclusion to his article on Turgenev's famous character, "we must not dream about orange trees and palms, when under foot are snowdrifts and cold tundra."[52]

Other travel writers followed the example of Iakushkin and Maksimov and began to focus primarily on the difficulties of life in the provinces. Much of Vasilii Sleptsov's *Vladimirka and Kliazma* (1861), for example, described the lives of peasants in provincial factories.[53] A. Tarachkov's *Travel Notes in Orel and Its Surrounding Provinces* (1862) was filled with practical suggestions for the improvement of rural conditions. His landscape consisted mainly of poor roads and bad weather. He concluded his travelogue with an unintentionally comic appeal to educate the peasants in natural history so they would understand that "everything existing in nature is directed by eternal and unchanging laws."[54]

This rejection of landscape imagery resulted from the embrace of new ideals. The radicals of the 1860s (still more so in the 1870s) looked to the rural population as an embodiment of Russianness and as the site of their aspirations for a bright Russian future. "Whenever educated Russia set out to investigate the *narod*," Cathy Frierson has written, "they were also invariably engaged in the process of national self-definition."[55] A. A. Molchanov's travelogue *Around Russia* (1876), written once the Russian populists had fully embraced the ideal of serving and learning from the *narod*, provides a clear demonstration of the tendency to denigrate the landscape in order to celebrate the people. Recalling a trip on the Volga, Molchanov refers to the scenery as "dirty," "gray," and "tiresome." He counters this image of the landscape, however, by arguing that the region's history and people make it "rich with inner life."[56]

In a more refined version of "going to the people," Molchanov presented a plan to rent a Volga steamer with room for five hundred people (by his calculation at 100 rubles a head) in order to acquaint urban Russians with the provinces along the river. He proposed using the services of a staff that would include ethnographers, botanists, and even an orchestra![57] Molchanov based his travelogue on the populist conviction that educated Russia should study the sufferings of the peasants in order to learn from their capacity to overcome adversity. For

Molchanov the gloom of the countryside directly contrasted to the brilliance of the people. The tougher the climate and the bleaker the landscape, the more impressive were the people who inhabited it. The character of the impoverished peasant could be considered one of Russia's national advantages: "Homeless people, who in foreign countries hide themselves from the eyes of the tourist on distant side streets, in Russia always present themselves as the liveliest people on the road."[58] This vision of the countryside established an alternative image of Russian space. The bleak nature of provincial Russia accentuated and reflected the noble suffering of the peasants.

BITTERSWEET SCENERY

Not every reform-era Russian, of course, was wholly devoted to an interest in the Russian peasant. A melancholy landscape could also serve as a metaphor for misery in the lives of elites. The poet Nikolai Ogarev, like his friend Alexander Herzen a radical Westernizer, began as early as the 1830s to depict Russian nature as a dreary reflection of the inner state of his country. His poem "Travel Impressions" (1839) equates the natural landscape with the social landscape:

> The moon shines pallidly through a smoky cloud,
> Shines on the white field;
> Cold is the flying air, cold the land,
> The snow holds it in slavery.
>
> How sad to me this pale land! There's no life in it,
> Everything in it is frozen,
> Oh what cold people in it! and no life in them,
> Their hearts have frozen.[59]

The harsh winter landscape of Russia here reflects Ogarev's personal disappointments and political bitterness. While Ogarev did write some poetry—notably the long poem "The Village" [*Derevnia*] (1847)—that paralleled Grigorovich's use of landscape as a reflection of peasant suffering, he typically used nature imagery to express moods characteristic of educated urbanites. His Russian landscapes evoked a bleak and melancholy terrain, but he deployed that vision of the national terrain both as praise and as criticism. "In the Misty and Sad North" (1842) makes the sort of comparison already noted between northern and southern landscape. In this case Ogarev abuses Russia by contrast to Italy. But in the final stanza he reverses himself and rejects southern Europe in favor of his native climate: "I wander through Italy and again I grieve / I want to go back to my snows / To hear the sad native song . . . / And [to see] the gray sky

through a half-frozen window."⁶⁰ For Ogarev, Russia's mournful landscape contained something bittersweet and nostalgic. On a less grandiose scale than in Tiutchev or Gogol, this poem expresses the idea that Russia's cold and gray terrain could be understood as one of the country's positive distinguishing features.

Ogarev was a source for Turgenev's character Lavretskii in the novel *A Nest of Gentry* (1858). Turgenev emphasized the image of a meager, but admirable, Russian countryside in his description of Lavretskii's return to provincial Russia from years spent abroad in Europe. Traveling home through the countryside in his carriage, Lavretskii begins to revive his attachment to his childhood haunts: "As he gazed, the fresh, fertile, remote solitude of this steppe wilderness, the verdure, the rolling slopes, the valleys filled with stunted oak bushes, the gray little villages, the scant birch trees—the entire Russian landscape, which he hadn't seen for so long, stirred emotions that were gratifying yet almost painful to his heart at the same time."⁶¹ Shortly thereafter, Lavretskii admonishes himself to "be sobered by the monotony of life here." As he attains a new purchase on life in this unspectacular environment he also develops a new admiration for Russia: "Sorrow over the past was melting in his soul like snow in the spring, and—strangely enough—never before had feelings for his native land coursed through him so deeply and strongly."⁶² Turgenev had avoided this kind of bleak imagery in his *Notes of a Hunter* some ten years earlier, but subsequently he seems to have incorporated it into his own conception of the national terrain. Several years later, in a letter of 1876 to Gustave Flaubert, he wrote from Russia, "I find with regard to the color of the landscape that everything here is pale—the sky, the vegetation, the earth; true, this pallor is warm and golden—it would be that much sweeter, if the wide lines and endless monotonous expanse did not impart to it a sort of grandeur."⁶³

Nowhere was the sentiment of bittersweet admiration for the bleak Russian landscape expressed more clearly than in the poem "Native Land" [*Otchizna*] (1862) by A. N. Pleshcheev. This poem can be read almost as a compendium of approaches to the national landscape that had been created during the previous twenty years:

> Scanty nature of my native land, you are dear to my sad soul! Formerly, in the days of my fleeting spring, the distant shores of other countries enticed me.
> And my glowing imagination painted brilliant pictures before me: I saw the transparently blue vault of the heavens, and the crenelated summits of mighty mountains.
> Merged in the gold of midday beams, it seemed to me, the myrtle, the planes, and the olive trees called me into the shade of spreading branches, and roses beckoned silently to me—

Those were days when my spirit did not ponder, among the seductions of life, over the aims of existence, and, being frivolous, I only demanded enjoyment from it.

But that time speedily disappeared without a trace,—and grief unexpectedly visited me, and much with which my soul was not familiar suddenly became dear to it.

I then abandoned my secret dream of a magic and distant land,—and in my country I discovered beauties invisible to the worldly eye.

Furrowed fields, ears of yellow grain-fields, the speechless, majestic expanse of the steppes, the freshets of broad rivers in the spring, mysteriously rustling oak-forests;

Sacred silence of poor villages, where the laborer, oppressed by misery, prayed to heaven for a new, a better day,—the great day of liberty, to rise over him;

I understood you then,—and near to my heart suddenly grew the song of my native land, whether in that song was heard deep pining or unrestrained hilarity.

My country, nothing in thee captivates the stranger's eye; but thou art dear by thy stern beauty to him who himself has yearned for freedom and the wide expanse, and whose spirit has borne oppressive fetters.[64]

Pleshcheev's "Native Land" brings together many strands of the developing image of the national landscape. The one clearly new idea here, a yearning for *prostor* based on a shared sense of oppression, may intentionally recall Pleshcheev's personal experiences: along with the more famous Dostoevsky, Pleshcheev was arrested for involvement with the Fourierist Petrashevskii Circle and brought to the brink of execution before being exiled to Siberia. Invoking the absence of freedom as an experience that teaches love of open space, both for himself and for the Russian peasant, Pleshcheev managed to claim a sympathy of interest with the *narod*.

In other respects, Pleshcheev sounded a series of notes familiar from earlier writers. Like Pushkin in *Eugene Onegin,* he had to learn to admire his own landscape by maturing into the acceptance of a quieter form of picturesque scenery from the devotion to spectacular southern landscape he had first found appealing. Like Tiutchev he argued that Russian nature could not be understood by "worldly" foreigners but was a peculiarly national predilection. Like Lermontov and Gogol he was attracted to the enormousness of the steppes, forests, and rivers and learned to love the Russian landscape on a nostalgic and spiritual, rather than a simple aesthetic, level. Like Grigorovich and the Russian populists he had learned to admire the village as a site of noble endurance amid hardship. By uniting these separate visions of Russian national space in 1862, Pleshcheev's "Native Land" consolidated them

into a settled aggregate. A similar sort of consolidation process went on in the work of two other writers, both of whom had gentry roots: Mikhail Saltykov-Shchedrin and Nikolai Nekrasov.

SALTYKOV-SHCHEDRIN: GLIMPSES THROUGH A VEIL OF MISERY

As is evident from the passage cited above, Saltykov-Shchedrin was never convinced by any of the nostalgic idealizations of the countryside in which many of his contemporaries indulged. Russia's premier satirist of the second half of the century, Saltykov subjected provincial Russia to merciless ridicule in his parodies of the rural gentry. Although never entirely at one with the materialist idealism of the radical critics, he was a major contributor to and supporter of social criticism from the left. As such he was perhaps the single most vehement critic of the nostalgic gentry landscape.

Saltykov's condemnation of Russian life accorded respect to the peasant. One of the bases of this respect was his conviction that peasants were more closely connected to nature than were other Russians. Like Belinskii and Grigorovich, he admired Kol'tsov as a representative of this supposed intrinsic bond between unprivileged rural Russians and their natural surroundings. In an 1856 review of Kol'tsov's poetry, Saltykov argued that Kol'tsov understood better than any other Russian writer the deep connection between the peasants and their environment. This review of Kol'tsov's work foreshadowed the direction Saltykov was to take in his own depiction of nature. It explicitly placed Kol'tsov's nature description above that of Sergei Aksakov because Kol'tsov focused on the rural laborer and tried to convey the difficult conditions of peasant life: "Along with serene pictures of rural nature and life he evokes other pictures, in which this same rural life appears in less attractive forms. . . . In general they show that the life of the villager has its own sort of alarms and anxieties, although perhaps they will not catch the eye of any passing tourist."[65]

In his memoirs, Saltykov separated himself from the kind of unadulterated love of nature that characterized Aksakov's image of a gentry childhood. He confessed that he read *The Childhood Years of Bagrov the Grandson* with envy because he himself had never experienced a similarly warm attachment to his own native surroundings. He describes his native region as "dark and mute" and admits that his experiences out of doors came haphazardly and left him uninspired.[66] Saltykov's landscape imagery, whether in winter or summer, is almost always gray and lifeless, and he put to work an uninspiring landscape as part of his satirical attack on life in the provinces. Descriptions of a bleak and leaden terrain often reflected the dulled feelings of the provincial landowners he criticized. Yet if the Russian countryside appeared a

cruel and unattractive place in Saltykov's satires, he also worked to reveal certain redeeming features of this dismal space.

Nowhere is Saltykov's landscape bleaker than in his most famous (and also most dreary and tragic) novel *The Golovyov Family* (1875–1880). Charles Moser has pointed out that the novel reads as a sort of polemical response to Aksakov's characterization of the gentry estate.[67] Indeed, it is an anti-idyll of the most extreme kind. It places the reader in the position of witness to the slow and agonizing death of a provincial gentry family, the implication being that the Golovyov family represents the death of the Russian gentry as a whole. Nature in this novel constantly reminds the reader of death. More than once the snowy terrain is described as a "shroud." The autumn landscape gives rise in one of the characters to an obsessive sensation of being trapped inside a coffin. Not surprisingly, most of the nature description depicts fall and winter, but even the summer landscape is portrayed as morbid and infernal: "It was a hot midday in July. At the Dubrovna estate it was as though all life had ceased. . . . Even the trees stood there subdued and motionless, seemingly in anguish. . . . The earth, covered with short, scorched grass, was aflame."[68]

Georges Nivat saw Saltykov's landscape as a parodic counterimage to that of the dominant idealization of Russian landscape by such writers as Aksakov and Turgenev.[69] This argument works perfectly for the landscape in *The Golovyov Family*, but it does not apply to some other nature description in Saltykov's ouevre. To begin with, Saltykov did not use this vision of a gray and desolate countryside only to condemn rural Russia. At least in his early years, rural Russia could inspire national pride. In his first major work, *Provincial Sketches* (1856–1857), he made this explicit:

> I love this impoverished nature, maybe because no matter what it is, it still belongs to me. It has grown acquainted with me just as I have made friends with it. It nurtured my youth and was witness to the first tremblings of my heart, and from that time the best part of myself belonged to it. Carry me away to Switzerland, Italy, or Brazil, surround me with any kind of luxuriant nature, toss over this nature any kind of transparent, deep blue sky, everywhere I will still find dearest to me the gray tones of my homeland because everywhere and always I carry them in my heart, because my soul guards them as its most cherished domain.[70]

In a more practical and psychological manner than Tiutchev or Gogol, Saltykov expressed here the idea that the Russian landscape contains inner richness despite its outward poverty.

How does one align the two separate sides of Saltykov's response to Russian space? As suggested by his admiration for Kol'tsov, the Russian

people provided the key to Saltykov's sense of his native landscape. The *narod* made the hidden richness of the countryside a potential reality. In the introduction to *Provincial Sketches,* Saltykov points out what he considers to be the noteworthy sites along the Russian road: "Before your eyes stretch out the boundless fields, fringed by forests which seem to have no end . . . the land, the land! such free, open space here [*razdol'e*] for the toiler on the land! It seems he would live and die here, carefree and lazy in this profound quiet."[71] Although this statement is tinged with Saltykov's mordant sense of humor, when connected to the peasants, Saltykov's depictions of Russian nature always contain an optimism and promise generally absent elsewhere in his work.

The first chapter of the story "Quiet Refuge" includes what may be Saltykov's most extended piece of landscape description, a meditation on the appearance and meaning of the Russian countryside.[72] For the story's urban traveler, first met riding through rural Russia, the road is "empty" and "excruciating." It inspires in him nothing more than a strong desire to reach the city: "How unwelcoming you look, native plain! You do not gladden nor comfort the weary traveler." From the traveler's perspective the landscape appears "impoverished," "sickly," "pale green," "exhausted," "forgotten," and "unsheltering." Only rarely and for a short time does it brighten amid "the general boredom and poverty."[73] Having entirely derided the landscape from the traveler's point of view, however, Saltykov proceeds to contrast this urban perspective with the perspective of the countryside's peasant inhabitants: "But easygoing and agreeable is the native citizen of this monotonous plain, the Russian muzhik! No matter how poorly endowed, no matter how inhospitable the surrounding nature, he resigns himself to it without complaint."[74] The peasant's difficult fate as a laborer on this soil harmonizes him with the desolate surroundings, each ennobling the other with the mark of tragic endurance and suffering.

But Saltykov was of course writing for a literate, urban audience, and he sought to make this desolate landscape meaningful to his own social milieu as well. For the urban traveler looking out on a view of the Russian countryside the scene is not exactly beautiful. It does suggest, however, a kind of sublimity not far removed from the metaphysical magnificence Gogol imparted to the landscape in *Dead Souls* with his evocation of its ghosts of "legendary heroes" and its "infinity of space":

> The picture is severe and unvaried, but it also strikes the viewer with the magnificence of its simplicity. It is generally noted that severe tones produce a livelier impression on the soul. Seeing this open space [*prostor*], seeing this poetic strength, at one and the same time destroying and

creating, a man feels sobered, feels how there rises and grows within his entire being his passionate impulse for the wide and free spaces [*shirokoe razdol'e*], which has slept at the bottom of his soul, held down by the laboriousness of life's petty cares.[75]

Saltykov transforms "simplicity" into "magnificence" in this landscape. He uses the idea of *razdol'e* to convey the sensation of being swept away from the cares of everyday life into a world of elemental forces. Both the simplicity and the openness of the Russian countryside inspire a sense of awe reminiscent of romantic reactions to the Alps. In other words, Saltykov here draws on the aesthetic of the sublime, applying it to Russia's great expanse of level space.

In contrast to the romantic's universal longing for the infinite, the celebration of these open spaces is bound up in distinctly Russian concerns. In the context of the story this is not an individualistic, romantic removal from daily life. The main character, Verigin, is searching for a way to attain "social harmony." Like many of Saltykov's contemporaries in the 1860s and 1870s, Verigin wants to overcome Russia's extreme social stratification that renders peasants the inhabitants of a gloomy countryside and city-dwellers their removed onlookers. In the context of this story, the "passionate impulse," stimulated by observing the vast terrain, cannot be understood as an individual impulse to escape everyday reality. It is the potentially revolutionary social impulse of a disconnected urbanite wishing to be reunited with the inhabitants of a neglected rural sphere.

NIKOLAI NEKRASOV: LAYERS OF COUNTRY LIFE

Nikolai Nekrasov's poetry espoused a similar mixture of resigned tolerance for the grim conditions in rural Russia and hope for resurrection of the nation's future based on the promise of the ennobled, suffering *narod*. As a result of his compassion for the peasants, a minor key tonality dominates Nekrasov's descriptions of the countryside. More often than not his songs to Russian nature resonate a sad and mournful quality. The opening couplet of the poem "Sasha" (1854) provides a good representative example of his response to rural Russia: "Like a mother over the grave of her son / The snipe moans over the sad plain."[76] But Nekrasov's poetic evocation of the Russian countryside was one of the most elaborate and extensive in the language. The minor key he always returned to formed the basis of an entire symphony to rural Russia, complete with departures into complex, multilayered figurations, which ranged across both major and minor tonalities. As a result of this complexity, Nekrasov created some of the most powerful and memorable nature description in nineteenth-century Russia.

Conflicting impulses lay at the basis of Nekrasov's landscape. One of his early critical essays celebrated Tiutchev precisely for the older poet's nature descriptions. Like Tiutchev, Nekrasov loved nature, and he was unable to ignore Tiutchev's work, as many of his contemporaries had. Even though Tiutchev was one of his ideological opponents, Nekrasov almost singlehandedly revived Tiutchev's career with a critical appraisal of his poetic gift. "The most difficult kind of poetry," Nekrasov wrote in defense of Tiutchev, "is the landscape in verse."[77] He admired Tiutchev's straightforward, gemlike images of nature. But unlike Tiutchev, Nekrasov never showed any powerful attachment to foreign scenery. He took for his subject primarily the central Russian landscape in which he had been raised. At times Nekrasov's overt love of Russian landscape equalled Tiutchev's habitual distaste for it. "Oh, Mother Russia," wrote Nekrasov about returning from a trip to Europe, "you welcome your son / So tenderly it makes my head spin!"[78]

Nekrasov's admiration for the beauty of "Mother Russia" never prevented him from seeing in this sometimes gentle landscape a cruel and brutally unjust rural society. As a Russian landowner he felt complicit in this brutality and hated his own upbringing. In stark contrast to the nostalgic reminiscences of some of his contemporaries he wrote with satisfaction about the deterioration of his own inherited estate. His poem "Homeland" [*Rodina*] (1846) was published five years after Lermontov's poem "Native Land" [*Rodina*] of the same title, but it approaches the nation on entirely different terms. The difference in translation is intentional. Nekrasov's *"Rodina"* referred to his own family estate rather than the entire homeland of the nation, and yet the implicit metonymy of the title allowed him to subject the whole country to the harsh criticism he had for his own estate. *"Rodina"* managed to imply a metaphorical comparison between the state and the institution of serfdom, reminding readers of the literal power structures of Russian society in which they participated.

The poem "Silence" (1857) was written during the short-lived period of left-wing optimism that lasted from Alexander II's accession to the throne to the disillusionment that arose around the abolition of serfdom. Again describing a return home from abroad, it is full of admiring images of specifically Russian landscape features such as "the level tablecloth of the meadows," "green walls of thick birches," and "the quiet of a little village." As many Russian writers before him, Nekrasov contrasts the environment of southern Europe to that of Russia, and places Russia at a higher level, at least as experienced by Russians themselves. Characteristically for Nekrasov's nature description, however, presiding over the entire landscape is a powerful, and in its own right nostalgic and nationally distinctive, Russian misery. The first stanza sets the tone:

> Rye all around, like the living steppe,
> Neither castles, nor seas, nor mountains . . .
> Thank you, native region,
> For your healing open space! [*prostor*]
> Beyond the far Mediterranean,
> Beneath skies brighter than yours,
> I sought reconciliation with my grief,
> And I found none at all!

And further:

> No matter how warm the foreign seas,
> No matter how beautiful the foreign views,
> It is not for them to heal our wounds,
> To open up our Russian sadness—

At first this evocation of sadness will seem personal, then generally national, but by the end of "Silence" one discovers its origins in a different source. Describing the misery of the Crimean War that had recently concluded, Nekrasov comingles the grief experienced by peasant families with the physical landscape itself: "Russian path, familiar path! / Flattened to the earth with the tears / Of the recruits' wives and mothers." The grievous condition of Russian space results from the constant hardship of the peasant soldier and laborer, who, as Nekrasov puts it at the end of the poem, "lives without enjoyment" and "dies without complaint."[79]

Much of Nekrasov's nature description is built around a tension between the poet's enjoyment of the special beauty and peace of the landscape and his outrage over the social injustice that occupies the same space. One might say he took the cognitive dissonance of Pushkin's "Countryside" and transformed it into one of the foundations of his poetry. Nekrasov's landscape maintains a multiple, or layered, quality. It can rapidly shift from enjoyment and beauty to gloom and misery and back again. In many of Nekrasov's poems nature will appear in different lights according to the perceiving eye. "On the Volga" (1860) provides a good example of this shifting perspective. It begins with pleasant reflections of an idyllic gentry childhood spent on the river, not dissimilar from Karamzin's and Dmitriev's response to the Volga some seventy years earlier. But the last stanzas introduce a sudden reversal when the child's pastoral world is torn away by an encounter with the conditions of life among the Volga barge haulers. Nostalgic and idyllic space undergoes a sudden metamorphosis into "the river of slavery and grief." In a very different way from the Volga's earlier admirers, Nekrasov's Volga represents a compendium of Russian life, from the pleasant gentry

childhood to the harsh exploitation of the lower classes. This is not the same national symbol the sentimental poets had in mind.[80]

Another poem that exhibits similar layers of natural beauty and social misery reverses the order of "On the Volga." The above-mentioned poem "Sasha" begins with a resolute acceptance of the melancholy face of the landscape—its "miserable fields" that create "the unhappy, native picture." The mournful tone of the first section is broken by the introduction of the character Sasha, an innocent sixteen-year-old girl connected to the surrounding countryside through a deep personal attachment to her native environment. Sasha knows all the vegetation in the surrounding fields by name. In her presence the countryside appears peaceful, beautiful, and benevolent. When she makes an appearance "nature rejoices." Nekrasov demonstrates Sasha's closeness to nature in a passage that describes her sympathy for the trees and animals as the neighboring forest is cut down. In contrast to Sasha stands the Europeanized landlord Agarin, a sophisticate who admires the "freedom, luxury, and wonder" of Europe but remains unmoved by the nature of his native surroundings. Agarin represents the corrupted older generation, whereas Sasha foreshadows a bright future for Russia's youth. Her attachment to the land points to the superiority of the peasant understanding of Russia.[81]

Nekrasov's peasants often demonstrate a profound identification with nature. In "Peasant Children" (1861), the gentry narrator encounters a group of children who exhibit a spontaneity and joie de vivre he respects and tries to learn from. While "Peasant Children" is one of Nekrasov's most joyful poems, still he rarely managed to convey an unambiguous portrait of the countryside, and the conclusion contains one of his more wrenching images. In the depths of winter, the narrator runs across a six-year-old peasant boy at work in a forest. The child casually refers to himself as a grown laborer. His plight, as well as his strength of character, gives rise to a meditation that tells us a good deal about the way Nekrasov tried to negotiate his simultaneous contempt for and love for his native land:

> The sledge, the brushwood, and the piebald horse,
> The snow, piled high as a hut's window,
> The cold fire of the winter sun,
> It was all so purely Russian,
> With that mark of barren, desolate winter,
> That is so agonizingly dear to the Russian soul,
> That Russian thought imprints on the mind,
> The noble Russian thought, which is unfree
> Which—whether wanted or not—cannot die,
> In which there is so much resentment and anguish,
> In which there is so much love.[82]

As a result of his sympathy for the *narod*, Nekrasov conceived of the Russian countryside as essentially desolate and cruel. Yet it was precisely in relation to this harsh image of the landscape that the noble, long-suffering, Russian soul found itself in its most characteristic condition. Out of the empathetic capacity of educated Russians to suffer along with the impoverished peasants, a form of national identity emerged that linked the people and those who sympathized with them into a unified whole of sacrifice, anguish, and love.

Nekrasov's long poem, "Who Can Be Happy and Free in Russia?" (1876), in the words of one scholar "the sum and synthesis of Nekrasov's creative works," also exposed the harsh conditions of life in reform-era Russia.[83] In line with Nekrasov's other work, it juxtaposes the sins of educated society with the strengths of the people. The apparently self-contradictory final lines of the song *"Rus'"* at the end of the poem remind us of Russia's intractable contradictions and, as so often before, launch us into a reverie on the mystery of Russia:

> You are wretched
> You are abundant
> You are downtrodden
> You are all-powerful
> Mother Russia.[84]

Although Nekrasov's closeness to the camp of radical materialists in the 1850s and 1860s placed him far from Tiutchev's Slavophile conservatism, the similarity of their interpretations of the Russian countryside cannot be overlooked. Tiutchev's Orthodox faith led him to see the Russian countryside as meek and miserable but touched by the hand of God. Gogol, Sollogub, and Saltykov-Shchedrin, also widely varying in their politics, all connected the barren landscape to the presence of some metaphysical, transformative force. Nekrasov, connected to Russian populism, viewed the rural landscape as downtrodden and miserable, but he found in it a connection between the melancholy surroundings and the suffering people. This relationship suggested a union of transcendant national potential.

How did the landscapes of such widely different writers come to be so closely connected? Despite ideological differences, every one of these writers at various points explicitly asserted his vision of the Russian landscape in terms of a contrast between Russia and western Europe. No matter what his political leaning, each used the landscape to affirm a certain Russian exceptionalism. It is customary to discount the influence of nationalism in this era, since other more overt ideological battles had begun to heat up by midcentury. Nationalism proper was certainly the province of conservative late Slavophiles and Pan-Slavs during the latter half of the nineteenth century. But the search for an

acceptable national identity affected Russians of every political inclination. Anguished searches for an affirmation of the national character, dissatisfaction with the comparative shortcomings of Russian life, and grandiose invocations of intangible qualities like the Russian soul and the bright Russian future touched the lives of almost every literate Russian, regardless of ideology or personal belief. The search for a viable nationality formed an underlying intellectual and emotional substratum in Russian cultural life. With respect to the landscape, the notion that outer poverty was equivalent to inner richness, that outer gloom betokened inner glory, proved an irresistible idea. For all of the writers discussed in this chapter, this paradoxical image made it possible in a single stroke to surmount the nagging question of Russia's second-rate status and to affirm the comforting view of Russia as a unique entity that could not and should not be subjected to standards formulated in the West.

CHAPTER FIVE

To Paint the Russian Landscape

> Give me a muddy pool as long as it has truth and poetry in it.
> —Pavel Tret'iakov[1]

At the turn of the nineteenth century, literary images of Russian landscape rarely surpassed the level of hackneyed idylls or one-among-many evocations of northern European terrain. By midcentury—in literature, criticism, and travel writing—Russian landscape imagery had developed a variety of distinct, aesthetically admirable, and nationally representative forms. In painting, on the other hand, new aesthetic approaches to the depiction of Russian landscape scarcely registered until the 1850s. Even then it took several years for artists to develop a means, and even a reason, to paint the Russian countryside.

This lag between literature and art resulted in part from the social position of the artist in Imperial Russia. Unlike the writing of fictional literature, which was seen as a suitable activity for well-educated Russians, painting never really achieved the status of a socially respectable art form before the middle of the century. During the late eighteenth and early nineteenth centuries, in fact, some of the best painters in Russia were serfs who had received training under the auspices of their gentry owners and were employed by them to lend beauty and prestige to their estates.

Some change in the conditions for artistic production had begun as early as the eighteenth century. The Imperial Academy of Arts had been established by Catherine the Great in 1764. In many cases this venue did provide a means of social advancement for artists, but during the reign of Nicholas I (1825–1855), the academy, in the words of one historian, "was transformed into an instrument that molded artists into servitors of the state, subordinated art to the needs and tastes of the court, and controlled artistic life throughout the country."[2] In spite of strict censorship during this period, Russian writers managed to attain a degree of freedom and experimentation, while

in the plastic arts self-expression was subject to severe restrictions. A conservative, neoclassical standard remained the prescribed mode of artistic expression throughout the first half of the century.

Perhaps in part as a way to escape this stultifying environment, some painters moved far away from it physically. The Russian vogue for Italy that had been most notable during the 1820s remained a dominant trend among landscape painters throughout the first half of the century. Russia possessed talented landscapists as early as the late eighteenth century. Many of them lived and painted abroad and sent home beautiful, sunny, often panoramic, works of art. Silvestr Shchedrin's majestic and inviting coastline, or Mikhail Lebedev's serene, sun-dappled alleyways, offered Russian viewers and collectors glimpses of an idyllic present on the shores of the Mediterranean. While these painters were influenced by the nascent naturalism common to the romantic era, their work remained fairly traditional, especially by comparison to such French contemporaries as Corot and Rousseau.[3]

In the 1850s, however, several landscape painters—chief among them Baron Mikhail Klodt (1833–1902), Lev Kamenev (1833–1886), Aleksei Savrasov (1830–1897), Ivan Shishkin (1832–1898), Fedor Vasil'ev (1850–1873), Petr Sukhodol'skii (1835–1903), and Vladimir Orlovskii (1842–1914)—began to develop a new approach to Russian landscape similar to that which had been carried out in Russian letters. These artists worked to establish in the visual arts a new way of seeing and depicting their native surroundings. They struggled to find a way to paint the Russian landscape. But why "struggled"? Why not simply paint what they saw before them? In practice, to paint Russia's natural environment meant to negotiate a visual compromise between the appearance of Russian space and the demands of conventional, "painterly" representations of nature. These artists could not simply and easily forget the traditions they had incorporated and techniques they had learned. Neither could they ignore the impact of recent literary reconceptualizations of Russian nature that had cast their native environment in a new and distinctive light.

All of these painters began their careers in (or closely connected to) the strictly regulated creative environment of the Imperial Academy of Arts. It was within this context that they first forged an aesthetic image of their native land. From roughly the late 1850s to the early 1870s, collectively they succeeded in establishing a new visual image of rural Russia. Through their innovations in painting they became some of the most important contributors to the creation and dissemination of a national image of the Russian land. The following two chapters will explore the origins and significance of landscape painting in Russia. The present chapter examines the technical and aesthetic development

of the new landscape imagery, and the next chapter will analyze the relationship between landscape painting and national identity during the late nineteenth century.

THE PROBLEM OF REALISM IN ART

Like other artists of their generation, the landscape painters considered themselves to be realists, and they have been designated as such by future generations of critics and art historians. The term makes sense according to their own stated aims. Above all, they strove to present an accurate reflection of the world around them. One of the leaders of realist painting in Russia, G. G. Miasoedov, attributed the success of Russian realism to the painters' ability to create a "truthful" depiction of Russian life once they had "resolved to express only that which was near and dear to them."[4] High-minded aspirations to portray the world truthfully were, of course, common to all forms of realism in nineteenth-century Europe. Such statements as Miasoedov's say little about what sort of paintings these particular realists produced. Even in such a medium as photography, the composition, the technique, and the choice of subject matter transform "real" reflections of the world into a universe of expressive possibility. Realism can refer to a wide variety of different styles and subject matter, from seemingly objective and dispassionate representations of inconsequential moments in time to grandiose sympathetic evocations of misery and impoverishment. Realism encompasses ennobled historical themes as much as squalid scenes of contemporary street life. Perhaps the only constant in realist art beyond a certain verisimilitude was its self-conception as a counterpoint to existing aesthetic standards. It based its claim to represent the "objective truth" on the *unreality* of other artistic models such as those of the academy or later the avant-garde.[5]

Russian realist landscape painters often produced nearly photographic likenesses of rural Russia. But the lifelike quality of these paintings should be understood as a means to an end rather than an end in itself. In the same statement cited above, in which Miasoedov celebrates the realists for the authenticity of their work, he also credits realist landscape painting for having surpassed mere faithful representation. According to Miasoedov, Russian realism strove "to convey not only the exterior of nature, but also its life and mood."[6] As for the realist landscape painters, they certainly intended to convey much more than a drily accurate reflection of the Russian countryside. What merits scrutiny is why these painters chose to depict the specific images they created, how they went about making their paintings worth the attention of their public, and why Russians came to admire them as important works of art.

The late Soviet art historian Faina Mal'tseva has written the only comprehensive study of the development of realist landscape painting. Her two-volume *Masters of Russian Realist Landscape* remains the only full-length scholarly study of the subject.[7] At the time of publication under Stalin, any historical subject had to be treated carefully to insure that it would conform to the proper Soviet values. Mal'tseva's theoretical framework follows a Leninist reading of Russian history: after the emancipation, Russia's progressive elements were called upon to espouse revolutionary ideology. As the sole representatives of the Russian people (who were not themselves in a position to wage their own ideological battles after centuries under the yoke of serfdom), this task fell to the enlightened intelligentsia. The progressive wing of painters in late-nineteenth-century Russia acquired the name *Peredvizhniki*—in English usually "The Itinerants" or "The Wanderers"—for their exhibiting association, which traveled between different Russian cities. In Mal'tseva's view, these painters, including landscape painters, became the historical representatives in the visual arts of the anti-autocratic and "democratic" movements in nineteenth-century Russia.

Like other Soviet art historians, Mal'tseva stressed the formative influence of progressive critics like Chernyshevskii or Vladimir Stasov on all Russian realist painting. She credits radical criticism in large measure for the socially engaged nature of the realist's work. From this point of view, landscape painters supported the struggle for democratic goals. They strove to provide Russian society with a view of the countryside independent of government authority or the conservative tastes of gentry collectors. Their images helped the urban public sympathize with the plight of the rural population. Thus landscape paintings were supposed to have been focused first and foremost on the Russian peasant. They either expressed "such motifs in nature as allowed artists in their own idiom to describe the people's sadness," or showed "the power and fertility of Russian nature as a source of the possible richness and happiness of peasant life."[8] In order to make this claim appear reasonable, Mal'tseva had to ignore certain salient points about the paintings themselves. Most conspicuously, the majority of landscape paintings at the Peredvizhniki exhibitions did not include peasant figures, nor did they often portray the places where peasants lived and worked, such as villages and grain fields.

The interpretation of landscape painters as representatives of progressive values is therefore deeply problematic. If other genres, beginning in the 1860s, sometimes expressed points of view that criticized the autocracy and the injustices of Russian society, landscape painting was certainly the least effective and least demonstrative in this endeavor. It was also the most open to interpretation. Probably in part because of its very indeterminacy, it sold well to collectors, and it became

the best represented genre at the Peredvizhniki exhibits. For these reasons, as Elizabeth Valkenier has pointed out, "landscape as subject-matter neatly demonstrates how complicated it is to disentangle the component strands of *Peredvizhnichestvo* [The Wanderer movement]."[9]

Several developments took place that paved the way for the appearance of realist nature imagery in Russia. First and foremost, the literary aestheticization of Russian landscape established the idea that rural Russia possessed its own unique beauty. The different textual images of the countryside devised by Pushkin, Gogol, Aksakov, Turgenev, Nekrasov, and others generally emerged from literature that either styled itself as realism or had been designated as its immediate forerunner by sympathetic critics. Literary landscapes supplied a variety of models for Russian landscape painters to follow. Next, a new painterly naturalism, developed in Europe, penetrated Russian art galleries during the first half of the nineteenth century. Finally, the political liberalization surrounding the abolition of serfdom in 1861 created an environment conducive to innovation in all spheres of social and cultural life. Consequently, as early as the 1840s an interest in specifically Russian terrain began to be espoused by certain art critics and collectors.

LANDSCAPE AND THE RUSSIAN ART WORLD AT MIDCENTURY

One of the first essential steps toward a Russian landscape aesthetic in painting was taken by the literary critic Valerian Maikov, a young contemporary of Belinskii's. Maikov began to pay attention to landscape painting as early as 1846. In that year he wrote an admiring review of the illustrations for Gogol's *Dead Souls,* done by A. A. Agin. Maikov's article took the disdain for spectacular imagery that was being espoused as a new sign of nationality in Russian literature and proposed it as the basis for the re-creation of Russian visual art:

> A truthful expression of unsmiling, monotonous, and cold Russian nature directly contradicts the conventions of stylized drawing to which our artists are so susceptible, and which depends more on the effect of their work than on deep thought. All the *tableaux de genre,* whose subjects have been taken from Russian daily life (and there aren't many of them by the way), run counter to truthfulness precisely because outward effects are most precious to them. Our artists not only use powers of expression that are uncharacteristic of Russia . . . but they spoil things in the tiniest details with the wish to impart a brightness and shine to a nature that is dark. They forget they could reorient and enliven their drawings with a strict expression of these disadvantageous characteristics of the nature they have chosen, considering that this gray, dull nature is expressed in the physiognomy of its inhabitants.[10]

Perhaps for the first time in this passage, an art critic expounded the familiar antithesis between Russia's nautral surroundings and outwardly beautiful landscape imagery. Like a number of the writers already considered, Maikov felt that externally beautiful imagery ("effects," in his term) was dishonest and counterproductive for Russian art. Artists needed to reconcile themselves to the fact of Russia's unspectacular, perhaps even unattractive, appearance and simply reproduce it accurately on their canvases. Moreover, Maikov's final statement about the relationship between the "dark" nature of the Russian countryside and the physical characteristics of the peasants would become a commonplace among radical writers and critics by the late 1850s.

Not unrelatedly, Maikov was also one of the earliest Russian critics to focus his attention on the Swiss landscape painter Alexandre Calame. Calame's work gained a wide following in Russia during the 1840s and 1850s. Although Calame went through several different stylistic stages as a painter, it seems to have been his simple, straightforward depictions of nature in the Swiss Alps, which minimized compositional structuring or staginess, that drew Russian critics and artists to his work.[11] His apparent refutation of picturesqueness attracted the interest of Maikov as well as certain Russian landscape painters. One of Calame's paintings exhibited in 1846, that "impressed everybody" according to Maikov, seemed to convey an admiration of nature independent of conventional aesthetics: "It impresses . . . the viewer not so much by the richness of the chosen location, as by the soul of the artist, expressing his understanding of nature with his heart and the way his heart responds to its movement."[12] Calame's paintings, then, encouraged the hope that Russian painters would be able to create admirable landscapes from scenery that was not outwardly, or typically, beautiful. The beauty of a landscape depended on the painter's expressiveness and the viewer's sensitivity. The external form of the given location, from this perspective, held less significance.

Grigorii Sternin, a historian of the nineteenth-century Russian art world, has pointed out how important Calame was to Russian landscape painters in this period: "In Russian professional art circles [Calame] was usually held up as an example in cases where landscapists were called on to put an end to 'Italianism' and take motifs from their native nature."[13] In 1870, the painter Vladimir Orlovskii recalled the impact of Calame on the artists of the 1850s. He and others believed that the Swiss landscape painter "was the first to succeed in not idealizing nature."[14] So many Russian landscape painters began to imitate Calame, or at least appeared to imitate him, that a new verb "to Calamize"—"*okalamit'sia*"—was incorporated into the vocabulary of Russian art criticism in the 1850s and 1860s.[15] Calame's reputation

had grown so inflated in Russia by the early 1860s that one critic registered the following complaint: "Everybody bows to Calame, and practically prays to him; they go to him to study and don't recognize *anyone higher than Calame.*"[16]

Other artists were also important for the early development of Russian landscape painting. Many considered the German painter Andreas Achenbach a talent equal to Calame. One critic applauded his work in much the same language others had used to praise Calame:

> He never fantasizes; he's always true to nature. Achenbach doesn't even choose especially beautiful sites. But in these prosaic circumstances there is so much truth that the longer you look at the painting, the more nature comes to life before you. And it's possible to look for a long while at an Achenbach. His paintings don't wear you out the way you get worn out by paintings with strong effects, that might please you sometimes at first glance, but which never hold up under prolonged scrutiny.[17]

In addition to other German, Dutch, and Belgian painters, the French Barbizon school became widely known in Russia in the 1850s, particularly as a result of the collection of Count N. A. Kushelev-Bezborodko.[18] By midcentury this collector had amassed a large number of foreign works. The contemporary part of his collection contained landscapes by the best painters of the Barbizon school: Rousseau, Corot, Troyon, Daubigny, Millet, Dupré, and Diaz de la Peña. During Kushelev's life the collection was made available to art students at the Imperial Academy of Arts. At his death in 1863 it was transferred to the academy and put on display in 1866.[19] The Kushelev collection clearly had some influence on Russian landscape painting. In the late 1860s, the young landscape painter Fedor Vasil'ev, who had been unable to receive an education at the academy, included the collection among his most important influences: "My teacher Ivan Ivanovich Shishkin is superb; add to that the whole Kushelev Collection and, of course, the greatest teacher of all: nature, nature!"[20] One should be careful, however, not to overemphasize the influence of the Barbizon school. Russian landscape painters sometimes expressed a wariness about French art that contrasts sharply to their warm embrace of Calame and Achenbach.

While these various influences were coming to bear on Russian landscape painting, significant new developments were taking place in the rest of the Russian art world. In the 1850s, the art market began to undergo a period of rapid growth. According to one source, the number of galleries in St. Petersburg quadrupled in about twenty years from 19 in 1849 to 82 in 1871.[21] The writer Dmitrii Grigorovich (who, in addition to his sporadic literary activities, was also a patron

of the arts at the academy and the private St. Petersburg Society for the Encouragement of Artists) stated in 1863 that most Russian art collections were still full of foreign works, particularly when it came to landscape painting.[22] Already by 1863, however, there had begun to appear a new interest in collecting paintings of specifically Russian subjects. In the early 1860s, important critics and collectors started to call on Russian painters to turn their attention to local and topical issues and to establish a national school of Russian painting. At the same time a handful of painters had begun to take an interest in the familiar contemporary subjects around them.

The shifting tides in Russian art were related to larger changes taking place throughout Russia. As the rest of Russian society liberalized in the period surrounding the end of the Crimean War and the abolition of serfdom, artists too began to move beyond the conservative conventions held to by the academy. The most famous and dramatic example of this is the "secession of the Fourteen." In 1863, as an affirmation of their creative independence, fourteen artists collectively refused to paint the given subject of the academy's hallowed gold medal competition. The topic assigned was a theme from Norse mythology—"The Entrance of Odin into Valhalla."[23] The fourteen painters walked out of the competition en masse rather than accept what they considered to be an inappropriate and demeaning assignment. Many of these students soon formed an artel through which they helped educate each other in realist approaches and techniques. They also intended to use the artel to help sell their work. Although their artel never proved a financial success, it paved the way for future ventures independent of the academy, most notably the organization of the Peredvizhniki.

Some art critics called for radical change at around this time, and their views had direct implications for landscape painting. In an 1863 article that appeared in the satirical journal *The Spark*, I. I. Dmitriev condemned the state of contemporary Russian painting. As part of his attack, he castigated landscape painting as a hopelessly retrograde form of romanticism, most notable for its avoidance of anything resembling actual conditions in rural Russia. "He who in our present age enjoys reading Karamzin's 'Poor Liza' and the poetry of Fet," Dmitriev scolded contemptuously, "can innocently and shamelessly indulge in the contemplation of landscapes."[24] To Dmitriev, a representative of the left intelligentsia, landscape painting was an unnecessary, if not decidedly harmful, practice that allowed society to close its eyes to questions of vital importance. Images of peasants themselves would be the only truly useful subject matter: "if the painter depicting [a view of] *The Station at Mineral Waters (Property of Mr. Kokorev)* had expressed to us how the Orthodox peasant nearby this

station lives, what adversities he endures and happiness he experiences, we would certainly be grateful to such a painter."[25] By means of this contrast, landscape painting, at least in its more traditional role as a provider of pleasant views, had begun to come under attack as elitist and unnecessary.[26]

Vladimir Stasov, the most important Russian art and music critic of the latter half of the nineteenth century, in his criticism reflected all the intelligentsia's confusion and ambivalence about landscape imagery. Stasov supported a politically progressive role for Russian art, but he also considered the formation of a national school and style the essential goal of the Russian arts in his era. Consequently he accepted and praised the work of landscape painters as an important adjunct to the development of nationality in Russian art, but he tended to treat landscape painting as a minor genre, of secondary importance compared to such modes of expression as historical painting or urban and rural genre painting. These latter forms could express nationality while maintaining a level of social criticism, whereas landscape painting was too far removed from topical issues, with a tendency to dissolve into nostalgia.[27]

If liberal and radical critics often dismissed landscape as an unsatisfactory subject for the "engaged" artist, landscape paintings themselves were received with enthusiasm by the public and the new breed of art collector. The market for specifically Russian art came to be dominated by the figure of Pavel Tret'iakov. A collector from a family of Old Believer merchants, Tret'iakov was inspired by a sense of duty to his country in his attempt to amass a large collection of paintings by Russian artists on Russian themes. His collecting practices, along with those of a handful of other art patrons, helped sustain Russia's independent and progressive artists for many years. His collection would later form the basis of the most important museum of Russian art, the Tret'iakov Gallery.[28] With respect to landscape, like Maikov and other critics, Tret'iakov sought a Russian version of landscape painting that would embrace the simple and unassuming natural environment. As early as 1857 he wrote to the landscape painter, A. G. Goravskii, "I need neither bounteous nature, nor superb composition, nor dramatic light, nor any kind of wonders . . . just give me a muddy pool as long as it has truth and poetry in it."[29]

A critic for *The Russian Art Sheet* [*Russkii Khudozhestvennyi Listok*], writing in 1862 under the initials K. V., came close to Tret'iakov's view, foreshadowing future developments: "[Landscape paintings] no longer try to astonish us with the grandiose beauties of nature. We don't always want to be amazed; we want to love, and one does not love only the grandiose. It is even easier to love that which is simpler and near at hand."[30] By the early 1860s even a critic for this unabashedly

conservative publication had come to embrace a landscape imagery that rejected neoclassical standards. A taste for realism and a humble aesthetic was becoming widespread among art critics and collectors.

HOMESICKNESS

While the cultural environment surrounding landscape painters had begun to shift at around the time of the emancipation, it was still unclear in the early 1860s just how the painters themselves would respond to the call to create a school of Russian landscape painting. At midcentury the best academic landscape painters, after finishing their studies in St. Petersburg, were expected to perfect their trade on an extended trip to Europe subsidized by the academy. A good indication that Russian landscape painting was moving in a new direction by this time can be found in the increasing insistence on the part of many landscape students that they be allowed to complete their studies at home in Russia rather than going abroad.

In 1858, Mikhail Klodt won a gold medal at the academy. The award brought with it the usual accompanying stipend to study abroad for three years. In Europe he chose to spend most of his time in Switzerland and France, but he found himself at odds with contemporary French painting, considering the work of French artists "unfinished" and "careless."[31] Apparently he was also dissatisfied with the natural environment he encountered in the West. Two years into his European visit he requested the academy allow him to return home early "in order to occupy the remaining period of the pension painting views from nature in Russia."[32] Klodt received permission to return and spent the next two years painting and sketching landscapes in different regions of his native country.

After winning his own gold medal in 1864, the landscape painter Petr Sukhodol'skii succeeded in obtaining permission from the academy to spend his entire three years of study in Russia. He made the request to do so, in his words, "in order to obtain a sufficiently personal technique for greater independence in representing our still unconveyed nature."[33] Similarly, Vladimir Orlovskii, after winning the gold medal in 1868, asked to be allowed to study in his native Ukraine for at least a year before going to Europe because he "preferred only to work on Russian nature and Russian landscape."[34] After having arrived in Europe he wrote, "I don't think it worthwhile to collect motifs here—they are foreign to me and to Russia; beyond that they've been painted and repainted a hundred times."[35]

Other landscape painters at around the same time expressed intense displeasure at having to study in the West. Aleksei Savrasov felt that Russian painters "lose themselves abroad, and begin to learn late to

think about and understand genuine art."[36] Lev Kamenev wrote to Ivan Shishkin in 1864 about the "French disease" that he felt had "infected" the Russian painters working in Paris at the time: "They are certain they only see landscape in [French Barbizon painters] Corot, Daubigny . . . etc."[37] Kamenev believed he would improve as a landscape painter only by working on Russian soil. Although in Europe only for a short time, he continued to keep his native landscape uppermost in his thoughts: "To the Devil with the Oberland and all of Switzerland. . . . In order to paint it you need to be born Swiss, or become Swiss, but even in my dreams I see our wide Russian spaces with golden rye, rivers, groves, and the Russian distance—very little looks like that here."[38]

In 1862, Ivan Shishkin was awarded the same three-year scholarship for study in Europe that Klodt and Sukhodol'skii had received, but he had to be persuaded for months before he accepted the honor of traveling to Europe. Instead he petitioned to take sketching trips down the Volga or to paint in the Crimea. Entreated by his teachers to "go straight . . . to Italy"[39] to study the countryside, Shishkin finally acquiesced to the sojourn in Europe. He went straight to Germany, however, spent time in Switzerland and Prague, and never left northern Europe during his entire three-year stay. He was determined to steer clear of those parts of Europe that visiting artists typically frequented, namely Paris and Italy. The vehemence of his determination is evident in a letter he wrote from Zurich to his friend and fellow artist at the academy, I. V. Volkovskii:

> You will say later—look at him, look at this freak who went abroad and never went to Paris. What kind of a person is this? They'll disdain me. And I don't even speak of Italy. Such horrific scoldings there will be for me. What? You were abroad and never in Italy? For shame Sir, and you a landscape painter . . . but I still won't go to Italy, even if there were a chance to. I don't like it because it's too sweet.[40]

Shishkin shared the same view as Kamenev that landscape painters must develop their inborn link to the native terrain. In his European diary of May 1862, shortly after he had gone abroad, he wrote:

> The landscape painter is the true artist. He feels more deeply, more cleanly. Devil knows why I'm here, why I'm staying in a hotel room in [Germany], why I'm not in Russia, I love her so! Sadly, I sing and whistle, practically with tears in my eyes, "Don't fly away my dear! Don't desert your native fields!" In my repertoire of songs comes almost every Russian theme I know. Sad, it's terribly sad, but it's pleasant at the same time—God grant I don't lose this feeling, wandering through this cursed foreign land.[41]

In this page from his diary, Shishkin directly associated landscape painting with devotion to Russia. He subscribed to the view that Russian artists were incapable of creativity abroad. Making excuses to one of his patrons (the collector N. D. Bykov) for not having sent home the kind of landscapes Bykov had originally requested, Shishkin noted the "sickened condition" of all the Russian artists in Europe: "They certainly don't want to imitate," he said, "and they feel somehow unrelated."[42] Shishkin's vehement disdain for the West helps clarify what it was that troubled Russian landscape painters about working in Europe. Defining the Italian landscape he had never seen as "sweet," he seemed to fear the effect of the picturesque qualities he had encountered in paintings of Italy. He felt threatened by the terrain upon which classical landscape painting had first been conceived, and he refused to come under the influence of Paris, a center for both traditional painting and modern reactions against it. Shishkin and many of his contemporaries seem to have believed that the powerful influence of European art and nature would impede their progress toward new, national forms of expression.

TOWARD THE RURAL LANDSCAPE

It is clear from their language that at least some of the above painters had been drawn into the valorization of Russian space described in the preceding chapters. Their goal of representing that space in oil, however, was far more difficult to achieve than it might at first appear. Conventional languages of landscape painting remained strongly internalized by Russian artists in the 1850s and 1860s. In order to create a visual version of Russia's landscape, painters not only had to circumvent the academy's pressure to paint European scenery, but they also had to overcome their training in traditional methods and techniques. Still more importantly, they had to rid themselves of deeply ingrained ways of seeing nature that made it difficult to envision Russian terrain as a landscape painting.

They confronted a challenging task. As pointed out in the Introduction, to see one's natural surroundings *as landscape* requires the (usually unwitting) possession of a formidable structure of visual knowledge. This structure tells us what makes one particular block of visual data, that is, a "view," more aesthetically pleasing than another. The idea of landscape as either a picturesque and pleasant (or sublime and grand) *view* had dominated European landscape aesthetics from the sixteenth through the nineteenth centuries. In order to portray the special Russian landscape aesthetic that had been developed in Russian literature during the first half of the century, landscape painters had to reject some of the basic techniques of nature depiction long considered the stock-in-trade of their work.

These painters left only one well-documented record of their efforts: the paintings themselves. Among the landscape painters most devoted to the portrayal of specifically Russian landscape, the work of Aleksei Savrasov can be traced back furthest in time. Savrasov began to paint in the late 1840s at the Moscow School of the Arts. There he initiated a wide-ranging search for an acceptable aesthetic image of Russian terrain that would span the following two decades. His early work exemplifies the difficulty Russian painters encountered in trying to portray their native land.

A painting from his student years, the dramatic and almost gothically romantic *View of the Kremlin from the Crimean Bridge in Foul Weather* (1851) [fig. 5] put to use many of the most conventional landscape painting techniques. A frame formed by the clouds, trees, and riverbank helps establish the white walls and towers of the Kremlin as the painting's focal point. Patches of sunlight through clouds heighten the drama of the view and grant the eye an easy diagonal path from left to right. Except for the patently Russian Kremlin architecture, the painting has a timeless and placeless quality; there is nothing notably Russian about its natural surroundings. It is unmistakably a Russian landscape, but it addresses a viewer uninterested in the national characteristics of the natural scenery.

For most of the following decade Savrasov would continue to conceive of landscape painting in relatively conventional terms, but he did attempt some tentative departures into new representations of the countryside. His series of steppe paintings in the following year, done from sketches on site in Ukraine, mark his initial departure from a traditional and cosmopolitan style of landscape painting. In retrospect his *Steppe in the Daytime* (1852) [fig. 6] is a remarkable work. It was one of the earliest attempts in Russian painting to depict the level open space common to the southern regions of European Russia and Ukraine. Although such terrain would become a typical subject for landscape painters twenty years later, one can easily see why at this time Savrasov abandoned his innovative approach after only a few attempts. As an illustration of open space the image succeeds reasonably well, but as a landscape painting it is a failure. The grouse, the vegetation, and the brook, painted with great attention to detail in the foreground, appear detached from the fuzzy, uniform steppe and sky in the distance. The painting projects a feeling of vast openness at the expense of looking something like a second-rate museum diorama.

Another painting from the 1850s finds Savrasov moving from Gogolian open space to something resembling Aksakov's or Turgenev's interest in precise detail. *View in the Vicinity of Oranienbaum* (1854) places the viewer close to the earth, almost as though observing the scene from a prone position on the forested ground. The eye moves slightly upward toward a figure looking out at the Gulf of Finland. In contrast

to his steppe pictures, this landscape includes a middle distance, and has a more complicated perspectival structure, but it shares with the steppe paintings a rather claustrophobic proximity to the foreground. In their willingness to experiment with perspective and conventions of view painting, both landscapes suggest an ongoing struggle to redefine the visual image of Russian space. Neither painting, however, dispenses with the quiet tranquility and welcoming warmth of a nature still premised on its ability to please an elite audience accustomed to conceiving of natural beauty as essentially scenic and pastoral.

This last painting, along with many landscapes from the period, was given the title "view." Significantly, within a few years (by around the middle of the 1860s) that common designation had been dropped from most Russian landscapes. Rejection of the term "view" in the title may appear a trivial development, but one could argue that in its context it represented a major shift in the meaning and purpose of landscape painting in the early 1860s. The essential notion of the painting as a view implies a distance between the viewer of the painting and the countryside. In this regard it is notable that common use of the term ended at around the time of the emancipation. It seems likely that the formerly unproblematic leisured diversion of looking at pleasing pictures of the countryside could not be sustained once the rural world began to take center stage in Russia's social and political struggles. It is clear, at any rate, that by the early 1860s, at least in explicit terms, landscapes less often expressed the city-dweller's enjoyment of nature as a removed aesthetic object. Russian landscape painting acquired a new mission after the emancipation: to bring the urban viewer into closer connection with the rural world. But at the beginning of the decade two fundamental questions remained to be worked out: what kind of connection should it be, and how should the connection be made?

At first landscape painters were encouraged by radical critics to depict rural life in ways that echoed the work of ethnographers who documented its hardships, rituals, and daily grind. As a result of the importance he placed on the critical and polemical function of realist painting, Stasov, for example, praised landscapes that exposed difficult social conditions and lacked any veneer of beauty or warmth. More than at any other time, during the polemically charged 1860s Russian landscape painting adopted the function of social criticism. In these years, landscape painters associated with the "objective," critical approach advocated by Chernyshevskii, Stasov, and many others were at the cutting edge of their field.

Sukhodol'skii was one of the first among them. On receiving permission in 1864 to study in Russia, Sukhodol'skii went to Kaluga province southwest of Moscow in order in his words, to "execute views of nature."[43] When he began the attempt to portray the local country-

side, he encountered far more trouble than he had expected. Since Sukhodol'skii intended to create accurate images of the peasant village and its inhabitants, he needed to use them as models. But the peasants he tried to represent in paint "threatened the destruction of paintings and sketch books and even subjected the person of the artist to danger."[44] Just as they would a decade later when student activists went to the countryside in great numbers during the summers of 1874 to 1876, peasants sometimes greeted the interest of a well-intentioned outsider with mistrust and hostility.

Beyond these all-too-tangible difficulties, Sukhodol'skii also displayed a deep confusion about his relationship to the countryside. The painting *Noon in the Village* (1864) [fig. 10], which would remain his best known work, is a particularly odd and overreaching image. On the one hand, it conveys his kinship with the conventional landscape painting of the academy. His expressed wish to "execute *views* from nature" suggests that he may not have been ready to dispense with the expression of scenic beauty in his work. And indeed one finds here the unifying overview perspective, an interest in light and depth, and a complexity of composition that connects the painting to the academic conventions Sukhodol'skii had been trained to apply. On the other hand, the dilapidated village, the sow in the foreground, and the lounging, undignified peasants, place his work in the context of such village "realists" and critical ethnographers as Maksimov and Iakushkin, who were describing their encounters with the hardships of everyday peasant life in these same years. Stasov interpreted this painting according to the principles of critical realism. Granting that it contained "a dryness in its overall tone . . . in the manner of a daguerreotype," he praised it for its inclusion of everyday village sights and its "sad, flat horizon." In his words, the painting "puts an end to idealization in our landscape."[45]

Stasov's praise notwithstanding, by comparison with later efforts in realist landscape this painting seems an oddly composed and idealized work. The evident social criticism behind its description of village life gives it an air of strained condemnation that removes it from the more naturalistic landscapes that would begin to appear a few years later. Sukhodol'skii seemed torn between aesthetic inclinations and moral outrage. To be sure, he concurred with Stasov about the gloomy impression of the rural landscape. In 1868, the last year of his commission to paint in the provinces, his letter to the academy betrayed a certain disillusionment: "Our northern summers are wretched!" At the same time he boasted of having discovered a way "to fully comprehend our northern nature and its many remarkable aspects." "I came to the conclusion," proclaimed Sukhodol'skii, "that our Russian landscape and figures are no less interesting and cannot produce a less significant impression than that of Italy, not to speak of Germany."[46]

Sukhodol'skii's technique was soon outdistanced by other Russian painters, and he later came to be associated with the academic conservatives.[47] Although he had been one of Stasov's favorites in the 1860s, precisely for incorporating a critical perspective in his landscapes, Sukhodol'skii may have focused too closely on the subject matter of his work. He failed to keep current with new technical developments in the representation of natural space and fell behind in his own rapidly developing field.

The portrayal of a dark and dismal landscape in art paralleled similar developments in literature. In both cases, artists and writers responded to the urgings of the radical intelligentsia to use their work to unmask the burdens and impoverishment of rural life. If the entire countryside was bound up in the misery of the peasants, then the Russian landscape itself had to be seen as a difficult and melancholy place. Appropriately, the first artist to help establish this sense of the countryside was not a landscape painter but Vasilii Perov, a painter of provincial genre scenes. Perov's background landscapes are always poorly finished and usually subordinate to his main subjects, but they effectively establish a wretched atmosphere with which to convey his sense of rural Russia's squalor and misery. The natural environment in such works as *Village Easter Procession* (1861) or *On the Way to the Cemetery* (1865) is cold, gray, and dark. With their muddy trails and icy fields, Perov's landscapes reflect and magnify the despair he sought to bring out in the lives of his rural subjects.[48]

In later depictions of peasant genre, bleak landscapes continued to be used as a way to intensify the viewer's appreciation of the suffering *narod*. One might recall some of Il'ia Repin's most famous paintings. The desertlike banks of the Volga in *Boat Haulers on the Volga* (1870) or the dusty, denuded hill behind the marchers in *Religious Procession in Kursk Province* (1880) seem to confirm both the misery and determination of the peasants who form their primary subject. The sketchiness and monotone quality of Repin's landscape in these paintings suggests a feeling of the absence of landscape. This sense of absence seems to say that Russian peasants live in a world utterly antithetical to the idealization implied by the mere presence of natural forms.

Mikhail Klodt's *Big Road in Autumn* (1863) [fig. 8] was one of the earliest landscape paintings to base its full effect on an image of the Russian countryside as a dismal place. The monotonous colors of the gray sky and muddy brown earth, and the vastness of the open, level plain (emphasized by a few minimal vertical structures) mainly serve to heighten the viewer's sympathy for the traveler in the middle distance, stuck in the mud with a broken wheel. Unlike Perov's and Repin's works, which pointedly drew attention to the plight of the peasantry, this image is more closely related to the experience of Russian urban-

ites. Although Klodt depicts a peasant cart, fear of a broken carriage in some "godforsaken corner" of the world was a common theme of urban Russian culture. Klodt's empty landscape invited the viewer to respond to this stretch of road as an alien and uncomfortable space. The painting may have been interpreted as a sympathetic reaction to the difficulties encountered by peasants in the countryside, but the image was, in fact, seen by an urban audience. In order to create a mood of despair, Klodt played on urban fears and anxieties.

Stasov admired Klodt's *Big Road in Autumn* for aesthetic reasons: "With a subtle beauty it conveyed a picture of Russian autumn in the wide plains."[49] He also praised it for shunning picturesqueness: "Klodt seeks only to grasp Russian nature in all its ugliness; there is no pretense of dressing it up in some gold-braided uniform, without which other landscape painters cannot imagine nature. And yet these truthful paintings bring such deep and sincere enjoyment."[50] Stasov commended the work of Klodt and Sukhodol'skii because, he believed, they rejected the conventional search for nature's beauty. For traditional aesthetic methods they substituted the realist assertion of an apparently more truthful, because less beautiful, rendering of the countryside. Their paintings did not always emphasize the hardships of peasant life, but because they could stake a claim to a greater truth that superseded conventional sensibilities, such critics as Stasov viewed their work as a praiseworthy and politically engaged act.

Yet even in those landscapes associated with "critical realism," enjoyment of landscape painting on balance remained an aesthetic response. The miserable open road, for instance, became a common theme for Russian landscape painters. It was interpreted by a host of them, including Savrasov, Vasil'ev, and Arkhip Kuindzhi. The road offered a rare space of potentially mutual experience between the urban and rural segments of Russian society. A Novgorod reviewer of Kuindzhi's *Cart Driver's Highway in Mariupol* responded to the painting with a voice that again appears sympathetic to the peasant traveler, but seems more to convey the uncomfortable and aesthetically nonplussed response of an urban traveler: "So much sadness, grief, woe, and need on this gray, uncomfortable steppe. So much unmerciful indifference on this wet, foggy day, in this ocean of mud, so much hopelessness in this vast expanse. . . . And this tavern in the distance. This cart driver's haven. There is shelter, there is a roof, there is rest, there is vodka. And then? Then again rain, mud, cold, again that boundlessness, again that grief."[51]

In these scenes of the open road, painters had found a rare point of mutual experience between urban and rural Russia, but it was a shared experience dependent on common hardship. For a short time during the late 1860s, Russian landscape painters sought to represent peasant

lives in a more favorable light. Kamenev, Vasil'ev, Shishkin, and Savrasov all focused directly upon the world and experience of the Russian peasant during this period. Vasil'ev's *The Village* (1868), Shishkin's *Noontime* (1869), and Savrasov's *Village View* (1867) number among the landscapes of peasant life that appeared during the late 1860s. Kamenev's *Winter Road* (1866) is a good example of this kind of painting. It blends an evocation of rural hardship with a celebration of the strength of the Russian villager. Some peasants traveling in a simple sled along a snowy road approach a village. A dog running ahead of the travelers seems to embody their joy and enthusiasm on returning home. The viewer of this painting is positioned closer to the figures than is the viewer of Klodt's *Big Road in Autumn*. Unlike in *Big Road*, no sense of alienation clouds Kamenev's presentation of rural space. The village is low to the ground and nestled among a stand of pines. Although the atmosphere is harsh, something warm and nostalgic fills this picture of travelers returning to the fold.

The sort of landscapes that emphasized the gloom of the countryside and the misery of the *narod* gave way around the end of the 1860s to a new vision of Russian landscape closer to that of Kamenev. But now the emphasis would be on Russian nature alone. Although peasant figures had appeared in most landscapes of the 1860s, by the early 1870s painters minimized their significance or even ceased to portray figures altogether. Three artists—Vasil'ev, Shishkin, and Savrasov—began to make rapid progress toward the creation of a new landscape imagery in the late 1860s and early 1870s. Each of these painters responded to different natural environments and produced distinct bodies of work, but their aims and intent remained interconnected by the fact that all of them believed the Russian countryside possessed a special beauty that could be expressed in paint. Moreover, all of them struggled against the influence of conventional landscape painting in attempting to make that beauty visible on their canvases.

VASIL'EV

Of these three artists, Fedor Vasil'ev was younger and died much earlier than the others. Born in 1850, he succumbed to tuberculosis at the age of 23 in 1873, but not before having made extraordinary strides in his chosen field. Vasil'ev never entered the academy. Instead he became a pupil of two progressive painters—Shishkin, almost twenty years his senior, and Ivan Kramskoi, a leader of the Peredvizhniki. Vasil'ev was clearly influenced by the polemical strain that predominated in landscape painting during the 1860s. Many of his early works portrayed Russian peasants as they lived and worked in the village.

If during the early 1860s the radical intelligentsia tended to focus on the brutality of peasant life, by the end of the decade an important change had come about. The left began to revive the idealization of the *narod* that had previously been closely associated with conservative Slavophilism. A new admiration for peasant life took root among the intelligentsia in this period, giving birth to various ideologies referred to collectively as Russian Populism [*narodnichestvo*]. This new populist glorification of rural Russia allowed, even encouraged, landscape painters to approach the countryside anew as a space to be ennobled and admired for its nurturance of and closeness to the *narod*. Vasil'ev painted at least five finished oils in 1868 and 1869 that included a village setting and laboring peasant figures. The natural environment depicted in these paintings seems to enfold the peasants into an easy, almost organic, embrace. The repeated theme of peasant life and labor, blended symbiotically into their natural surroundings, makes visible a pastoral version of the Russian populist ideal of a unified, uncorrupted life in the countryside.

Take, for example, the largest of this series, entitled simply *The Village* (1869) [fig. 9]. The viewer seems to stand at the end of a little log bridge, not far from two of the village inhabitants washing clothes in the shady stream. The bridge runs up onto a bank painted in precisely the same tones and textures as the bridge itself. The grass in the meadow, the straw used to patch the roofs, and the trees in the distance share in common the same rust and yellow colors and the same feathery texture. Color and texture unify the image, connecting the village to the forest and fields in the distance. Thus the humble everyday lives of these peasants quite naturally emerge from the landscape itself: food wanders around the village in the form of chickens and a cow; clothing is visible as woolly sheep in the field to the right; and shelter comes from the roofing straw in the fields and logs cut down from the forest at left. The bright sunlight of a September morning renders these ramshackle huts warm and inviting, nestled as they are amid the sparkling, multicolored glade. Even the poverty of the patched huts seems to celebrate this updated pastoral of peasant life.

Vasil'ev's village paintings present both a picturesque and a populist face to his viewers. Vasil'ev had devised a populist *locus amoensus:* a good solution for the creation of an admirable Russian landscape perhaps, but unhelpful as an expression of sympathy for peasant hardship. In subsequent paintings Vasil'ev created new ways of blending the populist and picturesque elements in his work. A good example of this mixture is found in one of his best-known works, *The Thaw* (1871) [fig. 16]. This portrayal of two foot-travelers on a raw and bitter day somewhere in the depths of the countryside does not immediately invite the viewer to appreciate rural Russia for its scenic charm. It seems

more a Russian version of the middle of nowhere. The crossing tracks in the road and the birds picking at the ground seem contrived to appear leaden and ugly. Yet there are features of this landscape that might be referred to as scenic. Patches of sunlight illuminate the middle distance, stands of trees are scattered in uneven fashion to provide interest, the snow-covered cottage has an air of quaintness about it, and the travelers are placed in an easy, familiar pose—a father listening to his daughter, who points ahead of her, either to show the way or to motion to the group of birds just ahead.

In formulating a landscape that united the raw and unattractive with a rustic visual appeal, Vasil'ev had to negotiate both the complicated layers of meaning imposed upon the Russian countryside as well as the demands made upon pictorial representations of natural space. He wanted his viewers to appreciate the scenic qualities of Russia's landscape while maintaining an awareness of rural hardship. *The Thaw* implied that there was great visual beauty in this setting, amid the dismal surroundings, if only the viewer knew how to look for it. It also reminded urban viewers that both the beauty and gloom of this landscape were an integral part of peasant lives. This image has much in common with Nekrasov's rural Russia. As in Nekrasov's "Peasant Children," the urban viewer imagines the Russian landscape through the eyes of the sympathetic peasant child, who appreciates her surroundings as an innocent being, still lacking any preconceived notions about the "proper" admiration of scenic beauty.

The simple act of choosing to focus his viewers' attention on objects or phenomena that usually go unnoticed allowed Vasil'iev to create a landscape out of what formerly would have been considered unpaintable space. *Wet Meadow* (1872) [fig. 11], one of Vasil'iev's last major works, eschews the representation of figures, structures, striking trees, or bodies of water, almost anything that might lend the landscape a picturesque quality. It uses a different method to teach viewers to admire Russian landscape. Vasil'ev employed a conventional landscape formula on the lefthand side, where golden light pours out of the clouds illuminating a small body of water, and a foreground that consists of nothing more nor less majestic than a field of weeds and tiny wildflowers. It is a strange use of conventional landscape technique indeed. *Wet Meadow* conveys a striking and memorable atmosphere— early morning just after the passing of a storm cloud—to ask the viewer to admire the warmth of sunlight and the beauty of a damp field. The view is remarkably low; it places the beholder down in the brush, where the horizon is perceptible but not the focus of interest. In this painting Vasil'ev sought, insofar as possible, to remove the distance between the viewer and the landscape. He managed to create a powerful image out of what had recently been considered unpaintable space.

The public had difficulty finding the proper reaction to this landscape. Ivan Kramskoi wrote with amusement about the painting's initial reception to the eagerly curious Vasil'ev, who was in Yalta trying to recuperate from his illness:

> Delighted, impulsive exclamations I generally did not hear. People's faces wore the expression of crushed peas; they were stupefied about how to treat this phenomenon. With comic distress they approached others and asked them to explain what, would you say, this was. There isn't one aspect of tradition in this painting, not one patented effect—i.e., about which all opinions agreed and the brain could puzzle over. It would be a good painting, of course, if it had just this or just that—the painting is lyrical, almost foggy, kind of boring. God knows how you go about understanding it.[52]

Wet Meadow baffled many of its viewers because it lacked the customary invitation in landscape painting to scenic appreciation of the natural environment. It did not add up to a landscape. It was not understandable to viewers who conceived of landscape painting in terms of conventional views and scenes. It left them bored and numb, at least so one might interpret Kramskoi's characterization of faces with "the expression of crushed peas."

Despite its novelty, this work received one of the top prizes at the exhibit. It offered a new model of Russian landscape painting in its visual assertion of an entirely unprepossessing space as a fit subject for art. In this regard, *Wet Meadow* obviously drew on literary evocations of Russian landscape, which had so often located the beauty of the countryside in rural openness and simplicity. But the painting also contributed something of its own to the construction of Russian landscape. Simply to depict a virtually empty meadow without any figures or narrative significance was a major step forward in the representation of Russian space. It helped confirm that rural Russia's humble environment could stand alone as a visual image. That confirmation gave new impetus to the notion that the Russian landscape was admirable in its own right.

SHISHKIN

Vasil'ev's teacher (and incidentally brother-in-law) Ivan Shishkin had been making progress toward a similar revaluation of Russian landscape, albeit more gradually, beginning in the late 1850s. In 1856, Shishkin entered the Imperial Academy of Arts. One of his earliest extant landscapes from this period, the rote and simplistic *View in the Vicinity of St. Petersburg* (1856), reveals the influence of his academic teacher, Sokrat Vorob'ev. One also senses the looming presence of his

Italianate predecessor, Mikhail Lebedev. The lush variety of vegetation, the heavy geometry of the composition, and the peasant at rest in a shady alley converge to make this work appear a sort of garden scene, or Italian view, rather than a depiction of the environs of St. Petersburg. Not long after completing this painting, however, Shishkin's work sketching the rocky, uncultivated forests on the island of Valaam (on Lake Ladoga north of Petersburg) initiated his move away from the more stylized composition of his teachers toward what would become his signature slice-of-nature realism.

With the model of such painters as Shishkin, and without a formal education, Vasil'ev had perhaps been spared some of the difficulties of making progress away from traditional technique and subject matter. For his own part, as a promising young academic landscape painter, Shishkin often wrestled with the pressure to satisfy conventional tastes. His relationship with the collector Nikolai Bykov makes a good example. Bykov had commissioned Shishkin to paint some landscapes in Europe, but he was dissatisfied with the work Shishkin sent him from Germany. He wanted Shishkin to paint in a manner that corresponded to his taste for Italian scenery:

> I asked you to paint a view, not a study of the forest. . . . I need your painting to have a view, forest, air, water, etc., etc. You'll remember that I asked you, when you go to Rome, to repeat that alley in Albano, which all our artists have painted, and which has an astonishing perspective. You'll remember that I asked you specifically, if you will not be in Rome, to paint in this style even in Saxony.[53]

Despite Bykov's entreaties, Shishkin clung tenaciously to his own artistic plans. He responded to Bykov that he would send him a new painting, this time of a northern European forest interior after a lightning storm.[54] The forest interior would subsequently become Shishkin's metier. Returning to Russia in 1865, he began to study forests intently and to transform them into a new personal vision of Russian landscape.

Two notable, large-scale works of this period, *Pine Forest in Viatka Province* (1872) and *Backwoods* (1872) demonstrate the difficulties Shishkin faced in trying to depict his native forests. The attempt to paint deep forest wilderness was, it seems to me, his most radical departure. Like the Barbizon painters in the forest of Fontainebleau, Shishkin was constrained to paint landscape in new ways because of the new space he confronted. Although forest landscapes date back to the early history of landscape painting, deep forest scenery never conformed to mainstream conventions. Forest space is enclosed, rarely conducive to the extended view. This is all the more true of the thick pine forests that became Shishkin's specialty. The constrictedness of

this landscape focuses the observer's attention on the objects of nature that are close at hand. Thus the forest view is much more difficult to organize into a unified whole.

In *Pine Forest in Viatka Province* [fig. 12], the foreground has become prominent; its assertive presence compels the viewer to scrutinize the forest floor. The various natural forms of this landscape call attention to themselves and in the process distract from the unity of the scene. Shishkin wanted to bring the viewer into closer proximity to the small details of the landscape, but in this painting he had not yet entirely given up the notion that nature must be represented as a view. Demonstrating that he had not yet resolved the contradictions between forest space and view painting, he made sure to include the tops of the trees to the right and to provide a limited vista between stands of trees to the left. The confusion left its mark in the poor composition of the work: the bears at the bottom of the tree in the center appear to be close by, whereas the top of that same tree seems much farther away.

If, as Kenneth Clark has written, "penetration into space is the essence of landscape," then the painting *Backwoods* [fig. 13] marked the beginning of Shishkin's turn away from landscape in its "essential" form.[55] With this work Shishkin attempted to reconcile the view and the forest in a different way. A light source in the center of the painting provides a limited sense of depth, but the tops of the trees are no longer visible; the eye loses its escape route into the horizon and must return to the objects and effects of the forest in the foreground. By minimizing the role of a distant perspective, Shishkin made the particularities of the foreground and middle ground the primary subject of his landscape. *Backwoods* was Shishkin's largest painting to date, and it served as a declaration of things to come.

Shishkin's work after this period, the mature stage of his development as an artist, can be described as naturalistic landscape painting in that it aspired to give an almost photographic rendering of nature, a documentary study of the Russian forest. Indeed from the mid-1870s, he began to take an interest in photography, and he felt perfectly comfortable using photographs to assist his painting.[56] Shishkin's compositions from this time forward almost always begin at eye level. Often a small trail extending from the immediate foreground postulates the position of the viewer as standing just outside the frame of the picture. Although his paintings are elaborate in detail, their composition is subtle, or masked, suggesting that they lack any composition at all. His forest scenes seem to have been chosen arbitrarily, as if he might have simply turned ninety degrees to the right to paint whatever he saw before him. These landscapes, one might say, appear to describe the space between the landscape paintings.

The presence of a rough trail on which the viewer seems to stand in so many of Shishkin's landscapes implies that he wished his viewers to experience the image as if from within, and in many of Shishkin's forests the distance is completely obstructed by a wall of trees. This composition compels the viewer to observe only the objects in the immediate foreground. In *Trees Felled By the Wind (Vologda Woods)* [fig. 14], the eye is deprived of any special focal point and wanders amid the diffuse natural forms in the immediate foreground. The viewer contemplates the lush growth of moss, mushrooms, and twigs that seem to be almost underfoot. Such paintings lavished attention on precisely those aspects of nature that had previously seemed unworthy of representation. Dead limbs, scrub brush, grass, wildflowers, weeds, puddles, twigs, broken branches, mossy ground, bark, and stands of undifferentiated trees acquired a place in their own right in Shishkin's work. Shishkin made visible, even unavoidable, those features of the natural world that were typically passed over in conventional landscape painting in favor of nature's grander aspects. Bodies of water, for example, are often situated in the middle ground of the classic landscape view, lending a feeling of monumentality or grandeur. In Shishkin's work, water is often brackish and appears to flow nowhere.

Shishkin did not avoid painting other environments. Some of his landscapes depicted vast open space, or relatively open woodlands, but his paintings of the forest interior were his trademark and most often repeated composition. These paintings stressed the seemingly trivial or insignificant in nature for a reason. They drew on the emerging conception of the Russian land that simplicity and plainness were more genuine and therefore more valuable than any ostentatious beauty. Uncultivated nature, as Aksakov had held, was superior to that which had been spoiled by the corrupting intervention of European civilization.[57] Shishkin's forest landscapes often seemed deep and impenetrable; they distinguished Russian *nature* from European *scenery* by the depth and extent of their wilderness.[58] Natural beauty for Shishkin was unmediated, or only lightly touched, by human inhabitancy. Both in the composition and in the subject matter of Shishkin's work, outward poverty was again equivalent to inner richness, just as it had been in literary representations of a humble, simple, and beloved rural Russia.

SAVRASOV

Through most of the 1850s and 1860s, Aleksei Savrasov had struggled to devise a gentle, pastoral approach to his native countryside. Like Shishkin, he did not arrive at his mature style in landscape painting until the late 1860s. In the interim, his work had a good deal in common with some of the gentler landscapes of the Barbizon painters.

Two works of the late 1860s, *Village View* (1867) and *Elk Island in Sokolniki* (1869), mark a fresh departure for Savrasov.[59] *Village View* [fig. 15] was painted at a time when Vasil'ev, Kamenev, and others were beginning to celebrate rural life in the peasant village. Savrasov joined in the effort after having spent a five-year hiatus working mostly on Swiss Alpine landscapes. In contrast to some of his earlier paintings, this work emphasizes the foreground, whereas the distance remains open and relatively uninteresting. Rather than blend together foreground, middle ground, and background into a harmonized scenic whole, as Savrasov had done in the past, the foreground dominates this painting.

By minimizing the role of the distance, *Village View* draws the viewer closer into the space of the foreground. Not unlike the effect of Shishkin's forest landscapes, the viewer almost seems to be standing within the space of the painting looking out toward the horizon rather than simply observing a removed scenic vista. Perhaps Savrasov intentionally called the painting *Village View* in order to draw attention to the new perspective he sought to convey. The painting seems to present itself less as a view *of* the village than as a view *from* the village. It is no longer a scenic tableau set out for the spectator's removed enjoyment. With its novel composition, it asks the viewer to enter into this nondescript rural space and appreciate it for its gray sky, bare trees, ramshackle structures, and empty plains.

Two years later, in *Elk Island in Sokolniki* [fig. 16], Savrasov had moved away from scenes of village life, but this painting maintains and reinforces the same compositional techniques that draw the viewer closer to the land. The foreground in *Elk Island* stands out in greater prominence, yet with even fewer details of visual interest. A muddy field and some stagnant puddles are the main subjects in the foreground of this landscape of a park outside Moscow. By comparison to one of Savrasov's studies for this work, in the finished product he intentionally emphasized the foreground and separated it from the distance. The main subject of the study is quite clearly a herd of cows grazing by a stand of pines. In the painting he put on exhibit, on the other hand, the cows and pines play a subordinate role by comparison the muddy and weed-covered field in the immediate foreground. Whereas the study suggests a rather bucolic impression of nature, Savrasov's finished work creates an entirely different impression.

As in Vasil'ev's *Wet Meadow*, or Shishkin's *Trees Felled by the Wind*, this painting draws the viewer's attention downward, close to the earth. At the same time, the lowered perspective lends the sky, the forest, and the fields beyond a certain monumentality not apparent in the study. Perhaps for the first time in this work, a Russian landscape painter found a way to incorporate both essential cultural myths of Russian space into one image. The foreground emphasizes a closeness to the earth, a love of

nature's simple objects, and a fondness for overgrown, out-of-the way places. The size of the overcast sky, the grandeur of the ominous stand of pines, and the lack of any compositional structure that could be construed as scenic or viewlike powerfully evokes the size and sweep of the Russian land. By restructuring the landscape composition he had formerly learned and practiced, Savrasov managed to devise a way to portray the special aesthetic approach to Russian nature that heretofore had been fully expressed only in literature. This is the first work to offer a visual affirmation of the ideal of Russian terrain as a simultaneously meager and majestic space, a land of profound and imposing simplicity.

As important a step as *Elk Island* was for Savrasov, another landscape painted in 1871 became his most famous painting and remains perhaps the most familiar Russian landscape of any period. *The Rooks Have Returned* [fig. 17] maintains the same compositional approach, with an emphasized foreground and an open distance. It places the viewer at an everyday, eye-level vantage point, close to the melting snow and bird-filled birches that form its main subject. The trees obstruct some onion-domed turrets that would otherwise be a central motif in a standard scenic view, and little in the gray emptiness of the distance attracts the eye into the painting's depth. Again, Savrasov's composition resists the eye's training and expectation to perceive the landscape as scenic space. The viewer's gaze remains relatively undirected, allowed to focus on such would-be insignificant details as broken branches and bird tracks in the snow, or wispy nests in the fragile limbs of the trees.

These modest foreground details draw the viewing eye into a new, nonscenic relationship with the landscape. An unremarkable sight in the corner of some insignificant village takes precedence over the river vista in the distance, or the village church in the middle ground. Savrasov's emphasis on the noisy, early spring return of the rooks implies an intimacy with nature's overlooked details. This familiarity with the seemingly trivial sights and sounds of the countryside contrasts sharply to scenic landscape composed for the aesthetic enjoyment of the removed urban viewer. Savrasov's new approach invites his audience to rethink the Russian countryside. The mundane surroundings of this rural environment can be enjoyed and admired in visual form so long as the viewer's perspective is reoriented away from the expectation of a scenic vision of nature. If viewers are given the opportunity to appreciate the minor, formerly insignificant, details of this apparently empty and unattractive space, they will respond to it with a sort of gentle, nostalgic recognition.

With respect to the distance presented in this painting, Savrasov's manner of arranging open space creates the opposite response from that aroused by the panoramic prospect. In a panoramic painting the eye is intended to travel through the distant vista on a visually satisfying jour-

ney. As one interpreter of Russian landscape painting has pointed out, these paintings do not facilitate the eye's movement; they "fix the position of the observer," inducing a sensation of immobility.[60] But this is not the stifling immobility produced, for instance, by certain Caspar David Friedrich landscapes. Works by all these Russian landscape painters exude a kind of warmth, an invitation to enjoy the simple pleasure of sunlight glinting from a puddle, a mossy stump, or, as in Savrasov's seeming realization of Tret'iakov's wish, "a muddy pool [with] truth and poetry in it." To the extent that these overgrown, out-of-the-way places are in many ways an unavoidable result of Russia's enormous geographical expanse, so these landscapes bring the humble foregrounds into close alliance with the unbounded distance. They hint that similar such landscapes carry on inexhaustibly, as if on a vast ocean of land.[61]

Moreover, as in Gogol's novels, Kol'tsov's poetry, or Shevyrev's travelogue, the open space that characterizes much of the Russian countryside takes on a special national function in *The Rooks Have Returned*. Like a blank stage backdrop that highlights the emotive force of an actor's performance, these familiar surroundings acquire a heightened grandeur and importance by contrast to the open, empty distance. The intangibility of this huge space helps fuse together the lonely foreground and middle ground scene that stands somewhere in the midst of it, endowing the meager birches with some of the spirituality of the village church and the church with the naturalness of the rooks' return home. The conjunction of a sanctified location and a vast yet familiar terrain resonates with implications of a Holy Russia glimpsed through the veil of an unassuming and remote rural scene.

When Kramskoi first saw *The Rooks Have Returned*, he remarked in a letter to Vasil'ev that the painting possessed "a soul."[62] This sanctification of Russian space began to form an important element of Russian realist landscape painting in subsequent years. Vasilii Polenov's overgrown Moscow backyard in the shadow of a splendid Orthodox church, in his painting *Moscow Courtyard* (1878), also won acclaim as an image of simple Russian space in the 1870s. Toward the end of the century, Isaak Levitan would repeat the motif many times over. Like *The Rooks Have Returned*, these paintings drew on the symbolically national and spiritual form of Orthodox towers and onion domes to help reinforce a consciousness of nationality and spirituality, usually in otherwise unremarkable locations. In these and many less well-known works by other landscape painters, Orthodox church architecture marked the unassuming corner of nature as one of the most significant, and most Russian, of landscapes. Savrasov, Shishkin, and Vasil'ev had succeeded in the attempt to reconstruct Russian space in the visual arts. In the process they laid the foundation for an iconography of landscape images that would offer Russians a new vision of the nation as natural space.

CHAPTER SIX

A Portrait of the Motherland

> I love the Russian landscape. You feel the meaning of Russian life, the Russian soul, better and more clearly against its background.
> —Mikhail Nesterov[1]

In the late 1850s, Mikhail Klodt still believed that the special character of Russia's landscape remained unknown to and unappreciated by most Russians, even including his fellow landscape painters. One of Klodt's student reports to the Imperial Academy of Arts charged Russian painters with the task of making it visible: "As it has in the past, Russia continues to be unknown; the beauty of its nature and its rich vegetation remain unfamiliar even to artists themselves. . . . What treasures it contains, we Russian artists must, at all costs, make widely known; we must present it to the judgment of our art experts."[2] Over the next two decades, Klodt and other landscape painters of his generation succeeded in the task he set for them. Not only did they manage to submit paintings of the Russian countryside to the judgment of the experts, they even helped make Russian landscape painting a favorite among the wider public.

Although the characteristic Russian ambiguity toward the beauty of the landscape was never fully overcome, by the mid-1870s assertions of the unique and admirable nature of rural Russia had become commonplace. Images of the countryside finally found their place at the center of the visual arts in urban Russia in venues ranging from exhibits to popular magazines. In the 1870s and 1880s, then, a new Russian "sense of place" came into its own as a widely accepted and integral feature of the culture of educated Russia. The consolidation and dissemination of the visual image of Russian landscape owed its greatest debt to its initial popularization at the Peredvizhniki exhibits. By widening the aesthetic appeal of the native countryside among educated Russians, the Peredvizhniki landscape painters aroused an interest in the national significance of Russia's natural environment. Yet in the end, the form taken by Russian landscape painting speaks most eloquently of the difficulties encountered in the attempt to construct

· 192 ·

an aesthetic image of rural Russia. If these paintings succeeded in creating a durable portrait of the Russian land, it was a vision that grew out of the lasting problems that beset Russian nationality itself. The complicated web of significance that underlay the creation and reception of these paintings forms the subject of the present chapter.

A NEW ROLE AND IMAGE

After its initial crystallization in the work of such artists as Shishkin, Vasil'ev, and Savrasov, by the early 1870s landscape painting had begun to assume greater importance in Russia's artistic culture. In 1872 a review in the journal *Conversation* [*Beseda*] saw the proliferation of new Russian landscape paintings as "a revolution similar to that accomplished by Pushkin, Gogol, Turgenev, and others in literary descriptions of nature." The reviewer, G. G. Urusov, attributed the success of landscape painting to the artists' newfound ability to convey "simplicity, truth, and unpretentious content, with a remarkably well-cultivated technique." He also noted their interest in making available to viewers "an especially native and familiar nature."[3] A few years later the more nationalistic Adrian Prakhov elevated landscape painting above other realist genres: "not one genre of painting in Russia has attained such a high degree of perfection . . . as landscape. This is the general consensus and it is unnecessary to prove it. Earlier and more decisively, Russian landscape painting turned down the *national path*."[4]

The previous chapter noted how the creation of a new landscape imagery resulted from a complicated process of technical innovation and cultural change. Of course those who enjoyed paintings at art exhibits, or in inexpensive reproductions in popular magazines, were more interested in emotional content than technical innovation. They tended to characterize their new appreciation of landscape in terms of an innate love for native places, expressed through the talent of the artist. Fedor Dostoevsky, for example, in his *Diary of a Writer* in 1873 cast the Russian landscapes at a Viennese exhibit in the light of a special Russian sensitivity to the native land. Characteristically, he added an explicitly nationalist dimension to his analysis:

> Of course I wouldn't say that in Europe they will not understand our landscape painters: views of the Crimea, the Caucasus, even of our steppes will certainly be curious to them. But then our Russian, primarily national, landscape—that is of the northern and central regions of our European Russia—will not, I think, produce much of an impression in Vienna. "This meager nature," the whole character of which consists, so to speak, in its lack of character is sweet and dear to us. Well, what do the Germans have to do with our feelings? Take for example these two

birches in the painting by Kuindzhi *(View on Valaam):* in the foreground is a swamp and some marshy brush, and in the background is a forest; from there are seen not clouds exactly but mist and moisture: moisture that seems to penetrate everything so that you almost feel it. In the middle, between you and the forest are two white birches, bright and firm—the strongest spot in the painting. Well, what's so special here? What is characteristic here? And yet how fine it is! . . . Perhaps I'm mistaken, but the Germans cannot love it so.[5]

Dostoevsky's response to Arkhip Kuindzhi's painting, and to the new landscape painting in general, allowed him to affirm his own nationality in such an intimate way as to isolate Russian consciousness from that of other Europeans. These simple, unpicturesque spaces, entirely lacking in "character," could only be enjoyed and admired by those who were deeply familiar with them, those who could respond to their inner mystery rather than focus on any outward manifestation of identifiable beauty. The meager nature of Kuindzhi's birches serves as a support for the vehement nationalism that would play such a large part in future pages of *Diary of a Writer.*

Dostoevsky was one among many Russians in the 1870s who had come to see the landscape as a means of identifying and asserting Russian nationality. Changes in the reception of landscape painting were predicated on large-scale transformations in Russian politics and society. By the time a school of Russian landscape painting had finally been established, circumstances for the reception of a national landscape imagery had been altered by the advent of the Great Reforms. Beginning in the 1860s with the abolition of serfdom, the autocracy instituted several policy reforms in an attempt to incorporate limited public participation in governmental affairs. To such forms of public involvement as jury trials, local elections, and greater journalistic freedom, Russians in the 1870s responded with varying degrees of enthusiasm and revolt. Some willingly contributed their "small deeds" of public service; others believed reform measures added up to too little too late. In part as a result of the reforms, a small but engaged reading public, and the shadowy rudiments of a mass culture, were beginning to take shape as the urban population expanded.[6]

The reforms and the response they engenderd lent the entire era a dynamic of alternation between hope and discouragement. In the wake of the emancipation, Russian society—from the autocracy to the radical intelligentsia (albeit in very different ways)—had committed itself to a restructuring of the nation. Taken as a whole, the reform era set for itself the mission of establishing the basis for a cohesive national community lacking the social dislocation and injustice serfdom had represented. But the task was daunting, if not insurmountable, in

part because of the tendency among Russians of different political leanings to gravitate toward radical solutions, further polarizing left from right and both from the center. It was this era that witnessed the assassination of Tsar Alexander II by terrorists on the left. It also saw the advent of some rather extreme forms of Russian nationalism, particularly with respect to pan-Slavic support of Serbia against Turkey in the Balkan Wars. The image and idea of a unique and deeply meaningful Russian landscape came to occupy an important position in public expressions of national identity during this same period. In a gentle, apolitical, and often very personal way, visions of "native nature" became a central figure in the construction of Russianness.

LANDSCAPE AND THE PEREDVIZHNIKI

While stern critics like Stasov had responded somewhat warily to the new Russian landscape painting, the growing public for Russian art willingly welcomed its arrival. As earlier mentioned, in 1870 realist artists established "The Association of Traveling Art Exhibits," i.e., the Peredvizhniki. This association of artists based its reputation as much on its commitment to the moral regeneration of Russian society as on its artistic talent. According to its leaders, realist painting served in part to promote beneficial civic or ethical ideals conducive to the amelioration of Russian life. This was a fairly open philosophy, and it meant something different to every artist who participated. The flexibility of the artist's position in the exhibiting association helps explain how landscape managed to become the best-represented genre at the exhibits.[7] The predominance of landscape seems odd in light of the self-interpretation (and subsequent Soviet celebration) of the Peredvizhniki, which has at times construed the entire movement as a form of social activism. The simple fact of the prominence of landscape painting at their exhibits renders problematic the common assumption that these painters constituted a politically and morally engaged movement in the arts.[8]

Certainly most of the founding members of the Peredvizhniki conceived of their association as a challenge to existing institutions, particularly to the Imperial Academy of Art's domination of the lives and work of Russian artists. Furthermore, Russian artists followed in the footsteps of the politically engaged Russian writer. In the words of Elizabeth Valkenier, the foremost non-Russian specialist on the Peredvizhniki: "The disposition to consider art not as an autonomous realm but as intertwined with 'life'—as primarily expressing extrinsic moral, civic, or national values, not intrinsic esthetic qualities—is a pronounced Russian trait."[9] The original platform of the Peredvizhniki nevertheless neglected to include any special content requirements for the works exhibited.

The platform was explicit, on the other hand, in settling questions of sales and receipts. In a founding document from 1869 it summed up the primary goal of the association in the following decree:

> The establishment of the Association of Traveling Exhibits has as its aim: to provide the inhabitants of the provinces with the opportunity to follow the attainments of Russian art. By such means the association, in the attempt to widen the circle of art lovers, will open up new avenues for the sale of artistic works.[10]

Quite sensibly, the attempt to sell their own work was at, or near, the top of the agenda for the realist painters. Financial success would allow artists finally to free themselves from the conservative surveillance of and dependence on the academy. Attempts to interest the buying public supported the Peredvizhniki fundamental goal of achieving artistic and financial independence. In short, Russian realist painting operated within a market, and over the years it realized its financial aims in admirable fashion. It attained the financial success it sought within about a decade of its founding. Whereas visitors numbered around 30,000 at the first exhibit in 1871, by the 1880s the number of visitors ultimately reached levels of between 100,000 and 170,000. Ticket revenues rose from about 6,000 rubles to as high as 25,000 rubles. The sale of paintings also began modestly at around 23,000 rubles, but by the mid-1880s receipts from sales of artworks eventually quadrupled to almost 95,000 rubles on two separate occasions.[11] Since only 5 percent of sales redounded to the association, the association itself cannot be called a financial success, but it did facilitate respectable profits for a number of individual artists.[12]

As the most popular genre among collectors, landscape painting was integral to the goal of drawing in wealthy buyers. From the outset, the Peredvizhniki landscapes asserted a degree of realism and an interest in national motifs that separated them from the landscape painting at the academy. In this respect, at least, they satisfied progressive critics who, as we have seen, were not predisposed to welcome the genre of landscape. Such critics were, however, generally willing to accept landscape painting on practical grounds. Since it brought viewers and buyers to the realists' exhibits it helped support the entire movement and could be politely admired while relegated to a secondary position. Stasov, for instance, always praised landscapes for their strict fidelity to nature and their evocation of nationality, but he usually mentioned them only briefly at the tail end of his reviews. The fact that none of the Peredvizhniki painters exhibited still lifes suggests the degree to which landscape was on shaky ground with leftist critics for its dangerous proximity to the reviled notion of art for its own sake.

Russian realist landscape painting thus developed under certain restrictions. It had to justify itself as a form of moral or civic realism even as it sought admiration from the general public and more conservative reviewers, who were inclined to admire landscape paintings for their expression of such "artistic" intangibles as sensibility, mood, poetry, lyricism, etc. On the whole, realist landscape painters were able to satisfy these contradictory requirements by producing canvases that emphasized Russian nationality. They drew on and extended the celebration of Russian landscape that began in Russian prose and poetry during the first half of the century. The vast majority of the Peredvizhniki landscapes depicted northern and central Russian settings and expressed, in the visual language described in the previous chapter, the simple, uncultivated spaces and the open, level plains that originally had comprised the image of native landscape in Russian literature.

This approach proved remarkably successful and durable. Even as some of the critical and reformist edge of genre painting diminished in the 1880s, Russian landscape painters continued to produce images in a nationalistic vein. The public did not require dramatic or exotic locations to satisfy its interest in landscape. In fact, the realists' approach to the national landscape so dominated public attention that contemporary painters associated with the academy and considered conservative and traditional—such as Orlovskii, A. I. Meshcherskii, K. Ia. Kryzhitskii, I. E. Krachkovskii, and Iu.Iu. Klever—developed approaches to the native landscape quite similar to those pioneered by Savrasov, Shishkin, and Vasil'ev. By the 1870s, a shift among almost every significant Russian landscape painter to national themes and a recognizable national aesthetic had taken place. Although, to be sure, the taste of such an amorphous collective as "the public" is an elusive object to gauge, based on the paintings that were popular in the 1870s and 1880s, it is difficult to refrain from the conclusion that depictions of rural Russia as rough and rustic, vast and empty, bleak and gray, yet suffused with feelings of nationality and nostalgia, came to occupy the attention of the large majority of Russians interested in art.

This new landscape imagery was also brought to the attention of the public through venues other than art exhibits. Most importantly, from around the mid-1870s, magazines such as *Grainfield* [*Niva*], *Worldwide Illustration* [*Vsemirnaia Illiustratsiia*], and *Picturesque Survey* [*Zhivopisnoe Obozrenie*] regularly produced engravings of similar such landscapes, often from works by the Peredvizhniki painters themselves.[13] The magazines praised these reproductions for their beauty and service to Russia. Through popular journals, new images of Russia acquired an audience larger than that found even at the well-attended art exhibits. In addition, some landscape painters organized independent exhibits, or sold books of their own engravings.[14] In this way, the

more prolific landscape painters, such as Shishkin, Kuindzhi, and Klever, achieved notable financial success among their peers.[15]

THE NATIONALITY OF RUSSIAN LANDSCAPE

One of the remarkable characteristics of the landscape image is its ability to carry a multiplicity of potential meanings. This multivalent quality ought to be kept in mind in the case of Russian painting as much as it would in reference to the work of any other school. As argued below, expressions of nationality formed the central motif of Russian landscape painting throughout the last third of the century. It should be mentioned from the outset, however, that concern for the distinctive Russianness of these images did not necessarily eclipse a more general interest in nature as a universal phenomenon. These separate strands were so wholly intertwined with one another in Russian painting that at times it is difficult to disentangle the one from the other. Realist landscape painters often understood their work in the familiar, supranational terms of a devotion to nature in the abstract. Aleksei Savrasov, for instance, was said to have frequently repeated to his landscape class that above all they must cultivate an admiration for the natural world. "You must be in love with nature," he explained to his students; "only then is it possible to paint."[16] For his part, Vasil'ev saw landscape painters as spiritual pilgrims "searching for harmony, purity, and holiness, instinctively becoming devotees of nature—not finding anything so complete in man."[17]

In some ways the notion of a universal nature occupied the attention of Russian landscape painters even more than it interested landscape painters elsewhere. In contrast to the impressionists, their contemporaries in France, Russian painters rarely made a point of depicting specific localities. While the impressionists often chose to title their paintings after the location of the place represented, the Russian realists gave titles to their paintings that reflected general conditions, i.e., *Morning in a Pine Forest, After the Rain, Birch Grove*. They also drew on Russian common knowledge for their titles, such as proverbs or familiar lines from folk songs. Where much realist painting consciously sought to limit its vision to specific locations or isolated moments in time, the Russian titles prepared viewers to see landscapes as part of a larger whole. It is known, for example, that *The Rooks Have Returned* was painted in a small village overlooking the Volga not far from Iaroslavl. But that information had to be pieced together later by art historians. Savrasov offered his viewers no information about the geographical location or historical moment of the image other than the evident fact of its being somewhere in central Russia. He wanted his painting to summarize an experience common throughout northern and central Russia.

This image might have been observed without alteration for generations before his time, and presumably after it as well.

In this sense, Russian realist landscape painters were more closely linked to the romantic, pastoral vision of the Barbizon school. Both the Barbizon and the Russian painters saw nature as a corrective to modern life, a separate world into which one might escape from the constraints of time and place. In a romantic phase early in his career, Shishkin had made distinctions between nature and history after studying some historical paintings in Prague:

> I'm already bored by all these heroic deeds and whims of kings, whether secular or spiritual. All this has passed, thank God. It's carrion. I would sooner go to nature [*natura*], to the fire of a beautiful little sun. Nature [*priroda*] is always new, not stained in the same way, and it's always prepared to offer up its unending store of gifts that we call life. What could be better than nature [*priroda*]? Certainly not the distorted exploits of mankind! I just get bored and annoyed as soon as I see all this history; history alas![18]

Shishkin's nature was a realm that transcended time and place, and this desire for transcendence provided a common frame for the admiration of the new Russian landscape painting. Kramskoi, for instance, admired Vasil'ev's *The Thaw* as "decidedly new, but with roots somewhere far away."[19]

The profusion of natural forms in the foregrounds of Shishkin's paintings in some ways evinced a universal, rather than specifically Russian, relationship to nature. Shishkin's forests sprawl in every direction. Trees spill outside the frames of the paintings and overlap each other into the interior until it becomes impossible to differentiate one from another [see fig. 14]. The abundance of weeds, or wildflowers, or moss serves to remind us of nature's seemingly inexhaustible richness. At the same time, Shishkin filled his forests with natural memento mori. Dead branches, fallen trees, and decaying vegetation occupy a prominent position in almost all of these landscapes. And yet again mushrooms grow out of a dead stump, and saplings stand next to fallen trees. Growth, decay, death, and rebirth all play a part in the drama of these wild and overgrown forest floors. Shishkin's landscapes call to mind the eternal recurrence of natural phenomena; life and death compete with each other, replace each other, and persist in a world more durable than that of humanity. Like the flowers that peer over Bazarov's grave at the end of Turgenev's *Fathers and Sons*, Shishkin's natural phenomena "tell us not of eternal peace alone, of that great peace of 'indifferent' nature; they tell us, too, of eternal reconciliation and of life without end."[20]

Just as Shishkin's uncultivated Russian forests offer a potential entry point into a more profound relationship to time and space, other Peredvizhniki painters produced landscapes that frame nature as a universal and abstract phenomenon. N. N. Dubovskii, for example, painted some of the more powerful images of vast open space to appear at the Peredvizhniki exhibits. It is clear from such paintings as his *Native Land* that he could conceive of such space as a symbol of nationality. At other times, he was capable of presenting vast open space from a different perspective, which he referred to as pantheistic. "I saw a magnificent picture," he recalled, "clouds, as if over the ocean, and everything rose higher and higher to infinity; you feel your insignificance before [this picture], and at the same time your spirit vaporizes in the boundless vastness. Everything is endlessly magnificent—this is immortality."[21] Vasil'ev could express himself in a similarly ecstatic manner with regard to the transcendant capacity within the natural world. Not long before his death he described his rapture over Crimean scenery in a letter to Kramskoi:

> If one could paint a picture, consisting of this blue air, these mountains, without any clouds, and convey it just as it appears in nature, then I'm certain the criminal thoughts of a man, gazing at this picture full of the abundance and endless solemnity and purity of nature, would be torn away and reveal him in all his ugly nakedness.[22]

Such visions of nature's universal grandeur and ascendancy over humanity did not necessarily exclude the national dimension; instead they often implied a deeper relationship between Russians and their native land. Although Shishkin usually painted a forest devoid of human forms, the figure in Slavic dress and beard that appears in *Countess Mordvinova's Forest, Peterhof* [fig. 18] embodies this ideal relationship between man and nature. Walking through the woods, stick in hand, the figure is dwarfed by the immensity of the wall of pines behind him. Even the pine sapling to his right, a mere wisp relative to the full-grown pines, rises higher than his head. He is embedded, as are the viewers of this painting, in the variegated forms of the forest floor. In his somber coat, he himself seems to constitute one small part of the forest world. In terms of visual effect, he is literally "close to nature." His age is meant to suggest a kind of Slavic wisdom, perhaps, but it also implies, by contrast to the immensity of the forest, that human life is brief. He represents Shishkin's feeling of "annihilation" and "insignificance" in the forest. In the sense that he seems to fit naturally into the forest scenery he embodies an ideal that hearkens back to both Aksakov and Rousseau, wherein a person learns to accept human insignificance in the face of nature.[23]

As much as landscape painting encouraged abstract contemplation of life and the elements, the question of the landscape's Russianness, the desire to celebrate native nature, remained at the top of the agenda for realist landscape painters. Russian painters of this era often betrayed an acute awareness of their identity and calling specifically as Russian artists. One of Savrasov's students, Isaak Levitan, the most prominent Russian landscape painter during the waning years of the nineteenth century, reinterpreted what Savrasov had called "love of nature" as love of the native land. In an obituary published shortly after Savrasov's death in 1897, Levitan framed his admiration for Savrasov's artistic achievements in terms of his devotion to Russia:

> In Russian landscape before Savrasov reigned the pseudoclassical and romantic orientation; Vorob'ev, Shternberg, Lebedev, Shchedrin—these were all people of great talent who were nevertheless entirely, so to speak, ungrounded. They searched for the motifs of their paintings outside of Russia, their native country, and mainly considered landscape to be beautiful compositions of line and form. Savrasov radically refuted this relation to landscape, choosing what were not exclusively beautiful places for the subjects of his paintings but, on the contrary, trying to find in the most simple and ordinary those intimate, deeply moving, often sad traits that are felt so strongly in our native landscape and that so irresistibly act upon the soul. With Savrasov appeared lyricism in the painting of landscape and an endless love for his native land.[24]

Although he is often regarded as one of the landscape painters who moved away from a consuming interest in nationality, Levitan himself regularly received praise for his ability to convey in his work that which appeared uniquely Russian. His friend and fellow landscape painter Konstantin Korovin, for instance, referred to him as "the poet of Russian nature."[25] Another painter, Konstantin Iuon, said of Levitan that he "felt in all its intensity the unutterable fascination of the word Motherland [*Rodina*], and in his pictures he managed to convey his love for it, simple and plain, beautiful in its frankness."[26]

It was Shishkin who most clearly exemplified to contemporaries this special connection to the native terrain. "Shishkin's forest," one Soviet art historian has written, "ceased to be merely a phenomenon of nature; it became a part of real life, inextricably linked with our love for native nature."[27] Shishkin conceived of his artistic mission essentially as service to the native land. He took this calling seriously as is evident in the statement below, a synopsis of his aims as an artist. Shishkin attempts here to connect the local landscape to the larger national community in defining the role of Russian landscape painting.

This statement to his students comes closer than any other to a programmatic exposition of the intentions behind his work:

> The painting must be a complete illusion. This is impossible to achieve without thorough study of the chosen subject for which the artist feels the greatest attraction, and which remains in his memory from childhood, i.e., the landscape must be not only national, but also local. As a guarantee of all I've said I place my long years of experience and all my desire to serve the native landscape. I hope there will come a time when all Russian nature, alive and inspired, will look out from the canvases of Russian artists.[28]

The shorthand used in this passage to describe a complex set of assumptions requires a good deal of unpacking. Precise replication of the subject matter was, Shishkin makes clear, the result of his "desire to serve the native landscape." This statement is confusing in part because of the dual meaning of the word landscape. "To serve the landscape" meant to re-create images of nature inspired enough to make the viewer recall actual Russian terrain, or simply "Russian nature" (also metaphorically capable of existing on canvas). Thus, landscape here referred first to the painted images that Shishkin and other artists created and exhibited, but the term also served as a form of synecdoche for the entire terrain of (at the very least) northern and central European Russia. Shishkin, then, considered his images to be closely allied in spirit to that which they represented.

The above statement should help elucidate the place of realism in Russian landscape painting. It did not follow the French paradigm and move toward the depiction of modern life. In Russian landscape painting, verisimilitude was important for another reason. Naturalistic images of Russian nature facilitated the transition in the mind of the viewer between painted images and actual spaces. In this way, they enabled viewers to establish a close identification with Russian terrain. Magazines that included illustrations of artwork, such as *Grainfield* or *The Bee* [*Pchela*], usually appended their own interpretations of that work. Quite often in these interpretations the signifier was entirely equated with the signified. If you want to see the "real" Ukrainian night, advised *The Bee*, "go to the exhibit of the Peredvizhniki" to look at Kuindzhi's painting.[29] To see one of Shishkin's engravings of a forest landscape was tantamount to experiencing the forest itself: "You stand for hours concentrating on this isolated corner, you thoughtfully wander beneath these trees . . . you really feel as if you've pushed your way through the woods."[30]

But why would the viewer take an interest in the landscape in the first place? In Shishkin's statement, the mechanism that encouraged

· 202 ·

viewers to identify with Russian terrain was childhood memory. The idea of childhood in nineteenth-century Russia shared certain features in common with the blanket concepts "nature" and "the people." In Aksakov's *Family Chronicle,* for example, childhood memories of nature lent to the experience of the scion of a wealthy landowning family nearly universal appeal because the experience of childhood could stand for the experience of all Russians.[31] In Turgenev's "Bezhin Meadow" and a number of Nekrasov's poems, the reader gained a refreshed perception of nature through the eyes of peasant children.[32] Like idealized visions of nature and Russian rural life, childhood symbolized an ontological state prior to social division and the harmful effects of "history" or the introduction of Western civilization.[33]

For Shishkin, childhood memory referred to perception. Childhood perception established the artist's true bond with nature, i.e., the "subject for which the artist feels the greatest attraction." Of necessity, childhood memory rooted the Russian landscape painter in the specific localities and subjects of rural Russia. Representative of a universal link between all classes of Russians, impressions and recollections from childhood washed clean the divisions of the adult world and brought fresh perceptual innocence to the artist and viewers alike. In the process it authenticated that perception as genuine because childhood, like nature, was unspoiled by society. In this sense the local and the national were connected to one another within the common perceptions of the artist and the viewer. To Shishkin the relationship between Russians and Russian nature, forged in childhood, provided a common bond that could be activated by the landscape image.

Shishkin went so far as to say that Russians possessed a unique gift for understanding nature that would eventually enable them to raise landscape painting to a higher level than had yet been attained in Europe. This conviction derived from the notion that Russians were closer to nature because nature played a more dominant role in the lives of Russians than of other Europeans. One of his students reported the following conversation:

> Shishkin said about landscape that it is the youngest art form, since only a few years have passed from the time when people began to understand and study the life of nature; the former great masters were at a loss before trees, and a man out in nature is so minute and insignificant that he can't possibly have an advantage. Don't you really feel yourself to be weak and annihilated in the forest, and aren't you aware that you form only some insignificant part of this imperturbable and eternal nature? . . . In the future will come an artist who will do miracles, and he will be Russian because Russia is a country of landscape.[34]

Thus Shishkin's paintings, while responsive to a universal conception of nature's majesty and grandeur, were also conceived of as an especially Russian art form. On the reverse of the painting *Near Elabuga* he scribbled the words: "Open space, freedom, land, rye, God's blessing, Russia's wealth."[35]

Shishkin's entire oeuvre, including the numerous forest interiors, constituted parts of a larger whole—his vision of the nation. This devotion to Russia was not lost on contemporary critics, who often admired his landscapes precisely for their "national" character. He possessed "national originality,"[36] or managed to convey the feeling of "native, intoxicating Russian summer."[37] Many critics echoed Shishkin in directly linking images of landscape to the concept of Russian nationality. Prakhov, the critic who also published *The Bee,* credited Shishkin as the first painter to give a "place of honor" to "the real beauty of the all-Russian landscape."[38] Stasov, referred to Shishkin as an "artist of the people" [*khudozhnik narodnyi*] because "all his life he studied the Russian, mainly northern, forest."[39] Prakhov's admiration for the landscapes Shishkin sent to the Paris World's Fair in 1878 demonstrates the degree to which Shishkin's apparently unmediated style could be interpreted as a reflection of nationality. These landscapes were

> deeply national [*narodnyi*], healthy, serious, and severe, like northern nature itself. Shishkin is not caught up in picturesque [*milovidnyi*], so to say, genre motifs of nature, in which the severity of the landscape is softened by the presence of domestic animals or people. Neither is he wrapped up in the incidental effects of light, like a man who has only known the forest for an instant. No, he's like a true son of the wilds of the northern forest, in love with this impenetrable, severe wilderness, with its pines and firs, stretching to the sky, with the mute, untamed hinterlands of the gigantic trees. . . . He's in love with the distinctive character of each tree, each bush, and each blade of grass, and like a loving son he values each wrinkle on his mother's face.[40]

The link between nationality and nature in Shishkin's work must be seen as one possibility on a continuum of developing constructions of Russian national identity. In many ways his vision of Russianness is most interesting for what it is not. It does not rely directly on either of the two predominant forms of national identity in nineteenth-century Russia. It ignores the traditional institutions of Orthodoxy and autocracy, and it detours around the Slavophile and populist idealization of the peasantry. Although he celebrated a special Russian relationship to the countryside, Shishkin's ideas and style were developed within the newly established urban, public context of the late nineteenth century. Shishkin himself actually lived in Moscow and Petersburg most of his

adult life, and we must not forget that his landscapes came into being in the context of the burgeoning market for Russian art that arose roughly simultaneously with his career.

Hence the paradoxical nature of these paintings. Shishkin's formulation of a new vision of national identity was novel precisely because it originated in an unprecedented set of cultural and social circumstances. His paintings did not portray the landscape of the laboring peasant as had so many mid-nineteenth-century literary descriptions.[41] Instead, with a few exceptions, they depicted the Russian land as removed wilderness. It should not be surprising that this idealization of the forest would have been formulated by an inhabitant of the city who conceived of nature as something external to the realm of ordinary experience. His landscape was *not* that of a rural inhabitant who saw land for its use value, but the landscape of an urbanite who saw nature as antithetical to life in the city.[42]

Yet, if it was the landscape of an urban consciousness, it was also steeped in preexisting Russian national mythology. In a culture that had idealized pastoral simplicity and rural life as the fundamental contrast to an urban sphere corrupted by Western values, Shishkin's representations of Russian nature offered his audiences of city-dwellers a chance to partake in appreciation of the rural values and spirit of the nation, an opportunity to feel themselves embedded in the isolated spaces of the largest nation in the world, which they observed from a detached, urban setting. His paintings spoke in a language similar to that of the liberal thinker Boris Chicherin, reminiscing about Russia on a trip abroad:

> Only in Russia, where the land is so immense and the population so sparse, where men have not everywhere laid their hands on nature, where they have not mastered it but have only touched it lightly, leaving it for the most part in its original state, is there real country. . . . There one can live with nature peacefully and tranquilly.[43]

By creating numerous realistic scenes of simple Russian forests and fields that stood as symbols of Russian nationality, Shishkin invited urban Russians to imagine a profound connection between themselves and their natural surroundings. What was new in Shishkin's work was the attempt to erase the distance between the Russian individual and Russian terrain to the extent that the land itself could be loved with the unquestioned familial affection of a son for his mother, in Prakhov's gendered formulation, or a child for his local surroundings, in Shishkin's terms. This is an important step in the development of Russian identity. Shishkin's landscapes contributed to a naturalization of the nation. They proposed that the nation could now be appreciated specifically as a geographical entity without special reference to tsar or people. If love

of country can be made to signify love of the land itself, national identity becomes a more stable property within a modern context, no longer subject to the vicissitudes of uncertain human institutions.

Shishkin was one of the most widely admired landscape painters of the 1870s and 1880s. He received a large share of personal acclaim for his work. Like Shishkin, virtually all Russian landscape painters of this era valued their work as contributions to the native land. Not only were Russian landscapes often rather monumental in size (reaching 10–12 feet in height or width), but at one time or another many of the Peredvizhniki painters produced programmatic landscapes intended to be viewed as essential summaries of the native land. From Shishkin's *Rye*, to paintings entitled *Motherland* by both Dubovskii and Apollonarii Vasnetsov, to Levitan's *Lake* (also called *Rus'*), Russian landscape painters sometimes sought to encapsulate symbolically the entirety of the land within a single image. Although the work of Shishkin differed in many respects, Levitan seemed to echo Shishkin's attitude about landscape painting in a letter to Vasnetsov. Writing in the spring of 1894 from Nice, Levitan dreamed of his native land: "I imagine how beautiful it is at home in Russia now—the rivers are overflowing, everything is coming to life. . . . There is no better country than Russia! Only in Russia is it possible to be a real landscape painter."[44]

For some Russian painters the former hierarchy of northern nature as subordinate to southern had been so completely overthrown by the late nineteenth century that southern landscape could appear positively distasteful. The kind of space found in the Russian countryside surpassed all others for its beauty and characteristic features. One of Shishkin's students, N. N. Khokhriakov, professed a reaction antithetical to that of those Russian travelers previously noted who during the first half of the century were drawn to the splendor of southern climates:

> What profound beauty there is here! How real it is! I was in the south, at the Crimea, but after two or three months I came to feel neglected, alone. I missed our northern nature so much; I wanted to forget everything, the burning sky and the blue sea. At first I'd been attracted to the exotic colors, but then I grew cold. I couldn't look at this brightness. I couldn't wait to get back to my native land.[45]

Of course Russian realist landscape painters should not be seen as a monolithic group. They perceived their chosen subjects in different ways, expressed their vision in different idioms, and had different goals in expressing it. Art historians have rightly celebrated these differences. But when viewing their collective contribution to larger trends in Russian cultural history one cannot help but feel impressed by the striking resemblances and commonalities in their work. Celebration of the spe-

cial character of the native land became the essential goal for Russian realist landscape painters during the 1870s and 1880s. The expression of nationality particularly concerned artists like Shishkin or Klodt, associated with the civic calling of the Peredvizhniki movement, but it would also become a significant factor in academic circles once the public had proclaimed its admiration for this kind of painting. A review of the academic painter K. Ia. Kryzhitskii's posthumous exhibit praised him in a manner similar to the way in which critics had valued the work of the Peredvizhniki: "Kryzhitskii has come into view as a remarkable, national Russian artist, able to express with striking poetry the boundlessness of the Russian plain, that Russian distance that beckons with its wide freedom [*prostor*] and its mystery [*neizvestnost'*], and in which, it seems, lies hidden so many unknown aspirations."[46]

RETHINKING RUSSIAN SCENERY

The abiding emphasis on nationality in Russian landscape painting was inseparable from the special conditions of artistic production in Russia. Russian painters found themselves in a peculiar position. They painted in what had originally been Western genres and traditions, but the social and cultural context in which they worked differed from that of western Europe. Russian artists were expected, and often expected themselves, to produce distinct, non-European compositions. To be sure, the European art world could be driven by a model of center and periphery (with Paris typically at the center), and this tension helped encourage an interest throughout Europe in local and national forms of art. The prevailing dichotomy in Russia went somewhat further, separating Russia from Europe as a whole. In this context, Russian artists experienced heightened pressure to produce work that possessed "national originality." This emphasis, not unlike that which developed in the arts of the United States, ensured that nagging questions about the Russianness of their paintings would loom over Russian artists.

The problem was compounded for some landscape painters by the fact that much of Russia had not yet fully overcome its anxiety about the lack of physical beauty or picturesqueness in the countryside, even as the landscape was more and more celebrated in educated circles. The experience of the landscape painter Lev Kamenev is instructive in this respect. After the 1860s, Kamenev's typically bleak evocations of the Russian village in raw and bitter weather never managed to inspire much of a public. He died destitute in 1876. In a sardonic passage from Konstantin Korovin's reminicences, quite at odds with the views of Shishkin, Kamenev expresses his bitterness in a warning to protect the young Korovin from the folly of trying to become a landscape painter in Russia:

Landscape is thought to be Swiss views: there have to be mountains and sheep. Is there really landscape in Russia? No. Rich people try to go abroad. The real views are over there. But we have none. We only have monotony. I'm telling you the truth. They don't see their own beauty. They don't see it, and they grow bored. Just recently I was at Vasil'chikov, not far from here. A wonderful estate, and what a garden! The young lady came out to me, her head wrapped in a towel, pale, with a migraine from boredom. "I can't wait," she said, "to leave with my husband for Baden-Baden." So I told her, "What do you mean, Mar'ia Sergeevna, look around—such beauty, spring, an alley of lindens. Such shade all the way to the river. And the river is radiant." Suddenly she says to me: "If you want to keep talking to me like this, I'll get angry. It's boring. There are no real paths here along which one can stroll beneath a parasol. Such melancholy."[47]

Among the Russian public it seems that only a thin line divided the new vision of an admirably and nostalgically melancholy landscape from the older conception of an outright bland and ugly countryside. According to Korovin, the young Levitan's relatives encouraged him to paint subjects that expressed an appreciation for modern, urban life: "Paint dachas, a platform, a moving train, flowers, or Moscow," they instructed him. They were disappointed by his actual choice of themes: "you paint a gray day, autumn, the woods. Who needs that? It's boring. This is Russia, not Switzerland. What kind of landscapes are there here?"[48]

Landscape painters had to fight the same uphill battle that Russian travel writers had long been waging. In the early twentieth century, a painter by the name of A. K. Denisov-Uralskii, a native of the Ural Mountains, organized an exhibition that included both his own landscapes of the Urals and a collection of minerals from the region. The exhibit included geographical information about the mountains along with landscape paintings portraying them. Intermixing geographical and aesthetic approaches to the utmost, one "landscape" actually depicted the mountain range from "a height of five or six versts"![49] Like the Chernetsov brothers' Volga panorama, Denisov-Uralskii's exhibit on the Urals sought to arouse interest in a specific region as a stimulus to appreciation of the entire country. The language of his accompanying publication echoed the defensiveness we have so often encountered: "Our natural surroundings are of little interest to us and seem foreign. But if we devoted some time to the study of our native land, then our relationship to it would surely change."[50]

One reviewer struck a similarly defensive posture in an 1876 article on Russian landscape painting. A. S. Shkliarevskii's review of the fourth Peredvizhniki exhibit managed to unite a similar disenchantment with

a new kind of admiration in its crafty discussion of Russian landscape. At first Shkliarevskii accepted as a point of fact that Russian space was aesthetically unappealing:

> There is no doubt that of all the European countries Russia, all in all, belongs among the least picturesque. Our endless, waterless, monotonous plains . . . are bundled up for half the year in the snowy shroud of winter, with towns and cities scattered about it like dots on the empty flatness. The eyes have much less reason to develop an instinctive feel for nature's beauty than in countries that are more fortunate than us in this regard.[51]

But if Shkliarevskii was willing to consent that Russia did not possess an appealing natural environment, he also argued that such a conception of beauty was inconsequential to landscape painting in Russia. The appreciation of nature had to do with the relationship between a people and its territory. It was a mistake to overvalue aesthetic qualities developed in Europe, and named with foreign words like *"landshaft"* and *"peizazh."* At the Peredvizhniki exhibit, his fellow countrymen would "find proof of the honest study of nature and the often successful conveyance of the impression produced by our very own Russian landscape, to which we must harness our feeling for nature's beauty."[52]

The appreciation of landscape, in Shkliarevskii's view, did not require a fondness for picturesque scenery as it did in Europe. Like Montesquieu, he saw the human relationship to nature as a bond dependent on regional or national origin. The mountainous landscapes prized at foreign art exhibits, then, were themselves foreign to Russian sensibilities. Unlike in western Europe, he pointed out, "no catastrophe has yet to any considerable degree disrupted [Russia's] mainly horizontal arrangement." The Russian landscape was formed as a "continental ocean," in which sense it resembled Dutch landscape. But Russian terrain possessed its own unique character: "the Russian landscape . . . is an original landscape and the artist can study it only in unmediated contact with nature."[53] Shkliarevskii felt that the painting <u>Orenburg Steppe</u> by the little known S. N. Ammosov recalled Russian nature in its most extreme and characteristic form—in the southern steppe region. This landscape could not be called beautiful according to the usual understanding of scenic beauty. For those who inhabit it, however, "it is not an evil stepmother but a dear, natural mother [*rodnaia mat'*]."[54]

Here Shkliarevskii resorted to the idea of motherhood in order to express the relationship between Russians and their land. Prakhov had used the same notion to convey the depth of Shishkin's love for Russia. As noted earlier, the use of gendered language to discuss landscape has been common in many cultures. The landscape assumes the role of the beautiful, passive, reclining object; its admirer adopts the masculine

role of active observer. In the late nineteenth century, to describe the native terrain Russians more commonly invoked metaphors of motherhood than of erotic attraction. This was no doubt partly adapted from the traditional folk culture appeal to the land (or parts of it like the Volga River) as a nourishing mother.[55] But within the public discourse of urban Russia, such appeals to the idea of motherhood were often used to reinforce the sense of national identity.

For Prakhov and Shkliarevskii the analogy of a filial relationship between the individual and the landscape suggested affection for a terrain not considered physically attractive but emotionally sympathetic and deeply loved. It presupposed a familial connection between the viewer and the nation. The appeal to motherhood carried the implication that the entire nation could be experienced as an interrelated family group, held together in part by an emotional connection to the shared mother, the land. Admiration for that mother/landscape could only gain credence by the notion that the land was unattractive. The less superficial the source of love for the mother, the more profound the individual's and the community's adoration must be. In this way, since all Russians were invited to join in this admiration of the mother/landscape, such readings helped encourage a vision of the nation as, in Michelet's terms, "une famille, une cité commune entre les vivant et les morts."[56]

Once Russian landscape painters had created a new visual imagery capable of celebrating the Russian countryside on canvas, critics like Shkliarevskii and Prakhov began to work out a theoretical basis capable of supporting the development of this new landscape painting. A zoologist by the name of N. K. Vagner published another critical appraisal of the rise of Russian landscape painting in 1873. Like Shkliarevskii, Vagner derived his position from what he called the "tribal or national requirements of taste." The appreciation of landscape depended primarily on the viewer's country of origin. Style and technique, Vagner held, mattered less than nationality in the viewer's empathy for a given image:

> It is not important to the viewer that a landscape be classical or realist, that it reproduce nature in all its truth, or be extremely beautiful. It is important that it answer his inner strivings, his personal taste. No matter how beautiful the landscape of southern nature, the inhabitant of the north, never having seen southern vegetation or bright colors, will admire them, but to him sincere delight will remain hidden in our northern nature.[57]

Unlike Shkliarevskii, Vagner argued that, in light of the tremendous variety contained within all the regions of the tsarist empire, Russia possessed as much traditionally picturesque beauty and variety as any European country. In this respect, he identified no characteristic national space. The proper character of the national landscape, however,

had to be located "in those places in which [a people] developed and took form; in this character is found the common particularities of any national landscape, including that of Russia."[58] In Russia's case, according to Vagner, the most characteristic national landscape was the steppe, or the open plains. In order to describe the relationship of this terrain to the character of the people, he invokes Turgenev's story "The Singers," mentioned above, in which a Russian peasant singer inspires a passionate sense of identification between his audience and the open steppe. Vagner expands on this notion. For Russians the steppe conjures up a lack of inhibition [*razgul*], open space, this boundless freedom, where a man almost dissolves into the impersonal, spontaneous powers of nature." Just as Turgenev had referred to this feeling as a Russian "birthright," Vagner adds that in the singer's voice "can be heard the sound of that ardent Russian soul, which finds an echo of itself only in the boundless and endless."[59]

Vagner's identification of the landscape and the national character emerges from the deep-rooted historical interconnection of geography and folk culture:

> Such is the character of the Russian song; such must be the character of the Russian landscape. Endless plains, hilly or entirely flat; the steppes, those plains that gave rise to the Russian bogatyr's bravery, and Russia's passionate, unbounded sympathy. They must determine the character of the landscape. Boundlessness is its essential condition. The horizon intermingles with the sky. It goes out into that endless distance, toward which Russian song strives.[60]

Vagner here readjusts the usual argument that this unbeautiful landscape is admirable because it is familiar to all who live on it. In his terms, the form in which Russia's landscape appears in literature and painting was forged by the experiences of the Russian people; its image lives as a sort of archetype, in the ur-memory of the entire population. The landscape itself does not serve as a locus of commonality between the peasants and the urbanized elite. Here the land has worked its way so deeply into the people's consciousness that peasant songs and tales have brought to life the essentially Russian admiration for the properties of the national terrain.

This argument allows Vagner to introduce the *narod* into his vision of the landscape. In the familiar language of populist idealization, he puts forward his own conception of Russian terrain as a way to celebrate the peasantry. Describing a view from the Urals he writes, "here one instinctively feels a kind of endless breadth, the power of a severe and wild nature, which is entirely reflected in the sullen ways of the northern peasant, in his mournful songs, full of deep and poetic feeling."[61] Such

allusions to folk music and peasant character again allow Vagner to identify the urban love of landscape, acquired through aesthetic training, as essentially at one with that of the *narod*. But just as he needed to rely on a Turgenev story to connect the landscape to peasant song, he quotes Nekrasov to establish a link between the peasant and the land:

> Everyone who has had the opportunity to travel through Russia is familiar with these plains, covered lightly with pine forests, or with birch and aspen:
>
> > Fir, and sand, birch forest, and aspen
> > Unhappy you are, native picture
>
> But under the influence of this picture was formed the soul of the Russian people. To them it is truly "native." It is a purely natural terrain, where nature itself is in charge of forest management. Wild, unproductive, uncultivated, and unplanted, it is striking in its enormous spaces, its empty, monotonous, untouched freshness. Here thinly and lightly hilly, with little ravines, there entirely low-lying, flat, damp, and swampy—it spreads itself out in an enormous expanse, almost everywhere in northern and central Russia . . . it unfolds before the artist a wide canvas, with rich, poetic themes, and with the most varied tones.[62]

Vagner comes to dismiss his initial contention that the whole empire provides an enormous palette of different climates and terrains for the artist to make use of. He encourages painters to interest themselves in the specific vision of central European Russia, which he believes to be present in folk song and which remains embedded deep in the collective memory of educated society. The Russian landscape painter should concentrate on the "unhappy native picture" made meaningful through the experiences of the Russian people. But note that Vagner addresses readers who know this terrain only because they have "had the opportunity to travel through Russia." In the same way that Belinskii transformed Kol'tsov's poetry into legend by treating it as a wellspring of peasant culture, Vagner reads this landscape as the native space of the *narod*, the image of nature that exists most essentially in the "soul of the Russian people." For Vagner the admiration of Russian landscape paintings has become an activity through which educated elites might commune with their rural cousins and penetrate to the depths of their native natures.

THE LAND AND THE PEOPLE

The project of revealing an affinity between the landscape and the people inspired the work of many Russian painters in the late nineteenth century. Not only Vagner but numerous other commentators

also interpreted landscape painting according to its willingness to convey messages about peasant life. In the Soviet period this interpretation would form the cornerstone of art historical approaches to Russian landscape painting. It is therefore again necessary to recall that landscape painting was created and admired in Russia's two large cities by people with aims and interests unconnected to those of peasant Russia. If the attempt to imagine an identification between the land and the people constituted an important goal for Russian landscape painting, we must keep in mind that such an identification remained a myth, relevant only to people at a safe remove from rural life.

As mentioned in the previous chapter, Soviet art historians managed to place Russian landscape painting in the pantheon of struggle against the autocracy by adopting a similar point of view to that expressed by Vagner, Stasov, and other nineteenth-century critics. Mal'tseva's biography of Savrasov, written more than one hundred years after Vagner's article, echoes Vagner's view of landscape painting in her interpretation of *The Rooks Have Returned:* "It was an image of the native country, which lived in the consciousness of the Russian people and had long awaited its artistic embodiment."[63] Another Soviet art historian, Aleksei Fedorov-Davydov, interpreted Shishkin in a language reminiscent of Prakhov's: "He was . . . a shining representative and exponent of democratic realism. All his great talent, colossal labors, and perseverance, Shishkin devoted to the development of the national theme in landscape painting."[64] Compare this to a nineteenth-century critic's view of Shishkin as "an interpreter of the aesthetic feelings of our people."[65]

There were important connections between the idealization of the *narod* and that of the countryside, but the precise nature of those connections requires careful analysis. To begin with, the new attention devoted to Russia's natural environment in art closely paralleled the rise of Russian populism. In the narrow sense of the term, populism comprised certain oppositional political organizations, some of them on the extreme left. It was also the force in the mid-1870s that roused several thousand educated Russians, the majority of them students, to venture into the countryside in order to establish connections between themselves and the peasants. Defined more broadly still, populism permeated much of urban Russia during the last third of the century. In this latter sense, it can be understood as the faith among educated urbanites that their world would find its distant reflection and its eventual savior in the culture and values of the Russian peasant. The echo of this faith in the people and desire for connection resounds in the literature of the reform era. Tolstoy's Levin from *Anna Karenina* (1876), learning to cut grain and fantasizing about settling down with a peasant bride, is a famous example. Equally familiar in music, Modest Mussorgsky's opera *Boris Godunov* (1874) put the *narod* at the moral center of Russian history.

Studies of Russian populism typically have focused on its radical manifestation. But other historians have explored its broader context. Dmitrii Likhachev, for example, has identified the origins of populism within a pan-European framework:

> The idea of human culture as a supposedly "anti-natural" phenomenon in opposition to "natural" nature became more entrenched with Jean-Jacques Rousseau and was evident in the distinctly Russian form of Rousseauism that evolved in the nineteenth century: in the *narodnik* [populist] movement and in Tolstoyan views on the "natural man"—the peasant—as opposed to the "educated class," or the intelligentsia.[66]

Rousseau's rethinking of the relationship between nature and humanity was, of course, fundamental to all European romanticism, including that of the reactionary Slavophiles and the radical populists. Throughout Europe, it laid the groundwork for new interpretations of individual identity, national cultures, and even the natural environment. Similar processes took place in Russia: where some Russian writers and intellectuals idealized the peasantry, others exalted Russian nature. The contrast between a sophisticated yet corrupt West and the simple, unspoiled rural world informed Russian views of the peasantry *and* of the land they lived on.

For this reason the "natural man" and his natural environment could at times appear virtually synonymous. Prakhov's definition of populist art, for example, managed to encompass both the peasant and the countryside. In a sort of manifesto statement on the new populist art, Prakhov contrasted the new interest in nationality to a false sentimentality he found in academic art. "He who wants to be a people's artist [*khudozhnik narodnyi*]," Prakhov wrote in 1875, "must appeal to nationality as naively as it treats itself. Setting aside all dirtiness, all squabbles, all the prose of ordinary life, [folk literature] in elegant, laconic, but keen form draws us an ideal picture of the life of the naive person, his deep bond of faith, so to speak, in nature."[67] Prakhov was at pains to link peasant life with nature in order to show that Russia's "natural man" represented the beauty and purity of the nation. The same process in reverse idealized the landscape and Russified it through its connection to the people. Thus reference to Russia's natural environment and landscape came to be associated with the *narod*.

In this respect, the problem with Soviet neopopulist analysis of landscape painting is that it ignores the actual circumstances of the relationship between painters and viewers. Around the year 1870, almost all notable Russian landscape painters began to minimize the presence of peasant figures in their work. The removal of the peasant figure from the landscape seems counterintuitive since it occurred precisely

at a time when the significance of Russian populist ideals was dramatically increasing in the cultural and political spheres of urban Russia. Wasn't this the moment for all progressive artists to turn their powers of observation on the world of the Russian peasant? I would argue, on the contrary, that an uninhabited landscape perfectly suited the aims of an urban public aroused by a fascination for the rural population. Those aims, however, cannot be understood in terms of the hagiographic Soviet reading of Russian landscape painting as "deeply democratic." The depopulation of Russian landscape imagery introduces a major complication into the argument that landscape painters were somehow expressing the views of the Russian people. This issue must be dealt with in order to attempt a viable interpretation of Russian realist landscape painting.

It was an urban interest in the countryside that brought Russian landscape painting into existence. Cathy Frierson's study of the image of Russian peasants helps illuminate the problems that beset idealization of the *narod* among educated Russians in the wake of the emancipation.[68] Following increased actual contact between urban and rural Russia as a result of the end of serfdom and the institution of social reforms, for many Russians the sacred peasant ideal broke down into several different and not particularly flattering images of a beleaguered population having to make do under difficult circumstances. Within educated society this caused, in the phrase of Konstantin Kavelin, "years of complete and bitter disappointment."[69] That disappointment not only resulted from the destruction of hopes for a quick solution to Russia's social problems; it also meant that now the idealized peasant could no longer be counted on as the symbolic figure and uncorrupted carrier of Russian identity.

Landscape painting offered an alternative to this dilemma, but it differed significantly from the alternative dreamed up by critics like Vagner. Contrary to the aspirations of populist critics, the actual cultural distance between landscape painters and the rural world they wanted to capture was wide. Fedor Vasil'ev's initial confrontation with the countryside proves instructive in this respect. Raised in St. Petersburg, Vasil'ev had little familiarity with the countryside when he began to paint. Much has been made of the "democratic" sympathy he espoused in his paintings of the peasant village, suggesting that he managed to document peasant life in its "real" and unembellished form.[70] As pointed out earlier, the idealization found in some of his village settings betrays his distance from the peasantry. The following lengthy passage from a letter written in 1869 on the occasion of his first trip into the deep countryside (to the estate of Count P. S. Stroganov in Ukraine) confirms the gap between his own world and his rural subject. Vasil'ev reports his observations while traveling by train:

> When it grew light I saw endless fields of rye and oats, verdure extremely welcoming for me. Here and there, shallow and wide ravines cut the even surface in two, and villages and streams with naive peasants settled down in them. On the horizon, at the left and the right, a road was visible, planted with two rows of quaintly formed white willows. When the roads drew nearer, you could see how lines of harnessed oxen with lazy Ukrainians stretched along them. I was quite surprised by the purple tone of the roads, made of clean, dark earth. . . . I enjoyed everything, for everything I felt sympathy and astonishment: it was all new. I'd never seen so many cattle, so many birds, etc., never experienced these miraculous impressions of the road—just that, miraculous: from everything old I was at once torn away, none of these petty, everyday worries; new places, people, and—consequently—impressions surrounded me on all sides. . . . From the corner of a grove a village suddenly swam out and riveted all my attention: tiny, straw-covered homes, a real caravan, arranged in disorderly and painterly order. Along the streets stood wells with tracks near them of mud and logs at which pigs wallowed, children washed, with linens, shining in the sun, with the heads of all kinds of domestic creatures pacing back and forth. In a willow grove in narrow rows there were whole sunflowers, rising up on the thin poles of a birdhouse; calves (inscribed with multicolored patterns of light and shade) with their shaggy ears brushed away gadflies enjoying the cool grove. All this struck me with its newness and typicality. All life is out of doors! These willows and huts, cattle and people formed paintings full of such life and strength that unwillingly, for a long time after, I squinted my eyes and into my head arose such a painting as to have made me lose heart.[71]

This rendering of the nineteen-year-old painter's first impression of rural Russia belies the assumption that Vasil'ev felt a special empathy for the lives of the "people." Vasil'ev's were the eyes of a traveler and painter on the lookout for motifs. Not only does this passage lack reference to the humanity of the peasants, it is positively demeaning in places. It incorporates the lives of the "naive peasants" or "domestic creatures" into the view as a whole. It does not separate the huts from the willows, nor the cattle from the people. It reveals an urban search for diversion in the picturesque image of the countryside which Vasil'ev hopes will remove him from "the petty cares of everyday life."

As Ann Bermingham has pointed out with respect to British painting and travel, interest in picturesque landscape cannot be interpreted simply as an innocuous aesthetic pastime. The search for picturesque scenery had specific social and ideological effects: "the distancing of the spectator from the picturesque object, and the aestheticization of rural poverty."[72] In other words, it offered its urban adherents a way to avoid thinking about the poverty and hardship of rural life. The hu-

man being, the peasant who lives in the countryside—like the shepherds and shepherdesses that were stock figures in the idylls of the eighteenth-century Russian aristocracy—becomes a part of the view, a component of the viewer's aesthetic satisfaction. Landscape, in short, can often serve to distance urban from rural, the viewer from the viewed, the elite from the mass. By the 1870s in Russia, however, such distancing had become unacceptable to a culture deeply embroiled in the search for itself in the mirror of the folk. Not only picturesque scenes but even nondecorative, realistic portrayals of peasants could detract from the sense of identification on the part of the viewer. The debased and miserable peasant that became a commonplace figure in the ethnographic literature of the emancipation era (or in Sukhodol'skii's *Midday in the Village*) ran counter to the celebration of the peasantry at the heart of Russian populism.

From the window of a train, Vasil'ev's eyes searched the landscape for the picturesque, even to the degree that it degraded the humanity of the peasants in his visual imagination. And yet the delineation of picturesque and populist views in these paintings is no straightforward matter. Vasil'ev's enjoyment of the "life and strength" of the village, his cry "All of life is outdoors!" might otherwise be understood as the painter's incorporation of populist values into his own idiom. Even radical approaches to peasant life, the willingness to unite with the people that produced the movement "to the people" in the summers of 1874–1876, have something in common with the distanced quality of picturesque seeing. Examined from one perspective, both Russian populism and picturesque tourism approached rural life from the outside, making use of it for alien purposes. Both found reassurance in the countryside that rural culture might help overcome problems endemic to modern, urban life.

While most landscapes of the 1850s and 1860s present a Russian countryside embellished by human figures, the end of the 1860s gave rise to a new, unpopulated landscape of "pure nature." The unpopulated landscape image became common just as the cultural and political influence of populism was reaching the apogee of its influence. The vast majority of Peredvizhniki landscape paintings portrayed neutral, socially nonassociated spaces such as forests, steppes, country roads, and rivers. The rise of a figureless landscape cannot be said to have educated the urban public about peasant life. Instead, it offered something else important to viewers of Russian art. These landscapes formulated a viewer position that allowed the urban spectator to fantasize looking at the countryside with the eyes of an insider, with the eyes of a Russian peasant. The depopulated Russian landscape managed to suggest the presence of the *narod* without either debasing or reifying peasants into a single image. For such an image would not be able to

carry the burden of the ideological weight with which the peasant had been saddled by Russian populism.

At the same time that Russian landscape painting began to omit peasant figures, it attempted to assert a view of the countryside that contrasted sharply with the earlier vistas, pastoral settings, and picturesque scenes meant to entertain an elite uninterested in the rural poor or actual conditions in the countryside. A depopulated landscape now served the interests of educated urbanites in a different way. Landscape painters created a new ideal in their evocations of rural Russia, a vision of the nation as a place in which the urban and rural worlds shared some common ground. For the ideologically disinclined, or simply the average, well-intentioned member of educated society, Russian landscape painting fulfilled a gentle wish for the reconnection of the urban and rural spheres. The panoramic and the picturesque landscape compose the natural world into a vision that makes nature amenable to the viewer as a casually intrigued outsider. By lowering the perspective to eye-level and immersing the viewer within the landscape, paintings like Savrasov's *The Rooks Have Returned*, Vasil'ev's *Wet Meadow*, or Shishkin's forest scenery worked against the kind of established perception of landscape familiar to the picturesque tourist, or the connoisseur of fine arts. They asked the viewer to ignore traditional aesthetic satisfactions and to engage in a process of nostalgic recognition, in which images of landscape recomposed the rural environment into a prototypical Russian space. The specific kind of terrain these paintings invited viewers into, with its unpretentious surroundings, its enveloping openness, and its closeness to nature's everyday life, proposed a kind of socially undifferentiated perception of rural Russia. It implied the possibility of a landscape that would be equally familiar and beloved to all Russians. These paintings offered urban viewers the opportunity not to *look at* peasants, but to partake of the peasant perspective, to see what the *narod* saw. In this way, images of Russian landscape became a ground of common perception, an imagined locus from which it was possible, for a fleeting moment, to bridge the abyss that still divided Russian society.

Landscape painters wrote about their work infrequently. The record of how they themselves might have conceived of the meaning and function of landscape painting is usually difficult to determine. One painter, however, did express her relation to landscape painting in almost precisely the terms described above. Vasilii Polenov's sister, Elena Polenova, became a landscape painter like her brother. In typical fashion she admired, in her words, "my familiar northern or central Russian nature, especially when it is expressed in slight, insignificant, but deeply poetic little corners."[73] At the same time she also hoped her paintings would express more than just her own admiration for this

landscape, and she devised a plan by which she could use painting to re-create the folk perspective on nature. "The thought I have proposed to myself," she wrote in a letter to a friend, "is very bold, but also terribly alluring. In an entire series of watercolor paintings I want to express the poetic views of the Russian people toward Russian nature."[74]

No matter how much artists of all kinds in late Imperial Russia struggled to express the peasant's perspective of nature, the indigenous Russian relationship to the landscape, it proved an intractable fantasy. Polenova ran into trouble and in consequence turned to the illustration of fairy tales. The composer Anatolii Liadov also tried and failed to find in folklore the idealized peasant landscape he needed for his tone poem "The Magic Lake":

> I knew one thing—this simple, forested Russian lake in its inconspicuousness and quiet was especially beautiful. . . . I started to search for descriptions of just such a lake in Russian folk tales. But folk tales don't like to stop the action and pace for the sorts of descriptions of natural phenomena that I needed for my music.[75]

Polenova and Liadov correctly received the message their culture was sending them. If one looks to the views of critics such as Vagner or Shkliarevskii, it would seem that artists had every reason to expect to discover the peasantry's "poetic views" of Russian nature. And yet they were disappointed. Like Vagner, they had to search for landscape imagery in the art of educated society. If there was poetry in Russian nature, it had come from people much like themselves.

Geoffrey Hosking's studies of Russian nationalism have argued persuasively that the imperial ideal obstructed the formation of a national community in Russia.[76] According to Hosking, by maintaining too tight a grip on authority and control throughout the period of nation building during the nineteenth century, the autocracy effectively blocked the possibility of forging a Russian nation-state on the basis of civic participation. The concept of an ethnically based nationality remained the only viable option in Russia. Indeed, in various guises on the left and right, Russian nationality emerged from the ideal of a return to roots in the *narod*. Again and again, however, this search for a connection between the urban and rural spheres, between the haves and the have-nots, proved untenable. It was not possible to maintain an ideal vision of the Russian *narod* as a distinct social and moral entity while at the same time reuniting Russian culture into a single national whole. Ultimately, Russia instead exploded in a social struggle of monumental proportions. In his famous lecture of 1882, "What is a Nation?" Ernest Renan pointed out that "the essential element of a nation is that all of its inhabitants have many things in common but

have also forgotten many things."[77] The deep divide between the two halves of Russian society made the act of forgetting doubly necessary in the attempt to envision some form of nationality. Russian landscape imagery, as we have seen, conjured up national community precisely by refusing to portray any specific, identifiable community. It allowed viewers to imagine the nation by avoiding, or temporarily forgetting, the lives of the people it comprised.

A NEW GENERATION

The 1880s witnessed some fresh departures in landscape painting. The most interesting innovations in landscape were connected to a circle of artists who began to study Russian folk culture at Abramtsevo, the estate of the merchant-patron Savva Mamontov (formerly owned by the Aksakov family).[78] Polenova was associated with this group. With them her desire to paint "the poetic views of the Russian people toward Russian nature" took her into children's literature. Her magical and charming "War of the Mushrooms" drew its readers into a world of archetypal peasant mythology somewhere on the floor of a deep Russian forest. Another member of the Mamontov circle, Viktor Vasnetsov, who had earlier produced realist scenes of urban street life, now began to compose grand visions of the legendary Russian past in the midst of the deep forest or the open steppe.

One of the notable reworkings of Russian landscape in the 1880s and 1890s was carried out by Mikhail Nesterov. Nesterov set his ecstatic visions of Orthodox spirituality amid a serene version of meager, yet vast, Russian space. Although his paintings were steeped in mysticism, Nesterov's landscapes hewed closely to the realist approach to Russian space. His portrayal of Russian nature is full of characteristic features: a sense of humble simplicity, vast open fields, and slender, delicate birches. But within these landscapes Nesterov placed his hyperstylized, sacred figures in the attempt to create a harmonious blend of Russian history, religion, and geography. One may consider Nesterov's work a powerful testament to the achievement of the realist landscape painters. "Striving in my artistic ideas toward the hidden side of man's soul and of his natural surroundings," he wrote, "I always prefer the most natural forms . . . even in projects of such fantasy as *Bartholomew* and *Dmitrii-Tsarevich*"[79] [fig. 19]. In Nesterov's paintings the realist depiction of rural Russia had come to cradle a forceful idealization of Russian nationality. Overlooked and belittled by painters and the public just a few decades earlier, "meager Russian nature" had now become the proper setting for depictions of Russian saints and martyrs.

The opposition between real and fantastic is of course something of a false dichotomy. Realist evocations of the landscape had already come

to express a special Russian mystique as early as the late 1860s. Levitan's paintings exemplify the interconnectedness of mystical and realist currents in Russian landscape imagery. Levitan developed a style that separates him both from the earlier realists and the later mythologists of Russian landscape. The impact of the realists, especially his teacher Savrasov, was always apparent in his work. He never ceased to portray images familiar and nostalgic to Russian eyes. And yet Levitan—among such other landscape painters of his generation as Korovin, Il'ia Ostroukhov, and Valentin Serov—began to devise a new, more scenic vision of the countryside that went beyond the rather severe composition and subject matter typical of earlier realist painting. Beginning in the late 1880s, the bright colors and viewlike composition of his work would convey a new sense that Russian landscape could be admired as unambiguously beautiful and inviting, a space of leisure upon which urban visitors might rest their eyes for comfort and pleasure.

Levitan's generation of landscape painters are sometimes referred to as Russian impressionists. Certainly Levitan's landscapes brought him closer to impressionism than his predecessors had come, but in spite of the warm colors and comparatively loose brushwork, Levitan's paintings remained more closely connected to his fellow realists among the Peredvizhniki, wrapped up as they were in the circumstances and concerns of Russian life.[80] Levitan did not seek to capture the transitory moments of modern life, nor did he prioritize the direct visual impact of his work. His paintings were premised on the familiarity of Russian viewers with the unprepossessing spaces of the native countryside. His motifs, like those of Shishkin and Savrasov, were mostly commonplace and nostalgic yet simultaneously imbued with a profound, if intangible, significance available only to those with the capacity to appreciate the gentle appeal of the Russian landscape.

Anton Chekhov was a close friend of Levitan's. In his 1895 story "Three Years," he described a young woman's encounter with a painting that seemed to be modeled on one of Levitan's works (probably *At the Pool* [fig. 20]).[81] Her response to the painting typified the reaction Russian realist landscape painters had long sought to inspire:

> Julia stopped by a small landscape and idly looked at it. The foreground was a stream crossed by a wooden bridge with a path merging into dark grass on the far side. On the right was part of a wood with a bonfire near it—there must be grazing horses and watchmen hereabouts. Far away the sunset's last fires smouldered.
>
> Julia imagined going over the bridge, and then further and further down the path. It was quiet there, sleepy landrails cried. A light winked far away. Suddenly she vaguely felt that she had often seen them long ago—those clouds spanning the red of the sky, that wood, these fields.

She felt lonely, she wanted to walk on, on, on down the path. There, at the sunset's end, lay an eternal, unearthly Something.

"How well painted!" She was surprised at her sudden understanding of the picture.[82]

Julia's transformation from bored indifference to a brush with the transcendent passes through an image that lacks grandeur or any striking visual enticement. Even as the painters of the 1890s had adopted a more vigorous and scenic style than that of the earlier realists, their images of quiet beauty still appealed to viewers through the mechanism of nostalgic identification, an identification with the landscape that was at once deeply personal and inescapably national. It was a landscape that had to be sensed deeply rather than seen clearly, and loved instinctively rather than admired willingly. Appreciation of this landscape hinged on a tacit understanding among the educated public that rural Russia's humble environment harbored, in Chekhov's words, "an eternal, unearthly Something."

CONCLUSION

A Russian Sense of Place

> A summer evening's stroll in the Russian countryside, through the fields and forest, through the steppe, would often carry me to such a state that I would lie on the earth utterly exhausted, having drunken my fill of the love of nature, reeling from all the inexpressibly sweet and intoxicating sensations induced in me by the forest, the steppe, the river, the village in the distance, the modest little church, in a word, that which constitutes the miserable Russian landscape.
>
> —Petr Illych Tchaikovsky[1]

Once the new Russian landscape imagery had been definitively established and accepted as a signifier of nationality in literature and painting, it began to exert an influence in other spheres. From high culture venues such as theater set design, it moved into popular journals, tourist guidebooks, children's literature, postcards, books of photographs, and advertisements. By the turn of the century, the imagery created to aestheticize the national terrain had become a fixture in Russian popular culture. At the same time, the notion that Russia's landscape had had a formative impact on the consciousness of Russian individuals transcended the boundaries of art criticism and appeared in new spheres of thought. Russia's preeminent historian of the late nineteenth century, Vasilii Kliuchevskii, felt comfortable making unsubstantiated assertions about the effect of the land on the individual:

> The forest, the steppe, and the river—these, one might say, are the fundamental elements of Russian nature in its historical significance. All of them and each separately by itself have taken a lively and original part in the construction of the life and ideas of the Russian individual.[2]

By the final decades of the nineteenth century, the humble native landscape had become a mark of national distinctiveness and a point of pride throughout Russian culture. But its rise to prominence would

also precipitate a change in status. When valorization of the native land entered into the wider arena of public consciousness, it was pushed in new directions. In the 1890s, popular magazines such as *Grainfield* had begun to regularly portray the forest as a space for summer recreation among the dacha-going community. By this point too a growing tourist industry had begun to market the Volga River as a destination for leisure travel. At least some parts of the countryside were now represented as a getaway for overworked urbanites rather than the native home of the *narod*. One tourist guide to the Volga published in 1888 sought to inspire travelers in the following language, not unfamiliar to contemporary tourists: "If you want to be refreshed, to relax your soul from the cramped, enclosed, ceaseless activity of life in the city, travel on the Volga: it will calm you, it will arouse new thoughts, new impressions."[3] Even the gloomy and impoverished image of Russian nature that had originated partly in the intelligentsia's ambivalence about rural Russia came to be circulated on postcards, often sent out to express birthday or New Year's greetings.[4] As the new landscape imagery entered the mainstream and was incorporated into Russia's rising commercial culture in the 1890s, the entire aesthetic was beginning to lose its claim to originality. The ennobled image of Russia's unassuming landscape could not maintain its most important characteristic—its stamp of unimpugned authenticity.

Beginning in the early twentieth century, painters began to reject this aesthetic. The "World of Art" movement tried to reassert the importance of a cosmopolitan and international perspective in Russian painting and graphic art. Their clean and brisk style, conscious of its own artifice and often frankly erotic, presented itself as a direct challenge to the predominance of the civic and sincere style of the Peredvizhniki. Painters like Aleksandr Benois and Konstantin Somov devised an image of Russian landscape nearly antithetical to that which the Peredvizhniki created. They returned to scenery such as the elaborate eighteenth-century garden parks of the tsar and the manicured estates of the high nobility in light-hearted springtime sunlight. Somov's *Bathers*, for example, depicts a view from an unlikely angle, directly above some evidently leisured women bathing in a green and inviting country retreat. His vision of natural space could not have been more directly at odds with the grounded perspective and ardently populist view of rural Russia popularized by Shishkin, Savrasov, Levitan, and others.

The contempt of the World of Art for the landscape of their predecessors ought to remind one of nothing so much as the familiarity the Peredvizhniki landscape had come to possess. From the pastoral ideal prized during the reign of Catherine the Great to its reprise as the new Arcadia among the World of Art painters, Russian landscape imagery had come full circle. The unspectacular and unadorned rural country-

side had been largely invisible in the eighteenth century as an aesthetically undesirable space. By the early twentieth century it had become so visible as to encourage artists to search for some new vision of the land. Now Catherine's cosmopolitan parks would seem a refreshing departure.

For all its significance as a national image, the emergence of the ideal of a "meager" Russian nature hardly helped clarify every Russian's aesthetic response to the natural environment. The confusion is evident in a description of the national terrain published in a geographical almanac in 1911. The author of this text still struggles against the aesthetic precedence of European landscape. His language strains to bring different visions of Russian space in line with one another:

> If in western Europe newer and newer pictures are continuously opening up before the eyes of the traveler—thanks to frequent alternations of peaks, valleys, fields, cities, and villages—in Russia one can travel tens and hundreds of versts, and pictures of nature will remain almost exactly the same in their essential features. But this only seems to be so as a result of the enormous distances. Because of such uniformity in scenery for travelers, one foreign writer says that having spent the night in the wagon of a train, when it grows light it often seems you have not moved from the same spot. Another asserts that at the foot of the Harz mountains (in Germany) across a stretch of a few miles one can see greater variety in nature than on seven crossings of Russia from the White Sea to the Black Sea. Although this is true, it still doesn't mean one must conclude that the whole expanse of Russia is boring and tiresome. Certainly not. No doubt we have greater variety in scenes of nature and popular life than in any other country, but it's all too widely spread out. If it were possible either to draw close together the various different regions of our country, or to sweep across the land in different directions in a train ten times faster than the ordinary messenger train, such a parade of scenery would flash past our eyes that cannot be found in a single nation in the world.[5]

This tortured comparison between the landscapes of Russia and Europe provides a succinct demonstration of the problematic situation that resulted from the attempt to revalue Russia's landscape as inferior in superficial form but superior in hidden beauty and inward promise. Russia's landscape, according to the statement above, was still supposed to *live up to* the picturesque landscape of western Europe, even if the two natural environments were patently incomparable. As a requirement of Russian national pride, moreover, Russia had to somehow surpass Europe even in the realm of landscape aesthetics.

The "ideology of compensation" that played such an integral role in the construction of Russian national identity always remained an essential feature of Russia's perception of the native landscape.[6] This

revaluation of values helps explain such enigmatic statements as that above made by Tchaikovsky, who claimed to revel to the point of intoxication in a setting he considered "miserable." The inability to simply accept the insurmountable dissimilarity between Russian and western European terrain in order to build a fully acceptable aesthetic of Russian national space resulted from unresolved conflicts about Russian nationality itself. Was Russia no more than a second-rate European country? Was it, on the other hand, a nation sui generis that should ignore the West and cultivate its own garden? Or was it an isolated and removed part of the West that would one day use its special national character, its kernel of superiority, to point the way to a better future for the civilized world and save Europe from itself? Such questions did not necessarily disturb the minds of the numerous figures who have appeared in these pages as they contemplated the meaning and the look of Russia's landscape. The appearance of the native land was not one of the "cursed questions" pondered over in intelligentsia circles. Yet like the more troublesome problems that concerned Russia's identity, politics, and social inequity, this issue never resolved itself satisfactorily. It was related to the larger and more explicit difficulties of Russian identity at an unacknowledged but important level.

The landscape, after all, was unavoidably equated with the land itself. Urbanites, whose relationship to the land was largely symbolic, could not comprehend the whole of Russia without calling to mind some pictorial representation of it. For urban Russians the countryside came to possess a mystical resonance that placed it near the heart of Russian national consciousness. Dostoevsky's and Grigor'ev's reactionary Native Soil movement drew on symbolic associations with the land just as the radical populist organization Land and Freedom based its appeal on an evocation of the earth. Through such pervasive appeals to the land, the appearance of Russia's landscape was unavoidably related to the fate of the land as a whole. Yet no matter how difficult it might have been to avoid, the equation of land and landscape is a shaky one. At least in the terms in which it has been treated here, landscape—as a set of cultural representations of the land—is an *image* of place, not the place itself.

One might consider an analogy between images of national territory and images of the human body. The body is a specific biological entity with different functions and different life stages, just as the terrain contained within a single national boundary has different types of climate and surface features. But the same body can be made to assert any number of separate messages depending on the image a given culture imposes upon it. As feminist scholars have shown in recent years, the female body can be "read" according to different stock images depending on the way it is posed, clothed, and portrayed. In our own culture alone one can point to many such images: the aesthetic nude,

the mothering body, the sexualized body, the assertive businesswoman, the housewife, the athletic body, the body of childbirth, etc.

If such a variety of images can be imposed upon a single individual, a given national terrain or geography must be even more receptive to interpretation according to a revolving series of representations. Such, as we have seen, was clearly the case with the landscape of Russia in the nineteenth century. By turns, depending on the location and historical context, the Russian landscape was perceived as a vast empire with widely varying types of terrain, an Arcadian retreat, a favored holy land, a boundless expanse, a collection of nostalgic and unpretentious spaces, a miserable and empty waste, and a place to experience scenery and leisure.

Certain alternative constructions of Russia's landscape have received little or no attention here. I mention them in passing as worthy of attention but outside the scope of this book. First, the breadbasket image of Russia as an agricultural land. Perhaps most famous from the mowing chapters in Tolstoy's *Anna Karenina,* it was also represented pictorially in such paintings as Miasoedov's "The Mowers" and Shishkin's "Rye." Representations of Soviet agricultural abundance would be commonplace in the twentieth century as well. Second, the image of Russia as a land of ice, snow, and tundra often appeared in the work of foreign travelers to Russia and Russian travelers to Siberia. Third, a landscape of peoples rather than nature, the image of Russia as a collection of interconnected populations, was created and used in different ways to depict the entire empire. Each of these visions of Russia was related to, but somewhat peripheral from, the primarily aesthetic images described in the preceding chapters.

Images of Russian landscape often corresponded to grander visions of the land itself. In the context of the search for national identity, the *land* came to be imagined according to certain idealized models. Whether Russia was conceived of as a pastoral rural nation, Holy *Rus',* or the native home of the Russian peasant, such dreams and visions of Russia existed in abstract form.[7] As often happened in Russia, however, abstract visions of the nation foundered when they ran up against concrete facts. Such representations of Russia, one might say, had a soul but lacked a tangible body. The various images of Russia's landscape attempted to supply a disembodied abstraction of the nation with some kind of concrete form. Landscape imagery, in other words, became a visible manifestation of the abstract ideal of Russian nationhood. As such, images of Russian landscape unavoidably contained within themselves an uncomfortable mixture of idealization and reality. Can it be any wonder that Russia's landscape evolved into an array of different, and often contradictory, forms? The landscape image was a moment of crystallization. It was a key point at which Russia as an abstraction put itself to the test as a visual and potentially realizable space.

Several different landscapes were produced to correspond with the variety of different approaches to Russian identity developed in the nineteenth century. And yet, as I have been arguing all along, one image (or, more accurately, a set of related images) of the national terrain came to dominate Russian imaginations. This was the landscape of uncultivated, or lightly worked, terrain associated with the *narod,* and the landscape of vast open steppes that betokened immensity and implied a special Russian sense of freedom. It included the bleak, rundown, snow-covered, and swampy places suggestive of Russia's ennobled impoverishment. "This meager nature," as Tiutchev called it, the national landscape of overgrown corners and boundless space, embedded itself in the national consciousness over the course of the nineteenth century as the special characteristic portrait of the native land.

The image of a miserable and simultaneously admirable landscape remained in the memories of certain expatriates who were unable to return home to Russia after the Revolution. In 1938, the Orthodox philosopher Sergei Bulgakov wrote an essay entitled "My Homeland" about the provincial city where he was raised. This short memoir incorporates much of the characteristic landscape imagery that first appeared during the nineteenth century. Bulgakov writes, for example, "Our region was wonderful in its vastness, with its wide fields, but poor and monotonous in the beauty of its natural forms."[8] For Bulgakov the absence of picturesque scenery only enriched his enraptured recollection of his childhood haunts:

> My homeland . . . is a small city in the Orel province—I think I would die from an excess of bliss were I to see it now—on the uplands of the river Sosna. It doesn't sparkle with any kind of beauty, in fact it's even covered in plainness, in drab gray, and clothed not just in modest attire but in poor and even rather dirty coverings. It didn't lack anything, however, that can be found in any region of our central Russia: the beauties of summer and winter, fall and spring, the sunrise, the sunset, the rivers and the trees. But all of it is so quiet, simple, meager, imperceptible, and—in its permanence—beautiful. . . . It also had such a calm and gentle character, like a mother. It was sincere like a Russian song, and similarly full of the poetry of music.[9]

Although this reminiscence is at pains to present itself as a transparent description of a remembered location, Bulgakov's memory of his native region was the product of a specific historical process. At the beginning of the nineteenth century no such statement was (or could have been) made. Over the course of many years, Russians learned to admire their native terrain in specific ways. The basic outline of this admiration was developed by educated elites in literary circles during

the 1830s and 1840s. It became a part of Russia's visual culture during the latter third of the century in painting. Although this special Russian imagery was never fully embraced as an unproblematic representation of the country, for many—prior to (and no doubt after) Bulgakov—it helped create a means of connecting in deeply personal ways to the nation as a larger whole. As we have seen, Belinskii wrote of Pushkin in 1844 "he didn't need to go to Italy for pictures of beautiful nature: beautiful nature was here beneath his feet, in Russia, in its flat and monotonous steppes, below its eternally gray skies, in its sad villages."[10] What had been presented as an heroic feat on Pushkin's part had by the end of the nineteenth century become a simple act of aesthetic recognition, a routine and conventional way of seeing the special beauty of the Russian land.

Notes

INTRODUCTION

1. V. G. Korolenko, *Sobranie sochinenii*, vol. 3 (Leningrad: Khudozhestvennaia literatura, 1990), 232. Where not otherwise noted, translations are my own.

2. Vladimir Soloukhin, *A Time to Gather Stones*, trans. Valerie Z. Nollan (Evanston, Ill.: Northwestern University Press, 1993), 44.

3. N. M. Karamzin, "Love of Country and National Pride," trans. Jaroslaw Pelenski, in *Russian Intellectual History: An Anthology*, ed. Marc Raeff (1966; [Atlantic Highlands], N.J.: Humanities Press, 1978), 107.

4. Russkoe obshchestvo turizma i otchiznovedenie, *Predlozhenie ob organizatsii ekskursii na Urale* (Petrograd, 1916), 4–5.

5. Fyodor Dostoevsky, *Winter Notes on Summer Impressions*, trans. Richard Lee Renfield (New York: Criterion Books, 1955), 35.

6. There is a common belief that Russian travelers scarcely showed any interest in domestic tourism during the nineteenth century. In G. P. Dolzhenko, *Istoriia turizma v dorevoliutsionnoi Rossii i SSSR* (Rostov na Donu, Rostovskii universitet, 1988), a recent, full-length study, the author claims that Russian travelers were interested in Europe during the mid-nineteenth century to the exclusion of Russia. He does not credit the initiation of a genuine tourism in Russia until 1895 when the first bicycle touring society was founded. This approach ignores dozens of travelogues and guides, organized tours and cruises produced by Russians to facilitate travel within Russia, all of which appeared before 1895 and date back to the first half of the century. Nevertheless, it is expressive of the general antipathy toward the Russian countryside as a place for scenery and leisure travel.

7. Quoted in Ian Ousby, *The Englishman's England: Taste, Travel, and the Rise of Tourism* (Cambridge: Cambridge University Press, 1990), 130.

8. One of the best examples of the shift in European attitudes toward natural scenery is the gradual change from revulsion against the Alps in the seventeenth century to adulation in the nineteenth century. This change is the subject of Marjorie Hope Nicolson's *Mountain Gloom and Mountain Glory* (Ithaca, N.Y.: Cornell University Press, 1959). For a more recent discussion of the historical reconceptualization of a variety of different terrains in European culture, see Simon Schama, *Landscape and Memory* (New York: Alfred A. Knopf, 1995).

9. Cited in Anne Farrar Hyde, *An American Vision: Far Western Landscape and National Culture, 1820–1920* (New York: New York University Press, 1990), 4.

10. Georges Nivat, "Le Paysage russe en tant que mythe," *Rossiia/Russia* 5 (1987): 7–20.

11. Aleksandr Benua, *Russkaia shkola zhivopisi* (Saint Petersburg: R. Golike and A. Vilburg, 1904), 79.

12. These definitions are taken from, respectively, *Webster's Ninth New Collegiate Dictionary* (Springfield, Mass., 1988); and *The American Heritage Dictionary of the English Language* (Boston, 1992).

13. *American Heritage,* s.v. "landscape."

14. Denis Cosgrove, *Social Formation and Symbolic Landscape* (Totowa, N.J.: Barnes and Noble Books, 1984), 13.

15. S. I. Ozhegov, *Slovar' russkogo iazyka* (Moskva: Russkii iazyk, 1988), 256, 401.

16. See Gina Crandell, *Nature Pictorialized: "The View" in Landscape History* (Baltimore, Md.: Johns Hopkins University Press, 1993)

17. See Vincent Scully, *The Earth, The Temple, and the Gods: Greek Sacred Architecture* (New Haven, Conn.: Yale University Press, 1962), 2.

18. Ancient Rome was also the first Western civilization to begin experimenting with perspective. In Roman pictorial representations of pastoral sacred groves, there developed a form of landscape depiction that represents a sort of halfway point between the informational picture of nature and the attempt to show a kind of naturalistic perspective. See Bettina Bergmann, "Exploring the Grove: Pastoral Space on Roman Walls," in *The Pastoral Landscape,* ed. John Dixon Hunt (Hanover, N.H.: University Press of New England, 1992), 20–46.

19. Medieval conceptions of nature were far more complicated than I am describing here. For an in-depth discussion, see Derek Pearsall and Elizabeth Salter, *Landscapes and Seasons of the Medieval World* (London: Elek Books, 1973).

20. On Chinese landscape painting, see, for example, Richard M. Barnhart, *Along the Border of Heaven* (New York: Metropolitan Museum of Art, 1983).

21. For some recent theoretical works on the historical development of landscape aesthetics, see Malcolm Andrews, *The Search for the Picturesque: Landscape Aesthetics and Tourism in Great Britain, 1760–1800* (Stanford: Stanford University Press, 1989); John Barrell, *The Idea of Landscape and the Sense of Place* (Cambridge: Cambridge University Press, 1972) and *The Dark Side of Landscape: The Rural Poor in English Landscape* (Cambridge: Cambridge University Press, 1980); Ann Bermingham, *Landscape and Ideology: The English Rustic Tradition, 1740–1860* (Berkeley: University of California Press, 1986); John Berger, *About Looking* (New York: Pantheon Books, 1980); Cosgrove, *Social Formation;* Crandell, *Nature Pictorialized;* Stephen Daniels, *Fields of Vision: Landscape Imagery and National Identity in England and the United States* (Princeton: Princeton University Press, 1993); Nicholas Green, *The Spectacle of Nature: Landscape and Bourgeois Culture in Nineteenth-Century France* (Manchester: Manchester University Press, 1990); Angela L. Miller, *Empire of the Eye: Landscape Representation and American Cultural Politics, 1825–1875* (Ithaca, N.Y.: Cornell University Press, 1993); Barbara Novak, *Nature and Culture: American Landscape and Painting, 1825–1875* (New York: Oxford University Press, 1980); Schama, *Landscape and Memory;* Keith Thomas, *Man and the Natural World: Changing Attitudes in England, 1500–1800* (London: Allen Lane, 1983).

22. For an especially instructive discussion of Claude's technique, see Barrell, *Idea of Landscape,* 6–12.

23. E. H. Gombrich, *The Story of Art* (Englewood Cliffs, N.J.: Prentice-Hall, 1983), 310.

24. Kenneth Clark, *Landscape into Art* (Boston: Beacon Press, 1949), 95.

25. See Barrell, *Idea of Landscape*, 6–20.

26. A thorough discussion of this theory can be found in Walter John Hipple, Jr., *The Beautiful, the Sublime, and the Picturesque in Eighteenth-Century British Aesthetic Theory* (Carbondale, Ill.: Southern Illinois University Press, 1957). For eighteenth-century nature aesthetics in continental literature, see Paul Van Tiegham, *Le Sentiment de la Nature dans le Préromantisme Européen* (Paris: A. G. Nizet, 1960).

27. See Jean-Jacques Rousseau, *La Nouvelle Héloïse*, trans. Judith McDowell (University Park, Pa.: Pennsylvania State University Press, 1968) and his *First and Second Discourses Together with the Replies of Critics and an Essay on the Origin of Languages* (New York: Perennial Library, 1986). For a discussion of Rousseau's views of nature, see Irving Babbitt, *Rousseau and Romanticism* (New York: Meridian Books, 1955), 209–35.

28. For important essays on the meaning of Siberia in Russian cultural history, see Galya Diment and Yuri Slezkine, *Between Heaven and Hell: The Myth of Siberia in Russian Culture* (New York: St. Martin's Press, 1993). See also Mark Bassin, "Inventing Siberia: Visions of the Russian East in the Early Nineteenth Century," *American Historical Review* 96, no.3 (June 1991): 763–94. Siberia played an increasingly significant role in Russia; its coming of age as an integral part of the national community probably occurred with the construction of the trans-Siberian railroad.

29. James S. Gregory, *Russian Land Soviet People: A Geographical Approach to the U.S.S.R.* (New York: Pegasus, 1968), 363.

30. Ibid., 34.

31. Russian does of course have words to describe a hill *[kholm, prigorka]*, but these correspond to the lower end of the implied scale of elevation in English usage.

32. *The Englishwoman in Russia: By a Lady Ten Years Resident in That Country* (New York: Charles Scribner and Sons, 1855), 33.

33. Herbert Barry, *Ivan at Home, or Pictures of Russian Life* (London: Publishing Company, 1872), 197.

34. Luigi Villari, *Russia of Today*, vol. 3 (Boston: L. B. Millet, 1910), 114.

35. Another eloquent testimony to the foreign traveler's distaste for Russian landscape was M. S. Emery's *Russia through the Stereoscope: A Journey across the Land of the Czar from Finland to the Black Sea* (New York: Underwood and Underwood, 1901). While the stereoscope was often used as a device to reproduce the effect of panoramic landscapes, Russian landscape was virtually ignored in this publication. Out of 100 pictures in all, there were 4 or 5 landscapes, 2 of Finland, 2 of Ukraine, and 1 of haymaking outside Saint Petersburg.

36. *The Antidote, or an Enquiry into the Merits of a Book Entitled A Journey into Siberia* (London: S. Leacroft, 1772), 81.

37. Anatole Leroy-Beaulieu, *The Empire of the Tsars and the Russians*, trans. Zenaide A. Ragozin (New York: G. P. Putnam and Sons, 1893–1896), 171. For an introduction to the career of Leroy-Beaulieu, see Georges Nivat's preface to the 1988 edition: Leroy-Beaulieu, *L'Empire des Tsars et les Russes* (Lausanne: Editions L'Age d'Homme, 1988), i–xvii.

38. Cosgrove, *Social Formation*, 5.

39. On some of the ways Russia's landscape was changed by its population, see Judith Pallot and Denis Shaw, *Settlement and Change in Romanov Russia* (Oxford: Clarendon Press, 1990).

40. Leroy-Beaulieu, *L'Empire des Tsars,* 1:160, quoted in Jerome Blum, *Lord and Peasant in Russia from the Ninth to the Nineteenth Century* (New York: Atheneum, 1968), 336.

41. William Hepworth Dixon, *Free Russia* (New York: Harper and Brothers, 1870), 199.

42. Kirill Pigarev, *Russkaia literatura i izobrazitel'noe iskusstvo: Ocherki o russkom natsional'nom peizazhe serediny XIX veka* (Moscow: Iskusstvo, 1972).

43. Faina Mal'tseva, *Mastera russkogo realisticheskogo peizazha* (Moscow: Iskusstvo, 1952).

44. Mikhail Epshtein, *Priroda, mir, tainik vselennoi: Sistem peizazhnykh obrazov v russkoi poezii* (Moscow: Vysshaia shkola, 1990), 3–10. Almost every view of the relationship between Russian culture and the native landscape has treated nationality as an essential category. Pavel Fedotov and Dmitrii Likhachev have offered well-known interpretations of the unique Russian sense of the land. Another example is the Orthodox scholar Nicholas Arseniev's "The Nostalgia for Space and the Contrasts of the Russian Soul," in *Russian Piety,* trans. Ashleigh Moorhouse (London: Faith Press, 1964). Arseniev argues that the open landscape has been a major determinant of Russia's spiritual character.

45. Another relevant essay on images of Russian national space is Ladis K. D. Kristof, "The Geopolitical Image of the Fatherland: The Case of Russia," *Western Political Quarterly* 19 (1967): 941–54. Kristof judiciously divides images of Russia into four types: ideals of the fertile southern lands, the Russia centered around Moscow, St. Petersburg alone, and Eurasia. While Kristof is primarily interested in this final image, only the first two have relevance for the visual/aesthetic conception of Russian landscape. With respect to the southern and central landscape, it seems to me, the distinctness and fixity of his typologies obscure the way in which images of these regions interacted with and influenced one another.

46. Nivat, "Le Paysage," 7.

47. Eric Hobsbawm and Terrence Ranger, eds., *The Invention of Tradition* (Cambridge: Cambridge Univesity Press, 1983), 14.

48. In addition to classic texts on nationalism, a considerable (and often contentious) literature on national identity construction has been produced in recent years. A short list of these texts includes Benedict Anderson, *Imagined Communities: Reflections on the Origin and Spread of Nationalism* (London: Verson, 1983); Ernest Gellner, *Nations and Nationalism* (Oxford: Blackwell Press, 1983); Liah Greenfeld, *Nationalism: Five Roads to Modernity* (Cambridge, Mass.: Harvard University Press, 1992); Hobsbawm and Ranger, *Invention of Tradition;* David Miller, *On Nationality* (Oxford: Clarendon Press, 1995); George L. Mosse, *Nationalism and Sexuality: Middle-Class Morality and Sexual Norms in Modern Europe* (Madison: University of Wisconsin Press, 1985); Anthony D. Smith, *National Identity* (London: Penguin Books, 1991).

49. Edward Shils, "Nation, Nationality, Nationalism, and Civil Society"

in *Nations and Nationalism* 1 (1995): 100.

50. The problems resulting from contradictions between Russia's imperial and national interests have recently been discussed in detail in Geoffrey Hosking, *Russia: People and Empire, 1552–1917* (Cambridge, Mass.: Harvard University Press, 1997).

51. Hans Rogger, *National Consciousness in Eighteenth-Century Russia* (Cambridge, Mass.: Harvard University Press, 1960).

52. This study, however, owes a debt of gratitude to those scholars who have similarly isolated specific aspects of national identity formation in Russia. Michael Cherniavsky has traced the idea of Holy *Rus'* from the Muscovite period into the twentieth century, pointing out in particular how the ideal of a chosen Orthodox nation contributed to the powerful sense of Russian exceptionalism that developed during the nineteenth century. See *Tsar and People: Studies in Russian Myths* (New Haven, Conn.: Yale University Press, 1961). Jeffrey Brooks has shown that by the last decades of the nineteenth century Russian popular literature expressed national identity as a collection of peoples and landscapes rather than as an appeal to the symbols of tsar and church. See "Nationalism and National Identity," in *When Russia Learned to Read: Literacy and Popular Literature, 1861–1917* (Princeton: Princeton University Press, 1985), 214–45. From another point of view, Mark Bassin has demonstrated how Siberia was shaped as a reflection of the entire nation during the nineteenth century. See his "Inventing Siberia."

53. Gregory and Alexander Guroff, "The Paradox of Russian National Identity," in Roman Szporluk, ed., *National Identity and Ethnicity in Russia and the New States of Eurasia* (Armonk, N.Y.: M. E. Sharpe, 1994), 81.

54. This novel, like others of its era, refuses to aestheticize the Russian landscape, thus it will not be discussed in these pages. For two important discussions of the novel's place in Russian cultural and intellectual history, see Cathy Frierson, *Peasant Icons: Representations of Rural People in Late Nineteenth-Century Russia* (New York: Oxford University Press, 1993); and Richard Wortman, *The Crisis of Russian Populism* (London: Cambridge University Press, 1967).

55. Chaadaev at times employed spatial metaphors to emphasize his critique of Russian society, likening Russia to an urban desert for example: "We seem to camp in our houses, we behave like strangers in our families; and in our cities we appear to be nomads who graze their flocks in the steppes, for they are more attached to their desert than we are to our towns." P. I. Chaadaev, "Letters on the Philosophy of History," trans. Valentine Snow, in Raeff, *Russian Intellectual History*, 163.

56. Greenfeld, *Nationalism,* 256. Greenfeld's chapter on Russian nationalism contains a provocative discussion of the Russian dilemma of being simultaneously too akin to and too distinct from Europe to establish an independent sense of national confidence.

57. F. I. Tiutchev, *Izbrannoe* (Moscow: Moskovskii rabochii, 1985), 153.

58. F. M. Dostoevskii, *Polnoe sobranie sochinenii v tridtsati tomakh,* vol. 20 (Moscow: n.d.), 148, quoted in Marcus C. Levitt, *Russian Literary Politics and the Pushkin Celebration of 1880* (Ithaca, N.Y.: Cornell University Press, 1989), 130.

59. Nikolai Nekrasov, "Zheleznaia doroga," in *Polnoe sobranie stikhotvorenii v trekh tomakh,* vol. 2 (Leningrad: Sovetskii pisatel', 1967), 159.

60. F. N. Mil'kov, "Srednerusskie landshafty kak ob'ekty geograficheskikh ekskursii," in *Po rodnym prostoram,* by V. V. Pushkarenko (Voronezh: Izd-vo Voronezhskogo universiteta, 1992), 4.

CHAPTER 1

1. Such language runs throughout the odic literature of eighteenth-century Russia. All of these citations have been taken directly from Stephen Lessing Baehr's discussion of the garden metaphor in *The Paradise Myth in Eighteenth-Century Russia: Utopian Patterns in Early Secular Russian Literature and Culture* (Stanford: Stanford University Press, 1991), 65–67.

2. On the revival of the pastoral, see Hunt, *Pastoral Landscape;* and Robert C. Cafritz, Lawrence Gowing, and David Rosand, *Places of Delight: The Pastoral Landscape* (Washington, D.C.: Phillips Collection; National Gallery of Art, 1988).

3. This may be in contrast to Kievan Rus' for which there is documentary evidence (some of it possibly unreliable) of an interest in the general beauty of Russian terrain. In the fragment known as *Slovo o pogibeli russkoi zemli* (1237–1246), for example, Russia is praised for its "marvelous and numerous lakes" as well as its rivers, springs, forests, fields, and other flora and fauna. See Serge A. Zenkovsky, *Medieval Russia's Epics, Chronicles, and Tales* (New York: E. P. Dutton, 1974), 196–97.

4. On Muscovite imagery and the rise of Western art, see James Cracraft, *The Petrine Revolution in Russian Imagery* (Chicago: Univeristy of Chicago Press, 1997).

5. Zenkovsky, *Medieval Russia's Epics,* 399–448.

6. Ibid., 430.

7. Ibid., 413, 428–29.

8. On the shift toward Western forms in Russian painting, see Cracraft, *Petrine Revolution.* Despite the adoption of Western styles and techniques in this period, Cracraft notes that landscape painting did not emerge as an art form until the end of the century, p. 217.

9. For an explanation of the icon's special use of perspective and presentation of natural space, see Boris Uspensky, *The Semiotics of the Russian Icon,* trans. and ed. Stephen Rudy (Lisse: Peter de Ridder Press, 1976); and John Stuart, *Ikons* (London: Faber and Faber, 1975).

10. With respect to Russian folk imagery, when *liubki* did depict some sort of landscape they often represented interesting natural phenomena, i.e., a beached whale, a comet, an erupting volcano. More often than not, such pictures seem to have represented imagined landscapes from abroad, on some level bringing popular art in line with the art of the educated classes. The fundamental difference was that whereas in educated circles Russian nature resembled Italian landscape, in popular engravings non-Russian nature looked like the Russian village. See, for example, Alla Sytova, ed., *The Lubok: Russian Folk Pictures* (Leningrad: Aurora Art Publishers, 1984).

11. On the treatment of nature in icons, see Aleksei Fedorov-Davydov, *Russkii peizazh XVIII–nachala XIX veka* (Moscow: Iskusstvo, 1953), 5–7.

12. Some suggestive work has been done in seeking out other sources for Muscovite perceptions of nature and geographical terrain. In studying seventeenth-century mapmaking, for instance, Valerie Kivelson has detected a secular and affir-

mative vision of the natural world that is nevertheless intimately linked to eschatological and eternal notions of man's place on earth. See Kivelson, "Landscape, History, and Biblical Time in Seventeenth-Century Russian Maps" (paper presented at the conference entitled *Architecture and the Expression of Group Identity in Russia and the Soviet Union*, Chicago, May 2–5, 1996).

13. D. S. Likhachev, *Poeziia sadov* (Saint Petersburg: Nauka, 1991). Monastery gardens were not intendedpurely for aesthetic purposes; they were also used to grow food and medicinal herbs.

14. Ibid., 110–47.

15. Although concrete images of landscape mainly expressed an Arcadian ideal in the eighteenth century, the idea of Eden also maintained an important presence in Russian culture and was intertwined at times with representations of idealized Arcadian landscape. On the continuing importance of Edenic imagery in the eighteenth century, see Baehr, *Paradise Myth*, 31–37 and 65–89.

16. Raymond Williams, *Keywords: A Vocabulary of Culture and Society* (New York: Oxford University Press, 1983), 219.

17. This contrast was voiced most famously by Rousseau, but earlier, in a different way, it was just as much a part of the Enlightenment linkage of nature and reason.

18. V. K. Trediakovskii, *Izbrannye proizvedeniia* (Leningrad: Sovetskii pisatel', 1963), 60–61, 76–77.

19. See Aleksei Fedorov-Davydov, *Russkii peizazh: XVIII–nachala XIX veka* (Moscow: Iskusstvo, 1953).

20. Feofan Prokopovich, "Laudatory Speech on the Glorious Victory over Swedish Forces," quoted in Greenfeld, *Nationalism*, 226.

21. Mikhail V. Lomonosov, *Sochineniia v stikhakh* (Saint Petersburg: A. F. Marks, 1893), 121, 141.

22. See *Catherine II's Charters of 1785 to the Nobility and Towns*, ed. and trans. David Griffiths and George Munro (Bakersfield, Calif.: Charles Schlacks, Jr., 1991), 1.

23. A. P. Sumarokov, *Izbrannye proizvedeniia* (Leningrad: Sovetskii pisatel', 1951), 152.

24. Ivan Ivanovich Dmitriev, *Polnoe sobranie stikhotvorenii* (Leningrad: Sovetskii pisatel', 1967), 87–89; N. M. Karamzin, *Izbrannye stikhotvoreniia* (Leningrad: Sovetskii pisatel', 1953).

25. N. M. Karamzin, *Istoriia Gosudarstva rossiiskogo*, vol. 1 (Saint Petersburg, 1892), viii.

26. Cited in Robert G. Wesson, *The Russian Dilemma* (New York: Praeger, 1986), 13.

27. See William Edward Brown, *A History of Russian Literature in the Eighteenth Century* (Ann Arbor, Mich.: Ardis, 1980) 17–19.

28. Z. A. Kamenskii, ed., *Russkie esteticheskie traktati pervoi treti XIX veka* (Moscow: Iskusstvo, 1974). See vol. 1, *"Klassitsizm."*

29. A. O. Lovejoy, "'Nature' as Aesthetic Norm," *Essays in the History of Ideas* (Baltimore, Md.: Johns Hopkins University Press, 1948), 69–77.

30. *Severnaia pchela*, no. 106 (1845), quoted in Ronald D. LeBlanc, "Teniers, Flemish Art, and the National School Debate," *Slavic Review* 50 (fall 1991): 580.

31. Hugh Honour, *Neo-classicism* (New York: Penguin Books, 1968), 106.

32. Ibid., 167. On Gessner, see John Hibberd, *Solomon Gessner: His Creative Achievement and Influence* (Cambridge: Cambridge University Press, 1976).

33. Poussin's famous painting *Et in Arcadia Ego* might be taken as evidence that mortality could be incorporated as an element of the pastoral, but it is more appropriately understood as a philosophical commentary making use of pastoral illusions.

34. Lomonosov, *Sochineniia*, 80.

35. See Epshtein, *Priroda*, 156. Epshtein points to the conventionality in this period of what passed for realistic description of Russia. Even for Lomonosov (born in the far north near Arkhangelsk), by contrast to idyllic southern nature, Russia is considered "an eternally snow-covered northern state."

36. Some of the information gathered on these expeditions was collected together in a multivolume work in the early nineteenth century under the title *Polnoe sobranie uchenykh puteshestvii po Rossii*, 7 vols. (Saint Petersburg, 1818–1825). On early geographical explorations of Russia, see also N. E. Dik, *Lomonosovskii period v razvitii russkoi geografii* (Moscow: Mysl', 1976).

37. A. P. Sumarokov, *Stikhotvorenniia* (Leningrad: Sovetskii pisatel', 1953), 185.

38. R. Iu. Danilevskii, *Rossiia i Shveitsariia: Literaturnye sviazi XVII–XIX vv.* (Leningrad, 1984), 80. This translation is taken from the Russian.

39. See M. N. Murav'ev, "Ob uchenii prirodi. Pis'mo k V. V. Khanykovu," *Stikhotvoreniia* (Leningrad: Sovetskii pisatel', 1967), 185.

40. P. N. Petrov, *Sbornik materialov dlia istorii imp. S.-Peterburgskoi akademii nauk za 100 let ee sushchestvovaniia, t. 1* (Saint Petersburg, 1864), cited in K. Pigarev, *Russkaia literatura i izobrazitel'noe iskusstvo (XVIII–pervaia chetvert' XIX veka)* (Moscow: Iskusstvo, 1966), 231. From "Kratkoe rukovodstvo k poznaniiu risovaniia zhivopisi istoricheskogo roda, osnovannoe na umozrenii i opytakh" (Saint Petersburg, 1793).

41. Ibid.

42. For studies of the history of gardens, see John Dixon Hunt, *The Genius of the Place: The English Landscape Garden* (London: Paul Elek, 1975); Hunt, *Gardens and the Picturesque: Studies in the History of Landscape Architecture* (Cambridge, Mass.: MIT Press, 1992); Charles Moore, William J. Mitchell, and William Turnbull, *The Poetics of Gardens* (Cambridge, Mass.: MIT Press, 1988); Christopher Thacker, *The History of Gardens* (Berkeley: University of California Press, 1979); Roger Turner, *Capability Brown and the Eighteenth-Century English Landscape* (New York: Rizzoli, 1985).

43. I. M. Dolgorukov, *Zapiski Kniazia I. M. Dolgorukova: Povest' o rozhdenii moem, proiskhozhdenii, i vsei zhizni, 1764–1800* (Petrograd, 1916), 137.

44. A. F. Merzliakov, "Ob iziashchnoi slovestnosti, ee pol'ze, tseli, i pravilakh," in Kamenskii, *Russkie estesticheskie trakty*, 87.

45. For discussion of the relationship between gender and landscape, see Stephen Adams and Anna Gruetzner Robins, eds., *Gendering Landscape Art* (New Brunswick, N.J.: Rutgers University Press, 2000); Elizabeth Bohls, *Women Travel Writers and the Language of Aesthetics, 1716–1818* (Cambridge: Cambridge University Press, 1995); Jacqueline M. Labbe, *Romantic Visualities: Landscape, Gender, and Romanticism* (New York: Saint Martin's Press, 1998); Darby Lewes, *Nudes from Nowhere: Utopian Sexual Landscapes* (Lanham, Md.: Rowan and Littlefield, 2000). On the ancient and European origins of the ideological relation-

ship between concepts of "woman" and "nature," see Carolyn Merchant, *The Death of Nature: Women, Ecology, and the Scientific Revolution* (San Francisco: Harper and Row, 1983).

46. Blum, *Lord and Peasant*, 422.

47. Renato Poggioli, *The Oaten Flute: Essays on Pastoral Poetry and the Pastoral Ideal* (Cambridge, Mass.: Harvard University Press, 1975), 31.

48. Leo Marx, *The Machine in the Garden: Technology and the Pastoral Ideal in America* (New York: Oxford University Press, 1964).

49. Hans Rogger, *National Consciousness in Eighteenth-Century Russia* (Cambridge, Mass.: Harvard University Press, 1960), 126–85.

50. Iurii M. Lotman somewhat similarly argues that the lives of eighteenth-century Russian nobles had become encoded to stress role-playing, and that such behavior had "a geographical component" in that it depended on the location in which the noble found himself, i.e., estate, court, Moscow, Petersburg, etc. See "The Poetics of Everyday Behavior in Eighteenth-Century Russian Culture," in Alexander D. and Alice Stone Nakhimovsky, eds., trans., *The Semiotics of Russian Culture* (Ithaca, N.Y.: Cornell University Press, 1985), 72.

51. For example, V. S. Turchin, "Usad'ba i sud'ba klassitsizma v Rossii," E. I. Kirichenko, "Russkaia usad'ba v kontekste kul'tury i zodchestva vtoroi polviny XVIII veka," and O. V. Dokuchaeva, "Individ i obshchestvo v russkom peizazhnom parke vtoroi poloviny xviii–nachala xix veka," in the series entitled, *Russkaia usad'ba: Sbornik Obshchestva izucheniia russkoi usad'by* (Moscow-Rybinsk: Rybinskoe podvore), 1994–1995. The country estate varied along many socioeconomic and cultural gradations and evolved over time. It is not possible to summarize Russian estates as a single phenomenon.

52. Cited in Priscilla Roosevelt, *Life on the Russian Country Estate: A Social and Cultural History* (New Haven, Conn.: Yale University Press, 1995), 82–83. I am indebted to this study for many insights about the role of the estate in helping formulate Russian ideas of landscape.

53. Ibid., 68.

54. See V. V. Kapnist, *Izbrannye proizvedeniia* (Leningrad: Sovetskii pisatel', 1973), 261–65.

55. A. T. Bolotov, *Zhizn' i prikliucheniia Andreia Bolotova opisannyi samim im dlia svoikh potomkov* (Moscow: Sovremennik, 1986), 476.

56. See Iu. V. Bespalov, *Andrei Timofeevich Bolotov: Ispytatel' prirody* (Pushchino: Akademiia nauk, 1988), 17.

57. See A. T. Bolotov, "Pis'ma o krasotakh natury" and "Zhivopisatel' natury," in A. K. Demikhovskii, *A. T. Bolotov: Izbrannoe* (Pskov: Poipkro, 1993), 137–203 and 210–342.

58. Lotman, "Everyday Behavior," 67–94.

59. Studies of sentimentalism in literature include Jerome McGann, *The Poetics of Sensibility: A Revolution in Literary Style* (Oxford: Clarendon Press, 1996); John Mullan, *Sentiment and Sociability: The Language of Feeling in the Eighteenth Century* (Oxford: Clarendon Press, 1988); Janet Todd, *Sensibility: An Introduction* (New York: Methuen, 1986). On Russian sentimentalism, see Gitta Hammarberg, *From the Idyll to the Novel: Karamzin's Sentimentalist Prose* (Cambridge: Cambridge University Press, 1991).

60. See Danilevskii, *Rossiia i Shveitsariia*, 65; and Ernest Simmons, *English*

Literature and Culture in Russia, 1553–1840 (Cambridge, Mass.: Harvard University Press, 1935), 131, 167, and 320 n.

61. On English writers, see Simmons, *English Literature;* on Rousseau and Gessner, see Danilevskii, *Rossiia i Shveitsariia;* and on the influence of Ossian, see Iu. D. Levin, *Ossian v russkoi literature: Konets XVIII–pervaia tret' XIX veka* (Leningrad: Nauka, 1980).

62. See Van Tieghem, *Le sentiment de la nature,* 266. Van Tieghem credits this expression to Myra Reynolds with respect to England, but adds that the idea of a picturesque revolution "s'applique encore mieux aux autres pays."

63. See Pigarev, *Russkaia literatura,* 234–35; and Likhachev, *Poeziia sadov,* 206–210.

64. Jacques Delille, *Les Jardins, ou l'art d'embellir les paysages* (Paris: Chez Valade, 1782), quoted in Likhachev, *Poeziia,* 197.

65. N. M. Karamzin, *Zapiski starogo Moskovskogo zhiteliia: Izbrannaia proza* (Moscow: Moskovskii rabochii, 1986), 228. The article is entitled "Derevnia," and Karamzin has in mind the natural environment on his estate near Simbirsk.

66. Ibid., 229

67. Likhachev, *Poeziia sadov,* 289.

68. Nikolai Karamzin, *Letters of a Russian Traveler, 1789–1790,* trans. Florence Jonas (New York: Columbia University Press, 1957), 115.

69. On the literary language of Karamzin's travel writing, see Andreas Xavier Schonle, *Authenticity and Fiction* (Cambridge, Mass.: Harvard University Press, 2000). Also on travel writing in the eighteenth and early nineteenth centuries, see Sara Dickinson, "Imagining Space and the Self: Russian Travel Writing and Its Narrators, 1762–1825" (Ph.D. diss., Harvard University, 1985).

70. On Fonvizin, see D. I. Fonvizin, *Sobranie sochinenii v dvukh tomakh,* vol. 2 (Moscow: Gosudarstvennoe izdatel'stvo khudozhestvennoi literatury, 1959), 412–95.

71. At this time most paintings of recognizable Russian landscapes, with the exception of garden and park landscapes, depicted Russian cities.

72. Karamzin, *Zapiski starogo moskovskogo zhiteliia,* 41–42.

73. Karamzin, however, was by no means indifferent to Russia's landscape, even in his later years. His *Memoir on Ancient and Modern Russia* (1811), for example, showers praise on the Muscovite countryside by way of contrast to the gloomy and impoverished pine forests of the Petersburg region.

74. See Reuel K. Wilson, *The Literary Travelogue: A Comparative Study with Special Relevance to Russian Literature from Fonvizin to Pushkin* (The Hague: Nijhoff, 1973).

75. For a representative example that is remarkably similar to Karamzin, see P. Makarov, *Pis'ma iz Londona* (Saint Petersburg, 1806).

76. The most important of these would include M. Nevzorov, *Puteshestvie v Kazan', Viatku, i Orenburg v 1800 godu;* P. Sumarokov, *Puteshestvie po vsemu Krymu i Bessarabii v 1799 godu;* K*. G*., *Novyi chuvstvitel'nyi puteshestvennik, ili Moia progulka v A***;* P Shalikov, *Puteshestvie v Malorossiiu;* V. Izmailov, *Puteshestvie poludennuiu Rossiiu.* A sampling of this literature can be found in V. I. Korovin, ed., *Landshaft moikh voobrazhenii* (Moscow: Sovremennik, 1990). A useful discussion of travel in this period, T. Roboli, "Literatura 'Puteshestvii,'" is included in the collection *Russkaia proza: Sbornik statei* (Leningrad, 1926), 42–73.

77. Korovin, *Landshaft,* 24.

78. Ibid., 555.
79. From M. A. Dmitriev, *Melochi iz zapasa moei pamiati* (Saint Petersburg: Gracheva, 1869), quoted in N. D. Kochetkova, *Literatura russkogo sentimentalizma (Esteticheskie i khudozhestvennye iskaniia)* (Saint Petersburg: Nauka, 1994), 221.
80. A. Martynov, *Zhivopisnoe puteshestvie ot Moskvy do Kitaiskoi granitsy* (Saint Petersburg, 1819), 39.
81. V. Orlov, *Poeti-Radishchevtsi: Volnoe obshchestvo liubitelei slovestnosti, nauk, i khudozhestv* (Leningrad: Sovetskii pisatel', 1952), 345.
82. Ibid., 795.
83. N. I. Novikov, *Izbrannye sochineniia* (Moscow: Khudozhestvennaia literatura, 1951), 215–19.
84. See discussion in W. Gareth Jones, *Nikolay Novikov: Enlightener of Russia* (New York: Cambridge University Press, 1984).
85. [S. fon F.], *Puteshestvie kritiki* (Moscow: Izdatel'stvo Moskovskogo universiteta, 1951), 23. Although the work was originally published in 1818, the introduction to this facsimile edition places the date of its creation between 1802 and 1809.
86. In Korovin, *Landshaft*, 142.
87. J. A. Cuddon, *The Penguin Dictionary of Literary Terms and Literary Theory* (London: Penguin Books, 1991), 929.
88. For an extended discussion of Ossian, see Levin, *Ossian*.
89. See *G. R. Derzhavin: Stikhotvoreniia*, ed. D. D. Blagogo (Leningrad: Sovietskii pisatel', 1957), 178–90.
90. Fet's poetry was far more complicated than the sorts of pastoral imagery we have been discussing so far. It is more about longing for the ideal place than attaining it. That ideal, nevertheless, was a cornerstone of his poetic imagination. For a selection of Fet translations, see Afanasy Fet, *I Have Come to You to Greet You*, trans. James Greene (London: Angel Books, 1982).

CHAPTER 2

1. Isaiah Berlin, "A Remarkable Decade," in *Russian Thinkers* (New York: Penguin Books, 1978), 118.
2. On different conceptions of nationality during the reign of Nicholas I, see W. Bruce Lincoln, *Nicholas I: Emperor and Autocrat of All the Russias* (Bloomington: Indiana University Press, 1978); and Nicholas Riasanovsky, *Nicholas I and Official Nationality in Russia, 1825–1855* (Berkeley: University of California Press, 1959).
3. See Levin, *Ossian*. A work that discusses many of these images pointedly refrains from attributing them to the influence of Ossian and recasts the image of northern space in terms of the semiotic significance of "the north" as a crucial marker for Russian culture in the eighteenth and nineteenth centuries. See Otto Boele, *The North in Russian Romantic Literature* (Amsterdam: Editions Rodopi, 1996).
4. P. A. Viazemskii, *Polnoe sobranie sochinenii* (Saint Peterburg, 1878), 40–41.
5. Both a discussion of Shirinskii-Shikhmatov's work and the translation of the passage cited here appear in William Edward Brown, *A History of Russian Literature of the Romantic Period*, 4 vols. (Ann Arbor, Mich.: Ardis, 1986), 1:298–301. The passage is found in a travel piece clearly written as a contrast to the sentimental travel literature of Karamzin and his followers. Shikhmatov gave it the

pointedly unpoetic title, "The Return to His Native Land of my beloved Brother Paul Alexandrovich from a Five-Year Naval Expedition, in the course of which he sailed on many seas from the Baltic to the Archipelago, saw many European lands, and finally returned to Russia overland from Toulon by way of Paris."

6. K. N. Batiushkov, *Sochineniia* (Saint Petersburg, 1885–1887; The Hague: "Academia" Reprints, 1967), 323.

7. F. N. Glinka, *Pis'ma russkogo ofitsera* (Moskva: Moskovskii rabochii, 1985), 121.

8. Ibid., 136.

9. See Levin, *Ossian,* 110. The quote is in reference to the poetry of Kondratii Ryleev.

10. D. V. Venevitvinov, *Polnoe sobranie stikhotvorenii* (Leningrad: Sovetskii pisatel', 1960), 99.

11. On this expression and the role of Italy in Russian culture during the first half of the nineteenth century, see Claudio Poppi, "Itineraries to the Happy Country," in *Nostalgia d'Italia: Russian water-colours of the first half of the XIX century* (Florence: Ponte alle Grazie, 1991.), 7–14. Russian poets who wrote about Italy without having been there include Batiushkov, Venevitvinov, and Gogol. Much of the work on Russians in Italy can be found in Ettore Lo Gatto, *Russi in Italia, dal secolo XVII ad oggi* (Rome: Editori riuniti, 1971).

12. Nikolai Gogol, *Sochineniia,* vol. 5 (Moscow: V. Dumanov, 1889), 44. There has been some suspicion Gogol might not have written this poem.

13. John Mersereau, Jr., and George Harjan, eds., *Orest Somov: Selected Prose in Russian* (Ann Arbor: University of Michigan Press, 1974), 173, 175–76.

14. Ibid., 176

15. Susan Layton, *Russian Literature and Empire: Conquest of the Caucasus from Pushkin to Tolstoy* (Cambridge: Cambridge University Press, 1994), 69.

16. K. N. Batiushkov, *Opyty v stikhakh i proze* (Moscow: Nauka, 1977), 95.

17. Somov wrote about a short excursion to the Imatra Waterfall, which he published as "Four Days in Finland" and "Letters to Moscow." See John Mersereau, Jr., *Orest Somov* (Ann Arbor, Mich.: Ardis, 1989), 67.

18. E. A. Baratynskii, "Eda," in *Polnoe sobranie stikhotvorenii* (Leningrad: Sovetskii pisatel', 1957), 228. For much of this information on landscape descriptions of Finland, I am indebted to William Edward Brown, *Russian Literature of the Romantic Period.*

19. Faddei Bulgarin in a letter to Pavel Svinin, *Severnaia pchela* 77 (27 June 1825).

20. See Fedor Glinka, *Stikhotvoreniia* (Leningrad: Sovetskii pisatel', 1961), 133–34; K. F. Ryleev, *Polnoe sobranie stikhotvorenii* (Leningrad: Sovetskii pisatel', 1971), 152–55; N. M. Iazykov, *Polnoe sobranie stikhotvoreniia* (Moscow-Leningrad: Sovetskii pisatel', 1964), 157–58.

21. Epshtein, *Priroda,* 158.

22. P. A. Viazemskii, *Stikhotvoreniia* (Saint Petersburg: M. M. Stasiulevich, 1880), 230.

23. For a discussion of Viazemskii's creation of this expression, see Lauren G. Leighton, *Russian Romanticism: Two Essays* (The Hague: Mouton, 1975), 49–51.

24. P. A. Viazemskii, *Sochineniia* (Leningrad: Sovetskii pistatel', 1958), 129–32.

25. Ibid., 20.

26. See Viazemskii's "In Place of an Introduction" to Pushkin's "Bakhchisarai Fountain," in P. A. Viazemskii, *Estetika i literaturnaia kritika* (Moscow: Iskusstvo, 1984), 48–53.

27. N. I. Gnedich, *Stikhotvoreniia* (Leningrad: Sovetskii pisatel', 1956), 184. For an extended description of the development of the idyll in Russia during these years, see Brown, *Russian Literature in the Romantic Period*, 1:266–71.

28. Idyll came from the Greek *eidos*, meaning "picture." It was borrowed from the diminutive form *eidullion*, or "little picture." See John Ayto, *Dictionary of Word Origins* (New York: Arcade Publishing, 1990), 293.

29. Cited in Danilevskii, *Rossiia i Shveitsariia*, 82.

30. *Aleksei Gavrilovich Venetsianov: Stat'i, pis'ma, sovremenniki o khudozhnike*, ed. A. V. Kornilova (Leningrad: Iskusstvo, 1980), 49.

31. *Venetsianov*, 271.

32. *Khudozhestvennaia gazeta* 2 (1837): 32. Kukolnik goes on to list Russia's potential picturesque sites and to urge the publication of such a work, but such a publication would not appear in his lifetime.

33. Richard Wortman has described a very different sort of Russian travel literature written during this era: descriptions of monarchial visits to the Russian provinces. See Wortman, "Rule By Sentiment: Alexander II's Journeys Through the Russian Empire," *American Historical Review* 95, no. 3 (June 1990): 745–71.

34. In addition to epigrams, Pushkin had Svinin in mind when he wrote the story "The Little Liar," and he is also said to have given Gogol the idea for *The Inspector General*, based on a story Svinin had told him about his travels in Bessarabia. Svinin was criticized primarily because he was prone to exaggeration, perhaps in part because of his penchant for placing output above accuracy in his work.

35. A recent edition of the Russian *Picturesque United States* has been published in English under the title *Traveling across North America, 1812–1813: Watercolors by the Russian Diplomat*, trans. Kathleen Carroll (New York: Abrams, 1992). See also Pavel Svinin, *Sketches of Moscow and St. Petersburg* (Philadelphia: Thomas Dobson, 1813).

36. A good example of Svinin's garden description is found in the travel article "Ropsha" in *Otechestvennyia zapiski* 10 (1821): 125–40.

37. "Liubit' otechestvo—velit Priroda i Bog/ A znat' ego—vot chest', dostoinstvo i dolg."

38. Svinin, "Novgorod," *Otechestvenniyia zapiski* 17 (1821): 328–62.

39. Svinin, "Stranstvyia v okrestnostiakh Moskvy," *Otechestvennyia zapiski* 22 (1822): 5.

40. A. N. Muravev, *Puteshestvie po sviatym mestam russkim: v dvukh chastiakh* (Moscow: Kniga, 1990), v.

41. See G. N. Gennadi, *Spisok knig o russkikh monastyr'iakh i tserkvakh* (Saint Petersburg, 1854).

42. E. S. Ivashina, "Puteshestvie kak zhanr russkoi literatury kontsa XVIII–pervoi treti XIX veka" in *Kulturologicheskii aspect teorii i istorii russkoi literatury* (Moscow, 1978), 53.

43. See Viacheslav Korb, "Blagochestivyi stranik," in Muravev, *Puteshestvie*, 389.

44. Muravev's travel writing was praised by his famous contemporary, Pushkin, and later it was even admired by Chernyshevskii.

45. See, for example, D. I. Matskevich, *Putevyie zametki* (Kiev, 1856); O. P. Shishkina, *Zametki i vospominaniia russkoi puteshestvennitsy* (Saint Petersburg, 1843); Vadim Passek, *Putevyia ocherki Vadima* (Saint Petersburg, 1838) and *Ocherki Rossii* (Moscow, 1838–1840); and Stepan Shevyrev, *Poezdka v Kirillo-Belozerskii monastyr': Vakatsionnye dni professora S. Shevyreva v 1847 godu* (Moscow, 1850).

46. G. V. Smirnov, "Grigorii Grigorovich Chernetsov i Nikanor Grigorovich Chernetsov," in A. I. Leonov, ed., *Russkoe iskusstvo: Ocherki o zhizni i tvorchestve khudozhnikov* (Moscow: Iskusstvo, 1958), 549.

47. This book was recompiled in 1971. See Grigorii and Nikanor Chernetsov, *Puteshestvie po Volge* (Moscow, Mysl', 1970). I am grateful to Irina Lapshina at the archive of the Russian Museum (GRM) in St. Petersburg for pointing out to me the existence of the original manuscript journals and helping me decipher them.

48. Ibid., 7.

49. Ibid., 32.

50. Ibid., 151. There is a supplement to these notes, probably written as late as 1862. It gives a different conception of the forest, but since the period between 1838 and 1862 witnessed major changes in Russian conceptions of nature, it is not surprising that the perspective of the Chernetsovs would have altered as well. This chapter only uses material from the 1838 trip.

51. Ibid., 107–9.

52. Dmitrii Likhachev, *Zametki o russkom* (Moscow: Sovetskaia Rossiia, 1981), 52. This remark echoes Pushkin's own comment about Karamzin—that he "discovered ancient Russia as Columbus did America."

53. N. L. Stepanov, *Lirika Pushkina: Ocherki i etiudy* (Moscow: Sovetskii pisatel', 1959), 389, quoted in Pigarev, *Russkaia literatura*, 11.

54. Alexander Pushkin, *Eugene Onegin*, 3 vols., rev. ed., trans. and with a commentary by Vladimir Nabokov (Princeton: Princeton University Press, 1964), 2:204. Nabokov also writes: "It is with this literary landscape, imported from France or through France, that in *EO [Eugene Onegin]* Pushkin replaces a specific description of summer in northwestern Russia, whereas his winters belong to the arctic order of such as were described by his predecessors and contemporaries in Russia, but selected and arranged by him with incomparably greater talent" (199).

55. See Brown, *Russian Literature in the Romantic Period*, 3:142.

56. Ibid.

57. This translation was made by Stephanie Sandler and appears in *Distant Pleasures: Alexander Pushkin and the Writing of Exile* (Stanford: Stanford University Press, 1989), 27. I agree with her choice of title, "The Countryside," as a better description of the kind of generalized country space Pushkin intended to describe than the usual translation, "The Village," which evokes the Russian countryside more as it would be understood at a later time.

58. Ibid., 29. For Sandler's interesting analysis, see pp. 25–39.

59. For other readings of landscape, perception, and power relations, see Bermingham, *Landscape and Ideology;* and Barrell, *Dark Side of Landscape*.

60. For a discussion of *tener'stvo* and its aesthetic implications, see LeBlanc, "Teniers, Flemish Art, and the National School Debate," 576–89.

61. A. S. Pushkin, *Evgenii Onegin: Roman v stikhakh* (Paris: Bokking International, 1994), 182.
62. Ibid., 91.
63. Ibid., 32–33.
64. Ibid., 85.
65. Ibid., 127.
66. Christopher Hussey, *The Picturesque: Studies in a Point of View* (New York: G. P. Putnam and Sons, 1927), 4.
67. John Dixon Hunt, "Ut Pictura Poesis, Ut Pictura Hortus and the Picturesque," *Word and Image* 1 (1985): i, 102. Quoted in Andrews, *Search for the Picturesque*, viii.
68. Pushkin, *Onegin,* 91–92.
69. Ibid., 181–82.
70. The translations of these two poems are found in Christine Rydel, ed., *The Ardis Anthology of Russian Romanticism* (Ann Arbor, Mich.: Ardis, 1984), 65–67.
71. A. V. Lunarcharskii, *Krasnaia gazeta* 1926, no. 201–9, cited in A. Gordin, *Pushkin v Mikhailovskoe: Literaturnie ekskursii* (Leningrad, 1939), 31–32.

CHAPTER 3

1. This translation is found in Andrew Durkin, *Sergei Aksakov and Russian Pastoral* (New Brunswick, N.J.: Rutgers University Press, 1983), 87.
2. For a recent discussion of the historical development of the idea of a Russian homeland, see Robert J. Kaiser, *The Geography of Nationalism in Russia and the USSR* (Princeton: Princeton University Press, 1994), 83–87 and passim.
3. N. V. Gogol, "Neskol'ko slov o Pushkine," in *Russkaia literatura XIX veka: Khrestomatiia kriticheskikh materialov,* v. 2 (Kharkov: Izdatel'stvo gosurdarstvennogo universiteta, 1961), 36.
4. V. G. Belinskii, *Polnoe sobranie sochinenii,* v. 14 (Moscow: Izdatel'stvo Akademii nauk SSSR, 1955), 331.
5. N. V. Gogol', *Izbrannye proizvedeniia* (Leningrad: Lenizdat, 1968), 12.
6. Cited in V. I. Gippius, *Gogol,* trans. and ed. Robert A. Maguire (Ann Arbor, Mich.: Ardis, 1981), 73.
7. See Simmons, *English Literature,* 237–68.
8. Gogol reworked *Taras Bul'ba* in 1842, but he left the sections on the steppe landscape largely unchanged. For the textual changes he did make, see E. I. Prokhorov, "Tekstologicheskie kommentarii," in N. V. Gogol', *Taras Bul'ba* (Moskva: Izdatel'stvo Akademii nauk SSSR, 1963), 233–51
9. Passek, *Ocherki Rossii,* 92 and passim.
10. Gogol', *Izbrannye proizvedeniia,* 232–34.
11. Comparison between steppe terrain and vast seas was not Gogol's own invention. Passek, for instance, had attempted the same approach. What was new in Gogol was his descriptive power, his ability to animate the maritime metaphor and make it compelling.
12. See James Creed Meredith, ed., *The Critique of Judgement* (Oxford: Clarendon Press, 1952). For a discussion of Friedrich, see Leo Koerner, *Caspar David Friedrich and the Subject of Landscape* (New Haven, Conn.: Yale University Press, 1990).

13. Gogol', *Izbrannye proizvedeniia*, 234. Much has been made of the innately Russian linkage of freedom and the open steppe. Dmitrii Likhachev has analyzed the word *udal'* (bravery) as an example of the primordial connection between open space and national character, and other literary scholars have seen an instinctive Russian longing for open space in the supposed twelfth-century epic *Lay of the Host of Igor*. Discounting any problems with these specific arguments, there does not necessarily exist any cultural connection between the modernized elite of nineteenth-century Russia and the distant cultural past. Thus such writers as Gogol, in my opinion, should be credited with having *invented* rather than simply rediscovered this conception of the Russian landscape in a modern context.

14. See V. P. Anikin, "Poeziia Kol'tsova i narodnaia pesnia," in N. V. Os'makov, *A. V. Kol'tsov i russkaia literatura* (Moskva: Nauka, 1988), 3–14.

15. See V. Iu. Troitskii, "Koltsov i russkaia romanticheskaia poeziia ego vremeni," in Os'makov, *Kol'tsov*, 54.

16. V. I. Belinskii, "Stikhotvoreniia Kol'tsova," in *Sobranie sochinenii*, vol. 1 (Moscow: Khudozhestvennaia literatura, 1976), 213.

17. Ibid., 8:111.

18. Ibid.

19. A. I. Liashchenko, ed., *Polnoe sobranie sochinenii A. V. Kol'tsova* (Saint Petersburg: Akademiia nauk, 1909), 70.

20. The idea of a special Russian longing for *prostor* became one of the hallmarks of the Russian national character in the nineteenth century. The following ecstatic description of the national significance of *prostor* can be found in a celebration of Russian culture and language written during the First World War: "[The word *prostor*] breathes of the distinctively Slavonic passion for yet another aspect of freedom. It bursts from Russian lips at the sight of space, far vistas, broad rivers, blue seas, steppes, golden corn-fields waving from horizon to horizon. . . . Prostor suggests to us endless possibilities; it is the seed-bed of creative impulse; it pours into Russian art its power of witching charm, and fills the Russian heart to overflowing with the power of love." See Madame N. Jarintzov, *The Russians and Their Language* (New York: Mitchell Kennerley, 1916), 25–26.

21. Cited in J. Alexander Ogden, "Fashioning a Folk Identity: The 'Peasant-Poet' Tradition in Russia (Lomonosov, Kol'tsov, Kliuev), *Intertexts* 5, no. 1 (2001): 40. This essay neatly dispels continuing romanticization of Kol'tsov as the Russian "natural man."

22. See Vladimir Dal', *Tolkovyi slovar' zhivogo velikorusskogo iazyka*, vol. 4 (Moscow: Gosudarstvennoe izdatel'stvo innostrannykh i natsionalnykh slovarei, 1955), 27.

23. Leonard J. Kent, ed., *The Collected Plays and Tales of Nikolai Gogol*, trans. Constance Garnett (New York: Pantheon Books, 1964), 427.

24. Ibid., 428.

25. Cited in David Magarshack, *Gogol: A Life* (London: Faber and Faber, 1957), 112. The statement comes from an unpublished review on St. Petersburg theatre in 1836 and 1837.

26. Robert Maguire, *Exploring Gogol* (Stanford: Stanford University Press, 1994), 116.

NOTES TO PAGES 98-121

27. Ibid., 115.
28. Ibid., 116.
29. Cited in Victor Erlich, *Gogol* (New Haven, Conn.: Yale University Press, 1969), 159.
30. N. V. Gogol', *Polnoe sobranie sochinenii: t. 11* (Leningrad: Izdatel'stvo Akademii nauk SSR, 1952), 141.
31. Henri Troyat, *Divided Soul: The Life of Gogol* (New York: Minerva Press, 1975), 181.
32. Cited in Erlich, *Gogol,* 159.
33. Gogol', *Polnoe sobranie sochinenii: t. 11,* 92.
34. Nikolai Gogol, *Dead Souls,* trans. David Magarshack (New York: Penguin Books, 1961), 121.
35. Ibid., 122.
36. Ibid., 231-32.
37. M. Iu. Lermontov, *Izbrannye proizvedeniia* (Minsk: Gosudarstvennoe uchebno-pedagogicheskoe izdatel'stvo BSSR, 1956), 129.
38. Another interpretation of these three forms of nationality might relate them to regions of Europe, respectively to France (with its revolutionary and military conquests), to England (a relatively peaceful and defensible island nation), and to Germany (with much of its potential national identity residing in legend and ancient historical accounts).
39. T. V. Kolesnichenko, "Filosofskiie istoki temy prirody v russkoi literature serediny XIX veka," in *Zhanry russkogo realizma: Sbornik nauchnykh trudov* (Dnepropetrovsk, 1983), 54.
40. S. P. Shevyrev, "Pokhozhdenie Chichikova, ili Mertvye dushi. Poema N. Gogolia," in V. K. Kantora and A. L. Ospovata, *Russkaia estetika i kritika 40-50-kh godov XIX veka* (Moscow: Iskusstvo, 1982), 59.
41. Ibid., 61.
42. D. I. Matskevich, *Putevyia zametki: Gruzino, Novgorod, Barovichi, Ustiuzhno.* (Saint Petersburg, 1851), 44-45.
43. Shevyrev, *Poezdka,* 1:80.
44. Ibid., 83.
45. Ibid., 2:56.
46. Ibid., 2:133-34.
47. Religious architecture as a symbol of Russianness was never eclipsed but rather marginalized in the more liberal and practical context of the reform era. Pilgrimages to monasteries continued as before, and apparently experienced a resurgence in the 1890s and 1900s. Village churches, moreover, play a substantial role in Russian landscape painting beginning in the 1870s.
48. Shevyrev, *Poezdka,* 1:60-61.
49. See, for example, Iosif Belov, *Putevye zametki* (Moscow, 1852); I. D. Dmitriev, *Putevoditel' ot Moskvy do S. Peterburga i obratno* (Moscow, 1839); Olimpiada P. Shishkina, *Zametki i vospominaniia russkoi puteshestvennitsy* (Saint Petersburg, 1848); I. M. Snegirov, *Putevoditel' iz Moskvy v Troitse-Sergievu lavru* (Moscow, 1856); A. P. Turchanov, *Poezdka na Valaam* (Saint Petersburg, 1850); K. D. Ushinskii, *Poezdka za Volkhov,* published in *Sovremennik* 9 (1852), no. 6, reprinted in *Poezdki po Rossii* (Iaroslavl: Verkhne-Volzhskoe Knizhnoe Izd-vo, 1969), 35-75.

50. I. S. Nikitin, *Polnoe sobranie stikhotvorenii* (Moscow-Leningrad: Sovetskii pisatel'), 81.
51. Ibid., 82–85.
52. A. I. Gertsen, *Polnoe sobranie sochinenii i pisem*, vol. 6 (Petersburg: Narodnyi Komissariat po Prosveshcheniiu, 1919), 6–7.
53. S. T. Aksakov, *Sobranie sochinenii v piati tomakh*, vol. 4 (Moscow: Pravda, 1966), 288–89.
54. Ibid., 288.
55. Thomas Cole, "Essay on American Scenery," in *American Art, 1700–1960: Sources and Documents*, ed. John W. McCoubrey (Englewood Cliffs, N.J.: Prentice-Hall, 1965), 98–109. See also Isaiah Smithson, "Thoreau, Thomas Cole, and Asher Durand: Composing the American Landscape," in *Thoreau's Sense of Place: Essays in American Environmental Writing*, ed. Richard J. Schneider (Iowa City: University of Iowa Press, 2000), 101.
56. Smithson, "Thoreau," 107.
57. Sergei Aksakov, *Sobranie sochinenii*, vol. 2 (Moscow: Khudozhestvennaia literatura, 1955–56), 403–16.
58. Sergei Aksakov, "Letter to Ivan Aksakov, 17 February 1850," quoted in Durkin, *Sergei Aksakov*, 71.
59. This idyll, "The Fisherman's Grief," told the story of two fishermen, one older, one younger. From the title and subject matter we can assume that it was probably in part inspired by Gnedich, but it retains even less of the traditional pastoral than in Gnedich.
60. Durkin, *Sergei Aksakov*, 69.
61. In this period a new conception of the rural surroundings as a pastoral, yet naturalistic, space can also be found in the work of such poets as Apollon Maikov, Iakov Polonskii, and Aleksei Tolstoi.
62. Ivan Goncharov, *Oblomov*, trans. David Magarshack (New York: Penguin Books, 1954), 103.
63. Ibid., 104.
64. Ibid., 105.
65. Ibid., 108.
66. Ibid., 134.
67. L. N. Tolstoy, *Childhood, Boyhood, Youth*, trans. Rosemary Edmonds (New York: Penguin Books, 1964), 32–33.
68. Serge Aksakoff, *A Russian Gentleman*, trans. J. D. Duff (reprint, Westport, Conn.: Hyperion Press, 1977), 130.
69. Ibid., 140.
70. Durkin, *Sergei Aksakov*, 242.
71. Ivan Turgenev, *A Hunter's Sketches*, trans. Raissa Bobrova (second printing, Moscow: Progress Publishers, 1979), 32.
72. Ibid., 245–46.
73. Cited in Pigarev, *Peizazh v russkoi literature*, 82.
74. I. S. Turgenev, *Polnoe sobranie sochinenii*, vol. 5 (Moscow-Leningrad: Izdatel'stvo Akademii nauk SSSR, 1963), 156.
75. Ibid., 113–14.
76. Ibid., 181.
77. I. S. Aksakov, *Pis'ma k rodnym, 1844–1849* (Moscow: Nauka, 1988), 373.

CHAPTER 4

1. Nikolai Berdyaev, *The Russian Idea,* trans. R. M. French (Hudson, N.Y.: Lindisfarne Press, 1992), 268.

2. The evolving perception of the *narod* within Russian educated society is, of course, an unavoidable subject in the study of Imperial Russian history. The topic runs through so many histories of the period, it would be impossible to list even a fraction here. Cathy Frierson's *Peasant Icons* scrutinizes the image of the Russian peasant in detail. It has been an invaluable source for the present chapter and a model for the book as a whole.

3. V. V. Tomashevskii, ed., *A. S. Pushkin: Lirika, poemy, skazki,* vol. 1 (Leningrad: Lenizdat, 1961), 245.

4. Gogol, *Dead Souls,* 232.

5. Ibid.

6. See Alexander Gershchenkron, *Economic Backwardness in Historical Perspective* (Cambridge, Mass.: Harvard University Press, 1962).

7. See Greenfeld, *Nationalism,* on the development of Russian *"ressentiment,"* 15–17, 191–274, passim.

8. Martin Malia, *Alexander Herzen and the Birth of Russian Socialism* (New York: Grosset and Dunlap, 1961), 292.

9. Gogol, *Dead Souls,* 337.

10. Tiutchev, *Izbrannoe,* 216. This untitled poem was written in 1866.

11. Ibid., 102.

12. Ibid., 169–70.

13. I. S. Aksakov, "Fedor Ivanovich Tiutchev: Biograficheskii ocherk," in *Izbrannoe,* ed. A. N. Petrov (Moscow: Moskovskii rabochii, 1985), 319.

14. Ibid., 153.

15. M. I. Gillel'son, *P. A. Viazemskii: Sochineniia v dvukh tomakh,* vol.1 (Moscow: Khudozhestvennaia literatura, 1982), 182.

16. Tomashevskii, *Pushkin,* 190.

17. Richard Mowbray Haywood, *The Beginnings of Railway Development in Russia in the Reign of Nicholas I, 1835–1842* (Durham, N.C.: Duke University Press, 1969). See pages 21–31.

18. Among the affirmative travel literature of this period, see, for example, Shishkina, *Zametki;* and Dmitriev, *Putevoditel' ot Moskvy do S. Peterburga i obratno* (Moscow, 1847).

19. Aleksandr Pushkin, *Polnoe sobranie sochinenii,* vol. 7 (Moscow-Leningrad: Akademii nauk SSSR, 1949), 289.

20. Matskevich, *Putevyia zametki,* 145.

21. V. A. Sollogub, *Tarantas* (Moscow: Khudozhestvennaia literatura, 1955), 13.

22. Ibid., 44–45.

23. Ibid., 53.

24. Ibid., 57.

25. See William Edward Brown, "Afterword," in Vladimir Sollogub, *The Tarantas: Impressions of a Journey (Russia in the 1840s),* trans. William Edward Brown (Ann Arbor, Mich.: Ardis, 1989), 144. E. A. Baratynskii wrote that "everyone criticizes" these initial chapters.

26. Sollogub, *Tarantas*, 137–38.
27. Ibid., 139.
28. E. A. Verderevskii, *Ot zaural'ia do Zakavkazia* (Moscow, 1857), 43–44.
29. Ibid., 245.
30. V. G. Belinskii, *Polnoe sobranie sochinenii*, 8:331.
31. Ibid., 368–69.
32. Ibid., 377.
33. D. V. Grigorovich, *Sochineniia* (Moscow: Khudozhestvennaia literatura, 1988), 1:141–46.
34. Ibid., 162.
35. Ibid.
36. Ibid., 166.
37. M. E. Saltykov-Shchedrin, *Sobranie sochinenii v dvadtsati tomakh*, vol. 6 (Moscow: Khudozhestvennaia literatura, 1968), 461.
38. N. G. Chernyshevsky, *Selected Philosophical Essays*, trans. Institute of Philosophy of the Academy of Sciences of the U.S.S.R. (Moscow: Foreign Languages Publishing House, 1953), 324–27.
39. Ibid., 321.
40. Ibid., 344.
41. See V. I. Nikol'skii, *Priroda i chelovek v russkoi literature XIX veka (50–60–e gody)* (Kalinin: Kalininskii gosudarstvennyi universitet, 1973), 166.
42. Ibid., 22.
43. Frierson, *Peasant Icons*, 24. For a compact discussion of the ethnographic sketch in context, see pp. 21–31. The rest of this work covers the literature in detail.
44. N. A. Dobroliubov, *Polnoe sobranie sochinenii* (Leningrad: Khudozhestvennaia literatura, 1934), 161.
45. Ibid., 162.
46. See *Peterburzhets puteshestvuet*, 78.
47. Iu. B. Lebedev, "Sergei Vasilevich Maksimov" in *S. V. Maksimov: Izbrannye proizvedeniia v dvukh tomakh*, ed. Iu. B. Lebedev, vol. 1 (Moscow: Khudozhestvennaia literatura, 1987), 15.
48. For a history of the Russian Geographical Society, see P. P. Semenov-Tian-Shanskii, *Istoriia poluvekovoi deiatel'nosti Russkogo geograficheskogo obshchestvo* (Saint Petersburg, 1896).
49. See Abbott Gleason, *Young Russia: The Genesis of Russian Radicalism in the 1860s* (Chicago: University of Chicago Press, 1980), 229.
50. See, for instance, P. I. Iakushkin, *Sochineniia* (St. Petersburg, 1884); or S. V. Maksimov, *Brodiachaia Rus'* (St. Petersburg, 1877).
51. See Ivan Turgenev, *Fathers and Sons*, trans. Ralph E. Matlaw (New York: W. W. Norton, 1966), 73, 33.
52. Dmitrii Pisarev, "Bazarov," trans. Lydia Hooke, in Turgenev, *Fathers and Sons*, 218.
53. V. A. Sleptsov, *Sochineniia v dvukh tomakh*, vol. 1 (Moscow: Khudozhestvennaia literatura, 1957), 239–362.
54. A. Tarachkov, *Putevyia zametki po Orlovskoi i sosedenim s neiu guberniiam* (Orel, 1862), 251.
55. Frierson, *Peasant Icons*, 33.
56. A. A. Molchanov, *Po Rossii* (Saint Petersburg, 1876), 92.

57. Ibid., 93.
58. Ibid., 87.
59. N. G. Ogarev, *Stikhotvoreniia i poemy* (Leningrad: Sovetskii pisatel', 1956), 78.
60. Ibid., 156.
61. Elizabeth Cherish Allen, ed., *The Essential Turgenev* (Evanston, Ill.: Northwestern University Press, 1994), 381.
62. Ibid., 387.
63. Cited in Pigarev, *Russkaia literatura i izobrazitel'noe iskusstvo*, 86.
64. Leo Weiner, *Anthology of Russian Literature: From the Earliest Period to the Present Time*, vol. 2 (New York: G. P. Putnam and Sons, 1903), 367.
65. Saltykov-Shchedrin, *Sobranie sochineniia*, 5:24.
66. Ibid., 17:35.
67. Charles Moser, "Saltykov and the Russian Novel," in Mikhail Saltykov-Shchedrin, *The Golovyov Family*, trans. Samuel Cioran (Ann Arbor, Mich.: Ardis, 1977), xxv.
68. Ibid., 49.
69. Nivat, "Le Paysage russe," 16.
70. Saltykov-Shchedrin, *Sobranie sochineniia*, 2:152.
71. Ibid., 12–13.
72. This story went unpublished during Saltykov's lifetime. The chapter in question, however, was published in a collection of stories entitled *Skladchina: Literaturnyi sbornik, sostavlennyi iz trudov russkikh literaturov v pol'zu postradavshikh ot goloda v Samarskoi gubernii* (Saint Petersburg, 1874).
73. Saltykov-Shchedrin, *Sobranie sochineniia*, 4:260–61.
74. Ibid., 261.
75. Ibid., 262–63.
76. Nikolai Nekrasov, *Polnoe sobranie stikhotvorenii v trekh tomakh*, vol. 1 (Leningrad: Sovetskii pisatel', 1967), 206.
77. Nikolai Nekrasov, *Polnoe sobranie sochinenii i pisem* (Moscow: Gosudarstvennoe izdatel'stvo khudozhestvennoi literatury, 1949), 205.
78. Nekrasov, *Polnoe sobranie stikhotvorenii*, 2:274.
79. Ibid., 7–12.
80. Ibid., 51–58.
81. Ibid., 1:206–24.
82. Ibid., 2:92–99.
83. M. B. Peppard, *Nikolai Nekrasov* (New York: Twayne Publishers, 1967), 142–43.
84. Nekrasov, *Polnoe sobranie stikhotvorenii*, 3:244. Stalin used these lines in a 1931 speech encouraging the rapid pace of Soviet industrialization as a matter of defending the "socialist fatherland." See Robert V. Daniels, ed., *A Documentary History of Communism*, vol. 1 (Hanover, N.H.: University Press of New England, 1984), 230.

CHAPTER 5

1. Cited in A. P. Botkina, *Pavel Mikhailovich Tret'iakov v zhizni i iskusstve* (Moscow: Iskusstvo, 1993), 42.
2. Elizabeth Valkenier, *Russian Realist Art: The State and Society: The*

Peredvizhniki and Their Tradition (New York: Columbia University Press, 1977), 4.

3. Among others, the Soviet art historian Aleksei Fedorov-Davydov considers these painters an important first step in the direction of a "realist" approach to landscape in Russia. This is a good point in terms of realist technique and subject matter from contemporary life, and it is especially true of Shchedrin. The argument was particularly important within Soviet art history because it helped draw a line between the already valorized realists of the late nineteenth century and the earlier painters, thus validating the work of these artists as part of a continuous line of progress toward a single defining goal—in this case realism. See A. Fedorov-Davydov, *Russkaia peizazhnaia zhivopis' kontsa XIX–nachala XX veka* (Moscow: Izobrazitel'noe iskusstvo, 1962).

4. "Otchet zachitannyi G. G. Miasoedovym obshchemu sobraniiu chlenov Tovarishchestva peredvizhnykh khudozhestvennykh vystavok," in Iu. K. Korolev et al., eds., *Tovarishchestvo peredvizhnykh khudozhestvennykh vystavok, 1869–1899: Pis'ma, dokumenty* (Moscow: Gosudarstvennaia Tret'iakovskaia galereia, 1988), 335.

5. For a synopsis of the realist movement, particularly in France, see Linda Nochlin, *Realism* (New York: Penguin Books, 1971). See also T. J. Clark, *Image of the People: Gustave Courbet and the Second French Republic, 1848–1851* (London: Thames and Hudson, 1973); and Clark, *Painting of Modern Life* (New York: Alfred A. Knopf, 1985).

6. Korolev, *Tovarishchestvo*, 335.

7. See Mal'tseva, *Mastera*. This two-volume study is primarily a collection of independent works on the key realist landscape painters of the 1860–1880s: Aleksei Savrasov, Ivan Shishkin, Fedor Vasil'ev, and Arkhip Kuindzhi. Its most useful section documents the rise of realist landscape painting in the 1850s and 1860s. Although I disagree with some of its essential premises, it is an invaluable work on Russian landscape painting. It should also be noted that in a later work, an exhaustive biography of Savrasov, Mal'tseva's interpretations of Russian landscape painting are more nuanced than in this work. She makes a variety of attempts to account for the issue of national identity, although without the theoretical apparatus to make a cogent argument on the large scale.

8. Ibid., 29.

9. Valkenier, *Russian Realist Art*, 76.

10. R. S. Kaufman, *Russkaia i sovetskaia khudozhestvennaia kritika s serediny XIX v. do 1941* (Moscow: Iskusstvo, 1985), 71.

11. For a detailed overview of Calame's work, see Valentina Anker, *Alexandre Calame Vie at Oeuvre: Catalogue raisonné de l'oeuvre peint* (Fribourg, Switzerland: Office du Livre, 1987). Critics such as Maikov were almost certainly responding to Calame's early work of the 1830s and 1840s, which Anker calls "neo-Dutch" in its intentional focus on mundane, rustic settings. He also painted much more spectacular Alpine landscapes and stormy romanticized settings throughout his career, and especially in the 1840s and 1850s, but these works seem to have made little impact in Russia. On Calame's various stylistic periods, see in particular pp. 129–68.

12. Kaufman, *Kritika*, 78.

13. G. Iu. Sternin, *Khudozhestvennaia zhizn' Rossii serediny XIX veka* (Moscow: Iskusstvo, 1991), 55.

14. F. I. Bulgakov, *Al'bom russkoi zhivopisi: Kartiny V. D. Orlovskago* (Sankt-Peterburg, 1888), 11.

15. Sternin, *Khudozhestvennaia zhizn'*, 55. Mal'tseva has pointed out that Savrasov and his fellow landscape students in the 1840s were asked to make copies of Calame's paintings. See Faina Mal'tseva, *Aleksei Kondrat'evich Savrasov: Zhizn' i tvorchestvo* (Moscow: Iskusstvo, 1977), 76.

16. Ibid., 163 (emphasis in original). According to Sternin this quotation, written by L. M. Zhemchuzhnikov, can be found in the foreign-published journal *Basis* [*Osnova*] for 1861. Anker notes about half a dozen minor Russian landscape painters who studied with Calame. The poet and occasional landscape painter Iakov Polonskii and the landscape painter Ivan Shishkin both tried unsuccessfully to study with him in Switzerland.

17. See K. V., "Vospominaniia o vystavke kartin i redkikh proizvedeniiakh iskusstva v Akademii khudozhestv," *Russkii khudozhestvennyi listok* 17 (1861): 67, quoted in B. I. Asvarishch, *Kushelevskaia galereia zapadnoevropeiskaia zhivopis' XIX veka: Katalog vystavki* (Sankt-Peterburg: Gosudarstvennyi ermitazh, 1993), 14.

18. Ibid., passim.

19. The collection is described in detail by Asvarishch. Today the paintings are housed at the Hermitage in St. Petersburg. For an account of Barbizon art, see R. L. Herbert, *Barbizon Revisited* (Boston, 1962).

20. I. E. Repin, *Dalekoe blizkoe* (Leningrad: Khudozhnik RFSFR, 1982), 240.

21. Asvarishch, *Kushelevskaia galereia*, 12.

22. Ibid., 16. Grigorovich remarked: "If our art lovers mainly buy the works of foreign artists, they are not to blame for it at all: is it not more logical to obtain an original Calame, Achenbach, or Leys than an imitation, which often costs as much as the original?"

23. For a full description of these artists and events, see Valkenier, *Russian Realist Art*, 33–34. The artists had to include "moonlight, wolves, ravens, clouds, etc." Valkenier's is the only full-length monograph in English on the Russian realist movement. It provides a detailed description of the origins of the Peredvizhniki. Also see Camilla Gray, *The Russian Experiment in Art, 1863–1922* (London: Thames and Hudson, 1970); and Valkenier, *Ilya Repin and the World of Russian Art* (New York: Columbia University Press, 1990).

24. I. I. Dmitriev, "Raskarkivaiushchesia iskusstvo" *Iskra* 38 (October 1863): 528.

25. Ibid. This painting was the work of Egor Oznobishin, a friend and colleague of Ivan Shishkin.

26. Vsevolod Garshin's 1879 short story "Artists" derided the genre as little more than an opportunistic ruse to cheat the public of its money. The heroic figure in the story refers to the venal landscape painter as "genial and innocuous as a landscape himself." See Vsevolod Garshin, *From the Reminiscences of Private Ivanov and Other Stories*, trans. Peter Henry et al. (London: Angel Books, 1988), 93–109.

27. On Stasov, see Valkenier's *Russian Realist Art*, 56–62, and *Ilya Repin*, passim. For a study that is primarily focused on Stasov's influence in the field of music, see Yuri Olkhovsky, *Vladimir Stasov and Russian National Culture* (Ann Arbor, Mich.: UMI Research Press, 1983).

28. On Tret'iakov and other art patrons, see John O. Norman, "Pavel Tretiakov and Merchant Art Patronage," in *Between Tsar and People: Educated Society and the Quest for Public Identity in Late Imperial Russia,* ed. Edith Clowes, Samuel Kassow, and James West (Princeton: Princeton University Press, 1991), 93–107. For a study of Tret'iakov's life, see Botkina, *Tret'iakov.*

29. Cited in Botkina, *Tret'iakov,* 42.

30. K. V., "Khudozhestvennyia zametki," in *Russkii khudozhestvennyi listok* 4 (2 February 1862): 12.

31. L. A. Bespalova, "Mikhail Konstantinovich Klodt," in A. I. Leonov, *Russkoe iskusstvo: Ocherki o zhizni tvorchestva khudozhnikov,* 5 vols. (Moscow: Iskustvo, 1952–62), 4:379.

32. Ibid., 381.

33. P. A. Sukhodol'skii, Report to Imperial Academy of Art, 1864, in RGIA, *delo* 783, *op.* 10.

34. Vladimir Orlovskii, Report to Imperial Academy of Art, 1868, in RGIA, *delo* 789, *op.* 14, no. 1903.

35. Ibid. Orlovskii eventually grew fond of painting in Italy and asked the academy to allow him to stay longer.

36. See Mal'tseva, *Savrasov,* 385.

37. I. N. Shuvalova, ed., *Ivan Ivanovich Shishkin: Perepiska, dnevnik, sovremenniki o khudozhnike* (Leningrad: Iskusstvo, 1984), 100. Kamenev had in mind the artists V. I. Iakobi and V. G. Perov.

38. Ibid.

39. Ibid., 74.

40. Ibid., 95.

41. Ibid., 241.

42. Ibid., 106.

43. See Sukhodol'skii, Report.

44. Ibid.

45. V. V. Stasov, "Vystavka v Akademii khudozhestv," *Sankt-Peterburgskie Vedomosti,* no. 10 (1867): 12.

46. Ibid.

47. Sukhodol'skii's drawings for the magazine *Niva* [*Grainfield*] in the 1890s appear quite traditional compared to the work of his contemporaries. On Sukhodol'skii's career, see Leonov, *Russkoe iskusstvo,* 2:423–26.

48. See O. Liaskovskaia, *Vasilii Grigorovich Perov: Al'bom reproduktsii* (Moscow: Izobrazitel'noe iskusstvo, 1956).

49. Stasov, "Vystavka," 12.

50. Ibid.

51. B., "IV Peredvizhnaia vystavka kartin," in *Novorossiiskii telegraph* (1876), no. 307. Quoted in Pigarev, *Russkaia literatura,* 41–42.

52. *Perepiska I. N. Kramskogo: Perepiska s khudozhnikami,* ed. E. G. Levenfish et al. (Moscow: Iskusstvo, 1954), 42.

53. Shuvalova, *Shishkin,* 103. Bykov was a Petersburg collector believed to have owned the best collection of landscapes by the painter M. I. Lebedev, known for his paintings of Italy, including at least one alley in Albano.

54. Ibid., 105.

55. Kenneth Clark, *Landscape into Art,* 66.

56. On Shishkin's interest in photography, see S. Morozov, *Russkaia khudozhestvennaia fotografiia: Ocherki iz istorii fotografii, 1839–1917* (Moscow: Iskusstvo, 1961), 58–60.

57. It might be relevant to note here that when asked in a newspaper interview to list his favorite prose writers, Shishkin included Aksakov among the first three. See Shuvalova, *Shishkin,* 432.

58. A similar use of wilderness as a signifier of national identity was also, of course, a part of nineteenth-century American culture. It should be mentioned that Shishkin's ouevre was not limited to enclosed forest scenes. He also painted a smaller number of landscapes of the Russian steppe. Two of them, "Rye" and "Amidst the Spreading Vale," number among his best-known works. Although they both portray huge, open vistas, they do not differ from the enclosed forest landscapes as much as might be expected. The distance is so vast and undifferentiated as to prohibit a sense of quick visual gratification. Even these portraits of the open, expansive steppe refuse to portray landscape as a scenic view.

59. Savrasov had visited the World's Fair in England in 1862 and the Paris Salon in 1867. In London he admired certain English landscape painters, among them Constable, John Linell, and John Harding, for their "depth of thought" and "strict observation." See Mal'tseva, *Savrasov,* 66.

60. E. Degot, "Bol'shoi i malyi mir v russkom peizazhe romanticheskoi traditsii," in Nataliia Olegovna Tamruchi, *Prostranstvo kartiny* (Moscow: Sovetskii khudozhnik, 1989), 125.

61. The sea of land was a favorite metaphor with Russian writers, in Gogol for example. For a discussion of this language, see James West, "The Russian Landscape in Early Nineteenth-Century Russian Art and Literature," in Roger Anderson and Paul Debreczeny, eds., *Russian Narrative and Visual Art: Varieties of Seeing* (Gainesville: University of Florida Press, 1994), 11–40.

62. Ivan Kramskoi, *Ivan Nikolaevich Kramskoi: Pis'ma, stat'i* (Moscow: Iskusstvo, 1965), 103.

CHAPTER 6

1. A. A. Rusakova, ed., *M. V. Nesterov: Iz pisem* (Leningrad: Iskusstvo, 1968), 210.

2. Cited in E. I. Shtanova, "Russko-frantsuskie khudozhestvennye sviazi v peizazhe 60–70-kh godov XIX veka," in the Nauchno-bibliograficheskii arkhiv of RAKh: Diplomnaia rabota, f. II, *op.* 2, *ed. khr.* no. 4113–4114.

3. G. G. Urusov, "Vystavka khudozhestvennykh proizvedenii tovarishchestva peredvizhnykh vystavok v porssii i moskovskogo uchilishcha zhivopisi, vaiania i arkhitektury," *Beseda* 12, no. 2 (1872): 25.

4. Adrian Prakhov, "Vystavka v Akademii khudozhestv: proizvedenii russkogo iskusstva prednaznachennykh dlia posylki na vsemirnuiu vystavku v Parizhe," *Pchela* 17 (1878): 262. Emphasis in original.

5. Cited in L. A. Gessen, ed., *Russkie pisateli ob isskusvte* (Leningrad: Khudozhnik RSFSR, 1976), 171–72. In view of my earlier assertion about the rejection of the designation "view," it should be pointed out that Dostoevsky gave an incorrect title for this painting, which was actually called *On Valaam Island.*

6. On Russia's expanding urban population in the late Imperial period, see Hans Rogger, *Russia in the Age of Modernization and Revolution* (London: Longman Group, 1983), 125–27.

7. See Valkenier, *Russian Realist Art,* 76–79.

8. Valkenier has approached these discrepancies mainly as a matter of historical change over the course of the association's existence, not to mention the effect of a wide array of different influences on the painters' sense of their mission, and their own various political views. Still, from the first Wanderers' exhibit, landscape painting represented a strain in Russian realist art that was removed from moral judgment and social criticism.

9. Valkenier, "The Intelligentsia and Art," in Theofanis George Stavrou, ed., *Art and Culture in Nineteenth-Century Russia* (Bloomington: Indiana University Press, 1983), 153.

10. Korolev, *Tovarishchestvo,* 1:51

11. Ibid., 2:631.

12. Aleksei Fedorov-Davydov's *Russkoe iskusstvo promyshlennogo kapitalizma* (Moscow, 1929) details the financial pursuits of the Peredvizhniki movement. He asserts that "the very idea of the travelling exhibits was oriented toward the enlargement of the provincial market for small goods" (175).

13. The magazine *Niva* even gave out engravings as an incentive to raise subscription rates. These included works by Shishkin and Klever among others.

14. Shishkin, for example, collaborated with the photographer Andrei Karelin, painting watercolors in a book of Volga river views of Nizhnii-Novgorod. See Shuvalova, *Shishkin,* 311, 429.

15. Klever was held up to ridicule by the Peredvizhniki and progressive critics for his supposed exclusive interest in the sale of paintings. His work was notable for its lurid expression of light, such as winter sunsets. But it should also be acknowledged that Kuindzhi and Shishkin were widely admired by the public and enjoyed significant profits from the sale of paintings. For example, toward the end of his life Kuindzhi was able to donate hundreds of thousands of rubles in support of the arts. See V. S. Manin, *Arkhip Ivanovich Kuindzhi* (Leningrad: Khudozhnik RSFSR, 1990), 69–70. On the Wanderers' financial concerns, see, in particular, Ia. D. Minchenkov, *Vospominaniia o peredvizhnikakh* (Leningrad: Khudozhnik RFSFR, 1964).

16. See Konstantin Korovin, *Konstantin Korovin vospominaet* (Moscow: Izobrazitel'noe iskusstvo, 1971), 145–46.

17. *Perepiska I. N. Kramskogo: Perepiska s khudozhnika* (Moscow: Iskusstvo, 1954), 87.

18. Shuvalova, *Shishkin,* 246.

19. Kramskoi, *Perepiska,* 187.

20. Turgenev, *Fathers and Sons,* 166.

21. Minchenkov, *Vospominaniia,* 48.

22. Kramskoi, *Perepiska,* 48–49.

23. On Shishkin's sense of personal insignificance, see Shuvalova, *Shishkin,* 318.

24. Aleksei Fedorov-Davydov, *I. I. Levitan: Pis'ma, dokumenty, vospominaniia* (Moscow: Iskusstvo, 1956), 108–9.

25. Korovin, *Korovin,* 163.

26. Fedorov-Davydov, *Levitan*, 196. The reminiscences of Levitan's friends and acquaintances published in Fedorov-Davydov's text are filled with such statements, mostly to the effect that Levitan deeply loved the native land, particularly in its melancholy aspect.

27. G. Ostrovskii, *Rasskaz o russkoi zhivopisi* (Moscow: Izobrazitel'noe iskusstvo, 1989), 252.

28. Cited in Shuvalova, *Shishkin*, 406. It should be noted that this statement was attributed to Shishkin from notes claimed to have been taken directly from him by his niece, A. T. Komarova, in the 1890s. She had studied with him during the last years of his life, and he had requested that she write his biography. This passage comes from a section of her notes entitled, "Introduction to a Program of Summer Studies for the Students of the Academy of Arts. Work on Studies from Nature."

29. "K risunkam," *Pchela* 6 (22 April 1876): 10.

30. Ibid., 2 (25 January 1876): 15.

31. Aksakov, *Russian Gentleman*.

32. Turgenev, *Sketches*, 99–120. As we have seen, this was also a favorite device in Nekrasov's poetry.

33. In Andrew Wachtel's study of gentry childhood in nineteenth-century Russia, he explores the development of a mythology of gentry childhood beginning around midcentury in Russian literature. See Andrew Baruch Wachtel, *The Battle for Childhood: Creation of a Russian Myth* (Stanford: Stanford University Press, 1990).

34. Shuvalova, *Shishkin*, 318. This statement appears in A. T. Komarova's memoir of Shishkin, "Lesnoi Bogatyr'-khudozhnik," cited in note 28 above.

35. Cited in Lev Anisov, *Shishkin* (Moscow: Molodaia gvardiia, 1991), 223. The whereabouts of this painting are not known today.

36. "Na puti na vsemirnuiu vystavki i shestaia peredvizhnaia vystavka," *Svet* (March 1878): 100, in Shuvalova, *Shishkin*, 267.

37. "I. I. Shishkin," *Sever*, no. 4 (1888): 15–16, in Shuvalova, *Shishkin*, 279.

38. Profan [Adrian Prakhov], "Vystavka v Akademii khudozhestv proizvedenii russkogo iskusstva, prednaznachennykh na vsemirnuiu v Parizhe," *Pchela* 17 (1878): 262, in Shuvalova, *Shishkin*, 268.

39. V. V. Stasov, "Vot nashi strogie tseniteli i sud'i," *Severnyi vestnik* 1, no. 2 (1892): 102, in Shuvalova, *Shishkin*, 284.

40. Profan "Vystavka," 262.

41. I have in mind here, for example, Gogol, Kol'tsov, Turgenev, Aksakov, Nekrasov, and Tolstoy. Each of these authors depicted the Russian landscape to great effect, but none of them portrayed it as a wilderness to be admired and appreciated in its own right independent of its use value and relation to the inhabitants.

42. A parallel to Shishkin's urban celebration of Russian nature is found among the late-nineteenth-century bourgeoisie of Sweden. According to Jonas Frykman and Orvar Lofgren in *Culture Builders: A Historical Anthropology of Middle-Class Life* (New Brunswick, N.J.: Rutgers University Press, 1987), as Sweden industrialized, the middle classes, whose parents and grandparents had lived on the land as peasants, became "nature lovers" in an attempt to

forge a new national identity that would overcome rising class conflict. Swedes established deep attachments to nature only once they had become urbanized. "It is the alienation from the natural world," write the authors, "that is a prerequisite for the new sentimental attachment to nature," 83. Shishkin's context, of course, fostered a somewhat different articulation of the significance of nature in Russia.

43. Boris N. Chicherin, *Vospominaniia (Puteshestvie za granitsu)*, 103. Cited in G. M. Hamburg, *Boris Chicherin and Early Russian Liberalism* (Stanford: Stanford University Press, 1992), 185.

44. Fedorov-Davydov, *Levitan*, 45.

45. Cited in E. Moskalets, "Poet severnogo peizazha," *Khudozhnik* 12 (1964): 42–43. For a short study of Khokhriakov, see G. G. Kiseleva, *N. N. Khokhriakov* (Kirov, 1966).

46. Ia. P. Zatenatskii, "Predislovie," in G. Kryzhitskii, *Sud'ba khudozhnika* (Kiev: Mistetsvo, 1966), 8.

47. Korovin, *Korovin*, 143.

48. Ibid., 164.

49. A. K. Denisov-Uralskii, *Ural i ego bogatstvo* (Saint Petersburg, 1911), 28. This was the catalogue of Uralskii's 1911 exhibit. A verst is slightly longer than a kilometer.

50. Ibid., 6. On Denisov-Ural'skii, see B. V. Pavlovskii, *A. K. Denisov-Ural'skii* (Sverdlosk, 1958).

51. A. S. Shkliarevskii, "Peizazhi chetvertoi Peredvizhnoi vystavki," in *Kievlianin* 29 (1876), 31 (1876), 32 (1876): 2. A year before this review Shkliarevskii had been engaged to the landscape painter Elena Polenova.

52. Ibid., 6.

53. Ibid., 7.

54. Ibid., 8.

55. See G. P. Fedotov, *The Russian Religious Mind* (Cambridge, Mass.: Harvard University Press, 1946), 9–20. Also see Joanna Hubbs, *Mother Russia: The Feminine Myth in Russian Culture* (Bloomington: Indiana University Press, 1988).

56. Jules Michelet, *Oeuvres complètes* (Paris, n.d.), xxi, 268. Quoted in Anderson, *Imagined Communities*, 198.

57. N. K. Vagner, "Peizazh i ego znachenie v zhivopisi," in *Vestnik Evropy*, April 1876, 759.

58. Ibid., 760.

59. Ibid., 761.

60. Ibid., 762.

61. Ibid.

62. Ibid. The second of these extracts from Nekrasov runs:
>El', da pesok, berezniak, da osina—
>Ne vesela ty, rodnaia kartina.

63. Mal'tseva, *Savrasov*, 121.

64. A. Fedorov-Davydov, "I. Shishkin," in *Russkoe i sovetskoe iskusstvo: stat'i i ocherki* (Moscow: Iskusstvo, 1975), 448.

65. V. I. Sizov, "XI Peredvizhnaia vystavka kartin v Moskve," *Russkie vedo-*

mosti, May 1883, quoted in Shuvalova, *Shishkin,* 272.

66. Dmitrii S. Likhachev, *Reflections on Russia,* trans. Christina Sever (Boulder, Colo.: Westview Press, 1991), 16.

67. Adrian Prakhov, "Chetvertaia Peredvizhnaia vystavka," in *Pchela* 10 (March 1875): 121.

68. Cathy Frierson, *Peasant Icons.* See also Hans Rogger, *National Consciousness in Eighteenth-Century Russia.* As Rogger points out, Russian idealization of the *narod* began as early as the eighteenth century, but its initial impact in Russian society was comparatively light.

69. K. D. Kavelin, "Topics of the Day," cited in Frierson, *Peasant Icons,* 181.

70. See N. N. Novouspenskii, *Fedor Aleksandrovich Vasil'ev* (Moscow: Izobrazitel'noe iskusstvo, 1991). The author writes that Vasil'ev, "keenly attuned to its social aspect, expressed a steady interest in the landscape of the Russian village, depicting it without a single element of idealization, in its genuine form" (38).

71. Vladimir Stasov, ed., "Pis'ma F. A. Vasileva k raznym litsam," in *Zhurnal iziashchnykh iskusstv* (1888): 299.

72. Bermingham, *Landscape and Ideology,* 75.

73. E. V. Sakharova, *Vasilii Dmitrievich Polenov, Elena Dmitrievna Polenova: Khronika sem'i khudozhnikov* (Moscow: Iskusstvo, 1964), 349.

74. Ibid., 373.

75. Cited in B. V. Asaf'ev, *Izbrannye trudy,* vol. 4 (Moscow: Iskusstvo, 1955), 88.

76. See, in particular, Hosking, *Russia: People and Empire.*

77. Ernest Renan, "What is a Nation?" in Wesley D. Camp, *Roots of Western Civilization,* vol. 2 (New York: Alfred A. Knopf, 1983), 145.

78. On the Mamontov circle, see E. G. Kiseleva, *Moskovskii khudozhestvennyi kruzhok* (Leningrad: Iskusstvo, 1979). Also see D. Kogan, *Mamontovskii kruzhok* (Moscow, 1970). Mamontov himself was not an artist, but he held strong views about the direction of art in Russia. On a trip to the far north in the 1890s, he argued that in those regions could be found the most characteristic features of Russian nature: "How stupid and dull are our artists for not coming here. The entire secret of Russian art can be found here. . . . Nature here is poorer, true, but it is just as joyful as at home. It is necessary to come here to know what is really Russian" (Kiseleva, 103). The boundaries of "authenticity" in Russian landscape were moving north as central Russia became a more familiar subject for Russian artists.

79. A. Fedorov-Davydov, *Russkaia peizazhnaia zhivopis' kontsa XIX-nachala XX veka* (Moscow: Iskusstvo, 1962).

80. See Alison Hilton, "Russian Impressionism," in *World Impressionism,* ed. Norma Broude (New York: Abrams, 1990), 370–406.

81. It seems to me that Chekhov's description probably refers to Levitan's *At the Pool.* Fedorov-Davydov argues that it was more closely associated with *Quiet Monastery.* In any event, Chekhov was familiar with both paintings, and certainly his description evoked a "Levitanian" landscape.

82. Anton Chekhov, "Three Stories," trans. Ronald Hingley, *The Oxford Chekhov,* 7:202.

CONCLUSION

1. Cited in Dmitrii Kaigorodov, *P. I. Chaikovskii i priroda* (Saint Petersburg, 1907), 60.
2. V. O. Kliuchevskii, *Sochineniia: Kurs russkoi istorii* (Moscow: Politicheskaia literatura, 1956), 66.
3. Nikolai Lender, *Na Volge* (Saint Petersburg, 1888), 235.
4. From the author's personal collection of pre-Revolutionary postcards.
5. A. Antonov, *Nasha strana: Zemlia russkaia* (Saint Petersburg: Vserossiskii natsional'nyi klub, 1911), 13–14.
6. See Malia, *Alexander Herzen*, 292.
7. An exception to such abstract idealization would be the common assertion of Moscow as a symbol of the entire nation. Moscow too, of course, had to be portrayed in specific ways to serve its representative purpose.
8. S. N. Bulgakov, "Moia Rodina," in *Russkaia ideia,* ed. M. A. Maslin (Mosocw: Respublika, 1992), 366.
9. Ibid., 364–65.
10. See chapter 3.

Bibliography

ARCHIVES

Rossiiskii Gosudarstvennyi Istoricheskii Arkhiv (RGIA), St. Petersburg
Rossiiskaia Natsional'naia Biblioteka (RNB)
Gosudarstvennyi Russkii Muzei (GRM), St. Petersburg
Rossiiskaia Akademiia Khudozhestv (RAKh), St. Petersburg

SELECTED JOURNALS

Khudozhestvennaia gazeta
Niva
Otechestvennyia zapiski
Pchela
Rodina
Russkii khudozhestvennyi listok
Severnoe siianie
Vestnik iziashchnykh isskustv
Vsemirnaia illiustratsiia
Zhivopisnaia russkaia biblioteka
Zhivopisnoe obozrenie

PRIMARY SOURCES

Afanasiev, A. F. *Poeticheskie vozrenie slavian na prirodu*. Sovremennyi pisatel', 1995.
Aksakov, I. S. *Pis'ma k rodnym, 1844–1849*. Moscow: Nauka, 1988.
Aksakov, S. T. *Sobranie sochinenii v piati tomakh*. Moscow: Pravda, 1966.
Antidote, The, or an Enquiry into the Merits of a Book Entitled, A Journey into Siberia. London: S. Leacroft, 1772.
Babst, I. K. *Rechnaia oblast' Volgi*. Moscow, 1852.
Baratynskii, E. A. *Polnoe sobranie stikhotvorenii*. Leningrad: Sovetskii pisatel', 1957.
Batiushkov, K. N. *Opyty v stikhakh i proze*. Moscow: Nauka, 1977.
———. *Sochineniia*. 3 vols. St. Petersburg, 1885–1887; The Hague: "Academia" Reprints, 1967.
Beketov, Andrei. *Naturalist: sbornik nauchno-populiarnykh statei po chasti estestvennykh nauk i sel'skago khoziastva*. Saint Petersburg, 1872.
Belinskii, V. G. *Polnoe sobranie sochinenii*. Moscow: Izdatel'stvo Akademii nauk SSSR, 1955.

BIBLIOGRAPHY

Bogoliubov, N. P. *Volga ot Tveri do Astrakhani*. Saint Petersburg, 1862.
Catherine II's Charters of 1785 to the Nobility and Towns. Edited and translated by David Griffiths and George Munro. Bakersfield, Calif.: Charles Schlacks, Jr., 1991.
Chernetsov, Grigorii and Nikanor. *Puteshestvie po Volge*. Moscow: Mysl', 1970.
Chernyshevsky, N. G. *Selected Philosophical Essays*. Translated by the Institute of Philosophy of the Academy of Sciences of the U.S.S.R. Moscow: Foreign Languages Publishing House, 1953.
Chistiakov, Mikhail. *Iz poezdok po Rossii*. Saint Petersburg, 1867.
Dem'ianov, G. M. *Putevoditel' po Volge*. Nizhnii-Novgorod, 1889.
Denisov-Uralskii, A. K. *Ural i ego bogatstvo*. Saint Petersburg, 1911.
Dmitriev, I. D. *Putevoditel' ot Moskvy do S. Peterburga i obratno*. Moscow, 1847.
Dmitriev, I. I. *Polnoe sobranie stikhotvorenii*. Leningrad: Sovetskii pisatel', 1967.
———. "Raskarkivaiushchesia iskusstvo." *Iskra* (October 1863).
Dmitriev, M. A. *Melochi iz zapasa moei pamiati*. Saint Petersburg: Gracheva, 1869.
Dolgorukov, I. M. *Zapiski Kniazia I. M. Dolgorukova: Povest' o rozhdenii moem, proiskhozhdenii, i vsei zhizni, 1764–1818*. Petrograd, 1916.
Dostoevsky, Fyodor. *Winter Notes on Summer Impressions*. Translated by Richard Lee Renfield. New York: Criterion Books, 1955.
Garshin, Vsevolod. *From the Reminiscences of Private Ivanov and Other Stories*. Translated by Peter Henry et al. London: Angel Books, 1988.
Gautier, Theophile. *Russia*. Translated by Florence MacIntyre Tyson. Philadelphia: John Winston Company, 1905.
Glinka, F. N. *Pis'ma Russkogo ofitsera*. Moskva: Moskovskii rabochii, 1985.
———. *Stikhotvoreniia*. Leningrad: Sovetskii pisatel', 1961.
Gnedich, N. I. *Stikhotvoreniia*. Leningrad: Sovetskii pisatel', 1956.
Gogol', N. V. *Dead Souls*. Translated by David Magarshack. New York: Penguin Books, 1961.
———. *Izbrannye proizvedeniia*. Leningrad: Lenizdat, 1968.
———. *Sochineniia*. Moscow: V. Dumanov, 1889.
Gogol, N. V. Goncharov, Ivan. *Oblomov*. Translated by David Magarshack. New York: Penguin Books, 1954.
Gordin, A. M. *Pushkin v Mikhailovskom: Literaturnye ekskursii*. Leningrad, 1939.
Grigorovich, D. V. *Sochineniia*. Moscow: Khudozhestvennaia literatura, 1988.
Iakushkin, P. I. *Sochineniia*. St. Petersburg, 1884.
Iazykov, N. M. *Polnoe sobranie stikhotvorenii*. Moscow-Leningrad: Sovetskii pisatel', 1964.
Kaigorodov, D. I. *Besedy o russkom lese: 2 seriia chernolese*. Saint Petersburg, 1881.
———. *Rodnaia priroda: Ocherki naturalista*. Moscow: Lesnaia promyshlennost', 1967.
Kapnist, V. V. *Izbrannye proizvedeniia*. Leningrad: Sovetskii pisatel', 1973.
Karamzin, N. M. *Izbrannye stikhotvoreniia*. Leningrad: Sovetskii pisatel', 1953.
———. *Istoriia Gosudarstva rossiiskogo*. Saint Petersburg, 1892.
———. *Letters of a Russian Traveler, 1789–1790*. Translated by Florence Jonas. New York: Columbia University Press, 1957.
———. *Ot Orenburga do Tashkenta*. Saint Petersburg, 1886.

BIBLIOGRAPHY

———. *S severa na iug: Putevye vospominaniia starogo zhuravli.* Saint Petersburg: Devrien, 1890.
———. *Zapiski starogo Moskovskogo zhiteliia: Izbrannaia proza.* Moscow: Moskovskii rabochii, 1986.
Kign, V. L. *Vokrug Rossii: Portrety i peizazhi.* Saint Petersburg: M. M. Lederle, 1895.
Kliuchevskii, V. O. *Sochineniia: Kurs russkoi istorii.* Moscow: Politicheskaia literatura, 1956.
Kol'tsov, A. K. *Polnoe sobranie sochinenii A. V. Kol'tsova.* Saint Petersburg: Akademiia nauk, 1909.
Konchalovskii, P. *Ot Moskvy do Arkhangel'ska: Po moskovsko-iaroslavsko-arkhangel'skoi zheleznoi doroge.* Moscow: A. I. Mamontov, 1897.
Korolev, Iu. K., et al., eds. *Tovarishchestvo Peredvizhnykh khudozhestvennykh vystavok, 1869–1899: Pis'ma, dokumenty.* Moscow: Gosudarstvennaia Tret'iakovskaia galereia, 1988.
Korovin, Konstantin. *Konstantin Korovin vospominaet.* Moscow: Izobrazitel'noe iskusstvo, 1971.
Kramskoi, Ivan. *Ivan Nikolaevich Kramskoi: Pis'ma, stati.* Moscow, Iskusstvo, 1965.
———. *Perepiska I. N. Kramskogo: Perepiska s khudozhnika.* Ed. E. G. Levenfish et al. Moscow: Iskusstvo, 1954.
Kuchin, P. I. *Putevoditel' po Volge.* Saratov, 1865.
Lender, Nikolai. *Na Volge.* Saint Petersburg, 1888.
———. *Volzhskii sputnik.* Saint Petersburg, 1892.
Leopol'dov, A. F. *Obshchie svedeniia o Volge.* Saratov, 1890.
Lermontov, M. Iu. *Izbrannye proizvedeniia.* Minsk: Gosudarstvennoe uchebno-pedagogicheskoe izdatel'stvo BSSR, 1956.
Levitan, I. I. *I. I. Levitan: Pis'ma, dokumenty, vospominaniia.* Moscow: Iskusstvo, 1956.
Lomonosov, Mikhail V. *Sochineniia v stikhakh.* Saint Petersburg: A. F. Marks, 1893.
Makarov, P. *Pis'ma iz Londona.* Saint Petersburg, 1806.
Maksimov, S. V. *S. V. Maksimov: Izbrannye proizvedeniia v dvukh tomakh.* Moscow: Khudozhestvennaia literatura, 1987.
Martynov, A. *Zhivopisnoe puteshestvie ot Moskvy do Kitaiskoi granitsy.* Saint Petersburg, 1819.
Matskevich, D. I. *Putevyia zametki: Gruzino, Novgorod, Barovichi, Ustiuzhno.* Saint Petersburg, 1851.
Molchanov, A. A. *Po Rossii.* Saint Petersburg, 1876.
Monastyrskii, S. *Illiustrirovannyi sputnik po Volge.* Kazan, 1884.
Muravev, A. N. *Puteshestvie po sviatym mestam russkim v dvukh chastiakh.* Moscow: Kniga, 1990.
Murav'ev, M. N. *Stikhotvoreniia.* Leningrad, Sovetskii pisatel', 1967.
Neidgart, P. P. *Putevoditel' po Volge.* Saint Petersburg, 1862.
Nekrasov, N. A. *N. A. Nekrasov: Polnoe sobranie sochinenii i pisem.* Moscow: Gosudarstvennoe izdatel'stvo khudozhestvennoi literatury, 1949.
———. *N. A. Nekrasov: Polnoe sobranie stikhotvorenii v trekh tomakh.* Moscow: Sovetskii pisatel', 1967.

BIBLIOGRAPHY

Nemirovich-Danchenko, V. I. *Po Volge*. Saint Petersburg, 1877.
Nesterov, M. V. *M. V. Nesterov: Iz pisem*. Leningrad: Iskusstvo, 1968.
Nikitin, I. S. *Polnoe sobranie stikhotvorenii*. Moscow-Leningrad: Sovetskii pisatel', 1961.
Novikov, N. I. *Izbrannye sochineniia*. Moscow: Khudozhestvennaia literatura, 1951.
Ogarev, N. G. *Stikhotvoreniia i poemy*. Leningrad, Sovetskii pisatel', 1956.
Ostrovskii, A. N. *Stikhotvornye dramy*. Leningrad: Sovetskii pisatel', 1961.
Ot Sankt-Peterburga do vodopada Kivach. Saint Petersburg, 1881.
Passek, Vadim. *Putevyia ocherki Vadima*. Saint Petersburg, 1838.
Polenov, V. D., and E. D. Polenova. *Vasilii Dmitrievich Polenov i Elena Dmitrievna Polenova: Khronika sem'i khudozhnikov*. Moscow: Iskusstvo, 1964.
Polevoi, P. N. *Khudozhestvennaia Rossiia: Obshchestvennoe opisanie nashego otechestva*. St. Petersburg: S. Dobrodeeva, 1884.
——. *Rodnye otgoloski: Sbornik stikhotvorenii russkikh poetov*. Paris and St. Petersburg, 1875.
Polnoe sobranie uchenykh puteshestvii po Rossii. 7 vols. Saint Petersburg, 1818–1825.
Predtechenskii, E. A. *Na pamiat' o Volge*. Saint Petersburg, 1892.
Profan [Adrian Prakhov]. "Vystavka v Akademii khudozhestv: Proizvedenii russkogo iskusstva prednaznachennykh dlia posylki na vsemirnuiu vystavku v Parizhe." *Pchela*, no. 17 (1878).
Pushkin, A. S. *Eugene Onegin*. Translated by Vladimir Nabokov. Princeton: Princeton University Press, 1964.
——. *Evgenii Onegin: Roman v stikhakh*. Paris: Bokking International, 1994.
——. *Izbrannye proizvedeniia v dvukh tomakh*. Leningrad: Lenizdat, 1961.
——. *Polnoe sobranie sochinenii*. Moscow-Leningrad: Akademiia nauk SSSR, 1949.
Putevoditel' po Urale. Ekaterinburg: Izd. gazety "Ural," 1899.
Ragozin, V. I. *Volga*. Moscow, 1880.
Razmadze, A. S. *Volga*. Kiev, 1896.
Repin, I. E. *Dalekoe blizkoe*. Leningrad: Khudozhnik RSFSR, 1982.
Rimsky-Korsakoff, Nikolay Andreyevich. *My Musical Life*. Translated by Judah A. Joffe. New York: Alfred A. Knopf, 1928.
Russkoe obshchestvo turizma i otchiznovedenie. *Predlozhenie ob organizatsii ekskursii na Urale*. Petrograd, 1916.
Ryleev, K. F. *Polnoe sobranie stikhotvorenii*. Leningrad: Sovetskii pisatel', 1971.
Saltykov-Schedrin, M. E. *The Golovlyov Family*. Translated by Samuel Cioran. Ann Arbor, Mich.: Ardis, 1977.
——. *Sobranie sochinenii v dvadtsati tomakh*. Moscow: Khudozhestvennaia literatura, 1968.
Semenov, D. D. *Otchiznovedenie: Rossiia po razskazam puteshestvennikov i uchenym issledovaniiam*. Saint Petersburg: Knigoprodavtsa, 1866.
[S. fon F.] *Puteshestvie kritiki*. Moscow: Izdatel'stvo Moskovskogo universiteta, 1951.
Shevyrev, Stepan. *Poezdka v Kirillo-Belozerskii monastyr': Vakatsionnye dni professora S. Shevyreva v 1847 godu*. 2 vols. Moscow, 1850.

BIBLIOGRAPHY

Shishkin, I. I. *Ivan Ivanovich Shishkin: Perepiska, dnevnik, sovremenniki o khudozhnike*. Leningrad: Iskusstvo, 1984.
Shishkina, O. P. *Zametki i vospominaniia russkoi puteshestvennitsy*. Saint Petersburg, 1843.
Shkliarevskii, A. S. "Peizazhi chetvertoi Peredvizhnoi vystavki." *Kievlianin* (1876).
Sidorov, V. M. *Volga*. Saint Petersburg, 1895.
Sleptsov, V. A. *Sochineniia v dvukh tomakh*. Moscow: Khudozhestvennaia literatura, 1957.
Sollogub, V. A. *Tarantas*. Moscow: Khudozhestvennaia literatura, 1955.
Somov, Orest. *Orest Somov: Selected Prose in Russian*. Translated by John Mersereau, Jr., and George Harjan. Ann Arbor: University of Michigan Press, 1974.
Stasov, V. V. *Stat'i ob iskusstve*. Moscow: Iskusstvo, 1937.
Subbotin, A. P. *Volga i Volgary*. Saint Petersburg, 1894.
Sumarokov, A. P. *Izbrannye proizvedeniia*. Leningrad: Sovetskii pisatel', 1951.
———. *Stikhotvoreniia*. Leningrad: Sovetskii pisatel', 1953.
Svinin, Pavel. *Sketches of Moscow and St. Petersburg*. Philadelphia: Thomas Dobson, 1813.
Tarachkov, A. *Putevyia zametki po Orlovskoi i sosedeniaiushchii s neiu guberniiam*. Orel, 1862.
Tiutchev, F. I. *Izbrannoe*. Edited by A. N. Petrov. Moscow: Moskovskii rabochii, 1985.
Tolstoy, L. N. *Childhood, Boyhood, Youth*. Translated by Rosemary Edmonds. New York: Penguin Books, 1964.
Trediakovskii, V. K. *Izbrannye proizvedeniia*. Leningrad: Sovetskii pisatel', 1963.
Tsimmerman, E. P. *Vniz po Volge*. Moscow, 1896.
Turgenev, I. S. *Fathers and Sons*. Translated by Ralph E. Matlaw. New York: W. W. Norton, 1966.
———. *A Hunter's Sketches*. Translated by Raissa Bobrova. Moscow: Progress Publishers, 1979.
———. *Polnoe sobranie sochinenii*. Moscow-Leningrad: Izdatel'stvo Akademii nauk SSSR, 1963.
Urusov, G. G. "Vystavka khudozhestvennykh proizvedenii tovarishchestva Peredvizhnykh vystavok v Rossii i moskovskogo uchilishcha zhivopisi, vaiania, i arkhitektury." *Beseda*, no. 12 (December 1872): 25.
Vagner, N. K. "Peizazh i ego znachenie v zhivopisi." *Vestnik Evropy* (April 1873): 753-64.
Valueva-Munt, A. P. *Po velikoi russkoi reke*. Saint Petersburg, 1895.
Venetsianov, A. G. *Aleksei Gavrilovich Venetsianov: Stat'i, pis'ma, sovremenniki o khudozhnike*. Edited by A. V. Kornilova. Leningrad: Iskusstvo, 1980.
Venevitvinov, D. V. *Polnoe sobranie stikhotvorenii*. Leningrad: Sovetskii pisatel', 1960.
Verderevskii, E. A. *Ot zaural'ia do zakavkazia*. Moscow: 1857.
Viazemskii, P. A. *Estetika i literaturnaia kritika*. Moscow: Iskusstvo, 1984.
———. *P. A. Viazemskii: Sochineniia v dvukh tomakh*. Moscow: Khudozhestvennaia literatura, 1982.

BIBLIOGRAPHY

———. *Stikhotvoreniia*. Saint Petersburg: M. M. Stasiulevich, 1880.
Vishniakov, E. P. *Istoki Volgi (nabroski perom i fotografiei)*. Saint Petersburg, 1893.
Zhivopisnaia Rossiia: Otechestvo nashe v ego zemelnom, istoricheskim, plemennom, ekonomicheskom, i bytovom znachenii. Edited by Petr Semenov-Tian-Shanskii. Saint Petersburg: M. O. Volf, 1881–1901.

SECONDARY SOURCES

Anderson, Benedict. *Imagined Communities: Reflections on the Origin and Spread of Nationalism*. London: Verson, 1983.
Anderson, Roger, and Paul Debreczeny, eds. *Russian Narrative and Visual Art: Varieties of Seeing*. Gainesville: University of Florida Press, 1994.
Andrews, Malcolm. *The Search for the Picturesque: Landscape Aesthetics and Tourism in Great Britain, 1760–1800*. Stanford: Stanford University Press, 1989.
Anisov, Lev. *Shishkin*. Moscow: Molodaia gvardiia, 1991.
Anker, Valentina. *Alexandre Calame: Vie at oeuvre: Catalogue raisonné de l'oeuvre peint*. Fribourg, Switzerland: Office du Livre, 1987.
Asaf'ev, B. V. *Russkaia zhivopis': Mysli i dumy*. Leningrad: Iskusstvo, 1966.
Asvarishch, B. I. *Kushelevskaia galereia zapadnoevropeiskaia zhivopis' XIX veka: Katalog vystavki*. Saint Petersburg: Gosudarstvennyi ermitazh, 1993.
Azadovskii, M. K. *Istoriia russkoi fol'kloristiki*. Moscow: Ministerstvo prosveshcheniia RSFSR, 1963.
Baehr, Stephen Lessing. *The Paradise Myth in Eighteenth-Century Russia: Utopian Patterns in Early Secular Russian Literature and Culture*. Stanford: Stanford University Press, 1991.
Barrell, John. *The Dark Side of Landscape: The Rural Poor in English Landscape*. Cambridge: Cambridge University Press, 1980.
———. *The Idea of Landscape and the Sense of Place*. Cambridge: Cambridge University Press, 1972.
Bassin, Mark. "Inventing Siberia: Visions of the Russian East in the Early Nineteenth Century." *American Historical Review* 96 (June 1991):763–94.
Benua, Aleksandr. *Russkaia shkola zhivopisi*. Saint Petersburg: R. Golike and A. Vilburg, 1904.
Berger, John. *About Looking*. New York: Pantheon Books, 1980.
Berlin, Isaiah. *Russian Thinkers*. New York: Penguin Books, 1978.
Bermingham, Ann. *Landscape and Ideology: The English Rustic Tradition, 1740–1860*. Berkeley: University of California Press, 1986.
Black, Jeremy. *The British Abroad: The Grand Tour in the Eighteenth Century*. New York: St. Martin's Press, 1992.
Blum, Jerome. *Lord and Peasant in Russia from the Ninth to the Nineteenth Century*. New York: Atheneum, 1968.
Boele, Otto. *The North in Russian Romantic Literature*. Amsterdam: Editions Rodopi, 1996.
Botkina, A. P. *Pavel Mikhailovich Tret'iakov v zhizni i iskusstve*. Moscow: Iskusstvo, 1993.
Brooks, Jeffrey. *When Russia Learned to Read: Literacy and Popular Literature,*

1861–1917. Princeton: Princeton University Press, 1985.
Brown, William Edward. *A History of Russian Literature in the Eighteenth Century.* Ann Arbor, Mich.: Ardis, 1980.
———. *A History of Russian Literature of the Romantic Period.* 4 vols. Ann Arbor, Mich.: Ardis, 1986.
Bulgakov, F. I. *Al'bom russkoi zhivopisi kartiny V. D. Orlovskago.* Saint Petersburg, 1888.
Burkhart, A. J., and S. Medlik. *Tourism: Past, Present, and Future.* London: Heinemann, 1974.
Buzard, James. *The Beaten Track: European Tourism, Literature, and the Ways to Culture, 1800–1918.* New York: Oxford University Press, 1993.
Cafritz, Robert C., Lawrence Gowing, and David Rosand. *Places of Delight: The Pastoral Landscape.* Washington, D.C.: Phillips Collection; National Gallery of Art, 1988.
Chernevich, Elena. *Russian Graphic Design, 1880–1917.* New York: Abbeville Press, 1990.
Cherniavsky, Michael. *Tsar and People: Studies in Russian Myths.* New Haven: Yale University Press, 1961.
Clark, Kenneth. *Landscape into Art.* Boston: Beacon Press, 1949.
Clark, T. J. *Image of the People: Gustave Courbet and the Second French Republic, 1848–1851.* London: Thames and Hudson, 1973.
———. *The Painting of Modern Life.* New York: Alfred A. Knopf, 1985.
Clowes, Edith, Samuel Kassow, and James West, eds. *Between Tsar and People: Educated Society and the Quest for Public Identity in Late Imperial Russia.* Princeton: Princeton University Press, 1991.
Cosgrove, Denis. *Social Formation and Symbolic Landscape.* Totowa, N.J.: Barnes and Noble Books, 1984.
Cracraft, James. *The Petrine Revolution in Russian Imagery.* Chicago: University of Chicago Press, 1997.
Crandell, Gina. *Nature Pictorialized: "The View" in Landscape History.* Baltimore: Johns Hopkins University Press, 1993.
Daniels, Stephen. *Fields of Vision: Landscape Imagery and National Identity in England and the United States.* Princeton: Princeton University Press, 1993.
Danilevskii, R. Iu. *Rossiia i Shveitsariia: Literaturnye sviazi XVII–XIX vv.* Leningrad, 1984.
Degot, E. "Bol'shoi i malyi mir v russkom peizazhe romanticheskoi traditsii." In *Prostranstvo kartiny.* Edited by Natal'ia Olegovna Tamruchi. Moscow: Sovetskii khudozhnik, 1989.
Dickinson, Sara. "Imagining Space and the Self: Russian Travel Writing and Its Narrators, 1762–1825." Ph.D. diss., Harvard University, 1985.
Diment, Galya, and Yuri Slezkine, eds. *Between Heaven and Hell: The Myth of Siberia in Russian Culture.* New York: St. Martin's Press, 1993.
Dolzhenko, G. P. *Istoriia turizma v dorevoliutsionnoi Rossii i SSSR.* Rostov na Donu: Rostovskii Universitet, 1988.
Durkin, Andrew. *Sergei Aksakov and Russian Pastoral.* New Brunswick, N.J.: Rutgers University Press, 1983.
Elliot, David. *Photography in Russia, 1840–1940.* London: Thames and Hudson, 1992.

Epshtein, Mikhail. *Priroda, mir, tainik vselennoi: Sistem peizazhnykh obrazov v russkoi poezii.* Moscow: Vysshaia shkola, 1990.
Erlich, Victor. *Gogol.* New Haven, Conn.: Yale University Press, 1969.
Fedorov-Davydov, Aleksei. *Isaak Il'ich Levitan: Zhizn' i tvorchestvo.* Moscow: Iskusstvo, 1966.
———. *Russkaia peizazhnaia zhivopis' kontsa XIX–nachala XX veka.* Moscow: Iskusstvo, 1962.
———. *Russkii peizazh kontsa XVIII–nachala XIX veka.* Moscow: Iskusstvo, 1952.
———. *Russkoe i sovetskoe iskusstvo: Stat'i i ocherki.* Moscow: Iskusstvo, 1975.
Fedotov, G. P. *The Russian Religious Mind.* Cambridge, Mass.: Harvard University Press, 1946.
Frierson, Cathy. *Peasant Icons: Representations of Rural People in Late Nineteenth-Century Russia.* New York: Oxford University Press, 1993.
Galkina, E. Z. *Russkaia khudozhestvennaia detskaia kniga.* Moscow, 1963.
Gellner, Ernest. *Nations and Nationalism.* Oxford: Blackwell Press, 1983.
Gennadi, G. N. *Spisok knig o russkikh monastyr'iakh i tserkvakh.* Saint Petersburg, 1854.
Gessen, L. A. *Russkie pisateli ob izobrazitel'om iskusstve.* Leningrad: Khudozhnik RSFSR, 1976.
Gippius, V. I. *Gogol.* Translated by Robert A. Maguire. Ann Arbor, Mich.: Ardis, 1981.
Gleason, Abbott. *Young Russia: The Genesis of Russian Radicalism in the 1860s.* Chicago: University of Chicago Press, 1980.
Gray, Camilla. *The Russian Experiment in Art, 1863–1922.* London: Thames and Hudson, 1962.
Green, Nicholas. *The Spectacle of Nature: Landscape and Bourgeois Culture in Nineteenth-Century France.* Manchester: Manchester University Press, 1990.
Greenfeld, Liah. *Nationalism: Five Roads to Modernity.* Cambridge, Mass.: Harvard University Press, 1992.
Gregory, James S. *Russian Land Soviet People: A Geographical Approach to the U.S.S.R.* New York: Pegasus, 1968.
Hamburg, Gary. *Boris Chicherin and Early Russian Liberalism.* Stanford: Stanford University Press, 1992.
Haywood, Richard Mowbray. *The Beginnings of Railway Development in Russia in the Reign of Nicholas I, 1835–1842.* Durham, N.C.: Duke University Press, 1969.
Herbert, R. L. *Barbizon Revisited.* Boston, 1962.
Hibberd, John. *Solomon Gessner: His Creative Achievement and Influence.* Cambridge: Cambridge University Press, 1976.
Hilton, Alison. "Russian Impressionism." In *World Impressionism.* Edited by Norma Broude. New York: Abrams, 1990.
Hipple, Walter John, Jr. *The Beautiful, the Sublime, and the Picturesque in Eighteenth-Century British Aesthetic Theory.* Carbondale, Ill.: Southern Illinois University Press, 1957.
Hobsbawm, Eric, and Terrence Ranger, eds. *The Invention of Tradition.* Cambridge: Cambridge University Press, 1983.
Honour, Hugh. *Neo-classicism.* New York: Penguin Books, 1968.

Hosking, Geoffrey. *Russia: People and Empire, 1552–1917.* Cambridge, Mass.: Harvard University Press, 1997.
Hubbs, Joanna. *Mother Russia: The Feminine Myth in Russian Culture.* Bloomington, Ind.: Indiana University Press, 1988.
Hunt, John Dixon, ed. *The Pastoral Landscape.* Hanover, N.H.: University Press of New England, 1992.
Hussey, Christopher. *The Picturesque: Studies in a Point of View.* New York: G. P. Putnam and Sons, 1927.
Hyde, Anne Farrar. *An American Vision: Far Western Landscape and National Culture, 1820–1920.* New York: New York University Press, 1990.
Jones, W. Gareth. *Nikolay Novikov: Enlightener of Russia.* New York: Cambridge University Press, 1984.
Kaigorodov, Dmitrii. *P. I. Chaikovskii i priroda.* Saint Petersburg, 1907.
Kamenskii. Z. A., ed. *Russkie esteticheskie traktati pervoi treti XIX veka.* Moscow: Iskusstvo, 1974.
Kantora, V. K., and A. L. Ospovata. *Russkaia estetika i kritika 40–50–kh godov XIX v.* Moscow: Iskusstvo, 1982.
Kashpurev, L. I., ed. *Peterburzhets puteshestvuet: Sbornik materialov konferentsii 2–3 marta 1995 g.* Saint Petersburg: Pilgrim, 1995.
Kaufman, R. S. *Russkaia i sovetskaia khudozhestvennaia kritika s serediny XIX v. do 1941.* Moscow: Iskusstvo, 1985.
Kiseleva, E. G. *Moskovskii khudozhestvennyi kruzhok.* Leningrad: Iskusstvo, 1979.
Kiseleva, G. G. *Khokhriakov.* Kirov, 1966.
Kochetkova, N. D. *Literatura russkogo sentimentalizma (Esteticheskie i khudozhestvennye iskaniia.* Saint Petersburg: Nauka, 1994.
Kogan, D. *Mamontovskii kruzhok.* Moscow, 1970.
Kohn, Hans. *The Idea of Nationalism: A Study in Its Origins and Background.* New York: Collier Books, 1967.
Kolesnichenko, T. V. "Filosofskiie istoki temy prirody v russkoi literature serediny XIX veka." In *Zhanry russkogo realizma: Sbornik nauchnykh trudov.* Dnepropetrovsk, 1983.
Korovin, V. I., ed. *Landshahft moikh voobrazhenii.* Moscow: Sovremennik, 1990.
Kristof, Ladis K. D. "The Geopolitical Image of the Fatherland: The Case of Russia." *Western Political Quarterly* 19 (1967):941–54.
Kryzhitskii, G. *Sud'ba khudozhnika.* Kiev: Mistetsvo, 1966.
Layton, Susan. *Russian Literature and Empire: Conquest of the Caucasus from Pushkin to Tolstoy.* Cambridge: Cambridge University Press, 1994.
LeBlanc, Ronald D. "Teniers, Flemish Art, and the National School Debate." *Slavic Review* 50 (fall 1991):576–89.
Leighton, Lauren G. *Russian Romanticism: Two Essays.* The Hague: Mouton, 1975.
Leonov, A. I., ed. *Russkoe iskusstvo: Ocherki o zhizni i tvorchestve khudozhnika.* 5 vols. Moscow: Iskusstvo, 1952–62.
Leroy-Beaulieu, Anatole. *The Empire of the Tsars and the Russians.* 3 vols. Translated by Zenaide A. Ragozin. New York: G. P. Putnam and Sons, 1893–1896.
Levin, Iu. D. *Ossian v russkoi literature: Konets XVIII–pervoi tret'i XIX v.* Leningrad: Nauka, 1980.

Levitt, Marcus C. *Russian Literary Politics and the Pushkin Celebration of 1880.* Ithaca, N.Y.: Cornell University Press, 1989.
Liaskovskaia, O. *Vasilii Grigorovich Perov: Al'bom reproduktsii.* Moscow: Izobrazitel'noe iskusstvo, 1956.
Likhachev, Dmitrii. *Poeziia sadov.* Saint Petersburg: Nauka, 1991.
———. *Zametki o russkom.* Moscow: Sovetskaia Rossiia, 1981.
Lo Gatto, Ettore. *Russi in Italia dal secolo XVII ad oggi.* Rome: Editori riuniti, 1971.
Magarshack, David. *Gogol: A Life.* London: Faber and Faber, 1957.
Maguire, Robert. *Exploring Gogol.* Stanford: Stanford University Press, 1994.
Malia, Martin. *Alexander Herzen and the Birth of Russian Socialism.* New York: Grosset and Dunlap, 1961.
Mal'tseva, Faina. *Aleksei Kondrat'evich Savrasov: Zhizn' i tvorchestvo.* Moscow: Iskusstvo, 1977.
———. *Mastera russkogo realisticheskogo peizazha.* Moscow: Iskusstvo, 1952.
Manin, V. S. *Arkhip Ivanovich Kuindzhi.* Leningrad: Khudozhnik RSFSR, 1990.
Mersereau, John, Jr. *Orest Somov.* Ann Arbor, Mich.: Ardis, 1989.
Miller, Angela L.. *Empire of the Eye: Landscape Representation and American Cultural Politics, 1825–1875.* Ithaca, N.Y.: Cornell University Press, 1993.
Minchenkov, Ia. D. *Vospominaniia o Peredvizhnikakh.* Leningrad: Khudozhnik RFSFR, 1964.
Morozov, S. *Russkaia khudozhestvennaia fotografiia: Ocherki iz istorii fotografii, 1839–1917.* Moscow: Iskusstvo, 1961.
Mosse, George L. *Nationalism and Sexuality: Middle-Class Morality and Sexual Norms in Modern Europe.* Madison: University of Wisconsin Press, 1985.
Nakhimovsky, Alexander D., and Alice Stone Nakhimovsky, eds. *The Semiotics of Russian Culture.* Ithaca, N.Y.: Cornell University Press, 1985.
Nebel, Henry M. *N. M. Karamzin: A Russian Sentimentalist.* The Hague: Mouton, 1967.
Neuhauser, Rudolf. *Towards the Romantic Age: Essays on Sentimental and Preromantic Literature in Russia.* The Hague: Martinus Nijhoff, 1974.
Nicolson, Marjorie Hope. *Mountian Gloom and Mountain Glory.* Ithaca, N.Y.: Cornell University Press, 1959.
Nikol'skii, V. I. *Priroda i chelovek v russkoi literature XIX veka (50–60–e gody).* Kalinin: Kalininskii gosudarstvennyi universitet, 1973.
Nivat, Georges. "Le Paysage russe en tant que mythe." *Rossiia/Russia* 5 (1987): 7–20.
Nochlin, Linda. *Realism.* New York: Penguin Books, 19071.
Novak, Barbara. *Nature and Culture: American Landscape and Painting, 1825–1875.* New York: Oxford University Press, 1980.
Novouspenskii, N. N. *Fedor Aleksandrovich Vasil'ev.* Moscow: Izobrazitel'noe iskusstvo, 1991.
Ogden, J. Alexander. "Fashioning a Folk Identity: The 'Peasant-Poet' Tradition in Russia (Lomonosov, Kol'tsov, Kliuev)." *Intertex* 5, no. 1 (2001): 32–45.
Olkhovsky, Yuri. *Vladimir Stasov and Russian National Culture.* Ann Arbor, Mich.: UMI Research Press, 1983.
Orlov, Vl. *Poeti-Radishchevtsi: Volnoe obshchestvo liubitelei slovestnosti, nauk, i khudozhestv.* Leningrad: Sovetskii pisatel', 1952.

Os'makov, N. V. *A. V. Kol'tsov i russkaia literatura*. Moskva: Nauka, 1988.
Ostrovskii, G. *Rasskaz o russkoi zhivopisi*. Moscow: Izobrazitel'noe iskusstvo, 1989.
Ousby, Ian. *The Englishman's England: Taste, Travel, and the Rise of Tourism*. Cambridge: Cambridge University Press, 1990.
Pallot, Judith, and Denis Shaw. *Settlement and Change in Romanov Russia*. Oxford: Clarendon Press, 1990.
Pavlovskii, B. V. *A. K. Denisov-Ural'skii*. Sverdlovsk, 1958.
Peppard, M. B. *Nikolai Nekrasov*. New York: Twayne Publishers, 1967.
Pigarev, Kiril. *Russkaia literatura i izobrazitel'noe iskusstvo (XVIII–pervaia chetvert' XIX veka*. Moscow: Iskusstvo, 1966.
———. *Russkaia literatura i izobrazitel'noe iskusstvo: Ocherki o russkom natsional'nom peizazhe serediny XIX veka*. Moscow: Iskusstvo, 1972.
Poggioli, Renato. *The Oaten Flute: Essays on Pastoral Poetry and the Pastoral Ideal*. Cambridge, Mass.: Harvard University Press, 1975.
Poppi, Claudio. "Itineraries to the Happy Country." In *Nostalgia d'Italia: Russian water-colours of the first half of the XIX century*. Florence: Ponte alle Grazie, 1991.
Roboli, T. "Literatura 'Puteshestvii.'" In *Russkaia proza: Sbornik statei*. Leningrad, 1926.
Rogger, Hans. *National Consciousness in Eighteenth-Century Russia*. Cambridge, Mass.: Harvard University Press, 1960.
———. *Russia in the Age of Modernization and Revolution*. London: Longman Group, 1983.
Roosevelt, Priscilla. *Life on the Russian Country Estate: A Social and Cultural History*. New Haven, Conn.: Yale University Press, 1995.
Russkaia usad'ba: Sbornik Obshchestva izucheniia russkoi usad'by. Moscow-Rybinsk: Rybinskoe podvore, 1994–95.
Sandler, Stephanie. *Distant Pleasures: Alexander Pushkin and the Writing of Exile*. Stanford: Stanford University Press, 1989.
Schama, Simon. *Landscape and Memory*. New York: Alfred A. Knopf, 1995.
Schonle, Andreas Xavier. "Authenticity and Fiction in the Russian Literary Journey, 1790–1840." Ph.D. diss., Harvard University, 1995.
Semenov-Tian-Shanskii, P. P. *Istoriia poluvekovoi deiatel'nosti Russkogo geograficheskogo obshchestva*. Saint Petersburg, 1896.
Shtanova, E. I. "Russko-frantsuskie khudozhestvennye sviazy v peizazhe 60–70-kh godov XIX veka," Diplomnaia rabota. Russian Academy of Art, 1988.
Simmons, Ernest. *English Literature and Culture in Russia, 1553–1840*. Cambridge, Mass.: Harvard University Press, 1935.
Smirnov, G. *Venetsianov and His School*. Leningrad: Aurora Art Publishers, 1973.
Smith, Anthony D. *National Identity*. London: Penguin Books, 1991.
Sokolov, Y. M. *Russian Folklore*. Translated by Catherine Ruth Smith. New York: Macmillan Company, 1950.
Soloukhin, Vladimir. *A Time to Gather Stones*. Translated by Valerie Z. Nollan. Evanston, Ill.: Northwestern University Press, 1993.
Stavrou, Theofanis George, ed. *Art and Culture in Nineteenth-Century Russia*. Bloomington: Indiana University Press, 1983.

Sternin, G. Iu. *Khudozhestvennaia zhizn' Rossii serediny XIX v.* Moscow: Iskusstvo, 1991.

Syrkina, Flora Iakovlevna. *Russkoe teatralno-dekoratsionnoe iskusstvo vtoroi poloviny XIX v.* Moscow: Iskusstvo, 1956.

Szporluk, Roman, ed. *National Identity and Ethnicity in Russia and the New States of Eurasia.* Armonk, N.Y.: M. E. Sharpe, 1994.

Troyat, Henri. *Divided Soul: The Life of Gogol.* New York: Minerva Press, 1975.

Valkenier, Elizabeth Kridl. *Ilya Repin and the World of Russian Art.* New York: Columbia University Press, 1991.

———. *Russian Realist Art: The State and Society: The Peredvizhniki and Their Tradition.* New York: Columbia University Press, 1977.

Van Tiegham, Paul. *Le Sentiment de la Nature dans le Préromantisme Européen.* Paris: A. G. Nizet, 1960.

Venturi, Franco. *The Roots of Revolution: A History of the Populist and Socialist Movements in Nineteenth-Century Russia.* Translated by Francis Haskell. Chicago: University of Chicago Press, 1960.

Wachtel, Andrew Baruch. *The Battle for Childhood: Creation of a Russian Myth.* Stanford: Stanford University Press, 1990.

Walicki, Andrzej. *A History of Russian Thought from the Enlightment to Marxism.* Translated from the Polish by Hilda Andrews-Rusiecka. Stanford: Stanford University Press, 1979.

Wesson, Robert G. *The Russian Dilemma.* New York: Praeger, 1986.

Wilson, Reuel K. *The Literary Travelogue: A Comparative Study with Special Relevance to Russian Literature from Fonvizin to Pushkin.* The Hague: Nijhoff, 1973.

Wortman, Richard. *The Crisis of Russian Populism.* London: Cambridge University Press, 1967.

Index

Abramtsevo (estate), 220
Achenbach, Andreas, 171
Agin, A. A., 169
Aksakov (family), 220
Aksakov, Ivan, 124, 133, 139
Aksakov, Konstantin, 124
Aksakov, Sergei, 87, 122–25, 130, 133, 151, 156, 157, 169, 177, 188, 200
 "The Blizzard," 123–24
 Family Chronicle, 127–29, 203
 Notes on Fishing, 122–23, 146
Alexander II, 77, 160, 195
Alps, The, 12, 48, 53–54, 70, 119, 149, 159, 170
Altdorfer, Albrecht, 11
Ammosov, S. N., 209
Ancient Greece, 13, 28, 38, 80
Ancient Rome, 9, 28, 35, 38, 41, 80
Arkhangelskoe (estate), 46
Avvakum, Archpriest, 29–30

Baikal (lake), 29
Baratynskii, Evgenii, 66, 81
Barbizon School, 171, 175, 188, 199
Batiushkov, K. N., 62–63, 66
Batteux, Charles, 37
The Bee [*Pchela*], 202
Belarus, 14
Belinskii, Vissarion, 89–90, 94–96, 145–46, 212, 229, 156
Benois, Aleksandr, 7, 224
Berdyaev, Nikolai, 134
Berlin, Isaiah, 60
Bermingham, Ann, 216
Blum, Jerome, 43
Boileau, Nicolas, 37
Bolotov, Andrei, 46–47
Bonaparte, Napoleon, 59–61, 88, 116

Brazil, 157
Bulgakov, Sergei, 228–29
Bulgarin, Faddei, 38, 67
Burke, Edmund, 11
Bykov, Nikolai, 176, 186

Calame, Alexandre, 170–71
Cameron, Charles, 41
Catherine II (the Great), 27, 39, 43, 59, 80, 128, 165, 224–25
 The Antidote, 16
 Charter to the Nobility, 35
 Instructions, 36
Caucasus, The, 13, 57, 65, 66, 67, 81, 97, 115, 144
Central Asia, 13
Chaadaev, Petr, 24, 88, 137
Chappe, d'Auteroche, Abbe, 16
Chekhov, Anton, 221–22
Chernetsov, Grigorii and Nikanor, 76–78, 92–93, 208
Chernyshevskii, Nikolai, 148–50, 151, 168, 178
Chicherin, Boris, 205
China, 10, 51
Clark, Kenneth, 187
Cole, Thomas, 123
Conversation [*Beseda*], 193
Corot, Camille, 166, 171, 175
Cosgrove, Denis, 9
Crimea, The, 13, 14, 66, 67, 81, 149, 175, 200, 206
Crimean War, The, 121, 161, 172

Daubigny, Charles, 171
Decembrist Movement, The, 60
Delille, Jacques, 48, 51, 69
Denisov-Uralskii, A. K., 208

INDEX

Derzhavin, Gavriil, 63
 "To Evgeny. Life at Zvanka," 46
 "The Waterfall," 57–58
Diaz de la Pena, Narcisse-Virgile, 171
Dmitriev, I. I., 172
Dmitriev, Ivan, 35, 51, 68, 77, 91, 161
Dmitriev, M. A., 51–52
Dmitriev, V. V., 53
Dnieper River, 34, 65, 91, 149
Dobroliubov, Nikolai, 150
Dolgorukov, I. M., 42
Dostoevsky, Fedor, 4, 24, 139, 155, 193–94, 226
Dubovskii, N. N., 200, 206
Dupre, Jules, 171
Durkin, Andrew, 124, 129

Epshtein, Mikhail, 19–20, 68
Egypt, 9
England, 6, 11, 12, 13, 53, 92
Ermenonville (park), 38

Fedorov-Davydov, Aleksei, 213
Fet, Afansii, 58, 172
Finland, 14, 57, 65, 66–67, 149
Flaubert, Gustave, 154
Fonvizin, Denis, 50, 63
Fremont, John C., 6
French Impressionism, 198
French Revolution, The, 60
Friedrich, Casper David, 93, 191
Frierson, Cathy, 152, 215

Gardens and Parks, 31, 41, 45–47, 48, 80–81
Gatchina (park), 41, 140
Geography of Russia, 6, 13–19
Germany, 97–98, 149, 175, 186
Gershchenkron, Alexander, 137
Gessner, Solomon, 12, 38, 47, 48, 49–50, 56, 69–70
Glinka, F. N., 63, 66–67
Gnedich, Nikolai, 69–70, 71, 72, 79, 81
Gogol, Nikolai, 15, 64, 73, 90, 91–94, 95, 119, 123, 133, 139, 140, 143, 144, 151, 154, 155, 157, 163, 169, 191, 193

Dead Souls, 98, 113, 115, 118, 119, 128, 132, 136–38, 142, 145, 147, 158
 "Nevskii Prospekt," 97
 "Old World Landowners," 92
 Taras Bulba, 93–94, 116
Gombrich, E. H., 11
Goncharov, Ivan, 125–27, 129
Goravskii, A. G., 173
Grainfield [*Niva*], 197, 202, 224
Gray, Thomas, 47
Great Reforms, The, 194
Greenfeld, Liah, 24
Grigor'ev, Applon, 24, 226
Grigorovich, Dmitrii, 146–47, 153, 155, 156, 171

Hegel, G. W. F., 88
Herder, Johann, 37, 68
Herzen, Aleksandr, 122, 125, 153
Horace, 27, 40
Hosking, Geoffrey, 219
Hunt, John Dixon, 83
Hussey, Christopher, 83
Hyde, Anne Farrar, 6

Iakushkin, Pavel, 151, 179
Iaroslavl, 34, 77
Iazykov, N. M., 68
Icon imagery, 28, 29–30
Imperial Academy of Arts, 34, 41, 71, 76, 165, 166, 171, 172, 174, 192, 195
Imperial Russian Geographical Society, 151
Italy, 10, 13, 48, 63–64, 97–98, 119, 143, 149, 157, 166, 175, 186
Iuon, Konstantin, 201
Ivanov, Aleksandr, 41

Jerusalem, 75

Kamchatka, 39
Kamenev, Lev, 166, 175, 182, 207–8
Kant, Immanuel, 93
Kapnist, Vasilii, 46, 58
Karamzin, Nikolai, 4, 35, 47–51, 54, 59, 64, 68, 77, 85, 91, 125, 161

· 274 ·

INDEX

"The Countryside," 49
History of the Russian State, 60
Letters of a Russian Traveler, 49–50, 113
"On Love of the Fatherland and National Pride," 3
"Poor Liza," 50–51, 172
Karelia, 67
Kavelin, Konstantin, 215
Khokhriakov, N. N., 206
Klever, Iu., 197
Kliuchevskii, Vasilii, 223
Klodt, Mikhail, 166, 174, 175, 180–81, 192, 207
Kolesnichenko, T. V., 118
Kol'tsov, Aleksei, 91, 94–97, 115, 121, 156, 157, 191, 212
"The Mower," 95–97
Korolenko, Vladimir, 3
Korovin, Konstantin, 201, 207–8, 221
Krachkovskii, I. E., 197
Kramskoi, Ivan, 182, 184, 191, 199, 200
Krasnoiarsk, 53
Kryzhitskii, K. Ia., 197, 207
Kuindzhi, Arkhip, 181, 194, 202
Kukolnik, Nestor, 73
Kurakin, Aleksandr, 46
Kushelev-Bezborodko, N. A., 171

Land and Freedom, 226
Landscape and eroticism, 42–43, 50
Landscape and gender, 42–43, 209–10, 226–27
Layton, Susan, 66
Lebedev, Mikhail, 41, 71, 166, 186
Lermontov, Mikhail, 91, 121, 155, 160
"Native Land," 115–18, 132
Leroy-Beaulieu, Anatole, 17–18
Levitan, Isaak, 7, 191, 201, 206, 208, 221–22, 224
Liadov, Anatolii, 219
Likhachev, Dmitrii, 31, 49, 78, 214
Lomonosov, Mikhail, 35, 37, 39
Lorrain, Claude, 11, 12, 13, 40, 41, 50, 82
Lotman, Iurii, 47
Lubok imagery, 30
Lunacharskii, Anatolii, 86

Maikov, Valerian, 169–70, 173
Maksimov, Sergei, 151, 179
Malia, Martin, 137
Mal'tseva, Faina, 19, 168, 213
Mamontov, Savva, 220
Martynov, Andrei, 52–53
Marx, Leo, 45
Matskevich, David, 119
Matveev, Fedor, 41
Merzliakov, A. F., 41–42, 50
Meshcherskii, A. I., 197
Miasoedov, G. G., 167, 227
Michelet, Jules, 210
Mikhalovskoe (estate), 86
Millet, Jean-Francois, 171
Molchanov, A. A., 152–53
Montesquieu, Charles de Secondat, 209
Moscow, 50, 73, 75, 140, 144, 204, 208
Moscow School of the Arts, 177
Moscow University, 118
Moser, Charles, 157
Murav'ev, Andrei, 75–76, 77, 118
Murav'ev, Mikhail, 40, 58
Muscovy, 14, 28–31
Mussorgsky, Modest, 213

Nabokov, Vladimir, 79, 83
Nadezhdin, N. I., 35
Nekrasov, Nikolai, 25, 134, 159–63, 169, 203, 212
"Homeland," 160
"On the Volga," 161–62
"Peasant Children," 162–63, 184
"Sasha," 159, 162
"Silence," 160–61
"Who Can Be Happy and Free in Russia?" 163
Neoclassicism, 36–44
Nesterov, Mikhail, 192, 220
Neva River, 70, 81
Nevzorov, M., 55
Nicholas I, 60, 89, 165
Nikitin, Ivan, 87, 121, 122, 125, 133
Nivat, Georges, 7, 20, 21, 157
Northern Bee [*Severnaia Pchela*], 67
Notes of the Fatherland [*Otechestvennyi Zapiski*], 73, 142

INDEX

Novgorod, 74
Novikov, N. I., 54

Odessa, 81
"Official Nationality," 60, 118
Ogarev, Nikolai, 153–54
Orlovskii, Vladimir, 166,170,174,197
Ossian (James MacPherson), 47, 56–58, 62–63, 66–67
Ostroukhov, Il'ia, 221
Ovid, 92
Ozerov, Vladislav, 62

Panaev, V. I., 70
Panslavism, 23, 163
Paris, 33, 176, 207
Paris World's Fair (1878), 204
Passek, Vadim, 92–93
Pastoral landscape, 27–28, 31–32, 38–54, 124–33, *passim*
Pavlovsk (park), 41
Pechorskii Monastery, 142
Peredvizhniki (Association of Traveling Art Exhibits), 168–69, 172, 182, 192, 195–98, 200, 202, 207, 208, 209, 217, 221, 224
Perov, Vasilii, 180
Peter I (the Great), 28, 31, 32, 34, 36, 60
Peter III, 39
Picturesque aesthetics, 12, 48, 59–86
Picturesque Survey [*Zhivopisnoe Obozrenie*], 197
Pigarev, Kirill, 19
Pisarev, Dmitrii, 152
Pleshcheev, A. N., 154–56
Pochvenniki, 24, 25, 226
Poggioli, Renato, 43, 87
Pogodin, Mikhail, 98
Polenov, Vasilii, 191, 218
Polenova, Elena, 218–19, 220
Polevoi, Nikolai, 94
Potemkin, Grigorii, 57
Poussin, Nicholas, 11, 40,41,49
Prague, 199
Prakhov, Adrian, 193, 204, 205, 210, 213, 214
Prokopovich, Feofan, 34

Pugachev, Emelian, 43
Pushkin, Aleksandr, 21,27, 51, 61, 63, 66, 73, 78–86, 88, 90, 91, 115, 117, 128, 132, 140, 169, 193, 229
"Autumn (A Fragment)," 85–86
"The Countryside," 80–84, 135, 161
Eugene Onegin, 81–85, 135, 155
"My Ruddy Critic," 135–36

Radishchev, Aleksandr, 54–55
Realism in art, 167–69
Repin, Il'ia, 180
Reshetnikov, Fedor, 150
Rhine River, 97–98
Robert, Hubert, 46
Rogger, Hans, 23, 45
Rome, 98
Roosevelt, Priscilla, 45
Rosa, Salvator, 11, 12, 38, 49
Rostovtsev, A., 34
Rousseau, Jean-Jacques, 12, 32, 47, 49, 200, 214
Rousseau, Theodore, 166, 171
Rubens, Peter Paul, 71
Russian Art Sheet [*Russkii Khudozhestvennyi Listok*], 173
Russian Orthodoxy, 28, 31, 75–76, 119–21
Russian Populism, 23, 182, 147–53, 213–20
Russian Society of Tourism and Study of the Fatherland, 4
Ryleev, K. F., 68

Saint Petersburg, 14, 31, 34, 39, 41, 62–63, 67, 69, 70, 73, 76, 97, 140, 171, 174, 204, 215
Saint Petersburg Herald [*Sankt-Peterburgskii Vestnik*], 47
Saint Petersburg Society for the Encouragement of Artists, 172
Saltykov-Shchedrin, Mikhail, 147–48, 156–59, 163
The Golovyov Family, 157
Provincial Sketches, 157–58
"Quiet Refuge," 158–59
Sand, Georges, 130
Sandler, Staphanie, 80

INDEX

Savrasov, Aleksei, 166, 174, 177–78, 181, 182, 188–91, 193, 197, 198, 201, 213, 221, 224
 Elk Island in Sokolniki, 188–90
 The Rooks Have Returned, 190–91, 218
 Steppe in the Daytime, 177
 View of the Kremlin from the Crimean Bridge in Foul Weather, 177
 View in the Vicinity of Oranienbaum, 177
 Village View, 188
Scandinavia, 13, 44, 66–67
Scott, Walter, 92
Sentimentalism, 47–51, 52
Serov, Valentin, 221
Shakespeare, William, 38
Shakhovskoi, Aleksandr, 55
Shalikov, Petr, 51
Shchedrin, Semen, 41
Shchedrin, Silvestr, 41, 71, 166
Shelgunov, Nikolai, 150
Shevyrev, Stepan, 118–21, 122, 132, 191
Shils, Edward, 22
Shirinskii-Shkhmatov, S. A., 62
Shishkin, Ivan, 166, 171, 175–76, 182, 185–88, 191, 193, 197, 199–206, 207, 213, 218, 221, 224, 227
 Backwoods, 186–87
 Countess Mordvinova's Forest (Peterhof), 200
 Pine Forest in Viatka Province, 186–87
 Trees Felled by the Wind (Vologda Woods), 188, 189
Shishkov, Aleksandr, 59, 62
Shkliarevskii, A. S., 208–10, 219
Siberia, 14, 18, 29, 39, 51, 53, 65, 155
Slavophilism, 88, 145, 163, 182
Sleptsov, Vasilii, 152
Sollogub, Vladimir, 140–46, 163
Solukhin, Vladimir, 3
Somov, Konstantin, 224
Somov, Orest, 64–66
Stasov, Vladimir, 72, 168, 173, 178–81, 195, 204, 213
Steele, Richard, 40
Sterne, Laurence, 47, 55
Sternin, Grigorii, 170

Stourhead (Park), 38
Stroganov, P. S., 215
Sublime aesthetics, 11, 56–58
Sukhodolskii, Petr, 166, 174, 175, 178–80, 181, 217
Sumarokov, Aleksandr, 35, 40, 51, 125
Svinin, Pavel, 72–75, 77, 88, 118, 140
Switzerland, 49, 51, 53, 66, 97–98, 119, 149, 157, 175, 208

Taine, Hippolyte, 130
Tarachkov, A., 152
Tchaikovsky, P. I., 223, 226
Teniers II, David, 82
Theocritus, 41, 70
Thomson, James, 11, 47, 48, 49
Thoreau, Henry David, 49, 123
Tiutchev, Fedor, 24, 138–40, 143, 144, 145, 228, 151, 154, 155, 157, 160, 163
 "On the Way Home," 139–39
 "These Poor Villages," 139–40
Tobolsk, 53
Tolstoy, Leo, 125, 127, 129, 213, 214, 227
Travel and tourism, 4, 5, 15–16, 49–50, 51–56, 72–78, 140–45, 151–53
Trediakovskii, Vasilii, 33, 40, 80
Tret'iakov, Pavel, 165, 173
Tret'iakov Gallery, 173
Trinity-St. Sergius Monastery, 75
Troyon, Constant 171
Tsarskoe-Selo, 38, 41, 140
Turgenev, Aleksandr, 69
Turgenev, Ivan, 125, 150, 151, 152, 157, 169, 177, 193, 199, 203, 211, 212
 Fathers and Sons, 152
 Nest of Gentry, 154
 Notes of a Hunter, 120–32

Ukraine, 14, 51, 65, 75, 91–94, 97, 215
United States, 6, 15, 45, 73, 116, 123, 207
Ural Mountains, 14, 53, 144, 208, 211
Urusov, G. G., 193

· 277 ·

INDEX

Uspenskii, Gleb, 24, 25
Uspenskii, Nikolai, 150
Uvarov, Sergei, 60

Vagner, N. K., 210–12, 213, 215, 219
Valkenier, Elizabeth, 169, 195
Van Rijn, Rembrandt, 8
Van Ruisdael, Jacob, 38
Vasil'ev, Fedor, 166, 171, 182–91, 193, 197, 198, 200, 215–17
 The Thaw, 183–84, 199
 The Village, 183
 Wet Meadow, 184–85, 189, 218
Vasnetsov, Appolonarii, 206
Vasnetsov, Viktor, 220
Venetsianov, Aleksei, 71–72, 79, 88
Venevitvinov, Dmitrii, 63
Verderevskii, E. A., 144–45
Viazemskii, Petr, 62, 68–69, 81, 83, 140

Virgil, 41, 51, 70
Volga River, 34, 35, 55, 63, 65, 68, 76–78, 92–93, 126, 149, 152, 161–62, 175, 180, 208, 210, 224
Volkovo River, 46
Volkovskii, I. V., 175
Von Haller, Albrecht, 12
Vorob'ev, Sokrat, 185

Westernism, 88
Williams, Raymond, 32
World of Art, 224
Worldwide Illustration [*Vsemirnaia Illiustratsiia*], 197

Zhiguli Mountains, 77
Zhivopisets [*The Painter*], 54
Zhukovskii, Vasilii, 51
Zubov, A. F., 34

94 Gogol Ukr nature v Ru nature - 97 g → Ru
 (inc. steppe as Ukr/Malor, not Asiatic)
 of Danilevsky??
95 Slavophiles extolling steppe. [Ukr/Novor steppe
 v StE steppe?]

 steppes - upcorded refs to as Ru in ch. 3, too
122 Aksakov. -[Orenberg - Asiatic steppes]
122-8. Populating steppe?, Russifying steppe?
177 Savrasov. painting of steppe, Ukr. of Gogol
188 Shishkin - forests - Ru nature
197- Dostoevsky on forests as national landscape
 v Shishkin forests as Ru
206 Nat landscape > Su landscape
209 steppe as Ru